Cartoon Vision

The publisher and the University of California Press Foundation gratefully acknowledge the generous support of the Ahmanson Foundation Endowment Fund in Humanities.

Cartoon Vision

UPA ANIMATION AND POSTWAR AESTHETICS

Dan Bashara

UNIVERSITY OF CALIFORNIA PRESS

University of California Press, one of the most distinguished university presses in the United States, enriches lives around the world by advancing scholarship in the humanities, social sciences, and natural sciences. Its activities are supported by the UC Press Foundation and by philanthropic contributions from individuals and institutions. For more information, visit www.ucpress.edu.

University of California Press
Oakland, California

© 2019 by Dan Bashara

Library of Congress Cataloging-in-Publication Data

Names: Bashara, Daniel, 1982- author.
Title: Cartoon vision : UPA animation and postwar aesthetics / Daniel Bashara.
Description: Oakland, California : University of California Press, [2019] | Includes bibliographical references and index. |
Identifiers: LCCN 2018038418 (print) | LCCN 2018042106 (ebook) | ISBN 9780520970380 (Epub) | ISBN 9780520298132 (cloth : alk. paper) | ISBN 9780520298149 (pbk. : alk. paper)
Subjects: LCSH: Animated films—United States—History and criticism. | United Productions of America. | Animated films—Aesthetics. | Art and motion pictures. | Motion pictures and architecture.
Classification: LCC NC1766.U5 (ebook) | LCC NC1766.U5 B38 2019 (print) | DDC 791.43/340973—dc23
LC record available at https://lccn.loc.gov/2018038418

28 27 26 25 24 23 22 21 20 19
10 9 8 7 6 5 4 3 2 1

*To my parents, Chris and Sue Bashara,
who made everything possible*

CONTENTS

List of Illustrations ix
Acknowledgments xi

Introduction 1

1 · Postwar Precisionism: Order in American Modernist
Art and the Modern Cartoon 21

2 · Unlimited Animation: Movement in Modern
Architecture and the Modern Cartoon 65

3 · Condensed Works: Communication in Graphic
Design and the Modern Cartoon 115

4 · The Design Gaze: Cartoon Logic in Hollywood
Cinema and the Avant-Garde 164

Conclusion 210

Notes 217
Bibliography 249
Index 263

ILLUSTRATIONS

1. Louis Lozowick, *New York, Brooklyn Bridge*, 1923. *32*
2. Charles Sheeler, *Church Street El*, 1920. *33*
3. *Punchy de Leon* (John Hubley, 1950). *34*
4. *Stage Door Magoo* (Pete Burness, 1955). *35*
5. Charles Sheeler, *Barn Abstraction*, 1917. *36*
6. *Gerald McBoing Boing* (Bobe Cannon, 1950). *37*
7. Stuart Davis, *Rue des Rats No. 2*, 1928. *48*
8. *Rooty Toot Toot* (John Hubley, 1952). *49*
9. Stuart Davis, *Men and Machine*, 1934. *50*
10. *Fudget's Budget* (Bobe Cannon, 1954). *51*
11. *The Expanding Airport* (Charles and Ray Eames, 1958). *68*
12. Walker Residence. *84*
13. *Pump Trouble* (Gene Deitch, 1954). *92*
14. Richard Neutra, Chuey House. *98*
15. *Gerald McBoing Boing* (Bobe Cannon, 1950). *99*
16. *Christopher Crumpet's Playmate* (Bobe Cannon, 1955). *105*
17. *Gerald McBoing Boing* (Bobe Cannon, 1950). *107*
18. *The Rise of Duton Lang* (Osmond Evans, 1955). *110*
19. *Christopher Crumpet* (Bobe Cannon, 1953): the impossible indoor/outdoor space. *113*
20. U.S. Army Air Force training manual (Will Burtin and Laurence Lessing). *131*
21. *Now Hear This* (Chuck Jones, 1962). *136*

22. *The Strange Case of the Cosmic Rays* (Frank Capra and Bill Hurtz, 1957). *137*
23. *The Tell-Tale Heart* (Ted Parmelee, 1953). *141*
24. Mural at the Container Corporation's Lake Shore Mill in Chicago. *147*
25. *The Four Poster* (Irving Reis, 1952), animated interstitials by John Hubley. *151*
26. *A Is for Atom* (Carl Urbano, 1953). *159*
27. *Fudget's Budget* (Bobe Cannon, 1954). *163*
28. *The Band Wagon* (Vincente Minnelli, 1953), "Triplets." *181*
29. *Singin' in the Rain* (Stanley Donen and Gene Kelly, 1952), "Broadway Melody." *183*
30. *Singin' in the Rain* (Stanley Donen and Gene Kelly, 1952), "Broadway Melody." *184*
31. *Funny Face* (Stanley Donen, 1957), "Think Pink." *185*
32. *Red Garters* (George Marshall, 1954), "Brave Man." *187*
33. *Red Garters* (George Marshall, 1954), "Meet a Happy Guy." *188*
34. *7362* (Pat O'Neill, 1965–1967). *194*
35. *Bridges-Go-Round* (Shirley Clarke, 1958). *195*
36. *The Band Wagon* (Vincente Minnelli, 1953), "Girl Hunt." *197*
37. *Broadway by Light* (William Klein, 1958). *199*
38. László Moholy-Nagy, *Light Prop for an Electric Stage (Light-Space Modulator)*, 1930. *202*
39. *Double Indemnity* (Billy Wilder, 1944). *204*
40. *D.O.A.* (Rudolph Maté, 1949). *205*

ACKNOWLEDGMENTS

This book, far from being a solitary intellectual endeavor, is the product of the support, guidance, friendship, and kindness of more people than I can thank properly here; as everywhere else, I will simply try to do by best.

My first gratitude goes to Northwestern University's Screen Cultures department, which provided me with the most profound, disorienting, stimulating, and ultimately rewarding experience of my life thus far. I am especially grateful to my dissertation committee, who oversaw this project in its first iteration. Their enthusiasm and guidance were invaluable as I built this manuscript. Scott Curtis, the consummate adviser, was a paragon of patience and wisdom; I am lucky to have been his student, and I am lucky to be his friend. Lynn Spigel taught me to balance the rigor of intellectual inquiry with the spirit of humor and fun that brings scholarly work to life. Jacob Smith pushed this project in thrilling directions while simultaneously keeping it on the right track. In addition, I owe much of my scholarly orientation to Jeffrey Sconce, Jacqueline Stewart, Christine Bell, Chuck Kleinhans, Hamid Naficy, and Mimi White, whose influence in my formative years as a scholar I carry with me today.

I am deeply grateful as well to the Graduate School at Northwestern University, whose Graduate Research Grant funded the archival visits so central to this project, and to DePaul University and its College of Communication for their generosity and flexibility, which greatly enabled the writing of the finished product. I am especially thankful to Michael DeAngelis, Salma Ghanem, and Bruno Teboul, whose support—both institutional and deeply human—at various points in my employment have kept a roof over my head and freed me to devote the necessary time and energy to this book.

At the University of California Press, Raina Polivka has been a gracious and patient editor, helping to shape this book into its finished form and answering my hundreds of questions along the way; it is a much better book because of her influence. Zuha Khan and Elena Bellaart have been immensely supportive and helpful as well, and I would have been utterly helpless throughout the publishing process without them. Finally, Anne Canright's meticulous attention to my manuscript saved me from many a syntactical misstep and grammatical hiccup, and always pushed me toward clarity.

The present work was also made possible by the help and kindness of the archivists and librarians at the Smithsonian Institution's Archives of American Art, The ASIFA-Hollywood Animation Archive, the Margaret Herrick Library, the Academy Film Archives, the UCLA Film & Television Archive, and the Museum of Modern Art, without whom I would have had to base this entire book on my simple enthusiasm for cartoons. I owe special thanks to Stephen Worth, who is doing the holy work of running Animation Resources and, at the time of my deepest research, curated the ASIFA-Hollywood archive and its miraculous hard drive of out-of-print UPA cartoons; to May Haduong, who put me in front of a rare print of *Christopher Crumpet*, unwittingly shaping the course of my research; to Mark Quigley, who was generous enough to share with me his personal VHS copies of *The Boing Boing Show*; to Barbara Hall, who shepherded me through the Herrick Library's massive collection; to Whitney May, who did the same for me at MoMA; and to Marisa Burgoin, who guided me through the György Kepes Papers at the Archives of American Art.

I am also profoundly thankful for the love and support of my graduate and postgraduate compatriots, whose intellectual energy has been a reliable source of inspiration, challenge, ideas, and love. This book would not have happened without Jocelyn Szczepaniak-Gillece, whose professional and personal example I have followed since the day we met and who at every turn has pushed this project to be the strongest and most complex exploration it could be. I do not know who I would be without her influence. Beth and Veronica Corzo-Duchardt have had a profound impact as well; their approaches to both my work and their own have greatly influenced my thinking, and I am lucky to be able to consider them family. Catherine Clepper, Jason Roberts, and Elizabeth Lenaghan round out my rogues' gallery; in addition to their friendship, they have contributed their time, thought, and sharp eyes to the development of this book, helping to shape its final form. These people, together with Richard Leson, Alex Thimons, Dave Sagehorn, Emily

Goodmann, Cary Elza, Alex Bevan, Linde Murugan, Alla Gadassik, Ryan Pierson, Hannah Frank, and Shira Segal, have been a crucial source of stability, insight, and support as this project has made its way from the rat's nest of my brain to the finished book you see before you. Outside of the academic world, I owe my gratitude to many friends for sticking by me through the period of this book's composition, during which I was surely insufferable. Nic McCarley, Gregg Medley, Michael Elias, Matthew Amador, Hallie Lieberman, Jamie Gentry, Michael St. John, Don and Nicole Semple, and Anthony Balderrama provided much-needed and warmly appreciated balance, love, and encouragement.

But of all of the people I couldn't have done this without, the most important are my family. Their limitless support and generosity, their belief in me that far surpasses my own, and their love and friendship mean more to me than any accomplishment of mine, past, present, or future. The respect, honesty, affection, and near-daily conversations I share with them are everything to me, and they are never out of my thoughts, not for a second. Mom, Dad, and Grammy, this book, like everything else I do, is for you.

Introduction

"THIS IS THE STORY OF GERALD MCCLOY and the strange thing that happened to that little boy." These words, despite their singsong cadence and children's-book diction, ushered in a new age of the American cartoon marked by a maturity widely perceived to be lacking in the animated shorts of Disney Studios and Warner Bros. Released in November 1950, *Gerald McBoing Boing* instantly made its production studio, United Productions of America (UPA), a major name in the Hollywood cartoon industry, netting the studio its first Oscar win two years after it began making shorts for Columbia's Screen Gems imprint. Six years later, in 1956, every single short nominated in the Best Animated Short Film category was a UPA cartoon.[1] *Gerald McBoing Boing*, a seven-minute Dr. Seuss–penned short about a small boy who finds himself unable to speak in words—only disruptive sound effects emerge from his mouth—became a box office sensation as well as a critical success. The *New York Times* observed, "Audiences have taken such a fancy to this talented young man that there has been a heap of inquiries about him and his future plans."[2] The *Washington Post* called it "so refreshing and so badly needed ... that its creators, United Productions and director Robert Cannon, rate major salutes," and international publications such as the *Times of India* dubbed it "the first really fresh cartoon work since Disney burst on the scene."[3]

The qualities that made UPA stand out—an abstract, graphic sensibility marked by simplified shapes, bold colors unmodulated by rounding effects or shadow, and a forceful engagement with the two-dimensional surface of the frame, as well as an insistence on using human characters—convinced audiences that it was aiming for an adult demographic while also retaining a childlike heart, positioning itself as a popular explorer of the human

condition. More than speaking to the human condition, however, UPA was speaking to the *modern* condition; contemporary reviews formed a growing chorus of voices referring to the studio as "modern" above all else.[4] Often considered an animated extension of modern art, not least by its own artists, the studio parlayed the abstract forms of modernist painting into whimsical cartoons designed to entertain moviegoers, repurposing for the screen, among others, Paul Klee, Raoul Dufy, and Stuart Davis.[5] However, UPA cartoons also engaged with a larger and more contemporary modernism, one percolating through the design community burgeoning in the postwar years and dominated by European émigrés who fled to the United States during World War II. This modern design, the backbone of the midcentury modernism that is the subject of this book, extended throughout all areas of cultural production in America in the middle decades of the twentieth century, determining the styles of painting, architecture, graphic design, and even live-action cinema, as well as other fields outside of the purview of the present study. Animation is much closer to the heart of this midcentury modernism than is commonly accepted in historical narratives of modernism's "influence" on the American cartoon. Rather, animation was a *partner* in this modernism, carrying out specific and important work alongside other, more putatively serious fields.

This book marks out a space for midcentury animation in scholarship on cinematic modernism, offering a new lens through which to view midcentury modernism's impact on cinema. UPA's cartoons are often situated within the history of postwar consumer culture, part of a narrative in which high modernism steps down from its pedestal and offers itself for sale to an expanding middle class. However, there is another way to view the animation that began with UPA and quickly spread to countless American animation studios, one that reimagines midcentury modernism as more than a period style popularizing more serious artistic experimentation, or a consumer phenomenon occurring alongside the work of the high modernists. Cartoonists, artists, architects, and designers were working with the same raw materials—vision, space, and abstract form—to fashion a new way to experience a new, modern America. In examining animation as part of a larger project of reorienting human vision, I also challenge the film studies tradition in which postwar cinematic modernism is aligned with a European art cinema descended from modernist experimentation in literature and theater.[6] Midcentury American modernism—the stuff we now look back on fondly as consumer kitsch, or disdainfully as pretentious and oppressive metal-and-glass boxes—came into

contact with cinema in ways that have yet to be explored, and the two spoke to each other in ways that have yet to be accounted for. The postwar American cartoon is fertile ground on which to begin such an exploration, and the primary practitioner of modernism in the postwar American cartoon is the studio United Productions of America.

UNITED PRODUCTIONS OF AMERICA: A THUMBNAIL HISTORY

The history of United Productions of America is well documented; however, a brief summary is useful here.[7] UPA, or rather Industrial Film and Poster Service, as it was first called, was founded in 1943 by Stephen Bosustow, Zack Schwartz, and David Hilberman, three ex-Disney employees who left the studio in the aftermath of the 1941 strike.[8] Following the production of their first filmstrip, a welding safety training piece called *Sparks and Chips Get the Blitz*, they quickly established themselves as independent animators in the sponsored film market, changing the company's name again to United Film Productions and producing animated shorts for industrial, educational, and political use.

Lacking the budgets of their entertainment industry contemporaries, they developed a spare, streamlined visual style that enabled fast production and simple animation. Their left-leaning politics secured them regular government work under the Democratic FDR administration, including the United States Army's First Motion Picture Unit, where many Hollywood denizens went to make wartime training films.[9] After the success of their army training films, *A Few Quick Facts about Inflation* (1944) and *A Few Quick Facts about Fear* (1945), they concentrated their energies in the yet again—and now finally—renamed United Productions of America in December 1945, serving mainly the government market. However, as anticommunist sentiment rose after World War II, their once-popular political views and their support of labor unions and Democratic presidential candidates became liabilities, and reliable government contracts began to dry up. In the absence of demand for sponsored films made by pro-union lefties, and of sufficient funds from low-paying industrial and educational assignments, they turned to the theatrical market, and in 1948 they struck a deal with Columbia Pictures' Screen Gems division.

It was here that the UPA cartoon style entered the public consciousness, to much critical acclaim. The studio's first two theatrical releases, *Robin*

Hoodlum (1948) and *The Magic Fluke* (1949), both received Academy Award nominations, resulting thereafter in less studio interference and greater creative autonomy for Bosustow and John Hubley, who had been running the studio since Hilberman and Schwartz's departure in 1946.[10] With autonomy came greater visual experimentation, and their theatrical work consequently saw the greatest development of their graphic design–oriented style. The 1950 short *Gerald McBoing Boing* struck bigger than any of their previous films, winning them their first Oscar as well as an avalanche of praise from the popular press—and not just from film and animation outlets. Lifestyle magazines, architecture and design journals, and theater and arts magazines all gave nods to UPA's signature style. For the first time, Amid Amidi notes, cultural critics "who, prior to UPA, often grudgingly acknowledged the animation medium, now couldn't stop singing the praises of the studio's graphic inventiveness."[11] In 1955 the Museum of Modern Art followed suit, offering them the high-culture blessing of an exhibition devoted solely to them, *UPA: Form in the Animated Cartoon*.

UPA's organizational structure resembled a revolving door: animators came, drawn by the promise of a workshop for stylistic experimentation, and went, parlaying their cultural capital as UPA cartoonists into jobs at other studios or their own startups.[12] This rapid turnover, coupled with the intense praise from both mainstream and specialized press, had a galvanizing effect on American animation across the board. By the mid-1950s, UPA style had become cartoon style. Even the relatively conservative Disney Studios released a small handful of modern pieces in line with UPA's output, the most famous of which is the 1953 pair *Adventures in Music: Melody* and *Toot, Whistle, Plunk and Boom*. As the fifties wore on, however, theatrical revenue declined sharply, and the animated prefilm short became a luxury. Production houses began to drop their animation studios, which were shifting to the cheap, assembly-line television cartoon model. UPA's own 1956 foray into television animation, *The Boing Boing Show*, was an underwatched, overbudget failure, and in 1959 Columbia shut down its animation house, selling UPA in 1960 to Henry Saperstein, who turned it into a television studio for *The Mr. Magoo Show*. By the end of its run, UPA had produced 109 sponsored films, ninety theatrical shorts, animated inserts in seven live-action films, over two hundred television commercials, over three hundred television shorts, and two feature films. In the process, it changed the face of American animation for decades to come.

It is for these reasons, though not only these reasons, that I focus on UPA as the exemplar of what animation historian Amid Amidi has called the

"modern cartoon," and that I use the terms "UPA-style cartoon" and "modern cartoon" interchangeably.[13] While other studios working in the "UPA style" play significant roles in this book, UPA's centrality is due not only to its reputation in its contemporary moment, but also, and more importantly, to its position as a proponent of a specific kind of modernism. If in what follows "Animation Learns a New Language," John Hubley and Zack Schwartz's 1946 manifesto in *Hollywood Quarterly,* plays a large role, it is because it is the clearest expression in the field of animation of a determination to change the form of the cartoon to fit a new, changing, modern world, and its insights and arguments extend beyond the cartoons produced directly by UPA whether later practitioners claimed allegiance to the manifesto or not.[14] Literature scholar Jennifer Wicke, in writing about modernism as a larger phenomenon, tweaks long-standing assumptions about authorial intent by arguing, "Modernist writers such as Joyce don't intend a single meaning or message, but do intend for their work to be received and consumed in dialectical relation to surrounding works, discourses, events, experiences, and so on—they intend the *slant* to the message, if you will."[15] Even if other, later producers of "modern cartoons" were merely picking up UPA's popular style—an unflattering charge I am not interested in leveling—their cartoons were still produced and consumed in a midcentury modernist moment in which UPA had slanted the cartoon with new meanings, and I do not see a reason to deny modernist intent, or modernist effect, to modernist form merely because the producers did not write an article about it. UPA's outspoken modernist impulses survive in the wider animation practice the studio helped to establish, transmitted through both its visual style and the resonances of this visual style with the design-based, architectural, and artistic currents in which the studio's cartoons floated.

LIMITED ANIMATION: WHAT IT IS AND WHAT IT ISN'T

Much has been said about UPA's pioneering of the process of "limited animation," a stripped-down form of cartooning that began during the World War II years of the First Motion Picture Unit and reached its zenith in the Saturday morning cartoons of the 1960s. Unfortunately, the discussion tends to conflate UPA's reduced animation process with its simplified graphic language and to lump both under the designation "limited animation." This is

not my moment to throw economics to the winds and rescue UPA's pristine artistic legacy from the taint of budgetary constraints. Schwartz, Hilberman, Hubley, and their colleagues innovated based on a mixture of creativity, ideology, and financial necessity, and those lines, I believe, should remain blurred.[16] At the same time, we should be clear about what we mean when we talk about UPA style, and about what we mean when we talk about limited animation.

To replicate the smooth movement of photographic cinema, a cartoonist draws twenty-four images per second of film, the same number of frames that produces the sensation of lifelike movement in live-action cinema; this is so-called full animation.[17] At bottom, limited animation means drawing twelve frames per second of film, or eight, or six, instead of full animation's twenty-four, or it means redrawing only the parts of the frame that have to be moving. It is a cartooning practice that involves reusing frames or parts of frames in an effort to cut back on labor and thereby save money—for instance, a character's mouth may move while the rest of its body remains still so that only the mouth has to be redrawn for each individual frame, or its body may alternate between a series of easily readable positions rather than progressing through the full sequence of "in-between" positions necessary for a fluid, lifelike motion.[18] In short, movement is limited to essentials. Central to this definition of limited animation is that it is indeed a particular kind of animation; that is, it refers to the way a cartoon moves, not to the way it is drawn.

It is true that graphic abstraction and limited animation are often fellow travelers, and that both are responses to the same budgetary pressures. Just as it is cheaper to draw twelve frames per second rather than twenty-four, so is it cheaper to put a character in front of a solid green background than to hire someone to paint a forest or to invest in a multiplane camera and film in five layers. The financial need to restrict character movement to essential body parts also demands, or at least asks for, simpler character design and more abstract background design. But this is true only to an extent, and it is most certainly not true to the extent that UPA's cartoonists built their reputations by agitating for a simpler, bolder graphic approach to animation not because it was less expensive, but because it was better suited to the social, cultural, and visual concerns of America in the postwar era than was Disney's three-dimensional, flesh-and-blood naturalism. To conclude that UPA's graphic style developed under the same budgetary duress as its practice of skipping frames in its animation is to engage in economic determinism at the expense

of the historical record, which indicates that the demand for a spare, abstract visual style predated the opportunity to forge it.[19]

While limited animation and graphic abstraction often occur together, then, they are not necessary bedfellows. One may imagine a fully rounded, detailed character animated in a minimalist fashion, or conversely, a simplified, geometrically stylized UPA character pulsing with full-animation life. In a 1973 interview, John Hubley explains: "The simplified nature of the UPA style was due to the fact that we were working on lower budgets. We had to find ways of economizing and still get good results." Notably, he is speaking specifically of the animation process, not of graphic stylization. He continues, "So we cut down on animation and got into stylized ways of handling action. . . . There's no substitute for full animation. What the character can do if you make use of full drawings is really irreplaceable. You just can't fake it."[20] In part, this half-lament explains UPA's use of limited animation, but it ultimately says little about the graphic innovations for which the studio is famous today. To explain UPA's visual style requires an exploration of its cultural context, a valuable element of cartoon history that becomes lost if we too easily equate graphic abstraction, limited animation, and low production budgets. UPA's graphic abstraction is a central element in the growth (and resurgence) of a uniquely American modernism, one that transcends the specificities of cost-cutting in the animation industry to engage with art, design, and new ways of seeing during and after World War II.

MIDCENTURY MODERNISM AND POSTWAR AMERICA

Periodization by way of wars can be a perfunctory practice; however, there is a general consensus, not least by the design community at the heart of this book, that in American history there is a "before World War II" and an "after." The full shift from Depression-era scarcity and recovery to consumer-culture abundance, the redirection of wartime technology to the domestic market, the newfound centrality of the suburbs at the expense of the urban center, the new cultural protagonist of the "organization man," the increasing presence of women in the workforce, the relentless bomb drills and paranoia of the Cold War, and the coalescence of the Civil Rights Movement, among countless other social and cultural developments, point to the postwar era as a qualitatively different time in the United States.[21] The modernism that rose to address these changes has been characterized in various ways

and to numerous effects. For example, American studies scholar W. T. Lhamon finds in it tremors of a nascent social rebellion leading to the liberation of a culturally pluralist and egalitarian postmodernism. Conversely, historian Daniel Singal figures midcentury modernism as a more entrenched and traditional modernism's swan song before its eventual lapse into caricature by the 1960s counterculture. And literature scholar Matei Calinescu views the immediate postwar period as a hard, immediate shift to a postmodernism where industrial modernity and its critical "other," aesthetic modernism, wear themselves out and call a truce, riding off into the sunset of a consumer culture that has subsumed them both.[22]

Happily, the task of identifying once and for all the moment when modernism ends and postmodernism begins lies outside the scope of this book. Instead, the goal here is to linger over this midcentury moment and to explore the ways in which its particular form of modernism manifested in the material world. My key assumption here is that, *pace* the scholars discussed immediately above, midcentury modernism is not a transitional period, either the dying-off of a "real" modernism or the stirrings of an oncoming postmodernism; rather, it is a discrete modernist moment that requires a pause to assess its very specific dimensions, concerns, and contributions. Corollary to this assumption is another one, my belief that talking about "modernism" as if it were a single, unitary phenomenon is a thankless and futile endeavor, one better replaced by talk of iterations of modernism. This conception of modernism as an iterative phenomenon allows for an accommodation of the various forms modernism has taken across its numerous manifestations throughout time and space, sidestepping the need to reduce an inherently multifarious idea to a monolithic ideal. With modernism reaching across so many boundaries in this postwar phase, it perhaps becomes more productive to talk about modernisms, or an assemblage of different threads that compose the fabric of midcentury modernism. While I prefer the latter designation, I feel the singular-vs.-plural question is less important than the reality subtending it, which is simply that modernism was doing many different things in America after World War II.

These many things, different threads of the modernist fabric, have also been conceptualized in various ways. Architecture historian Reinhold Martin's "corporate modernism," characterized by the remaking of the downtown urban landscape in a sleek, steel-and-glass modernist mold, uses design theory—particularly that of György Kepes and László Moholy-Nagy, to whom this book is indebted as well—to explain the physical changes in

urban space throughout the postwar era. However, Martin emphasizes the burgeoning culture of electronics and cybernetics, of Norbert Wiener and IBM; I share his Crary-meets-Foucault model of "new kinds of cities, new kinds of architectures, and with them a new 'self,'" but I depart from him in my focus on fields outside of architecture (and on architecture outside of the corporate office building), and in my extension of Kepes and Moholy-Nagy more in the direction of visual design than of network theory.[23] This is not to deny the centrality of network and informatics theory to midcentury modernism, and especially to these two designers so central to this moment and to this book. Together with Martin, scholars such as Orit Halpern, John Harwood, Justus Nieland, and Fred Turner have explored the intersections between a burgeoning cyberculture and the design profession in the decades following World War II.[24] But it *is* to acknowledge a slightly different focus: if these scholars examine the expansion and multiplication of screens and the interconnection of objects into complex and overwhelming networked 'environments' (and even, as Nieland and Halpern argue, to teach new vision *by* overwhelming), we may also see a countervailing impulse to *reduce* stimuli, to simplify the form of those very objects that are ultimately placed in networked relationships. The former leads to the expanded cinema of Gene Youngblood, the Eameses, and other design practitioners, while the latter leads to the modern cartoon.[25]

More central to my own vision of the modernist project of Kepes, Moholy-Nagy, and UPA is media historian Lynn Spigel's concept of an "everyday modernism" enabled by television: "Television offered a *quotidian* form of postwar modernism, showing the public how to enjoy new trends in the visual arts as an everyday national pastime. In the process, television contributed to a redefinition of the American vernacular that was ultimately based on the idea that American modern art was commercial art, with no apologies and no excuses."[26] This everyday modernism, characterized by a sense of all-overness and interdisciplinarity, or what Spigel calls "a new visual culture born of the corporate ethos of postwar consumer society," reorients Martin's "corporate modernism" beyond corporate architecture (though Spigel does address corporate architecture) and into the corporate world's wider engagements with modernism: the streamlined logos of corporate identity programs and the investments of television corporations in disseminating modernism through their programming and design practices.[27] Spigel's everyday modernism, however, definitionally entails a practice of "tactical poaching in which people could steal from a variety of artistic and decorative orthodoxies

to create their own more eclectic sense of style," a valence that does not occupy my own exploration, which is primarily concerned with the production end of the media circuit.[28]

To Spigel's "everyday modernism" we may add film historian Miriam Hansen's "vernacular modernism," according to which cinema was "the single most inclusive cultural horizon in which the traumatic effects of modernity were reflected, rejected or disavowed, transmuted or negotiated," processes which thus, as in Kepes, could be used to reeducate the besieged modern sensorium.[29] Her notion of cinema—and of visual culture more broadly—as a force that can be used to retune the senses lies at the heart of my project. But Hansen's model is a methodological mismatch, encompassing all cinema by virtue of its inherent modernity as a technological mode developed in, and in part constitutive of, modernity itself; conversely, my interest lies in a particular visual approach shared among particular strains of art, architecture, graphic design, animation, and live-action cinema.

In *Late Modernism: Art, Culture, and Politics in Cold War America*, historian Robert Genter offers a three-part taxonomy of midcentury modernism that hits closer to home.[30] He defines a midcentury modernism receptive to, and even constituted by, a communicative instinct that is at work in the writings of the modernists above, and in UPA's animation as well. Calling this postwar intellectual development "late modernism," he distinguishes it from other modernist philosophies of the time: the "high modernism" aiming to protect the autonomous artwork from the degradations of mass culture and politics on the one hand, and on the other, the "romantic modernism" oriented toward the artwork not as an autonomous object but as an expression of the artist's inner self.[31] In opposition to these, late modernism argues that art is neither an apolitical autonomous object nor an expression of the private self, but a form of rhetoric; art must persuade and communicate, must engage in a back-and-forth with a skeptical audience in an attempt to shift their worldviews.[32] Genter's schema offers an alternative to the abovementioned practice of positioning modernism's midcentury explosion in popular appeal as a capitulation to market forces and an abdication of the serious engagement with modernity in favor of the glib superficiality of consumer culture or postmodernism. Rather, an expressly rhetorical modernism critically engages with mass culture, advancing its worldviews for public consumption and debate instead of walling them off in a sacred preserve already populated by like minds.

An understanding of UPA's modernism as rhetorical acknowledges the studio's significant investments in sponsored and training—that is,

nonentertainment—films and provides an illuminating context for the consideration of its theatrical entertainment shorts. This diversity of UPA's artistic portfolio shows an unequivocal interest in turning the cartoon to rhetorical ends, whether to train, as in the Air Force training film *Flat Hatting* (1946); to persuade, as in the campaign film for FDR, *Hell-Bent for Election* (1944); to educate, as in the sponsored film for the American Cancer Society, *Man Alive!* (1952); or to advertise, as in the Mr. Magoo–themed commercials for Piel's Beer (1957).[33] Yet in addition to these outspoken rhetorical aims, UPA cartoons of all kinds also take up another rhetorical position, one that recalls Genter's invocation of late modernism as "a deliberate attempt to use the aesthetic form to challenge the choice of lens through which individuals made sense of the world around them and to persuade them that the visions offered by the artist were not merely more poetic but possibly more liberating."[34] The stylistic developments that originated on the UPA animators' drafting tables grappled with literal worldviews—that is, they provided visual experiences of the modern world. These visual explorations, akin to the refashioning of the visible world taking place in modern art, architecture, and design at midcentury, thus advance a particular rhetoric of vision, a preoccupation that defines the studio's contributions to modernist thought.

Thus, if postwar America merits its own periodization because of the wide array of cultural and technological shifts accompanying the end of World War II, for the design community—and this group includes the artists working at UPA—a narrower shift underlay the transition to a new period: the onset of an ever-accelerating sensory chaos and the concomitant need for a wholesale remaking of vision. Media historian Justus Nieland describes "the expanded scales of sensory experience afforded by postwar technologies, and an exemplary encounter with significant changes in the scope, speed, and nature of media now understood as an 'environment' that made quasi-evolutionary demands on the future of the human organism."[35] If this sounds familiar to students of modernism, it should: these concepts—new technologies, and with them new speeds, new mediations of life, and new pressures to adapt to all this newness—are central to what is often (and unhelpfully dismissively) referred to as "the modernity thesis."[36] In a thumbnail, as technological innovation, rapid urbanization, and scientific revolution converge at the end of the nineteenth century, a qualitatively new condition—modernity—arises, overturning preestablished rhythms and ways of life and assaulting the unprepared human sensorium with a host of new stimuli. These historical and social changes give rise to new forms of art and

culture—modernism—that attempt to grapple with these concrete changes in lived experience. Walter Benjamin's "shock," Charles Baudelaire's "the transient, the fleeting, and the contingent," and film historian Benjamin Singer's "hyperstimulus," among other designations, have structured our understanding of turn-of-the-century modernity and its logics of sensory overwhelm, as well as of modernist literature, art, and cinema as they negotiated that overwhelm during the early decades of the twentieth century.[37]

In a sense, then, we may see midcentury modernism as a resurgence of this energy in the wake of the changes wrought by World War II's own acceleration of technological innovation and social change. The magnitude of this change seems clear; Nieland refers to the above-quoted shift as "the transfigured *physis* of the midcentury," and to the attendant disorder as "the vexing new nature of the postwar."[38] Likewise, science and design historian Orit Halpern points out: "Postwar design and communication sciences, believing the world to be inundated with data, produced new tactics of management for which observers had to be trained and the mind reconceived."[39] More shock, more overwhelm, more hyperstimulus, and therefore modernism must be updated for a new iteration of modernity's sensory dislocations. Spigel notes the increase in popular discussion of perception in the postwar era, arguing that art critics of the time "observed that transformative developments in science, art, technology, and consumer/media culture required new theorizations of visual experience in the postwar world."[40] If questions of visual perception entered the public consciousness through books, art exhibits, and television specials, they also formed the backbone of a design movement that saw vision as the primary ground upon which an effective and putatively liberatory midcentury modernism would fight its battle.

GYÖRGY KEPES, LÁSZLÓ MOHOLY-NAGY, AND A NEW LANGUAGE OF VISION

At the forefront of this movement were two Hungarian émigrés, György Kepes and László Moholy-Nagy.[41] Moholy-Nagy's New Bauhaus in Chicago (from 1944 the Institute of Design, and from 1949 affiliated with the Illinois Institute of Technology, at which point it became the first American program to offer a PhD in design) brought Bauhaus design principles to the United States, training a new generation of American designers and artists in the methods and practices of the Nazi-disbanded German art school.[42]

Teaching basic courses with titles such as Fundamentals of Vision and the Light and Color Workshop, Kepes and Moholy-Nagy instructed the artists, photographers, designers, and architects who went on to define this particular strand of midcentury modernism.[43] During and immediately after the war, Kepes and Moholy-Nagy published two books that set the tone for midcentury American design. Kepes's *Language of Vision* was published in 1944, and Moholy-Nagy's *Vision in Motion* in 1947. It is impossible to overstate the influence of these two publications on American design; as artist Elsa Kula writes in a 1960 issue of *Print* Magazine, "[*Vision in Motion* and *Language of Vision*] are required reading in many schools of design; in some they are used as texts, and there is hardly an art director who does not have them on his bookshelf."[44] Moreover, as Reinhold Martin documents, these heavily illustrated books gathered images from various sources—New Bauhaus class assignments, scientific publications, artists' works—and, thanks to their positions as foundational textbooks, disseminated them across the country, functioning as a sort of clearinghouse for cutting-edge and experimental postwar imagery.[45]

And most importantly for my purposes here, they made their way into Hollywood. Most histories of UPA nod to Kepes's influence on the studio's artists—studio founder Zack Schwartz had read *Language of Vision*, director Bill Hurtz had found it interesting—but it is UPA animator and Terrytoons creative director Gene Deitch, in a 2011 internet project aimed at documenting his recollections and interactions with the Hollywood animation community across his career, who offers the smoking gun: "Hub [John Hubley, creative director of UPA] gifted me with two books that became the underpinnings of my entire career"; one of them was *Language of Vision*, "by the master Hungarian graphic designer and filmmaker, György Kepes. Everything you need to know about the dynamics of graphic design is in there!"[46] Hubley's penchant for bestowing copies of Kepes's book upon his new hires indicates an engagement deeper than simple appreciation by some of UPA's artists, suggesting instead a studio-wide ethos informed by the graphic design theories of the New Bauhaus.

Language of Vision and *Vision in Motion* thus function as touchstones throughout this book, occupying the gravitational center of midcentury modernist design thanks to their widespread permeation of the American design profession at the most foundational levels. In both, the central dilemma is a rapidly changing world to which humankind has not yet caught up, a visual chaos engendered by technological development that has outstripped its

masters.[47] New technologies have provided new views of the world, from X-rays and aerial views to microscopy and extreme close-ups.[48] Kepes refers to it as "the world made newly visible by science," a change that necessitates new ways of understanding and perceiving this new visual material.[49] This new mode of seeing, what Kepes calls a new "language of vision" and Moholy-Nagy calls "vision in motion," is capable of grasping stimuli in networks of relation, in simultaneity and in motion, motion both of the object (transformation) and of the seeing subject itself (transportation).[50] The solution lies with artists, who can retrain human vision by rehearsing these new experiences on the picture plane. Kepes argues, "In the last hundred years technological practice has introduced a new, complex visual environment. The contemporary painter's task is to find the way of ordering and measuring this new world."[51] (Compare turn-of-the-century modernism's attempts to capture the fleeting and the ephemeral with Kepes's goal, as quoted by Halpern: "The essential vision of reality presents us not with fugitive appearances but with felt patterns of order.")[52] Spectators, through experience of responsibly produced art and design, would thus find their perception reeducated to successfully navigate this new postwar world. Moholy-Nagy agrees: "In fact, one could say that all creative work today is part of a gigantic, indirect training program to remodel through vision in motion the modes of perception and feeling and to prepare for new qualities of living."[53]

The centrality of vision here is essential, and contemporary media were a key element of this strain of midcentury modernism. Kepes notes, "The motion picture, television, and, in a great degree, the radio, require a new thinking, i.e., seeing, that takes into account qualities of change, interpenetration and simultaneity."[54] Telling here is Kepes's equation of thinking and seeing; this seeing-as-thinking stems from Gestalt theories of perception in circulation at the time.[55] The solution, running through both Kepes and Moholy-Nagy, is a simplification of form, a reduction to fundamentals of line, plane, shape, and color in order to enable a simpler, more immediate grasp on relationships of objects in space. And if, as Kepes argues, new forms of media are part of the increasing visual complexity of the postwar world and it is the artist's job to help with this simplifying effort, UPA's signature style begins to make a significant amount of design sense. Employing the simplified abstract forms advocated by these midcentury modernists, the modern cartoon joins the effort of helping to reorient the human sensorium amid environmental overstimulation. The theories of animation laid out by Hubley and Schwartz in "Animation Learns a New Language" likewise advo-

cate a kind of seeing-as-thinking that informs the studio's approach not only to their training cartoons but to their theatrical shorts as well.

This midcentury modernism, then, is fundamentally interdisciplinary, reaching out into not only art and animation, but also graphic design and architecture, all of which were taught at the New Bauhaus by Moholy-Nagy, Kepes, and their colleagues as part of an integrated curriculum patterned on that of the school's German predecessor. *Language of Vision* and *Vision in Motion* decry the harmful effects of specialization, a bureaucratic development that by the postwar era had separated emotion from thought and science from art, and had reduced democratic community to separate, mutually exclusive fiefdoms staffed by "human machines with record output in specialized fields."[56] As Kepes notes in a 1972 interview looking back on *Language of Vision* and the New Bauhaus years, "I sensed that one cannot do anything well if one doesn't see the whole human horizon. And the human horizon includes literally everything."[57] Bringing about this new vision would thus not only make life easier for people living in the tumult of postwar modernity; it would also unite them in a vision-based body politic held together by what Moholy-Nagy envisioned as "a biological bill of rights" based on the assumption that the binaries structuring modern consciousness—art/science, feeling/thought—could be shattered by teaching everyone to see fully, to apprehend their entire world through a simplified, streamlined vision.[58]

MODERN INSTITUTIONS, MODERN IDEOLOGIES

Here we may find another difference from turn-of-the-century modernism: if in turn-of-the-century modernism a wide variety of reckonings with modernity proliferated in galleries and salons imbued with radical energy and rule-breaking abandon, midcentury modernism was oriented toward a streamlined and institutionally affiliated program of democratic uplift. It is explicitly pedagogical, filtered through the Bauhaus sensibility of its practitioners and imbricated in the dominant corporate and governmental structures of its new American context. As a result of these entanglements, the role of design itself also changed in this period. Nieland finds in the design profession "a new cultural prestige and world-historical mission at midcentury," one in which "designers routinely functioned in media-pedagogical capacities with a worldly scope, playing important roles within a broader Cold War administration of culture."[59] This focus on worldliness carries

with it an unmistakable political dimension, one linked to the postwar project of capitalist democracy. Fred Turner traces the contacts between Bauhaus émigré designers and American intellectuals in the lead-up to World War II, illuminating the ways in which Moholy-Nagy's "new man" became a central figure in a national attempt to create a democratic personality type to challenge the fascist authoritarian personality.[60]

Yet as both he and others have noted, to merge art and institutions is to commingle ideologies in unanticipated ways. The utopian aims of midcentury design—aims inherited from the socialist ideals of the Bauhaus—adapted to the American context in their transmission across the Atlantic, maintaining a logic of democratic uplift and transparent communication while melding with the corporate structure of the postwar American economy.[61] In this sense, the consolidation and dissemination of midcentury modernism is a story of artists and designers with revolutionary and utopian aims linking arms with larger systems of social control. For Turner, "the World War II effort to challenge totalitarian mass psychology gave rise to a new kind of mass psychology, a mass individualism grounded in the democratic rhetoric of choice and individuality, but practiced in a polity that was already a marketplace as well," a consumerist logic he calls "the managerial mode."[62] Conversely, for art historian John R. Blakinger, Kepes's Bauhaus-aligned utopia borne of the marriage of art and science—and funded by MIT starting in 1967—was imbricated in the US military's use of scientific research in the prosecution of war: "by generously funding the arts, the Institute justified its even more generous funding of the sciences.... One culture—art—justified the corrupt activities of the other."[63] These two forces, Cold War militarism and postwar consumerism, are not, in the end, so separate; the famous Nixon-Khrushchev "Kitchen Debate" of 1959 is one of many clear manifestations of the capitalist-democratic ideology to which postwar design adapted itself.

UPA itself emerges from a place of utopian ideals mixed with pragmatic adaptation to institutional support. Beginning, as mentioned above, as a wartime training outfit paid by the US government, the studio's use of design principles in the service of American militarism is clear. Likewise, the use of UPA-style animation to explain organizational efficiency and atomic physics to the lay public draws a vivid line between innovations in cartoon form and the exploits of the army and the Manhattan Project. Moreover, the studio's television commercials in the 1950s and 1960s are evidence of a willingness to mingle artistic goals with the burgeoning consumerism of the postwar era.

Given its overtly (generally left-wing) politicized origins and its participation in the postwar growth of the advertising profession, UPA's story is not one of the maintenance of aesthetic purity amid the winds of political and cultural change. Rather, it is about midcentury animation as a presence *mediating* this change.

Nieland points out midcentury design's concern with "the reconciliation of order and growth, security and change, through the cognitive and perceptual training that saw individuals and individual units in broader webs of 'relationships,' and that allowed for the kinds of networked communications and decisions upon which nothing less than the future of the world depended."[64] This do-or-die impulse in the face of an increasingly global existence can be seen as well in Turner's aforementioned organizations aimed at bringing citizens together into networks of democratic actors dedicated to the preservation of peace and harmony, and we may also find it in UPA's work, such as the 1945 film *Brotherhood of Man*. A propaganda film sponsored by United Auto Workers, it preaches racial harmony and the necessity for common ground and fellow-feeling between different races and ethnicities in America. But it is also a response to UAW's need for racial harmony *on the factory floors of automobile manufacturing plants*—that is, UPA's left-leaning utopian goals were conscripted in the service of a smoothly functioning consumer capitalism.[65]

Across media, these attempts to shift individuals' perspectives reveal a strain of control running parallel to midcentury modernism's stated goal of uplift and democratic defense. As Turner notes of the New Bauhaus, "They wanted their school to produce not only a new kind of design, but a new community of designers, and above all a new kind of person."[66] Robin Schuldenfrei confirms this social engineering aspect of such design, which was "developed and implemented not in pursuit of a well-designed, useful *object*, but rather toward the aim of cultivating *individuals* as productive participants in the ongoing design of postwar American society."[67] Midcentury modernist design is about designing *people:* viewers, users, and above all, citizens—and more specifically, citizens of a technologized world. As Reinhold Martin notes, "We are speaking, during the atomic age and the space race, of the scaleless reinscription of the human into a technoscientific milieu that described the universe as a 'system of systems.' . . . It was a humanity that presupposed technological mediation, then—a humanity that came *after* technology, not before it."[68]

I do not wish to deny the complexity of these ideological entanglements; rather, they speak to the survival of an artistic program within and alongside

the ideological drift of the American midcentury. Blakinger speaks of "conversion," a logic by which Kepes maintained his faith in the power of art to change the ideologies of the institutions with which he collaborated and to convert them to his utopian aims over time.[69] It is worth noting that Blakinger himself is not utopian about the efficacy of this strategy; as he concludes, "[Kepes] hoped—naively, romantically, and also admirably—to change this culture through collaboration alone."[70] But Schuldenfrei corroborates this impulse across the design profession at midcentury, documenting the New Bauhaus's attempt at "a planned segue from its wartime work to preparations for the postwar period.... Indeed, the school's ability to contribute novel, practical solutions to the war effort aptly positioned its mode of modern design for participation in postwar technological progress and the boom-time affluence that accompanied it."[71] Here as well we may see a desire to work within the system, to "[use] their particular areas of expertise to address problems of war, simultaneously cultivating a postwar role for modern design in America as a form of process-oriented, social problem-solving to be cultivated through new practices of pedagogy," even as this ultimately means adopting the concerns of a state invested in nation-building.[72] What both of these scholars find in midcentury design is an aesthetic and utopian program—one located within Blakinger's "naively, romantically, and also admirably"—that nevertheless depends on hegemonic structures for both economic survival and cultural reach. If in what follows I focus more on the utopian goals than the ideological counterforces, it is because I am interested in what artists thought was possible with the raw materials of their various mediums. I do not wish to overlook their complicity in the dominant currents of midcentury hegemony, but I do wish to dwell more on the projective aims of their experiments, the "naive, romantic, and also admirable" dreams to which these designers felt they could eventually "convert" the United States' most powerful entities.

We can find the same tension in UPA's position, especially as the studio transitions from explicitly political messaging—the aforementioned *Brotherhood of Man,* the 1944 pro-FDR campaign film *Hell-Bent for Election*—to the consumer market of theatrical entertainment films. But as in Blakinger's assessment of Kepes and Schuldenfrei's assessment of Moholy-Nagy, I find in UPA's postwar output a utopian, democratic goal that piggybacks on its entanglements with market capitalism and Cold War culture. So in a way, this midcentury modernism *is* part of high modernism's entrée into the burgeoning consumerism of the 1940s and 1950s, but it injects an unusual

strain of perceptual thought into this environment. This is neither to deny nor to erase complexity; it is rather that, as Nieland argues: "Reckoning with the terrain of modernist cultural production at midcentury thus requires keener attention to the implication of the sensorium in debates about how screen cultures and their institutional sites abet forms of governmentality, and about the sensation of democracy itself in the designed environments of postwar life.... This would invite us to think of sensation itself as a scene of cultural, and beyond that, political administration, and to look to midcentury design as something beyond the mere aestheticization of the commodity's bold midcentury futures, or the superstructure of capitalism's globally extensive postwar markets."[73] This "something beyond" leaves open many possibilities, including the refashioning of vision outlined above. This book is the story of that vision as it was expressed and modeled across the arts, both fine and applied, in postwar America, and particularly as it was expressed and modeled in modern animation.

This is not to deny UPA's more explicitly political entanglements. Beyond its sponsored work for the US government, the modernism it partakes in was, in its Bauhaus origins, a political as well as an aesthetic project. There is a long history of abstract form as political gesture, both in Europe—such as Russian Constructivism—and in America—such as the American Artists School in New York—and as an animation studio involved in the dissemination of New Bauhaus design theory in the United States, the progressive label stuck. Avowed progressive and unionist Hubley himself, the studio's creative director, was a key victim of the Hollywood blacklist. His career at UPA ended in 1952 when he resisted interrogation by the House Un-American Activities Committee, and he founded his independent studio Storyboard, where much of his most remembered work was produced with his wife Faith in 1953 as a front to enable him to keep working (and, as Faith reveals, make good money doing it).[74] As a response to a labor strike at Disney, UPA was from its very inception a political entity, caught up in debates of labor, power, and national identity. However, while there is much to be said about UPA by way of interrogating global power dynamics through the arts, I also believe that an aesthetic approach to this studio, and to the historical moment in which it flourished, yields its own important results. By tracing the traffic of a particular style across the arts, and by using UPA as a focal point to do so, we can observe the development of a postwar design ethos that, yes, was necessarily political as all art is, but that also dramatically shifted notions of vision and perception in America during the period. To tell this history

through the lens of visual studies helps us capture a set of utopian dreams that spread across mediums, and it enables us to understand more clearly animation's conscription into design as a larger field of artistic production.

In this sense, the "all-overness" of midcentury modern design, and the impulse on the part of designers to extend it beyond its traditional boundaries and into all aspects of life, allows for a blurring of the line between design and animation. Throughout this book, I speak of cartoons *as* design, as a cinematic exhibition of modern design principles at a mass level. This is not to reduce the UPA-style cartoon to a member of design's entourage, but rather to highlight the ways in which design subtended the experience of the postwar world and popular representations of it. It is not that design *took over* animation; it is that animation *became* design by virtue of its shared investment in the design principles circulating through the reach of Kepes, Moholy-Nagy, and the New Bauhaus. This book charts this merger between the modern cartoon and design in art, architecture, and graphic design, all in the shared investment in a rhetorical, pedagogical modernism that could teach new ways of seeing.

ONE

Postwar Precisionism

ORDER IN AMERICAN MODERNIST ART
AND THE MODERN CARTOON

FROM JUNE 22 THROUGH SEPTEMBER 27, 1955, the Museum of Modern Art ran a show titled *UPA: Form in the Animated Cartoon*. Devoted to the studio's output during the previous ten years, the exhibition was in many ways exactly what one would expect from a museum show about an animation studio: it offered to the public sketches, character drafts, animation loops, background paintings, cels, and photographs—assorted documentation of the kind of work the studio did and the ways, and places, in which they did it. These materials seem designed to give attendees the kind of "behind the scenes" experience one might expect from a show about a beloved, popular, and multiple-Oscar-winning animation company.

But MoMA's show also complicated the public's perception of a studio whose output they had likely only encountered in the movie theater. The preliminary notes for the exhibition reveal the breadth of the studio's output in a way that is largely lost to popular memory: "Here, in separate gallery sections of varying sizes to be determined by content, exhibition technique and available space, the five major branches of UPA activity would be symbolized." These five sections are "Entertainment," "TV Commercials," "Industrial," "School," and "Military."[1] This deemphasizing of UPA's most public-facing work, and the elevation of the sponsored films and training films made for niche, nonconsumer audiences, speaks to an underlying ethos of usefulness in the studio's cartoons—note the way "entertainment" becomes merely one of a number of functions animation is capable of performing, and how prosaic the other four are.

In addition to the cartoons' usefulness, MoMA's exhibition focused on their artfulness. Another, much less preliminary document (dated May 9) outlines the supporting material to be collected for the upcoming show, and

an entire section is devoted to UPA's artistic influences and to "choosing drawings, cels and frames which demonstrate general references to well known styles." The anonymous (and clearly frazzled) author of the internal memo notes:

> The purpose of this section is to indicate creative borrowing from modern art, E.G., the use of collage in the newspaper clip in *Christopher Crumpet* and the photograph of Fitzsimmons (or whoever) in *The Wonder Gloves* could be paired with Bellmer and other Dadaists. . . . I'd like the *Christopher* and *Wonder Gloves* examples, the international telephone machinery (spiral and zigzag, plus) scene in *How Now Boing [Boing]* (to go with Dada Picabia or Duchamp), the overlapping profiles of commentators talking about the *Fudgets* (to go with Klee), and ask Jules [Engel, background artist] to find a good UPA interior to go with the Matisse *The Red Studio*. . . . There are also Picasso references in my notes but I can't place them in specific UPA pictures at the moment. Sorry to have to put the burden of choice on you people, but haste dictates. (about 20 examples if possible.)[2]

The range of UPA's magpie modernism is clear here, but what stands out most in this account of UPA's artfulness is also one of animation history's most common assumptions about the studio: that it trades on "creative borrowing from modern art." This assumption is not entirely untrue. UPA sits at the center of a web of influences closely linked to European modernism, including Cubism, Fauvism, and the Bauhaus. In their professional correspondence—including correspondence with MoMA about the 1955 exhibition—the studio's artists are outspoken about their interest in, among others, Picasso, Paul Klee, Henri Matisse, and Raoul Dufy.[3] (Their debt to Dufy is directly acknowledged in their MoMA-commissioned 1955 short *The Invisible Moustache of Raoul Dufy,* drawn in the style of his paintings.)

Yet in addition to explicitly importing stylistic innovations from Europe, UPA also reopened a struggle with modernity that had already occupied American artists in the early decades of the twentieth century. This chapter focuses on postwar animation's relationship to Precisionism, a Cubism-inspired strand of American modernist painting that first appeared in the late 1910s, proliferated in the 1920s, and continued, albeit at a declining rate, throughout the 1930s and early 1940s, turning to greater abstract experimentation after the war and finally falling off the radar as Abstract Expressionism took shape. It is in connection with this earlier American modernism that MoMA's two central determinants of the importance of UPA's cartoons—their usefulness and their artfulness—come together. UPA's relationship to

the American art scene is a striking omission in the MoMA exhibition; by restoring the aesthetic and conceptual links between midcentury cartoon style and interwar modernist American painting, we can achieve a clearer view of the work cartoons were doing in the postwar period. Moreover, we can see that this work extends beyond the simple borrowing of stylistic influences, offering a theoretically engaged response to prevailing questions of vision and order.

The aim here is not to "dethrone" Abstract Expressionism as a key component of American midcentury modernism, or even to argue that UPA's animation style owes nothing to the Expressionists' innovations, but rather to fashion a more complex account of the development of modern animation by highlighting this earlier current in modernist art infrequently discussed in cultural histories of American modernity and modernism. Viewed alongside postwar cartoons, the theories and practices of Precisionism reveal these cartoons as a renewal of the energies and concerns of an earlier twentieth-century modernism. Midcentury modernism, like its interwar iteration, was a complex affair. As a response to a new postwar modernity, it proposed various sets of solutions to variously defined social, philosophical, and aesthetic problems. A close examination of UPA's style reveals striking similarities to the work of the Precisionists, and a close examination of the writings of and about Precisionists and UPA confirms that they were indeed occupied by similar problems and proposed similar aesthetic solutions to those problems: abstraction and simplification.

At stake is a fuller understanding of how, and when, a pervasive American modernism came to be. UPA is commonly discussed as an explosion on the animation scene, a revolution in cartoon aesthetics that wowed highbrow critics and confused lowbrow audiences with its innovative, entirely new approach.[4] While the bold, stylized forms of midcentury animation may have seemed new in the previously Disneyfied terrain of cartoon naturalism, many Americans had seen them before, in the Precisionist paintings that proliferated in the interwar years. In fact, in 1946, when UPA creative head John Hubley and cofounder Zack Schwartz published "Animation Learns a New Language," their attack on slapstick, sentimental, animal-centered cartoons,[5] they were rehearsing in animation a feud that had been simmering in American art since the 1913 Armory Show and had already come to a boil once, in the twenties, and was in the process of boiling over once again in a newly prosperous post-WWII America.

This is not a story of direct influence; to my knowledge, UPA cartoonists have never acknowledged Precisionist art.[6] Rather, it is a story of a series of

homologies across two different fields of cultural production in two different historical moments, bringing the combined disciplines of art history and film studies to bear on a singular visual problem that animated American modernism across much of the twentieth century. UPA's artists did not consciously situate themselves as the successors to Precisionism, but they nevertheless recreated Precisionism's gestures in the face of postwar modernity. My intent here is therefore threefold: a revaluation of Precisionism within the pantheon of American modernist art; a more precise description of UPA's visual style; and, through the meeting of these two ideas, a clearer picture of UPA's place within a multifarious midcentury modernism. Authorizing the merger between these two mediums is a shared language of design—specifically the language of design advocated by a figure central to the midcentury modernism of which UPA is a part: György Kepes, a Hungarian émigré whose Bauhaus sensibility offers a meeting point between the rarefied surface of the Precisionist canvas and the madcap spaces of the postwar cartoon.

This interdisciplinary approach, an iconographic survey of two moments of rupture in ideas about representation and vision, adds a new dimension to our understanding of UPA's cartoons and the work they were expected to perform in the public arena. As such, this chapter engages significantly with Precisionist painting—its aesthetics, its theories, its practices. If it does so at length, it is because examining Precisionism from an interdisciplinary standpoint can shift our current art-historical understandings of it, and also because the introduction of animation studies to the understudied phenomenon of Precisionism can help us learn something new about animation. Ultimately, this account unites the movie theater and the art gallery as spaces of sensory adjustment where artists and audiences reckoned with the rapidly changing world around them; it provides a key theoretical context for the style of animation that dominated the American cartoon in the 1950s and 1960s; and it introduces the language of design as an essential component of midcentury modernism in all its forms.

SQUARES AND CUBES, ARCS AND CYLINDERS: THE PRECISIONIST AESTHETIC

Precisionism occupies a liminal space in the history of American modernist art, squeezed between the European Cubism that brought modernist painting to America's attention in the 1910s and the Abstract Expressionism that

would come to define American modernism after World War II. The interim between these two periods was marked by a search for a uniquely American art, one that could be modernist without being European and that could address changes in the experience of time and space without merely copying Cubism. In addition to this "anxiety of influence" dilemma, another impetus for the development of a native modernism arose in the wake of the crash of 1929: New Deal programs, including the Public Works of Art Project (1933–1934) and the Federal Art Project (1935–1943), invested in the arts as a means of rebuilding the struggling nation's sense of identity.[7]

In this climate, the nationalistic duties of art, frequently couched in terms of competition and the maintenance of cultural relevance, assumed greater importance, often ballooning into debates over the relative patriotic loyalties of various schools of painting. Roughly speaking, a long-standing rivalry solidified on two opposing sides: on one, the "American Scene" painters, whose naturalistic representations of rural and urban life leaned toward the romantic and the narrative; on the other, the abstractionists, whose activity dates back to the 1913 Armory Show, where European modernism first entered the American lexicon. To their detractors, the American Scene painters offered aesthetically retrograde, jingoistic pap out of sync with the realities of modern life and modernist art, while the abstractionists were accused of sleeping with the (communist!) enemy, forsaking American exceptionalism in favor of dangerous—and worse, pretentious—European influences. Within this politicized arena of art, the question of how best to artistically represent American life became distilled into the far more controversial question of what was American life, and what was America.

One of the most significant abstract movements of this period, Precisionism was particularly outspoken in its efforts to redefine the subject matter of American art in the twentieth century. Years before the rancorous debates that characterized the New Deal–era art world, artists were adapting European modernism to the American landscape, seeking a way to make it relevant to the peculiarities of their own geography, history, and culture. As early as the late teens, painters such as Morton Schamberg and Charles Demuth embraced the mechanistic art of French artists Marcel Duchamp and Francis Picabia, attracted to both their technophilia and their wide-eyed declarations that America would be the new center of artistic innovation. Throughout the 1920s, as industrialization and urbanization were reaching the peak of their influence, these artists and others, including Charles Sheeler, Louis Lozowick, Niles Spencer, Peter Blume, and Joseph Stella,

turned their attention to industrial and architectural imagery, and found receptive audiences for their work in New York spaces such as the Whitney Studio Club and the Daniel Gallery. By the end of the decade, Precisionism was a vital, if not yet officially named, presence in the American art world.

Precisionism's search for the expression of a core American identity must be balanced by the recognition that there was no "Precisionist School" to speak of, but only a loosely defined group of artists whose membership varies with the commentator discussing them. There were no jointly written manifestos, no claims of a shared project; while they were overwhelmingly painters, some of Precisionism's practitioners made lithographs and drawings as well. Even the "Precisionist" moniker wasn't a universally accepted term, vying with designations such as "Immaculate," "Mechanist," and "Cubist-Realist," all of which were imposed from without by critics and scholars.[8] Martin Friedman, director of the Minneapolis Walker Art Center for three decades and perhaps the seminal chronicler of the Precisionists, characterizes the center of gravity around which their style revolved as "extreme simplification of form, unwavering, sharp delineation, and carefully reasoned abstract organization."[9] Art historian Gail Stavitsky is more specific: "The essence of the Precisionist aesthetic was an objectivist synthesis of abstraction and realism, manifested by hard-edged, static, smoothly-brushed, simplified forms rendered in unmodulated colors."[10] The Precisionist mode of representation rested on a reduction of peculiarly American subject matter to flat planes of solid color, partaking in the materials of abstraction while still remaining yoked to representation, but a representation starkly opposed to the naturalist renderings of the American Scene painters. Remarking on this abstracted realism, museum curator John I. H. Baur, writing in 1951, called the Precisionists "the backbone of our second period of abstract art in the 1920s" and "the first important bridge between native tradition and the modern vision."[11]

As their sometime designation as "Cubist-Realists" attests, the Precisionists owed much of their "modern vision" to the Cubists painting in the early decades of the twentieth century. Their practices of breaking up pictorial space into planes and of reducing objects to precise geometric forms echo the tenets of Cubism. However, in adapting it to the American landscape, the Precisionists did not stick entirely to the Cubist script, instead making use of its innovations to lay a foundation for further experimentation. As art critic Edward Alden Jewell notes, "Cubism played its part, though it does not anywhere survive as such."[12] In their catholic and idiosyncratic approach to modernist precedent, they drew on other sources of

European modernism as well. In fact, it is arguable that they developed their style by rummaging through the storehouse of modernist techniques, taking what they liked and jettisoning the rest—from Cubism, the dismantling of the object into planes (but not its extreme distortion of form); from Dada, the focus on industrially produced objects (but not its confrontational sense of humor); from Surrealism, the assemblage of everyday things (but not its penchant for the fantastical); from Fauvism, the nondescriptive use of color (but not its forceful, visible brushwork); from Constructivism, the use of solid colors and simple shapes (but not its pure abstraction and radical political commitments); from Futurism, the engagement with the machine (but not its celebration of speed).

The Precisionists infused these elements of European modernism with distinctly American characteristics, foremost among them the representation of American industry, land, and architecture. While some artists in the group, including Demuth, Sheeler, Georgia O'Keeffe, and Niles Spencer, nodded to American folk art by painting barns, New England cottages, grain silos, and domestic interiors, others directed their attention to the industrial cityscape, a subject widely deemed the ideal raw material for the art of the future. In a statement printed in the catalogue for the 1927 Machine-Age Exposition in New York, Louis Lozowick, one of the central figures of the Precisionist period, rhapsodizes, "The skyscrapers of New York, the grain elevators of Minneapolis, the steel mills of Pittsburgh, the oil wells of Oklahoma, the copper mines of Butte, the lumber yards of Seattle give the American industrial epic in its diapason."[13] Tellingly, the city of this modernism is not just the city center, but its outskirts as well, and the smaller outposts scattered across the country, even farms; wherever there is machinery and industry, there is America.

In a similar statement, Friedman explains the allure of the city to a new generation of American painters: "Here were ready-made 'cubistic' forms—skyscrapers, bridges, docks, grain elevators, turbines, cranes—and through Precisionist painting these became the dominant images in American art."[14] These forms, already geometrical, were not only the perfect subject matter for a post-Cubist style of painting; they were also its justification. The precision with which the Precisionists executed their art was thus a symptom of their era. In Friedman's words, "Today the localized boundaries of gallery loyalties that existed in the Twenties seem less urgent and it is clear now that we are dealing with a much broader, pervasive idea whose inspiration was in the air of that time."[15] This pervasive idea underlying the form and content of

Precisionist art is order, a concept that was indeed in the air of that time, apparent in the flowering of mass-scale industry, in the scientific efficiency experiments of Frederick Winslow Taylor and Frank and Lillian Gilbreth, and in the calls for stability in the wake of the transcontinental upheaval of World War I.[16] Elegantly synthesizing the zeitgeist and the visual forms it engendered, Lozowick argues: "The dominant trend in America of today, beneath all the apparent chaos and confusion, is towards order and organization which find their outward sign and symbol in the rigid geometry of the American city: in the verticals of its smoke stacks, in the parallels of its car tracks, the squares of its streets, the cubes of its factories, the arc of its bridges, the cylinders of its gas tanks."[17]

In their attempt to reflect and refine this order and organization, Precisionists undertook a rationalization of the American scene, employing abstraction as a means to simplify perceptual overload. Stavitsky observes, "Precisionism proposed a fundamental reordering of experience, a clarifying search for architectonic structure underlying the chaos of reality. Indeed, metaphors of architecture, science, engineering, and mechanization were often employed to characterize the Precisionists' methodical, rational construction of compositions."[18] Finding a common thread through all Precisionist art, from the more abstract end of the continuum to the more representational, Friedman likewise notes, "Photographically realistic or abstract, the art of the Precisionists . . . reflects an idealized state of absolute order."[19] Art critic M. Mannes finds in the work of Niles Spencer "the effort of a mature mind to instill order from surrounding chaos and relate things hitherto unrelated."[20] In using static, geometrical forms as their tools for representation, these artists identified an inherent order in the world and amplified it; Stavitsky calls them "selective realists who variously distilled the essential forms of a highly refined reality."[21]

The phrase "selective realism" recurs often in commentary on the Precisionists, testifying to the extent to which they blurred abstraction and representation, even at their most photorealistic (as in Sheeler's work in the late 1930s depicting close-ups of machine parts).[22] Lozowick offers a clear statement of this process of selection—at the same time distancing himself from the American Scene realists—declaring, "The artist cannot and should not, therefore, attempt a literal soulless transcription of the American scene but rather give a penetrating creative interpretation of it, which, while including everything relevant to the subject depicted, would exclude everything irrelevant to the plastic possibilities of that subject."[23] Stavitsky describes

what was to be excluded as irrelevant: "Transitory superfluities of expressive painterly process, time, atmosphere, and anecdotal details were removed to varying degrees as barriers to the essential integrity of the object and its direct apprehension."[24] In a sense, the Precisionist project thus entails the undoing of the work of the modernists who came before them, repudiating Baudelaire's invocation of the fleeting and the contingent,[25] denying the temporal complexity of Cubism and the anarchic dream life of Surrealism in favor of a stable, concrete certainty unbound to impressions, passions, or tricks of the light.

To offer "direct apprehension," to protect "the essential integrity of the object": these were considered the paramount aims of Precisionism, and they are a key element of its original contribution to an American modernism. Stavitsky again: "This sober, matter-of-fact mode of perception, nurtured by mechanization and vernacular design, was regarded as distinctively American."[26] Likewise, art historian Diane Kelder credits the Precisionists with "the gradual awareness of the distinctive visual experiences that distinguished America from Europe."[27] Linking these two descriptions is an emphasis on a new mode of perception in the face of a new environment. This engagement with a vexed perception of the outer world is precisely what sets the Precisionists apart from their American Scene contemporaries, and certainly from the inner-directed Abstract Expressionists who followed and ultimately supplanted them. Moreover, it resonates with the development of the modern cartoon in the postwar years, where the Precisionist aesthetic resurfaces in animation as the art world was finishing up with it. Uniting these two media through their reflection of a new and appropriately modern mode of perception uncovers a more serious strain in the postwar cartoon and illuminates the cultural work it performed in a changing visual environment, as fluid and chaotic after the Second World War as it was for the Precisionists after the First.

UPA AND PRECISIONISM:
HOMOLOGIES OF FORM AND STYLE

UPA's contribution to the development of the postwar American cartoon is both massive and well established. By the early 1950s, the work of its animators was, as animation historian Michael Barrier notes, "the reference point, the studio with which every other studio automatically compared its

cartoons, whether or not a given studio was trying to emulate the UPA films."[28] However, as Amidi argues, there was no "UPA style" to speak of, at least not specifically; rather, "UPA championed the contemporary graphic language of the era and encouraged its adaptation to the animated medium."[29] Its animators espoused a philosophy rather than a formula, one in dialogue with modern graphic design and capable of taking many forms. That is, UPA's cartoon form was defined by its multiplicity, in which each story received the visual treatment most appropriate for its aims—or, in UPA parlance, "The graphic representation grows out of the idea."[30] This inherent multiplicity gathered around a basic set of visual stylistic options: in this case, hard-edged, simplified forms; bold, unmodulated colors; an evacuation of detail; a minimalist environmental surround, often reduced to bare-bones geometry, regular patterns, or even a single flat color plane; the abolition of rounded, centerline character design; and a relaxed—to put it mildly—implementation of Renaissance perspective. This group of stylistic traits does not exhaust the variety of UPA's production, but it describes the vast majority of the studio's output. If there are exceptions, it still operates comfortably as a general rule. This understanding of UPA's style as a set of options that occur in differing combinations across its cartoon catalogue respects the variation within the studio's output and avoids the pitfalls of arguing for any particular cartoon as the "quintessential" UPA cartoon, or as being more "UPA" than any other cartoon UPA produced.[31]

In embracing this multiplicity and the stylistic boundaries within which it operated, UPA's artists staked the studio's reputation not merely on its flatness, or its boldness, or its minimalism, but on the condition within which these traits were contained: UPA became famous for its modernism—a modernism that, as we can see from the brief stylistic inventory above, is strikingly close to that of Precisionism. UPA cartoons have never, to my knowledge, been called "Precisionist"; what they *have* been called, however, is "Cubist."[32] But they are not quite Cubist, if we stick to the prevailing definition of Cubism as the condensation of multiple perspectives into a single image and the segmentation, analysis, and reassembly of space according to a theoretical model. What they are is "cubistic," in Friedman's sense of "ready-made 'cubistic' forms—skyscrapers, bridges, docks, grain elevators, turbines, cranes."[33] That is, UPA cartoons engage with geometry, and they utilize shapes and forms that resemble the results of Cubist process, but they take a different route to get there. They look nothing like, for instance, *Ballet Mécanique*, Fernand Léger's famous 1924 attempt to construct a Cubist

cinema in the form of rapid montage and the establishment of pure, abstract visual rhythm. If that is cinematic Cubism, UPA engages with Cubism in a very different way, situating itself in a lineage stemming from Precisionist appropriations of the form. Midcentury modernity, as we will see shortly, called for an artistic response to a salient perceptual question, and UPA answered in a Precisionist voice, echoing Precisionism's practice of joining abstraction and representation in the service of establishing a kind of simplified visual order. This shared concern, subtending the similarities of form between Precisionism and UPA style, is their foundational link: the yoking of abstraction to representation. And the similarities—and differences—of form between the two reveal the ways in which Precisionist modernism reappears in a new, midcentury moment.

Perhaps UPA cartoons' most defining characteristic is their flatness. Animation historian Esther Leslie notes that they "emphasized the two-dimensional plane"; media historian Norman M. Klein remarks upon their "flat graphics"; and Amid Amidi, defending UPA from this charge, reveals how central flatness is to common assumptions about the studio's style.[34] Composed of simple planes of bold, flat color, the worlds depicted in UPA animation eschew the rounded, three-dimensional approach of Disney illusionism, forgoing lifelike, painterly realism in favor of a more experimental and playful approach to representing space. Yet to call this space "flat" is a misrepresentation; it would be more accurate to say that UPA's artists constructed new models of spatial representation through the use of flat shapes. Precisionism, for its part, is not often discussed in terms of a perceived flatness of the picture plane; rather, commentators tend to discuss it in terms of the creation of space and depth. This depth, however, is suggested through the strategic positioning of Stavitsky's "hard-edged, static, smoothly-brushed, simplified forms rendered in unmodulated colors"—that is, flat shapes.[35] Most Precisionist art occupies the territory between the extremes of flat and deep space, confounding our assumptions about how space is most powerfully represented. Louis Lozowick's American city series, for instance, which features both paintings and lithographs, employs planes of abstract geometry layered on top of each other without suggesting the space in between. A painting such as Sheeler's *Church Street El,* in contrast, employs a forced overhead perspective to suggest extreme depth through the powerfully radiating diagonals of the same abstract geometry. UPA's continuum is likewise extensive, spanning both *Punchy de Leon*'s closely layered abstraction, which condenses great distances by driving the eye along the x- and y-axes, and the

Louis Lozowick, *New York, Brooklyn Bridge*, 1923. Lithograph on paper, 11 5/16" x 9". Courtesy of the estate of Louis Lozowick and Mary Ryan Gallery, New York.

Mr. Magoo series's more representational, vanishing point–oriented perspective that barrels into great, exaggerated depth.

UPA's artists were in fact overwhelmingly concerned with the creation of deep space, and they believed that this supposedly flat aesthetic was the way to create it. Animation designer Bill Hurtz, speaking of *Gerald McBoing Boing*'s design, argues, "We decided to dispense with all walls and floors and

Charles Sheeler, *Church Street El*, 1920. Oil on canvas, 16 1/8" x 19 1/16".

ground levels and skies and horizon lines.... If you put a doorway in a room with no boundaries, way, way back, that's a vast hall, far more vast than if you added the walls and the ceiling; there's nothing to contain the space."[36] As the preliminary notes for UPA's 1955 MoMA exhibition confirm, this simplification of form enhances the perception of spatial depth, especially through the studio's use of "diminishing perspective—not a UPA invention, but especially effective in UPA because of the elimination of inessentials in the scene."[37]

The quality, I suspect, that leads to the designation of flatness as a hallmark of UPA style is actually a different aesthetic marker that these cartoons also share with Precisionism: the unification of background and foreground design. This too is a significant departure from Disney style. Barrier observes, "In the Disney cartoons, and in American Hollywood cartoons of the thirties, the characters—composed of lines and flat, bright colors—typically stood out from the background paintings like actors performing in front of stage sets. The backgrounds were realistically modeled and painted in muted

Punchy de Leon (John Hubley, 1950).

colors, and so the characters 'read' against them as color accents."[38] Modern cartoons, however, designed their backgrounds according to the same principles that dictated their character designs, creating foreground figures that were, as media historian and filmmaker Howard Rieder describes them, "part of the overall design of the frame."[39] Many Precisionists worked in a similar mode, evacuating both foreground architecture and background environment of extraneous detail, often reducing both skyscraper and sky to flat color planes. The clear, "highly restrained surfaces of the Precisionist canvas," the "insistence on the clean and unencumbered surface," received much attention from those attempting to define the style, positioning Precisionism as an early proponent of a kind of painting governed by a unified design, a concern that UPA likewise shows in its cartoons.[40]

The unified foreground and background of the UPA cartoon, combined with the reduced, abstract nature of that unified design, evokes another bridge between midcentury cartoons and Precisionist painting. Klein characterizes UPA animation as consisting of "blocks of color that suggest a great stillness," and Michael Barrier describes UPA animator Bobe Cannon's approach as "a yearning for stillness and order."[41] In the production notes for *Gerald McBoing Boing,* Cannon himself refers to the cartoon's "understatement of movement as opposed to dynamic movement," a slowdown that "would be more effective because there has been a traditional excess of movement in cartoons produced at other studios."[42] Likewise, much of the dis-

Stage Door Magoo (Pete Burness, 1955).

course surrounding Precisionism latches onto stasis as a means of understanding its unique mode of representation.[43] As with the matter of outer-directed vision, this stillness sets postwar animation apart from its Abstract Expressionist moment, and its cultivation of stasis even as action painting became one of the standard-bearers of midcentury modernism links it again with that other modernism, Precisionism.

This feeling of stillness in midcentury animation is of course partly attributable to its actual, budget-directed stillness, that is, the literal reduction of movement within the frame of limited animation. However, there is more at work here, an element of conscious aesthetic choice that suggests great stillness through visual design itself. Compare the blank color fields of *Gerald McBoing Boing,* in which, for instance, the lightly sketched, roughly perpendicular outlines of a schoolhouse and its fence barely suggest the dimensions of the empty space surrounding them, with Charles Sheeler's 1917 drawing *Barn Abstraction,* in which a similar array of vertical and horizontal lines suggest the presence of architecture without allowing it to fill up the space it occupies. These minimalist representations draw attention not to the objects being represented, but rather to the emptiness of the frames in which they sit.

This evacuation of extraneous detail and the reduction to essential yet clearly recognizable forms, the aesthetic credos running through Precisionism and into UPA animation, convey a stance toward modernity that both styles

Charles Sheeler, *Barn Abstraction*, 1917. Black fabricated chalk on paper, 14 1/8" x 19 1/2".

share and that directly facilitates the establishment of visual order. This metaphorical "evacuation" creates the actual feeling of a vacuum running through this particular line of modernism, from art historian Barbara Rose's identification of Sheeler's "structures [that] are further simplified to a few straight lines and rectangles set squarely and directly in the middle ground, coolly floating in an anonymous setting" to Klein's description of *Gerald McBoing Boing* as "a world that seems floating in a void."[44] This still void, this designed emptiness, rests at the heart of the search for visual order in a modernity that provides too much perceptual detail in too much motion, and it functions as a governing aesthetic that Precisionism and modernist animation share.

GYÖRGY KEPES AND A NEW LANGUAGE OF VISION

Linking these two moments in the history of modernist visual culture, and these two sets of practitioners of a particular kind of American modernism, is a design philosophy that became central to the American art and design worlds during and after World War II through the work of Hungarian émigré György Kepes. As a member of Moholy-Nagy's faculty at Chicago's

Gerald McBoing Boing (Bobe Cannon, 1950).

Institute of Design (also known as the New Bauhaus) from 1937 to 1943, he participated in the foundation of a design education curriculum that rapidly spread across America, revolutionizing the way art and design were practiced and taught. Equally pivotal was his tenure at MIT (1947–1974), where he pioneered the first program in Visual Studies within the School of Architecture and Planning. The basis of his work, and his influence, rests on the notion of the arts as interconnected and nonhierarchical, integrated with daily life and functioning to habituate the human eye to an increasingly complex visual surround. (As a painter, designer, theorist, and teacher, he walked this walk as well.) Deeply rooted in the perceptual theories of the Gestalt psychologists, his program for a new modern design rests on a conception of vision as essentially abstract, composed of line, plane, and color. For him, simplified forms only acquire real-world reference once the mind, aided by memory, interprets them.[45]

His most famous publication, the 1944 design primer *Language of Vision*, is also his most influential; by the mid-1940s, it had become an introductory-level textbook in rapidly proliferating design programs nationwide.[46] It is a manifesto of sorts, calling for the overthrow of an outmoded naturalism and

a return to the "plastic dimensions" of the image, to considerations of form and surface that fell out of favor during the reign of Renaissance perspectival space. However, he also takes European high modernism—particularly Constructivism and Suprematism—to task for running too far in the opposite direction, foreclosing questions of representation and isolating themselves in a realm of sterile abstraction unconnected to everyday life. Kepes's focus is on the absolute integration of art and life, and his utopian goal is a visual language in which human vision becomes "autonomous," thus freeing humankind's minds for higher pursuits. An abstracted representation is the vehicle that would get us there.

Given his investment in a method of artistic representation rooted in the plastic dimensions of abstract art and oriented toward quotidian use, Kepes, one would imagine, ought to have composed odes to Precisionism's abstracted representations of the material of the everyday world. His omission of any mention of Precisionist painting in *Language of Vision*'s whirlwind tour of art history is thus puzzling—although perhaps less so if one considers the overwhelmingly European skew of his sample set. (This inattention was not reciprocal; in a 1955 letter to the editor of *Art in America,* Charles Sheeler writes, "I am very glad to have had the opportunity of reading Gyorgy Kepes' current article on 'The New Landscape in Art and Science.' I think it is wonderful.")[47] While I do not wish to speculate on his private reasoning, it seems that Kepes considered modernism a strictly Old World affair. The first iteration of American modernism he briefly mentions is Abstract Expressionism; it is only with advertising and graphic design that he sees America as perhaps coming into its own on the modern front (see chapter 3). It is in this light that Precisionism becomes central, as an artistic movement struggling with the same questions in the 1920s that Kepes poses to American artists and designers during the globalizing upheaval of World War II, just as Precisionism itself is heaving its final breaths.[48]

As discussed above, Precisionism carried the innovations of Cubism into an American context, placing perception and the technologically induced redefinition of space at the forefront of its philosophy; driving these experiments in representation was a search for order in a complex world, a precursor to Kepes's own mission for art. Just as Lozowick identified "order and organization" as the dominant trend in America, and therefore in Precisionist art as well, so did Kepes figure art as a method of containing the chaos of the outside world, declaring, "In the last hundred years technological practice has introduced a new, complex visual environment. The contemporary

painter's task is to find the way of ordering and measuring this new world." Or even more succinctly: "Space-time is order, and the image is an 'orderer.'"[49]

Likewise, Precisionism presages the logic underlying Kepes's own *rappel à l'ordre,* calling for a method of representation privileging the "direct apprehension" of the represented object, one that, as Lozowick argued, need not slavishly imitate its empirical appearance. Or, in Kepes's words, "Representation of spatial experiences cannot be the facsimile of the spatial reality, but must be a corresponding structure based upon the human receiving set."[50] That is, art must provide not the final product of perception—lifelike images—but rather the basic materials of perception—abstract forms— in order to reveal in the conscious mind the mechanisms by which we make sense of visual stimuli. We must know how we see in order to see better. Art must be integrated with the natural world ("natural" meaning "outer," not necessarily "green"—a redefinition of nature that enables Kepes's theory to incorporate contemporary urban life) on the level of visual perception, a concern that Lozowick publicized in his *Little Review* essay, and that art historian Merrill Schleier has also traced to Precisionist painters Stefan Hirsch and Joseph Stella, both of whom "believed artistic regeneration would occur in communion with nature."[51] Ultimately, Kepes's is a movement concerned with harmonizing a disunited humankind with its immediate environment, which is to say, it is an argument about ecology and nature, even if that nature has changed to something technological and urban.

By 1944, then, when Kepes published his foundational design text, a subset of modernist American art had already addressed the concerns he set forth in his manifesto calling for an artistic practice properly attuned to the modern sensorium. All of his buzzwords were present in Lozowick's piece, published sixteen years prior:

> The artist who confronts his task with original vision and accomplished craftsmanship, will note with exactitude the articulation, solidity and weight of advancing and receding masses, will define with precision the space around objects and between them; he will organize line, plane and volume into a well knit design, arrange color and light into a pattern of contrast and harmony and weave organically into every composition [an] all pervading rhythm and equilibrium. The true artist will in sum objectify the dominant experience of our epoch in plastic terms that possess value for more than this epoch alone.[52]

This declaration could plausibly characterize many of the varied schools of modernist art. However, Precisionism's dedication to honoring these plastic

concerns of abstraction in the service of orderly representation sounds a singular note, one that resonates with Kepes's theories in a way that few other modernisms did, particularly within the American context into which Kepes introduced his educational program for the postwar generation. It points to a conception of a modern life lived visually, one that troubled American modernist aesthetics well before Kepes came onto the scene. And most importantly, it provides a context for the aesthetic innovations of American animation in the postwar era, allowing us to see more clearly the specific modernism of modern animation.

There is, however, a troubling historical gap: Precisionism began to lose influence in the 1930s and eventually petered out, ultimately eclipsed by the cultural juggernaut of Abstract Expressionism. As Stavitsky observes, "The end of Precisionism can be linked to the devastations of World War II, which effectively destroyed the machine-age beliefs in industry as a beneficent force. Largely forgotten after the triumphant rise of Abstract Expressionism were the contributions of America's major generation of modernists, active since the 1913 Armory Show."[53] This early American modernism ultimately gave way to Abstract Expressionism, often figured as the pinnacle of American modernist art, even as Kepes established the fledgling field of an integrated art and design education upon principles Precisionism held dear, instilling them into an entire generation of American artists, not just in painting, but also in architecture, photography, and graphic design—and animation.

Moreover, the images that close *Language of Vision,* those on which Kepes stakes the future of visual art, are not even paintings, but advertisements, magazine covers, and posters. They show that his investment in perception and the ordering of it through art was not, as it was with the Precisionists, an endgame; rather, Kepes argued for a redirection of this artistic energy into popular culture, a project that would revitalize all areas of art, painting included, by uniting them in a mass-oriented utopian goal of a perfect integration of society, with itself and with its surroundings.[54] While Precisionism's critics were undoubtedly being uncharitable (and obtuse) in labeling its paintings as overrefined and sterile, a "bloodless and attenuated subterfuge," perhaps they were picking up on a certain insularity in its outlook and a possible seed of the decline of its relevance to the postwar art scene.[55]

In fact, the question of Precisionism's cultural usefulness seems to have been on the minds of its various practitioners, particularly in the 1930s, which saw the rise of Popular Front leftist thought, the foundation of the antifascist American Artists' Congress, and a general politicization of the arts. During

this period Precisionist output declined from its highs in the 1920s. While Sheeler and Spencer, among others, continued working in the Precisionist mode, many of their fellow travelers moved on to other styles, often as a result of increased political commitment. For instance, Lozowick, adopting a Marxist stance influenced by his personal relationships with Russian Constructivist painters, turned to social realism, depicting the lives of everyday laborers in place of his depopulated, geometric cityscapes of the 1920s. Peter Blume turned to surrealism, painting dreamlike, symbol-laden tableaux that likewise deviated from Precisionism's representations of architecture and machinery in a personless vacuum. Even Sheeler, while considered to be developing Precisionism in the 1930s, came ever closer to photorealism, painting close-ups of machinery that feature a hyperrealist, trompe-l'oeil effect lacking in earlier manifestations of his style.[56] The imposition of visual order through abstracted representation assumed lesser importance in the face of the concrete threats of economic depression, industrial stagnation, and totalitarian encroachment, and many artists veered away from Precisionism in service to the new cause. The style lingered, but its ascent in the previous decade had stalled. However, there is one artist who may help us build a bridge between Precisionism's 1920s peak and UPA's own dominance decades later: Stuart Davis, a late maybe-Precisionist whose work brings together Precisionism, Cubism, and popular culture in ways that amplify Precisionism's resonance with Kepes and UPA and that clarify the reasons behind the resurfacing of its visual style in the postwar era.

THE MISSING LINK: STUART DAVIS'S CARTOONISH PRECISIONISM

Stuart Davis is an American modernist who stands uneasily astride categories without falling conveniently into any single one, Precisionism included. The literature on American modernist painting has not yet made up its mind on Davis, treating him rather as a curiosity—and here Precisionism's lack of coherent unity as a self-defined school contributes heavily to the confusion. Stavitsky calls him "a unique individual" who "transcends tidy classification," ultimately acknowledging that "he was related to the Precisionists by contemporary critics."[57] Davis art historian Karen Wilkin observes, "The Stieglitz circle's [Precisionist] work often seems close to Davis's in motivation and aspiration. Like Davis, Stieglitz artists such as Arthur G. Dove, Georgia

O'Keeffe, and Charles Demuth were committed modernists whose work was rooted in their experience of their immediate surroundings"; yet finally, "Davis's work refuses to sit comfortably with theirs, no matter how similar their intentions."[58] Friedman credits him with "special relevance to this last phase of Precisionist development [in the 1940s]" but concludes that Davis "was never a central figure to Precisionist history as such"[59]—although he included Davis's 1928 work *Eggbeater #3* in his seminal 1960 exhibition at Minneapolis's Walker Art Center, *The Precisionist View in American Art*.

The tendency to designate certain painters "Precisionist" even as, in the eyes of another commentator, they fail to meet the proper criteria relies on the concept of an ideal Precisionism, a star around which the painters orbit, sometimes entering the solar system and sometimes swerving into other zones of modernist practice such as photorealism or pure abstraction. In most analyses of the style, Charles Sheeler is the sun of the Precisionist universe, closely followed by early adopters Charles Demuth and Preston Dickinson; other Precisionists rank variously as satellites, or sometimes as comets merely passing through.[60] But even if Sheeler, Demuth, and Dickinson were among the first American artists to "do" Precisionism, this perspective is unnecessarily limiting.[61] In place of a Precisionism defined as a concrete ideal surrounded by a number of near-approaches and departures, then, is a more multifarious conception defined as a series of variations on a theme, a group of responses to American technological and architectural modernity that partake, in varying degrees and combinations, of a shared set of stylistic options.[62]

To think of Precisionism this way is to avoid the pitfalls plaguing the attempt to isolate a rigid definition of the style, which runs afoul of Precisionism's inherent multiplicity: it is all about machinery and urban architecture, except when it's about barns; it trades in technological optimism, except when it critiques the progress of modernity; it is self-effacing and humorless, except when Charles Demuth cracks jokes in his titles. The question of whether or not Davis is a Precisionist prevents us from recognizing the ways in which Precisionism might be a more open classification than we think it is, and the ways in which his work, by shifting Precisionism's center of gravity, carries a form of it into the midcentury era. Often, Davis is viewed as a precursor to Pop Art—and yes, absolutely—but it is equally valuable to view him as a practitioner and developer of this earlier form of modernism.

Davis's supposed crucial difference from Precisionism proper rests on three elements of his style: his "pure" Cubism, his lack of modern technologi-

cal triumphalism, and his sense of whimsy. But these lines of demarcation are in fact quite blurry. For example, Stavitsky quotes a 1935 exhibition review that "drew a distinction between Davis as a true practitioner of Cubist abstraction and such Precisionists as Dickinson, 'who used cubism to clarify their ideas in art.'"[63] Yet Davis's Cubism is already a hybrid, performing the disassembly and reconstruction of space fundamental to Analytical Cubism, as in his 1927–1928 *Eggbeater* series,[64] while employing the vivid colors and collage aesthetic of the later Synthetic Cubism, in the 1930s and early 1940s introducing his own "optical geometry" and "color-space theory" elements,[65] and in the later 1940s even adding a visual transmediation of jazz music into the rhythms of his compositions. Davis's repurposing of Cubism is therefore not entirely different from what the Precisionists did with it, particularly in light of Davis's stated intent to "do some really original, American work," a prospect influenced by newspapers, magazines, and ragtime music.[66] His motivation for "an original note without parallel as far as I can see" springs from the same source as the Precisionists' quest for a uniquely American artistic expression descended from a Cubist exploration of form and space.[67]

If Davis's Cubism is perhaps not so different from Precisionist appropriations, his position on technology is likewise not as diametrically opposed as is often claimed. This is not to say that Davis is a full-blooded technological triumphalist. His depictions of machinery, after all, are not the dynamos and steam engines of Precisionist celebration, but electric fans, eggbeaters, and light bulbs. Far from extolling the power of American industry, Davis's engagement with the machine age seems largely to manifest as an affection for the gadget. Rather, it is to say that Precisionism's supposed techno-lust is perhaps overstated; even without taking into account the rural-landscape and still-life painting gathered under the style's banner, we may still locate ambivalence in Precisionism's outlook on technological and urban modernity. For example, art historian Sharon Corwin identifies "elisions and, perhaps more important, tensions and ambivalence" in the Precisionist attitude toward modernity that suggest a sustained critique across artists' oeuvres.[68] Even the seminal Precisionist Sheeler's work, art historian Mark Rawlinson argues, offers a veiled critique of urban-industrial modernity in its "imprecise [p]recisionism," a faint but definite skewing of perspective and regularity that "highlights im-precisely the irrationality ... that hides behind the facade of rationality."[69] If, as Friedman argues, "in spite of stylistic similarities in Davis's work to that of Spencer or Crawford, he has never shared the Precisionist reverence for modern technology," he may be said instead to

share some of its ambivalence.⁷⁰ In this light, Davis's quirky gadgets and street scenes (and appreciative and affectionate ones, at that) painted in sharply defined planes of flat colors with often invisible brushwork do not seem to differ so significantly.

Revisiting the literature that does not quite know where to place him in the pantheon of American modernism, we perhaps find the source of Davis's *je ne sais quoi* in his attitude. Friedman, for example, notes: "The uniqueness of his art stems from the strident color and syncopated rhythms of the urban scene. The vivacity and humor of Davis's art has no equivalent in Precisionist painting."⁷¹ Likewise, Wilkin argues: "His pictures seem more aggressive and more physically substantial than the elegantly finished, discreet pictures by Sheeler and the Stieglitz artists. Davis's language is more vernacular, his touch more vigorous."⁷² At bottom, Davis is playful where the Precisionists are not. But not *so* playful. Stavitsky, speaking of "his logically arranged compositions in which nonessentials are eliminated," points out that "Davis himself had defined his goals in terms that relate to aspects of the Precisionist aesthetic: 'A work of art . . . should be impersonal in execution . . . direct . . . well built.'"⁷³ Each of these traits—the removal of evidence of the artist's hand, the emphasis on the aforementioned "direct apprehension" of the object without the interference of the medium, the painstaking attention to composition and underlying abstract structure—are the hallmarks of Precisionist painting. Moreover, they suggest an impersonality of approach that has less to do with the artist's attitude toward the subject—after all, staid admiration is just as much of a personal attitude as playful vivacity—than with the mode of representation. To return to Davis's own words, art "should be impersonal *in execution*." Art historian Milton Brown links Davis to the Precisionists through the clean surfaces of his paintings, and his avoidance of visible brushstrokes and his sharp delineation between shapes suggest a similar investment in a simplified visual perception of a chaotic world.⁷⁴ That Davis's precise imagery is less calm and more visually in tune with the stimuli of modernity than that of more centrally located Precisionists is less important than the fact that it, like the rest of Precisionism, attempts to instill order through the reduction of the world to precisely drawn, firmly bounded, and solidly colored shapes.

And yet Davis's work *is* different from most of the Precisionists' work, if not in ways that render him "non-Precisionist," then in ways that shift the focus of Precisionism, or at the very least reorient Precisionist technique and philosophy in a different direction. As the Depression wore on and more and

more Precisionists turned to other styles to represent the American scene, Davis moved the center of Precisionism toward the polar positions he occupied. Friedman observes, "In the Forties, Precisionist painting, particularly in the work of Sheeler, Spencer, and Crawford, returned with a new vigor and sophistication to something very much like its initial Cubist-inspired form."[75] This is not to say that by midcentury the Precisionists were chasing after Davis, but rather that Davis, working within the Precisionist world, even if on the margins of it, had greater influence—Friedman's "special relevance"— on its direction by the 1940s. This influence, perhaps due to the defections of earlier luminaries such as Lozowick and Blume (and even Sheeler, with his move toward photorealism in the 1930s), was, as we will soon see, of central importance to both the future of Precisionism and the birth of the modern cartoon.

One site of fundamental difference from Precisionism in Davis's art is his stewardship of the everyday, which Wilkins acknowledges when she argues that "Davis's language is more vernacular" than that of the Precisionists. This difference underlies, among other things, his architectural imagery, which represents not just the skyscrapers and clusters of buildings so familiar to Precisionism, but also cafes, streets, and storefronts, still largely unpopulated in keeping with the Precisionist mode but nevertheless more engaged with quotidian life and the experience of urban modernity from the ground rather than with distanced, abstracted views from above. It is precisely this difference that complicates our traditional understanding of Precisionism's decline and eventual end in the aftermath of World War II—and that provides a link to UPA's own representational modes. If, as some art historians have argued, Precisionism ended after 1945 because of the horrors of wartime and, more importantly, because those horrors were directly enabled by the rationalization and the technological progress in which Precisionism placed so much of its faith, what are we to do with Stuart Davis's midcentury prominence?[76]

The answer cannot be to divorce Davis completely from Precisionism in favor of the above-mentioned Pop Art connection. While his investment in the theoretical side of Cubism, his move toward greater abstraction, and his jazz-inflected dynamism constitute genuine differences from the bulk of Precisionist practice, they are differences of degree, not of kind; they are extensions, developments. In a sense, the "was he or wasn't he?" question falls by the wayside if we, as Friedman hinted, consider Precisionism something that was happening in the first half of the twentieth century in America rather than something that Painters X, Y, and Z were doing in the studio and the gallery.

Scholars have identified Precisionist currents in photography and poetry in the 1920s and 1930s. As a response to modernity, Precisionism was perhaps centrally a painterly response, but it was also a cultural response.[77] (Might we even include Frederick Winslow Taylor and Frank and Lillian Gilbreth in the Precisionist pantheon, working out these same questions not on canvas, but on the bodies of factory workers?) The art of Sheeler, Lozowick, Spencer, and their contemporaries was then one iteration—we may even call it the "main" iteration, if we like—of this response, and as such it was subject to modification. It is Davis's modification of the Precisionist impulse that is worth exploring here, and it is in connection with Kepes that this exploration is most productive, particularly in the service of understanding midcentury animation.

Concurring with Wilkins, curator John R. Lane describes Davis's central contribution to American art as the "invention of a vernacular Cubism—his masterful synthesis of specifically American subject matter and European modernist style."[78] Yet this is precisely the intervention with which the Precisionists are credited; as we have seen, some variation of "synthesis of specifically American subject matter and European modernist style" is often the phrase employed to provide a sweeping definition of Precisionism itself. So let us adapt Lane: Davis's central contribution to American art was his infusion of Precisionist modernism, already a synthesis of Cubism and the American scene, with the vernacular and the popular. Where the Precisionists, broadly speaking, engaged with technology and industrial modernity, Davis engaged with popular culture. Where the Precisionists melded American modernist art with industrial and architectural design, Davis melded it with corporate and product design, incorporating brand logos and packaging into his compositions, yoking abstraction to representation not just of the outer world, but of the consumer goods populating that world as well, as in his paintings of Odol toothpaste dispensers and Lucky Strike cigarette packs. Presaging Andy Warhol's famous collapse of the distinctions between art, life, and commerce in the 1960s, in 1921 Davis declared, "I do not belong to the human race but am a product made by the American Can Co. and the N.Y. Evening Journal."[79] This willingness to acknowledge popular forms and their role in shaping modern American life positioned Davis for greater popularity and success in the increasingly consumerist-oriented postwar era, even as it resonated with Kepes's own celebration of American advertising as the summation of *Language of Vision*'s art-historical arc.

As it was for Kepes, the purpose of art for Davis was to reintegrate art and everyday life, a project that, like Precisionism, called for the yoking of abstrac-

tion to representation. Almost a decade before Kepes challenged pure abstraction's excesses, Davis positioned himself against the American Abstract Artists, a group of painters looking to European modernisms such as Constructivism and Neo-Plasticism for stylistic cues. Kelder acknowledges Davis's "insistence that the content of abstract art seek its sources in nature," observing, "The generally geometric orientation of the artists in the organization was too limiting and too exclusive of the vital human experience that was fundamental to Davis's concept of abstraction."[80] This emphasis on contemporary experience, manifesting in *Language of Vision* as a celebration of advertisements as a promising direction of an art fully integrated with daily life, appears in Davis's work in other commercial fields such as textile design, album and book covers, and ceramics.

It also appears in Davis's painting itself, and in the specific kind of abstraction he advocated. Davis, like Kepes, was invested in the perceptual theories of the Gestalt psychologists. From 1940 to 1950 he taught at the New School for Social Research, where Gestalt psychology pioneer Max Wertheimer developed his theories into the field of cognitive psychology that blossomed in America after World War II. Lane describes Gestalt theory as maintaining that "the process of vision integrates significant structural patterns, and that images can be extensively abstracted and still retain their affiliation with reality," and argues that exposure to these theories of perception "encouraged further abstraction in Davis's art."[81] In 1945, Davis would remember his *Eggbeater* paintings of 1927 as a fulfillment of the intention "to strip a subject down to the real physical source of its stimulus,"[82] a merging of scientific rhetoric and artistic practice that Kepes championed in his work and that Kelder calls Davis's "commitment to an empirical and objective approach to painting."[83] Key to this approach was the conviction that abstraction really does represent reality, at least as apprehended by Kepes's aforementioned "human receiving set."[84] Importantly, the ability to apprehend this reality must be learned. Davis described his aesthetic as "a realism that every man in the street has the *potential* to see, but in order to see, would have to see it in himself first."[85] Davis also shares with Kepes the identification of a new kind of vision in modernity, one for which imitative realism is no longer appropriate—or as Kelder calls it, "the new reality offered in modernism."[86]

For Davis, modernist art's relationship to this new reality was one of acculturation and the training of vision; he believed that "human experience could be objectified, clarified, and expanded through the system and structure of art."[87] Tellingly, Davis spoke of the nature of this relationship in the

Stuart Davis, *Rue des Rats No. 2*, 1928. Oil and sand on canvas, 20" x 29". Art © Estate of Stuart Davis/Licensed by VAGA, New York, NY.

rhetoric of an ordering art later used by Kepes: "The quality which is common to all works of fine art throughout history is the existence of real physical order in the space of the material of expression.... 'Art order' and 'real physical order' are synonymous."[88] His interest in systems, relations, and conceptualizations resonates strongly with Kepes's relation-based system of artistic perception and vision in general, according to which "one can not... perceive visual units as isolated entities, but relationships."[89] And his color-theory system, based on the premise that "every time you use a color you create a space relationship" and codifying a system of retreating and advancing colors,[90] mirrors Kepes's own explorations of the forward and backward movements of different colors on a two-dimensional picture plane.[91] Kepes's perceptual system rests on the brain's interpretation of light rays given off by interrelated forms in space, and his project for art rests on the proper and efficient harnessing and redirection of that process toward the interpretation of increasingly complex stimuli through the training of the eye to manage abstract shapes on the picture plane.[92] Twenty-four years earlier, Davis identified a similar goal for his own art: "What is the object and concern of painting.... To reproduce the personal conception of the organization—unity—synchronisation—of the diverse phenomena of lighted form in space of

Rooty Toot Toot (John Hubley, 1952).

which the eye takes account and the brain analyses."[93] When he took the regionalist American Scene painters to task for their imitative realism, he denounced their disregard for this kind of relational, system-based thinking about vision and art, declaring that a "great art ... will come from artists who perceive their environment, not in isolation, but in relation to the whole."[94]

All of this is to say that for Davis and for Kepes, art possessed a practical use value, and for both of them this use value trended toward the utopian—more specifically, a utopia based on systematic sensory mastery. Kepes argues: "To perceive a visual image implies the beholder's participation in a process of organization. . . . Here is a basic discipline of forming, that is, thinking in terms of structure, a discipline of utmost importance in the chaos of our formless world. Plastic arts, the optimum forms of the language of vision, are, therefore, an invaluable educational medium."[95]

Davis, meanwhile, according to art historian Cécile Whiting, was attempting to "translate the local environment into a universal and orderly image. Davis's artistic language of logic promised both control over the chaos of war and unity in the face of Nazi racism and nationalism."[96] An abstract-representational art was a democratic necessity, one that "would be able to

Stuart Davis, *Men and Machine*, 1934. Oil on canvas, 32" x 40". Art © Estate of Stuart Davis/Licensed by VAGA, New York, NY.

inspire a psychological and intellectual uplift or stimulus through the viewer's intuitive response to the formal characteristics of a given work."[97] This democratic outreach through visual art, a program of retraining human vision to assimilate a complex world—in Davis, "the new lights, speeds, spaces of our epoch," in Kepes, "space-time relationships never recognized before"[98]—finds fulfillment in the realm of the modern cartoon.

Moreover, if UPA's films sit quite comfortably with Precisionism's style, examining them alongside Davis's work brings new resonances to the fore. Recalling Precisionism, Davis's development of "a new conception of the painting as a totally ordered, continuous surface"[99]—that is, a form of representation governed more by coherent design than by the rules of theatrical or photographic realism and depth—also aligns with UPA's own unification of foreground and background design. Additionally, Davis introduces some sketchy textural innovations that we may also find in UPA's style. Witness, for instance, the nearly identical visual styles of Davis's 1928 painting *Rue des Rats No. 2* and the 1951 UPA cartoon *Rooty Toot Toot*. The simple geometry

Fudget's Budget (Bobe Cannon, 1954).

and unmodulated colors of Precisionism are evident here, but so is the abovementioned playfulness, the willingness to be a bit messy in the precision of these forms. Or consider the work Davis and UPA do with outlines in the 1934 painting *Men and Machine* and the 1954 film *Fudget's Budget,* again preserving Precisionism's geometrization of the outer world but experimenting further with color and hollowness. In fact, *Fudget's Budget*'s rendition of the bold outline turns Davis's search for visual order into a literal representation of the organization tool of the financial ledger. The visual parallels are striking, and they point to a stylistic harmony between Davis and UPA, and the Precisionism they both develop. But more importantly, they suggest a theoretical harmony. UPA's artists envisioned their signature style as a distinctly modern medium of communication and education, developing animation along the lines sketched both by Davis and Kepes in their contemporary moments and by Precisionists in the decades preceding it.

UPA'S "NEW VISUAL LANGUAGE": DESIGNING A MORE MODERN CARTOON

When John Hubley and Zack Schwartz fired their first shot across the bow of the American animation industry with their 1946 article "Animation Learns a New Language," they explicitly positioned themselves against the

bulk of American cartooning practice in their argument for a more human-centered cartoon freed from vaudeville roots and animal-based slapstick. Much attention has been paid to the article's call for a shift away from "pigs and bunnies," a move constructed as central to postwar animation's greater focus on character psychology and everyday modern life—and rightly so.[100] However, equally important is Hubley and Schwartz's insistence on a new visual language divorced from Disney's obsession with photographic pictorial space. Even before the 1941 strike, tensions between Walt Disney and his artists rested on the latter's desire to experiment with forms influenced by modern art and the former's refusal to sacrifice the illusion of life.[101]

Animation theorist Paul Wells has thoroughly argued in *Animation and America* that postwar modernist animation is a rebellion against a retrograde, conservative naturalism, of which Disney was the figurehead. "It might be properly argued," he notes, "that all cartoon animation that follows the Disney output is a *reaction* to Disney, aesthetically, technically and ideologically. . . . American animation is effectively a history of responses to Disney's usurpation of the form in the period between 1933 and 1941."[102] This intergenerational unrest maps neatly onto the conflict in the 1930s art world over naturalist American Scene painting versus abstract-representational Precisionist painting, implicating the American cartoon in the art world's fight for modernism, but in a parallel battle that erupted almost two decades later. That these battles never conclusively decide the matter of how best to artistically represent a continuously updating modern life calls attention to the striking fact that the proposed solutions remain likewise locked in a cycle of eternal return.[103] At midcentury, in the wake of World War II, just as in the 1920s after World War I, the American modernist response to disorder and massive social and technological change is a reimposition of sensory order through an abstracted form of representation aimed at reducing the visual field to its most basic constituent elements of line, shape, and color.

This resurgence of Precisionist visual strategies at midcentury begs the question, to what extent do UPA's formal innovations represent a significant engagement with modernity rather than a fashionable appropriation of a contemporary, and increasingly popular, modernism in the "higher" arts? The answer lies in the strain of serious research into methods of visual communication underlying UPA's commercial success in the entertainment market. UPA's early education and training films are a necessary prologue to the studio's later theatrical cartoons, and its crowd-pleasing shorts cannot be fully understood in isolation from its more workmanlike and didactic out-

put. To view the famous shorts in this context reveals the theatrical films as participants in the struggle to attune the human sensorium to the changing American landscape after World War II.[104] The key figure in this mission, again, is György Kepes.

If Kepes is in dialogue with Precisionism by way of spiritual and conceptual affinity, his connection to midcentury animation is more concrete: various UPA animators, including Bill Hurtz and Gene Deitch (who received *Language of Vision* as a gift from Hubley upon being hired at the studio), refer to Kepes as a widespread influence,[105] and animation historian Michael Barrier refers to "the ideas that had shaped UPA's films in the middle forties, the ideas that György Kepes had advanced in *Language of Vision*."[106] As with Lozowick's manifesto, Kepes's language is strikingly present throughout Hubley and Schwartz's seminal, medium-defining article; the difference here is that for the latter, the similarities are intentional (not to mention chronologically possible) and indicative of a shared project of negotiating postwar modernity. Not for nothing do they phrase the promise of a revitalized animation in Kepesian terms, as "the possibility of a new visual language."[107]

Essentially a manifesto for the creation of a mature, modern cartoon, "Animation Learns a New Language" builds a case for animation as a medium of education and communication rather than merely of childlike amusement. As the engine of this new conception of animation, World War II had introduced new possibilities for visual communication through the necessity of training films aimed at large groups of unskilled recruits responsible for learning large amounts of information in small amounts of time. In demanding a new, more efficient form of mass communication, the First Motion Pictures Unit brought two incomplete modes of address, the workmanlike educational film and the zany theatrical cartoon, into conversation with each other—or, as Hubley and Schwartz put it, "Because of wartime necessity, pigs and bunnies have collided with nuts and bolts."[108] Outlining the development of the modern animated training film, the authors call for the redirection of a former military tool into wider public culture, positing a broader pedagogical role for the cartoon short.

For Hubley and Schwartz, animation is an ideal medium for mass communication not because it is entertaining, but because of its unique symbolic properties: "Within the medium of film, animation provided the *only* means of portraying many complex aspects of a complex society. Through animated drawings artists were able to visualize areas of life and thought which photography was incapable of showing."[109] In other words, animation,

untethered to photographic representation, could perform a kind of conceptual abstraction that live-action film could not. And if animation's independence from external reality enhanced its ability to convey ideas, its capacity for movement also differentiated it from the other contemporary form of training document used to visualize knowledge, the drawing or diagram. It could show invisible processes in action—a new language of vision indeed. If Hubley and Schwartz got their way, animation could render the inner reality of things more accurately than any previous imaging technology.

In the third and final section of *Language of Vision*, titled "Toward a Dynamic Iconography," Kepes outlines his utopian goal for a modern visual language: "The plastic structures must expand to absorb, without giving up their plastic strength, the meaningful images of current concrete social experiences. The task of the contemporary artist is to release and bring into social action the dynamic forces of visual imagery."[110] That is, in the same way that art must enable its spectator to reassert visual order upon the American scene (as was the goal of Precisionism), it must also engage the spectator's interior process of meaning-making in a more dynamic, associative way. It must retrain the spectator's vision so that it can be brought into line with changing systems of knowledge in modernity. As Justus Nieland observes, "The midcentury object is thrown into pronounced crisis: its solidity fissured, catastrophically, by atomic science; its materiality flattened in a post-industrial society driven by the circulation and consumption of images; its capacity to function as an autonomous fragment of non-self challenged by expanding informatic networks that force it into scenes of communicative transparency."[111] As ways of understanding human and human-object relations are overturned in the postwar era, a new way of seeing these new relations is required.

As if in response to this call for a "dynamic iconography," Hubley and Schwartz assert the primacy of "the *dynamic* graphic symbol," arguing, "In short, while the film records what we *see,* the drawing can record also what we *know,*" thereby aligning themselves with Kepes's mission of using art to reconcile vision with the advances in knowledge that modernity had wrought.[112] Media historian Fred Turner places this visual education in connection with newfound rhetorics of democracy after World War II. In this sense, "patterns of media reception aped and foreshadowed patterns of political interaction. To listen to the radio, watch a movie, or wander among a roomful of sounds and pictures was to rehearse the perceptual skills on which political life—fascist or democratic—depended."[113] Kepes's goal of

democratic, mass meaning-making through a dynamic, symbolic iconography found purchase in the newly revitalized medium of the training cartoon. (Of this third section on the dynamic symbol, Kepes says in retrospect, "To carry the ideas out, it would have led to filmmaking, to television, to whole new idioms of kinetic or dynamic communications.")[114]

Reprising his argument from "Animation Learns a New Language" in a 1975 article, "Beyond Pigs and Bunnies," Hubley channels his inner Kepes further, arguing: "The physical character of the line plus its symbolic meaning presses for a breaking out of its space into a dynamic image. It has a potential energy that suggests motion—life. . . . When the entity of time is added, a series of drawings becomes a symbolic transformation of energy."[115] This transformation enables the visualization of "inner facets of the character and, at the same moment, the nonvisual aspects of the environment," a revelation of inner reality that he calls "the primary property of animation."[116] If Kepes's ideal art form for habituating the human sensorium to the space-time relationships and the new realities of modernity was the print advertisement ("They could train the eye, and thus the mind, with the necessary discipline of seeing beyond the surface of visible things, to recognize and enjoy values necessary for an integrated life") UPA would seem to have done him one better with the medium of the animated cartoon, activating the potential energy Kepes aimed to cultivate in *Language of Vision* and allowing an invisible inner reality to unfold in visible space-time.[117]

However, UPA's quest for a mature, streamlined, uniquely communicative cartoon did not subside along with the need for wartime training films, or even for sponsored informational films in general. As political opinion shifted in the transition to the Cold War and UPA's left-leaning politics began to deprive them of government and industrial contracts, Hubley and his colleagues brought their new visual language into the theatrical market, focusing their modernist, goal-oriented sensibility on the entertainment cartoon. In this, they recall design historian Robin Schuldenfrei's account of the midcentury designers of the New Bauhaus, Kepes among them, who used their wartime output to lay the groundwork for a peacetime in which "the restorative power of art in the postwar period [would put] a fragmented civilization back together again."[118] UPA's graphic approach to the training film—stylized, simplified figures that are both readily legible and freighted with symbolic and conceptual rather than representational meaning—lent itself to a new kind of character design. Gone were the fully rounded, squash-and-stretch, centerline-drawn figures of Disney and Warner Brothers; in

their place cavorted characters composed of off-kilter, geometrical, nonrepresentational shapes whose abstract surreality and unnatural transformations reveal, as Hubley discusses in "Beyond Pigs and Bunnies," their invisible, inner psychology in their very physical form.[119] For example, in *Rooty Toot Toot* (1952), the slinky, seductive temptress Nellie Bly twists her arms around each other like snakes, while the sad-sack bartender is a plain brown oval whose color alternately runs outside or fails to fill his outline, visually representing his skill at blending into the background to better enable the projection of his drunk customers. This choice to dispense with imitative realism opened the way for a more psychological realism descended not from cinema, as in Disney films, but from graphic design.

UPA's use of modern graphic language offered more than heightened character psychology, however; it also offered a new, modern visual sensibility for which the studio's abstract, geometric style was an appropriate way to represent the world. In "Meep Meep," animator Richard Thompson proposes the idea of an "inverse-reality dynamic" inherent in animation (as well as in genre films, interestingly), according to which the farther a film form strays from imitative representation of reality (either visual or narrative), the more thoroughly it lays bare its cultural relevance by foregrounding its fantastical nature, which is then read as an idealization of or commentary upon its cultural moment.[120] Klein, meanwhile, argues that the gag-dependent cartoon is even more tied to its cultural moment than other kinds of filmmaking because its ability to be read as funny by its audiences rests on its timeliness (or, in the best-case scenario, its timelessness).[121] Combined, these analyses position the cartoon as a powerful index of cultural tensions and forces at the time of their reception, and UPA style, as a particularly radical departure from contemporary animation practice, points to significant disruptions at midcentury, paramount among them the perceptual overload Kepes locates as the source of modern angst in the twentieth century.

In his 1953 article "Two Premières: Disney and UPA," film critic David Fisher acknowledges the centrality of perception in UPA's approach to animation, observing, "Most UPA films reveal a preoccupation with visual reality unusual in any cartoon."[122] Yet as hand-drawn, consciously composed, largely representational artifacts, all cartoons are preoccupied with visual reality; it is merely their stance toward it that differs. Disney is preoccupied with preserving traditional notions of visual reality, while UPA is preoccupied with making sense of the new, modern notions of it that were asserting themselves over the course of the twentieth century and, if Kepes is to be

believed, coming to a head in the middle decades. Fisher espouses a curious contradiction: first, speaking of *Gerald McBoing Boing,* he notes, "He exists in a never-never land of flat-colored backgrounds and outline people." Then, in the same paragraph, he argues, "[UPA] rejects the traditional never-never land of the film cartoon in favor of human reality, even though its style is less realistic on the surface."[123] How might we reconcile the competing ideas that UPA cartoons fashion never-never lands even as they reject never-never lands in favor of human reality? At the heart of Fisher's paradox, and of Hubley and Schwartz's manifesto and of various interviews with UPA staffers and modernist cartoonists from other postwar studios,[124] is the conviction that the superficially "less realistic" visual style of the modern cartoon enables a clearer view of modern life, a conviction that makes little sense unless it is considered in the context of the assorted developments in American modernism leading up to midcentury. These developments grew out of the belief that old models of vision were inefficient and inaccurate, and that a new vision must be cultivated if humankind was to properly see the world in which it found itself within the chaos of postwar modernity.

Klein, in establishing a lineage for modern animation design, contends, "[UPA's] linear style was more a part of the emerging consumer world than older pre-industrial crafts, like illustration."[125] Specifically, he is referring to famous midcentury developments such as the freeway, the growing reliance on the personal automobile, the blossoming of the shopping mall and the theme park, and the facilitation of an emerging consumer culture engendered by these developments—a collection of aesthetic and cultural innovations he dubs "consumer cubism."[126] This is a compelling argument, and a fun one; however, in striving to situate modern animation within its contemporary context, Klein perhaps goes too far, cutting off this "new" style from its own history. For example, he claims that "UPA was not simply a return to linear animation [of the 1920s], much as [that] would give my argument an easy symmetry."[127] Granted that it was not "simply" a return to that and nothing more—Klein's identification of the homologies of midcentury "consumer cubism" is persuasive—UPA was indeed a return to at least one concern of 1920s linear animation: graphic experimentation with a significant modernist bent. Moreover, when Klein argues, "I see UPA cartoons of the fifties as primarily an adaptation to the fantasies associated with advertising, architecture, and open consumer spaces more than painting," as if painting had nothing to do with developments in these other fields, he dispenses with the very modernism that binds all of these media forms together.[128] Or rather, he dispenses

with the concept of a continuous or resurgent modernism in favor of a merely different one, one that disregards the first eruption of American modernism in the 1920s and 1930s painting and its resonance with midcentury modernism. Klein's contemporary context for modern animation design therefore ought to be balanced with a historical one that views UPA style as a resurfacing of the Precisionist impulse through the perceptual philosophy of Kepes, and as a new iteration of the effort to bring order to the modern visual surround through abstraction and simplification.

As Kepes argues in *Language of Vision,* the visual surround in postwar America presented larger perceptual challenges than the human eye could master: skyscrapers, airplanes, subways, elevated trains, automobiles, and urban concentration conspired to produce an increasingly occupied visual field, a multiplication of layers of depth with which human perception had to catch up. It must be noted that these changes in the urban environment are all hallmarks of early-twentieth-century modernity—indeed, this assumption is foundational to the branch of aesthetic history out of which this book grows[129]—and this continuity is central to both Kepes's agenda and my own argument: European modernism and its American iterations started the job of adapting to modernity, but meanwhile the world kept on undergoing its own revolutions, and humankind was thus still attempting to sort out its confusion at midcentury, and in very similar ways. Even the turn-of-the-century discourse of attention, distraction, and retention elaborated in the work of art historian Jonathan Crary returns in the 1940s, here in reference to wartime training films and the suitability of the cartoon for mass education.[130] Still on modernists' minds in the middle of the twentieth century are the problems of vision and order, a project that the Precisionists began in the early 1920s. And as with the Precisionists, attempts to reinscribe visual order on the American scene rested on an appeal to geometry. Identifying the grid as "the theme of consumer life in the early fifties," Klein notes that the proliferation of "squares within squares," in shopping malls, in streets and freeways, in television, and in home decor, "suggested a conquest of chaos. Very early on, one saw the consumer prairies emerging, outlined by geometric space."[131]

Film occupied a special place in this assertion of order, and for the reasons outlined above, animation's place was even more privileged. Recalling Thompson's "inverse-reality dynamic," cartoons carry the distinction of providing a peculiarly direct gloss on their times, unburdened by photographic representation and the laws of physics. Discussing the modernism of the car-

toon form, Klein argues that "cartoons constantly adjust to media, perception, and marketing. They are constantly 'redrawn' by the crises of modernity."[132] Esther Leslie concurs, emphasizing the serious work cartoons perform for the sake of vision and space: "Cartooning was the place where research into flatness and illusion and abstraction was most conscientiously carried out. Cartoon trash could cast the most curious and fantastic lights."[133] This curious term, *research*, recurs often in the writings of modernist art theorists, particularly in the circle of European émigrés who came to America during and after World War II—including, of course, Kepes. It positions the artist's canvas—or the cartoonist's cel—as a laboratory, a place where art seeks solutions to scientific problems, and in the postwar context it implicates the arts in the explosion of better-living-through-science rhetoric as wartime technological developments were redirected toward the consumer market.

The cartoon's research into visual representation carried a cultural component as well, one that should be familiar to any student of Precisionism. Wells calls post-Disney animation "a response to and a development of a variety of 'modernities' and a consistent commentary upon America as a machine culture."[134] This commentary, couched within the rhetoric of training, education, and mass communication, was aimed at facilitating the adjustment to modernity and its accompanying forces on a mass scale, particularly after the war, when, as with other technologies, these developments in animation were redirected toward the broader American public rather than solely at soldiers. Film producer Leonard Spigelgass speaks tellingly of the use of cartoons as "therapy through films," an enlistment of animation in the service of calming fears and easing anxiety.[135] He is referring specifically to fear engendered by misinformation, but his colleagues in the animation field clearly saw other applications for cartoon therapy, as a way of easing anxiety caused not by rumors and falsehoods, but by disordered vision. Schuldenfrei finds this across the design fields; as New Bauhaus founder László Moholy-Nagy claims in 1944, "Art educates the receptive faculties as well as revitalizes the creative abilities. In this way art is rehabilitation therapy through which confidence in one's creative power can be restored."[136]

Among these applications is a seminal element of 1950s American technological and visual culture: television. UPA's sparse, minimalist style was particularly well suited for the small screen, having developed in the often ad hoc and improvised exhibition spaces of the war, where, as Ted Geisel (better known as Dr. Seuss) famously noted in defense of the Signal Corps' stripped-down visuals, "Our films have to be legible projected on the side of a dead

cow."[137] Likewise, graphic designer John Halas touts the appropriateness of the modernist approach for home viewing: "Television, with its limiting size and tone range, provides a natural trend towards simplification and abstract characterization."[138] UPA took advantage of this new medium, producing animated ads for products such as Piel's Beer and Jell-O, as well as the ill-fated *Boing Boing Show*.[139] These forays into the middle-class American living room did more than raise the studio's cultural and financial profile, however. As Lynn Spigel observes, "For the general public, the abstract animated commercial came to be an everyday form of modernism, a way of looking at ordinary things through visual and audio engagements with cutting-edge graphic and sound design."[140] UPA's visual style, both in theatrical films and in television production, thus disseminates Hubley and Schwartz's new visual language on multiple fronts, exposing broad audiences to the studio's attempts at perceptual adjustment—and it does so by appealing to the same process advanced by Davis and Kepes: the marriage of high-art impulses to everyday consumer objects.

Wells speaks at length of the visual work carried out by UPA cartoons, noting, "The UPA studios were instrumental in recovering animation from the structures and limitations that sought to define it, returning the form to the proper embrace of *perceived reality* and its place within artistic and cultural contexts." UPA style, he argues, "required the fresh-sightedness of artists versed not merely in progressing art traditions, but in artists who would embrace a philosophical approach to perception, and to the possibilities of synaesthetic cinema, and ways of 'post-styling' the reality of both the real world and the Disneyesque orthodoxy."[141] This "post-styling of the real world" is, perhaps, a defining feature of modernism writ large, and even of representation in general. What is important about UPA's particular "post-styling" is the way in which it reanimates both Precisionism's sensory concerns and its stylistic methods for addressing them. The similar visual styles of Precisionism and UPA point to the modernism they both represent, and underneath that stylistic resonance is a shared theory of vision, a shared complaint about humankind's relationship to a changing world, and a shared sense of art's educational duty as part of a widespread project of sensory rehabilitation.

For all their similarities, however, UPA style differs from Precisionism in important ways. Most noticeable is the playfulness with which UPA's artists approach their art. While Precisionism is not as cold and humorless as its commentators suggest, it is also nowhere near as rambunctious as its ani-

mated counterparts. Precisionism's straight lines and perpendicular angles look positively rigid next to the wrenched perspectives and skewed geometries of Mr. Magoo's world—and the Mr. Magoo series is perhaps the most realistic and representational of UPA's output, what Rieder describes as "about a halfway point between the extreme literalism of Disney and the stylized animation of the more offbeat UPA films."[142] Beyond Davis, Francis Criss's work, with its bright colors and distorted perspective, perhaps marks one of Precisionism's closest passages to UPA's crooked cartoon space, as in *Jefferson Market Court House,* in which skewed perspective, unnaturally solid colors, and judiciously placed squiggles wrench the image of a civic building into the whimsical world of the cartoon. However, as a whole, UPA's modernism strikes a different position on modernity, perhaps bemused and affectionately mocking where Precisionism's is disciplined and constructive. Fisher hints at the novelty of UPA's critique, positioning its brand of cartoon as mischievous cultural criticism: "For them visual eccentricity reflects the oddities of life. They appeal to that something inside us whose reaction to politics, for instance, manifests itself in a desire to paint mustachios on public statues."[143] This shift from cautious optimism and tentative critique to gleeful, outright irreverence recalls Stavitsky's above-quoted assessment of Precisionism's decline, according to which "the end of Precisionism can be linked to the devastations of World War II, which effectively destroyed the machine-age beliefs in industry as a beneficent force."[144] In a sense, UPA was well adapted to the new cultural marketplace in which Precisionism found less of a foothold—or which Precisionism had vacated—employing humor to accommodate a widespread disillusionment with the promises of modernity.

In its quest for a more efficiently communicative modern cartoon, UPA thus shows a lesser devotion to rationalism than did Precisionism, still interested in establishing visual order, but doing so in a post–World War II world that could no longer make such unproblematic use of the specific kind of order proposed by the industrial logic of interwar America. In fact, as Precisionism ceded the mantle of painterly modernism to Abstract Expressionism in the mid-1940s, the postwar output of Precisionist painters veered ever closer to a cartoon aesthetic, indicating that the forces prompting UPA's aesthetic approach to representation occasioned a reevaluation of Precisionism within its original context of the art gallery as well, though on a much smaller scale. Niles Spencer's postwar work resembles nothing so much as Jules Engel's *Mr. Magoo* backgrounds, sporting the same kind of wrenched perspective as its animated counterparts, and Ralston Crawford

begins to simplify his forms so radically that they seem designed expressly for the small television screen—perhaps even for Geisel's projection on the side of a dead cow. Even Charles Sheeler's midcentury work shifts in this direction, playing with impossible and paradoxical architectures, injecting a note of whimsy and fantasy that is absent from his earlier work but that is clearly visible in the warped spatialities of the midcentury cartoon. In their use of carefully controlled line and shape, they still sit outside the furious activity and chance-based looseness of Abstract Expressionism, but their increasing simplification and unrealism seem to acknowledge the different modernity, and modernism, of UPA's midcentury.

Another of UPA's differences from 1920s Precisionism is its devotion to jazz, an influence that further links the animation studio with Stuart Davis. Davis famously painted under the influence of jazz music, claiming, "Jazz has been a continuous source of inspiration in my work from the very beginning for the simple reason that I regard it as the one American art which seemed to me to have the same quality of art that I found in the best modern painting."[145] UPA's artists shared a similar affinity for the genre. In his memoir *How To Succeed in Animation,* Gene Deitch remembers, "My luck was that the leaders of UPA were all jazz fans, and during the mid-1940s I was doing cartoons and graphics for an obscure jazz magazine, called 'The Record Changer,' which they all read." That bond, in fact, led to his hiring at the studio.[146] The influence of jazz is visible—and, of course, audible—across UPA's cartoons, which sport scores from Phil Moore (1952's *Rooty Toot Toot*) and Billy May (1956's *The Jaywalker*), among other luminaries, and Hubley worked with Dizzy Gillespie on the 1958 film *A Date with Dizzy.* The studio's 1952 short *The Oompahs* literalizes their jazz obsession, presenting the story of a young trumpet whose family's musical traditionalism drives him to illness; unsurprisingly, running away to join a jazz band is the cure. This last cartoon in particular is a pointed narrative justification of UPA's positioning within the field of animation. As with their visual style, the musical style of UPA's cartoons stands in opposition to Disney's practice, in this case the sweeping orchestral scores of the latter studio's feature-length musicals.

This departure from the industry standard is not merely about adolescent contrarianism; rather, UPA's investment in jazz is a marker of the studio's cosmopolitan outlook, another connection to Davis. As curator Lowery Stokes Sims observes of Davis, "The structure of jazz was seen by Davis as a means by which he could utilize an American art form to liberate his own creativity from provincialism."[147] This struggle, to liberate creativity from

provincialism, maps neatly onto the UPA animators' own dissatisfactions with Disney's naturalist approaches, animal characters, and fairy-tale narratives. It also fits with Nieland's assessment of the new world of midcentury, which was "glimpsed with a new acuity of vision by designers with newly global ambitions, and whose spatial sense of 'worldliness' was part and parcel of the postwar globalization of the economy, and the geopolitical hegemony of the United States."[148] And as may perhaps be expected from a studio whose earliest film projects include *Hell-Bent for Election,* a 1944 campaign film for FDR, and *Brotherhood of Man* (1945), a plea for international solidarity in the face of racism—and a studio whose founding member was named as a Communist by Walt Disney himself during the 1947 HUAC hearings—a musical style with origins in the African American community and a distinctly urban and international outlook fit the bill for their artistic identity.

In employing the same formal elements Precisionism used, but in a less naive postwar culture—or, to be more generous, a postwar culture that had seen Precisionism's hints of critical unease borne out in political and technological reality—UPA redirected its own aesthetic of geometrical efficiency to different ends. When the sharp lines, simple geometric forms, and unmodulated colors found in Precisionism appeared again in animation in the mid-1940s, their relationship to the visible, outer world changed. Precisionism looked the way it looked because it pictured precise objects—machinery, architecture, industrial materials. Modern animation, however, applied this aesthetic across the board, not only to modern architectural environments, as would be expected, but also to organic objects, most notably the human form, with which Precisionism dealt by simple exclusion (people were what Stavitsky refers to as irrelevant "anecdotal details").[149] Essentially, UPA style answered the question that Precisionism left hanging: what happens to people in a rationalized, industrially efficient world?

Narratively, they become avatars of neurotic modernity: Gerald McCloy cannot communicate without technological mediation, Mr. Magoo disastrously relies on a premodern understanding of a modern world his failing eyesight cannot assimilate, and the protagonist of *The Unicorn in the Garden* (1953) is subjected to psychoanalysis because of his overactive imagination engendered by the boredom of suburban domesticity.[150] But more importantly, they reveal the effects of this modern neurosis in their very visual form—human figures living in a Precisionist universe, turned Precisionist themselves, but wrenched out of shape by the upheaval of war, increased global consciousness, social unrest, and technological overreach. Where Precisionism left room for

intimations of disorder, ambivalence, and irrationality in their eerie stillness and faintly skewed perspectives, John Hubley and his cohort found themselves in a world where these suspicions proved true, and as their cartoons make perfectly clear, the only thing to do was laugh.

In developing its modern cartoon style, UPA certainly took cues from its immediate surroundings: modern design and architecture, as we will see in the following chapters, complemented modern animation's visual approach in their own explorations of form and space. However, UPA also participated in the resurgence of an earlier, homegrown modernism that, in the 1920s, had been where the animators were in the 1940s and 1950s, attempting to craft a simplified form of abstracted representation to establish a sense of order and communicability in tumultuous times. At the intersection of these three presences on the art scene—Precisionism, Kepes, and UPA—is an ethos of efficiency, in both representation and communication. For Precisionist painter Charles Sheeler, "Not to produce a replica of nature but to attain an intensified presentation of its essentials, through greater compactness of its formal design by precision of vision and hand, is my objective."[151] For Kepes, "The mass spectator demands the amplification of optical intensity and a leveling down of the visual language toward common idioms. Such idioms demand simplicity, force, and precision."[152] And for UPA animators John Hubley and Zack Schwartz, "We have found that line, shape, color, and symbols in movement can represent the essence of an idea, can express it humorously, with force, with clarity."[153] In all these cases, a mixture of reductive abstraction and selective representation offer an efficient way to replicate the perception of the external world and make sense of its chaos. The common thread binding these figures together is a stance toward reality that lays the burden of translating the visual field upon the shoulders of art; art can filter reality, getting at what's really real in the real and presenting what's essential in a way that the actual world cannot. This mediation of the outer world, clearing away extraneous detail and leaving the spectator with the most basic constituent elements of the observable world, facilitated an order that the Precisionists, Kepes, and the UPA animators believed that the human mind craved but that the eye, unaided, could not provide. This concern, as vital in the industrial America of the 1920s as in the postwar America of the 1940s and 1950s, unites these two modernist moments, revealing the continuity between these two periods in American history and the durability of this central question of modernism, the question of visual order.

TWO

Unlimited Animation

MOVEMENT IN MODERN ARCHITECTURE AND
THE MODERN CARTOON

IN THE AUTUMN OF 1953, CHARLES EAMES TAUGHT AN experimental course at the University of California, Berkeley, called "Architecture 1 and 2." Rather than an overview of architectural history or a survey of building techniques, the course was a primer in visual communication and design thinking. The lecture titles were abstract and decidedly nonarchitectural: "Visual and Intellectual Awareness," "Entropy and Morality," "The Importance of Speculation." Students were asked to focus on drawing, lettering, and audiovisual combinations, as well as on philosophical questions relating to time, conceptual association, and the senses. They analyzed slide shows of ephemeral moments "designed to show various pattern relations of line, mass, and color," set to city noises, jazz, marching songs, and readings of experimental poetry.[1] They pondered questions of philosophy, history, epistemology, and spirituality. And they watched UPA cartoons.

Eames screened UPA creative director John Hubley's animated interscenes from the 1952 Columbia film *The Four Poster,* paired with images of Max Bill's geometric sculptures and Charles and Ray Eames's own short film *Blacktop.* These scenes were shown, he said, "as an example of the capturing of the essence and spirit of their own times."[2] Yet elsewhere in the course, UPA cartoons served a more concrete purpose; as Eames's lecture notes state, "Drawing can be used to exactly communicate anything to anyone. The type and quality of drawing contained in the UPA cartoon productions is an example of this."[3] This is a strange way to talk about UPA style, which in its removal of details, minimalist use of nondescriptive color, and skewed perspectival relations would seem to be anything *but* exact. This is especially true of its treatment of architecture, which is often reduced to blank color fields with no floor or wall lines whatsoever—that is, UPA's method of

representing architecture is in many ways to get rid of it entirely. So what is it about the studio's mode of visual communication that would render it a key case study for this course?

Perhaps we may find an answer in a 1974 lecture Eames gave to the Western Center of the American Academy of Arts and Sciences about his and Ray's midcentury work, titled "Language of Vision: The Nuts and Bolts."[4] The lecture, addressing the power of film to serve as a medium of mass visual education, directly refers to György Kepes's 1944 book *The Language of Vision*, which Eames tried to insert into experimental college curricula at schools such as UCLA and MIT (a section heading of his report to MIT declares, "'Language of Vision' in each department"),[5] and the design duo's use of the term dates back to at least 1953, when it informed their film *A Communications Primer*.[6] The lecture title also refers to John Hubley and Zachary Schwartz's 1946 manifesto "Animation Learns a New Language," itself heavily influenced by Kepes. Hubley's perennially famous line, "Pigs and bunnies have collided with nuts and bolts," speaks to animation's power to communicate precisely by distilling complex, abstract ideas into simple drawings that communicate only the essentials.[7] (That Eames may have thought enough of "Animation Learns a New Language" to pull a line from it twenty-five years later is not unthinkable, given his history with the studio. Besides screening UPA films in his course, he was so enamored with their output that, as media historian Lynn Spigel has confirmed in the archival record, "The Eameses acquired stock in UPA as early as 1954."[8] They also hired UPA veteran Dolores Cannata to design and draw their 1957 film *The Information Machine*.) It is in this sense that Eames may have considered UPA's style so "exact": while it may not represent architecture according to the dictates of realism, it exactly conveys the architectural *idea*—and as we can see in his UC Berkeley course, this architectural idea is as interdisciplinary and diffuse as Kepes's own exploration of visual communication.

And the Eameses did consider their investment in film and animation to be architectural; curator Donald Albrecht quotes Charles as saying, "Furniture design or a film, for example, is a small piece of architecture one man can handle."[9] However, their approach to animation is unique. Referring to the Eameses' "information-overload" multiscreen aesthetic, filmmaker and critic Paul Schrader contrasts their use of live-action film, which is marked by "a multiplicity of action," with their use of animation, which they employ "to simplify data, so that it can be delivered faster with clarity."[10] That is, animation works *against* "information overload," or at least it is capable of

doing so when it is drawn in the style UPA established to deliver information quickly and clearly.

The Eameses used this style of animation to communicate architectural ideas in their 1958 film *The Expanding Airport,* designed to help Eero Saarinen pitch his redesign of Washington DC's Dulles International Airport. *The Expanding Airport* does not convey the design of the actual buildings that will make up the airport, but instead conveys the experience of the airport. More specifically, it shows the ways in which the airport will *move,* both in a figurative sense—the ways in which traffic flows will be directed by the spatial layout—and also quite literally: the key to Saarinen's concept is the mobile lounges that detach from terminals and carry passengers directly to their planes. The architecture itself is animated. For an architectural construct that is intended to be in motion, it makes sense to have a film introduce it to the committee, rather than a static model; but because the subject of the film is not the architecture itself but rather the concept by which it operates, it also makes sense that animation would be the chosen medium, given Charles Eames's belief in modern animation's ability to "exactly communicate anything to anyone." This belief likewise occupies Hubley and Schwartz in "Animation Learns a New Language," in which they declare, "We have found that line, shape, color, and symbols in movement can represent the essence of an idea, can express it humorously, with force, with clarity."[11] Accordingly, this animated model of the new Dulles is represented through the reduced, abstract form of the UPA cartoon: simple squares, circles, and rectangles slide across the blank background of an otherwise empty frame, reducing architecture to solid blocks of color floating in space. What is communicated, with force and clarity, is the architectural *idea.*

Charles and Ray Eames were not only interested in architecture through film; perhaps their most famous contribution to the canon of midcentury modernism is the Eames House, built for *Arts & Architecture*'s Case Study House Program in 1949—and for their own habitation. This house, a rectangular assemblage of glass walls and brightly colored panels, participates in the same stylistic impulses that define modern animation: simplified geometric form, solid fields of bold color, and an experimental approach to delineating space. Unlike Saarinen's airport, the Eames House contains no moving parts or changes of form (although its colored panels were designed to be repainted regularly, the Eameses opted to preserve the original color scheme for the entire time they lived in the house); however, as design historian Lucinda Kaukas Havenhand observes of its modernist design, "The vertical lines of

The Expanding Airport (Charles and Ray Eames, 1958).

the linen drapes and the glimpses of the plants and furnishings through the transparent parts of the wall add to the complexity of the view. Instead of being static and rigid, as it may appear in a drawing, the façade is organic and constantly moving."[12] Here, as with the animated model of Saarinen's Dulles, we have architecture that is in motion, though two different kinds of motion. The Eameses' engagement with animation, and their tendency to view their animation and film work as merely another kind of "architecture," asks us to reconsider the boundaries we draw around these two categories. By blurring the line between animation and architecture, they open up the possibility of finding a place where the two might meet—another point of resonance with UPA. If for Eames the definition of architecture can expand to include film and animation, for UPA the definition of animation can open up to include architecture. UPA's connection to Charles and Ray Eames is not an outlier; their animation, as the Eameses realized early on, was primed to enter into the architectural conversations of midcentury modernism.

The postwar era saw a large-scale reevaluation of concepts of space, reopening questions that had occupied Western modernists throughout the late nineteenth and early twentieth centuries. And while architecture is the

obvious locus of this reevaluation, animation carried out its own spatial experiments. The obvious differences between the two mediums—one a composition of stationary materials in three dimensions, the other a moving image on a flat screen—allow their common threads to stand out more sharply. Both the architecture and the animated cartoons of this period are commonly understood to be "modernist," yet they are rarely taken together as agents working from a shared philosophy of perception and modernity. However, the midcentury cartoon cannot be understood apart from the debates and theories circulating in architectural discourse in their moment. Specifically, both fields sought visual solutions to spatial problems, and the elements of these solutions are fourfold: a use of free, nondescriptive color to destabilize space and to create ambiguous spatial relations; a more specific exploration of color's properties of advancing toward and receding from the eye; the use of directional lines and vectors to harness the ability of a shape, or a building, to emanate beyond its material borders into surrounding space; and a striving toward transparency, mingling inside and outside as a visual expression of mobile space. Ultimately, these approaches all converge on the quest for metamorphosis, a concept central to animation theory and one that rests at the heart of modern architectural strategies as well.

ARCHITECTURAL ANIMATION: NEW MODELS OF SPACE

Midcentury developments in animation and architecture comprise two sides of the same modernist coin. In animation, the move away from the "illusion of life" in favor of partial abstraction composed of flat shapes, simple lines, and bold color fields accompanied a "limited animation" involving fewer frames per second and less overall movement within the frame. In effect, the modern cartoon of the postwar era based its aesthetic on a certain stillness and immobility in its constituent parts, generating a sense of movement from directional lines, color contrasts, and rhythmic elements—that is, its animation approached the methods of architecture rather than those of the traditional cartoon. Meanwhile, in architecture, practitioners and theorists moved away from the idea of buildings as containers of inert space, arguing instead for an architecture that channeled, radiated, and defined a space that was always in motion, flowing in and out of the built environment. Modern architecture was meant to engage with this mobile space, harnessing

movement and generating movement of its own, becoming a dynamic object itself within this constant flux—that is, its design approached the rhetoric of animation rather than that of traditional architecture.

This dovetailing of approaches across fields comes from a shared investment in a utopian project of refashioning and retraining modern vision, whether through the construction of architectural spaces designed to accommodate a more therapeutic and harmonious mode of seeing or through the production of cartoons helping to assuage the perils of postwar modernity by visualizing this mode of seeing. These projects are underwritten by the aforementioned design concepts imported into American art and architecture education by the "intellectual migration" of the late 1930s and 1940s and disseminated across disciplinary boundaries by publications such as Sigfried Giedion's *Space, Time, and Architecture* (1941), György Kepes's *Language of Vision* (1944), and László Moholy-Nagy's *Vision in Motion* (1947), among others.[13] These books, influential to Hollywood creatives as well as to artists, designers, and architects, circulated widely in art, design, and architecture schools during the 1940s and 1950s, allowing the conversations of architects and animators to intersect and overlap, particularly their conversations about space.[14]

In the late 1940s and 1950s, architects such as Richard Neutra and George Howe called for a modernist understanding of space, one that, as with animation, was not new to the postwar era, but with which a mass-scale confrontation was becoming rapidly inevitable.[15] Moholy-Nagy likewise argued, "We are heading toward a kinetic, time-spatial existence."[16] He observed that in this increasingly mobile environment, "architecture appears no longer static but, if we think of it in terms of airplanes and motor cars, architecture is linked with movement," a sentiment that links him with that other influential postwar architectural thinker, R. Buckminster Fuller, who sought an architecture descended from transportation technologies rather than from the history of its own field.[17]

Motion was thus a central concern, both for the individuals caught in the flux of modern life and for the architects crafting buildings for them. In place of a geometrically structured field occupied by objects, modernist architects argued for an understanding of space as constantly changing and always in motion. Neutra based his architectural and design decisions on a rejection of Euclidean space in favor of what he called "physiological space, with its strong directional accents," an uncontained, multidirectional space with no defined center but rather emanating from the body and categorized relationally—and most importantly, itself changing in relation to the observer.[18] Howe,

arguing that this so-called "flowing space [could] be neither enclosed, nor excluded—not even limited, in thought or fact. It can only be directed," defined buildings as "not objects to be looked at in the light, but aggregates of planes of reference defining the movements, whether in or out or through, of certain portions of universal curvilinear space selected for use as building space."[19] For ex-Bauhaus architect Walter Gropius, the building must always be in flux: "Its quality must be dynamic, not static, to serve as an inexhaustible stimulus to man."[20]

The sticking point in this desire for a mobile architecture commensurate to modern mobile space, however, is clear: for all its engagement with movement, architecture is nonetheless composed of immobile materials. Howe's "planes of reference" do not actually move (thus Goethe's famous description of architecture as "frozen music"). What these theorists mean by "flowing space," or by a building that is "in flux," relies instead on emerging ideas about visual perception that enable an *illusion* of movement, as well as on emerging ideas about the nature of space itself, our experience of it, and our placement within it.[21] The physicality of architecture thus renders any "movement" of the built environment obviously metaphorical. In deferring to, and interacting with, a relentlessly flowing space, architecture's immobile materials may therefore still participate in a kind of animation, a figurative one that facilitates the flowing of space rather than attempting to contain it, and moreover, one that is in line with the visual style of modern cartoons.

As I argued in the previous chapter, Hubley and Schwartz's published manifesto and UPA's body of work show an investment in developing a new language of vision, for reasons aligned with those of Kepes in particular. This experimental impulse is not unique to UPA, however, even if UPA's rhetorical position is the most outspoken, and arguably the most influential; animated cartoons were reevaluating commonly held notions of space during the first half of the century as well, as was film more broadly. There is a strong body of work specifically linking the inherent dynamism of cinema to the mobile experience of architecture at the turn of the century, from film historian Giuliana Bruno's discussion of "architecture [that] joins film in a practice that engages seeing in relation to movement" to film theorist Anne Friedberg's assertion, "For the architectural spectator, the materiality of architecture meets the mobility of its viewer; for the film spectator, the immateriality of the film experience meets the immobility of its viewer."[22] The transmedial conundrum here—what does it mean that in architecture the spectator moves, while in cinema the spectator is kept still?—informs as well film

historian Brian Jacobson's exploration of the spaces of early cinema, both on the screen and in the studio. Here, cinema becomes a means of exploring the plasticity of space, a notion derived from Elie Faure's "cineplastics," in which "the cinema is plastic first: it represents a sort of moving architecture which is in constant accord, in a state of equilibrium dynamically pursued—with the surroundings and the landscapes where it is erected and falls to the earth again."[23] For Jacobson, the iron-and-glass (read: modernist) studio of Georges Méliès enabled him to develop a new sense of cinematic space born of "the technological changes that shaped the experience of fin-de-siecle architecture—especially spatial fluidity, plasticity, and artificiality."[24]

It is worth pointing out two things: the first is that these discussions place great emphasis on turn-of-the-century modernity. Midcentury modernism's engagement with space is very similar to that of this earlier moment, and this book sits firmly within this lineage; as this chapter argues, the nature of space may not have changed radically between these two periods, but the designers and architects of the postwar period developed new modes of discussing it and a more unified (and more outspokenly urgent) program to wrangle it. A shift in the ideological positioning of modernism's spatial experimentation does mark a slight departure, though. Through her notion of "window shopping," Friedberg links turn-of-the-century filmic/architectural spatiality with ideologies of capitalism and consumption, uniting the cinema, the arcade, and the department store.[25] But by midcentury—and in the United States, where European modernists relocated in the late 1930s—this spatiality entered into new contexts and acquired new ideological resonances. Consumption remained, to be sure, but space was now caught up in notions of democratic participation and the growing power of both corporations and arts organizations, as well as the nascent development of cybernetics and network theory.[26] If, as I have argued, midcentury brings an institutionally organized and explicitly pedagogical orientation to the "training of the senses" associated with turn-of-the-century modernism, it carries a slightly coercive element. More so than in the nineteenth century, the movements of the spectator—whether physically through architectural space or haptically through cinematic space—are being *designed,* and controlled. Running through the work of photography historian Olivier Lugon, Reinhold Martin, Fred Turner, and John R. Blakinger, among others, is the conviction that midcentury designers' utopian impulses, sharing orbits with corporate sponsorship and the military-industrial complex, operate in a complex push-pull of liberatory possibilities and repressive state and cultural mechanisms.[27]

The second thing is the presence of live-action cinema in the aforementioned theories of turn-of-the-century modernity—or rather, the absence of animation in them. Jacobson offers a way to bring animation into the fold; speaking again of Méliès's fantastical spaces and magical substitutions and transformations, he observes, "The on-screen space that appeared in Méliès's films was consistent with a studio space in which anything was possible—a blank slate that could be remade in any desirable form. This functional plasticity echoed the architectural plasticity that underpinned the studio's very existence."[28] That is, the glass-and-iron studio and the free passage of light through its transparent envelope partook in a certain flexibility and fluidity that was conferred onto the films that were shot in such a space. Méliès's breathtaking artificial worlds would not have been possible without the architecture within which they were made. Animation, however, bears a different relationship to architecture. Jacobson's "blank slate" is *really* a blank slate in animation, and likewise, truly *anything* is possible. The tension between indexical realism and cinematic fantasy that structures Jacobson's (and Faure's) cineplasticity is simply not a factor in animation. There is, of course, indexicality in animation: the indexical photograph of the animator's artwork. But that is a very different thing than the indexical photograph of *the pictured world* in live-action cinema, and animation's ability to draw space from scratch offers another set of ideas and experiments in relation to architectural space.

In *Animating Space,* animation scholar J. P. Telotte follows the shifting ideals of spatial representation in animation, charting the push-and-pull between flatness and depth, the fantastic and the real, and representation and abstraction. Defining a "modernist attitude toward space" in Winsor McCay's cartoons of the 1920s, he refers to animation's fundamental ability to "undermine a conventionally constructed space and, in the best modernist tradition, hint of an alternative."[29] Like Telotte, Esther Leslie links modernist animation to spatial concerns and to "abstraction, forceful outlines, geometric forms and flatness, questioning of space and time and logic—that is to say, a consciousness of space that is not geographical but graphic."[30] Midcentury animation marks a renewal of this exploratory modernist energy.

The postwar modernist cartoon's own graphic alternative to conventionally constructed space rests on an intense questioning of the illusion of the three-dimensional space perfected and popularized by Disney in the 1930s and 1940s. Often space is not delineated at all: floor and wall lines are invisible, perhaps suggested only by a desk or a window floating in an otherwise

empty plane. A blank, brightly colored background may signify extension into infinite space or, conversely, a wall directly behind a character—the difference is dependent on contextual clues such as the placement of other objects or the growing and diminishing size of moving figures as they advance toward or recede from the spectator. This spatial ambiguity is one of the hallmarks of the modern cartoon, encompassing not only UPA but various other studios that were either founded or revamped in the 1950s as well. Embedded in the "cartoon modern" style, these questions of space and its representation make themselves visible all over the animation of the 1950s. What Leslie calls the "research into flatness and illusion and abstraction" characterizing the modernist cartoon turns postwar animated theatrical shorts and sponsored films into laboratories of modern spatial representation, caught up in the search for spatial mastery driving much of midcentury modernism's artistic output.[31]

One of the midcentury cartoon's—and its attendant limited animation's—most noted features is its sense of stillness, a lack of fluid movement that highlights the differences between UPA animation and the preceding industry standard. It may seem obvious that UPA cartoons move less than Disney cartoons, less even than the superficially similar abstraction of Warner Brothers' postwar output, but it is perhaps more productive to say that they move *differently*. More importantly, they move in a way that, as we will see, architecture was attempting to "move" at the same time—through an attempt to create the sense of movement in the spectator's eye rather than literal movement in the materials themselves, using color, directional lines, and transparency. This kind of implied or simulated movement is joined by another type of movement in modernist architecture and animation, one derived from a deliberate instability of form. A central pillar of animation theory is the idea of metamorphosis, a ceaseless flux and provisionality that separates the cartoon from other fields of film practice. It engenders new modes of expression: when Felix the Cat's tail becomes a question mark, when the startled Fox literally comes undone in horror, when the Pink Panther emerges from an ill-fated trip to the dryer as a floating pink ball of fluff, animation is expressing something in a way that only animation can—through the visual experience of metamorphosis. For animation theorists such as Paul Wells and Esther Leslie, this metamorphosis provides the source of animation's subversive, modernist possibilities, its critical challenge to ways of living and being in the modern world. In courting a similarly deliberate instability of form, modern

architects metaphorically harnessed the metamorphic tendencies at the heart of animation to bring their own constructions to mobile life.

This architectural animation has an educational component: as Moholy-Nagy argues of architecture, "One of its most important components is the ordering of man in space, making space comprehensible, and taking architecture as arrangement of universal space."[32] And Moholy-Nagy is not alone; in the March 1944 issue of *Magazine of Art,* architecture critic Anneke Reens states: "Never before has architecture had such a chance to educate people as now. And rarely before does architecture seem to have had such perfect equilibrium between emotion and reason as it has in our time. We can only hope that it will maintain that equilibrium, and that it will ultimately be able to communicate it to our society."[33] By creating an environment, both public and domestic, more attuned to modern life, architects could thus foster a widespread mastery of spatial understanding, the main prerequisite to a fully balanced life in the modern world. The urgency of this dictate, as well as its utopian goal, is clear: until architecture learns to adapt to this new spatial order, space will remain incomprehensible to humankind, and humankind will thus remain disordered, uneducated in the spatial relationships that a newly trained vision would provide.

However, the esoteric nature of its spatial theories presumes and places an outsized faith in an expert eye, one that is conversant in revolutionary and counterintuitive concepts of space and perception. It also presumes experience of an architecture that, in reality, was prohibitively expensive, particularly in its "purest" and most freewheeling forms, and was often experienced as alienating and severe. Animation, though, was in a position to further develop architecture's perceptual experiments, dramatizing and directly showing new spatial relations that architecture was trying to achieve, or that at the very least had to wait for the arrival of the utopian "retrained eye" to come into being in the experience of the wider public. In this sense, the modern cartoon not only literalizes architecture's visual metaphors, but also opens these new spatial concepts to a wider audience in a more immediate format, enacting a less utopian and less elitist form of visual uplift that could then be transferred to the wider perception of the built environment. Animation thus becomes a laboratory for architectural ideas, working out in visible form the spatial theories of the midcentury modernist movement. If mainstream audiences were not reading abstruse architectural theory, they were nevertheless getting it through cartoons.

And if architectural theory was showing up in animation, animation theory appeared with increasing frequency in architectural discourse as well. In 1947 architect Fred N. Severud proposed the use of cartoons in architectural education predominantly for the dramatic interest that "little imps doing the work" would bring to the proceedings; however, by 1965 Donald Appleyard would raise the stakes, declaring that "animated cartoons would be ideal" as "an appropriate language for recording and creating motion and sequence" in urban planning.[34] It is in this context that the Eameses' *The Expanding Airport* takes shape, as an exemplar of animation's assumption of a primary role in communicating architectural ideas. This shift, from animation as a lighthearted way to find fun in the classroom to animation as a "language" of motion and sequence, a medium on par with urban planning in its complexity and its expressive capabilities, owes much to Kepes, whose systematization of vision into a language with its own rules, codes, and patterns established a keynote from which much of midcentury modernism, architecture included, developed its variations. It also owes much to Hubley and Schwartz, whose "Animation Learns a New Language" likewise argued for animation as a language, roping the cartoon into this visual system and setting the tone for the creative output of UPA and numerous other studios in the 1950s and 1960s. This merging of the languages of animation and architecture is rich with implications and constitutes a significant shift in conceptions of space and its representation. These two arts undertook this shift together, toward a form of rhetorical modernism aimed at challenging audiences' perceptions, teaching them a new and modern mode of vision adequate to the modern world.

COLOR UNBOUND: THE LIBERATION OF THE COLOR FIELD

Color was one of the most powerful strategies available to both filmmakers and architects in the visual manipulation of space, and midcentury output thus saw an increased focus on color as an independent element of design in both fields. If the interwar International Style mandated that "in the use of color the general rule is restraint," by midcentury the prohibition had been lifted, allowing for greater experimentation with palettes extending beyond white and neutral, natural tones.[35] Living in the United States during World War II and working alongside Giedion, the French painter Fernand Léger called for "free" color in his 1943 piece "On Monumentality and Color."

Color should be unbound to the object, leading him to predict, "The transformation of the wall by color will be one of the most thrilling problems of modern architecture of this present or the coming time." In the same way that color must be freed from the object, the wall must be conceptually released from the larger structure: "In order that architecture should be able to make use of [color] without any reservations," he argues, "the wall had first to be freed to become an experimental field."[36] This liberation of the wall to become a chromatic "experimental field" positions color as the site of meaning itself rather than as a mere property of an already meaningful object. While the wall might physically hold up the building (though even this was less and less likely as modern architecture embraced the structural skeleton over the load-bearing exterior), its function as a surface on which to carry out experiments in color places it under the purview of modernist theorists who saw the raw aesthetic matter of buildings as fundamental forces in and of themselves.

Léger's proposal anticipates an argument about film advanced by Sergei Eisenstein in a 1947 lecture in which he advocates the same liberation of color, claiming, "The key principle consists in separating colour from what necessarily lies beneath it, to draw it out into a general feeling and make this general feeling become a subject again." As in Léger's "experimental fields," Eisenstein sought a radical restructuring of the relationship between color and object: "How should we work in colour, so that the principle is taken to its limits? Where can you do the craziest things in colour? In what sort of pictures? Cartoons. To take the problem to its extreme, you have to make a cartoon."[37] This liberation of color manifested not solely in cartoons but also in architecture, as a means of articulating space and mobilizing processes of perception to create the sense of movement.

The animation studio most commonly linked to Eisenstein is Disney—unsurprising given his championing of the studio in his 1941 writings (collected in 1986 as *Eisenstein on Disney*)—and here Eisenstein explicitly praises Disney's use of color as a cure for the visual ills of modern life:

> Grey, grey, grey. From birth to death. Grey squares of city blocks. Grey prison cells of city streets. Grey faces of endless street crowds. The grey, empty eyes of those who are forever at the mercy of a pitiless procession of laws, not of their own making, laws that divide up the soul, feelings, thoughts.... That's why Disney's films blaze with colour. Like the patterns in the clothes of people who have been deprived of the colours in nature. That's why the imagination in them is limitless, for Disney's films are a revolt against partitioning and legislating, against spiritual stagnation and greyness.[38]

Yet by the 1947 lecture, the chromatic bloom was off Disney's rose. Unsatisfied with Disney's insufficient experimentation, Eisenstein laments, "As regards Disney's treatment of colour, those pictures of his that I have seen remain only at the threshold of colour cinema." Rather than taking advantage of color to experiment with new possibilities, Disney's color films were, for Eisenstein, "no more than his cartoon work, coloured in. There has been no sign in his technique of any new contribution, arising from his discovery of colour. He has not progressed to the next stage."[39] Moholy-Nagy looked forward to a development in the animated avant-garde that may not be so far off from Eisenstein's: "Viking Eggeling has been the pioneer for the black-and-white abstract film. Picabia, Léger, Fischinger, Ruttman, and I tried to solve some of its problems. The next step will be to produce such films in color."[40] While Moholy-Nagy's interest in pure "abstract film" led him to identify Oskar Fischinger as the next figure in this lineage, his bitter disappointment at Disney's excision of Fischinger's material from the final cut of *Fantasia* (1940) reveals a willingness to mingle the avant-garde with the popular and the abstract with the representational. One wonders what he would have thought of UPA's output, which began making headlines two years after his death, and one year after Eisenstein's.[41]

Postmortem speculation aside, the new animation style advanced by UPA engages in the kind of color play that Léger and Eisenstein sought, and incorporates the abstract experimentation that Moholy-Nagy employed in his animation genealogy, even if it is not the pure abstraction of Eggeling and Ruttman, nor Eisenstein's structural use of color based on an analogy with symphonic music. Nondescriptive color is the rule, as characters and backgrounds change color sometimes for symbolic effect, sometimes purely for compositional and structural rationales. On the most minute level, color is often literally freed from the object by way of the modern cartoon's tendency to color outside the lines, allowing colored shapes to bleed outside of or line up incompletely with their outlines, to be actual color fields only tenuously contained by their responsibilities of representation. We may see this, for example, in the Mr. Magoo cartoons, in which the intricate outline of a streetlamp is enveloped by a basic yellow square unrelated to the shape it is supposed to define. But more importantly, in much the way Léger dreamed for modern architecture, the modern cartoon uses this independent color to establish and manipulate space. *The New Vision* provides a sense of Moholy-Nagy's position on color, which he describes as "a force loaded with potential space articulation and full of emotional qualities."[42] The close conceptual

proximity of "space articulation" and "emotional qualities" in Moholy-Nagy's formulation is representative of this strand of midcentury design thinking and signals a way in which animation, with its combination of visual design and narrative progression, is particularly well situated to address the "split" within the emotional and sensory faculties of modern individuals that this group of modernists aimed to heal.

UPA's cartoons thus offer a privileged site for examining color through the lenses described above, combining the spatial and architectural explorations of Moholy-Nagy and Léger with Eisenstein's theoretical treatment of color as separate from its object. For instance, in *The Fifty-First Dragon*, a 1954 short adapted from Heywood Broun's 1919 story about a fledgling knight who must overcome his nervousness in order to slay dragons, the studio runs to the minimalist end of its stylistic continuum, forgoing detailed form in favor of color experimentation. The background lacks objects entirely, opting instead for blank color fields with an occasional rough polygon suggesting a tree or castle to signify place. More interesting, however, is the cartoon's approach to delineating foreground space: in a scene depicting a conversation between the knight protagonist and his king, all architectural indications of the space separating them are absent. The king does not visibly occupy a throne, or an elevated platform, or even a chamber that the knight must enter, even though narratively we come to understand that he does all three. The only signifier of a rarefied space indicating the king's station is a differently colored quadrilateral surrounding his body. The conscious decision to express meaning through color in this way is signaled in a letter from UPA's vice president in charge of public relations, Charles Dagget, to MoMA in the planning stages of the studio's museum exhibition, in which he states of the house style, "We use color for its own sake, not because Matisse painted an interior in terms of red, but because exaggeration can tell our audience something about the slightly mildewed opulence of a Florida hotel."[43]

Or about the exclusive grandeur of a king's chamber: in *The Fifty-First Dragon*, color carries the expressive power of architecture all on its own. Within the ludic space of this cartoon, the wall is literally, as Léger imagined, "freed to become an experimental field." Everything that architecture is used to connote within the context of royalty—class privilege, wealth, unapproachability—is reduced to a simple color field, and yet the barrier around the king is no weaker for the absence of stone and mortar, or even of a hastily sketched outline of a castle. The wall is a color field, and the color field is a wall. Color here serves an architectural function without being a mere

accessory to architecture or a property of a piece of architecture. On its own, it creates and delimits space, and reserves a limited space within a larger field for the practicing of kingliness. Color in effect *becomes* architecture, transforming a shape into a space. This creation of space within what is essentially a still frame—*The Fifty-First Dragon*'s animation is extremely limited—makes its own kind of movement, as immobile forms become places and new spatial relations are formed as the spectator watches.

UPA was not, of course, the sole innovator on the animation scene; UPA's critical success popularized the studio's house style, but contemporary and subsequent studios working in the modernist mode also contributed new stylistic options and variations. The 1957 film *Flebus,* designed and directed by UPA veteran Ernie Pintoff for the Terrytoons studio, builds upon—or rather, subtracts from—the spatial system developed in *The Fifty-First Dragon* to advance the project of liberating color from the object. The eponymous film tells the story of Flebus, an outgoing and affable fellow who is perennially happy until the ill-tempered Rudolph moves to the neighborhood and introduces him to the terrifying possibility that someone might not like him. In so doing, *Flebus* uses color both to articulate space and to chart the shifts in the relationship between its protagonist and antagonist, who finally become friends after visiting the town psychiatrist—bonded, naturally, by their shared diagnosis of neurosis ("The trouble with you, Flebus, is: you are neurotic!"). The complexity of the animated short comes into focus through the ways in which the cartoon undermines the solidity of objects in the film's narrative world in favor of the structuring power of abstract color fields.

Flebus's world is a hybrid of space and design, playing on the unexpected emergence of deep space within what at first appears to be a flat, abstract pattern. In animation perhaps even more limited than that of *The Fifty-First Dragon,* the eponymous protagonist walks horizontally in the front of the frame while remaining at its center, his progress marked instead by shifting vertical bands of color in the background. There are no objects or landmarks in Flebus's environment, which contains neither buildings nor nature, but simply blank, solid blocks of color. This absence of perspectival rendering solidifies the spectator's perception of these color fields as flat backdrops, so much so that the sudden appearance of another, smaller character walking above Flebus's head in the upper half of the frame is momentarily befuddling until it becomes clear that this newcomer is merely farther away. In this instant, flat color field becomes deep space, an abrupt spatial expansion that

almost requires a refocusing of the eyes, even though the background itself remains the same blank color. As the introduction of this distant character creates a new constellation of objects in space,[44] an extra plane of depth is added, established not by overlapping but solely by the work the spectator must carry out to make sense of the image. To the horizontal tensions across the x-axis are now added a forward-backward movement along the z-axis, an extension into space created by the process of perception rather than by the animation itself.

As Flebus's world is revealed to consist of deep space rather than flat color, the ambiguity of spatial perception becomes the central hook of the cartoon's novelty. The revelation of deep space is experienced as a shift in visual possibility, but more importantly, it is also a shift in the conceptualization of space, as it becomes retrospectively clear that *Flebus*'s space was deep all along, suggesting the possibility of the presence of depth in flatness, and vice versa. From here, Pintoff begins to play new spatial games with his abstract color fields. After the traumatic revelation that Rudolph does not like him, Flebus tends to occupy his own color fields when interacting with others, the borders between the blocks of color for the first time falling between him and others, separating him from his community. Like *The Fifty-First Dragon*, *Flebus* builds spaces out of flat shapes, though the spaces here seem to function on a metaphorical level as opposed to the former cartoon's evocation of a physical space—signifying, say, a feeling of isolation rather than a castle. (It is thus no surprise that after the two characters reconcile near the cartoon's end, *Flebus* dispenses with two- and three-color backgrounds to convey the healing of the split between them.) Soon even this spatial conceit, admittedly a simple one, becomes dizzyingly complicated when Flebus, occupying the middle ground in a yellow field, happens upon his new neighbor, in the foreground in red. Stopping short in anxious surprise, Flebus tiptoes *behind* Rudolph's red color field, disappearing momentarily before surreptitiously peering out around the corner. No longer metaphorical, the spaces created by color have definite dimensions: the red field has become a physical wall.

This further shift in the status of the fields, from background design to expressionist metaphor to concrete space, causes another reevaluation for the spectator: the red field now functions as the exterior of a building, around the corner of which Flebus is hiding. Yet this color field still remains liberated from its "wall" in a pointedly non-Euclidean way, which becomes clear when Flebus approaches the foreground of the frame to rendezvous with Rudolph, an extension along the z-axis signified by a gradual increase in his size. The

physical impossibility of this movement—remember that while still occupying the middle ground Flebus managed to somehow peer around the corner to spy on Rudolph—renders irreparably ambiguous the spatial status of this red field. When the rendezvous goes south—a bonk on the head for poor Flebus—the red space is further destabilized: Flebus, running head-on toward the front of the frame again, remains the same size while the red field shrinks amid a growing sea of yellow to show his forward progress, and here the red becomes something else, neither half of the frame nor a wall, but a horizontal rectangle, the first divergence from the film's solid vertical bands of color. Rudolph, a few seconds ago standing in front of a building, is now suspended in the center of the red rectangle's rapidly diminishing vertical dimensions, positioning the red block as something between its former selves: once alternately, or simultaneously, a background, a wall, and an abstract plane, it is now a floating space, receding into the distance along with its occupant without providing a logical place for him to be occupying. By collapsing these various spatial dimensions on top of each other, *Flebus* crafts an unstable spatial system in which color and architecture swap and merge functions, a "free[ing] of the wall to become an experimental field" for which Léger thought modern architecture was destined, but carried out in the language of animation, which allows for spatial possibilities that brute physics does not.

This does not mean that real architecture did not experiment with color fields; it merely experimented in different ways. Animation and architecture provide two different answers to the same question, among which we may find similarities even though they are expressed in the varying languages of their own media. As historian and curator Arthur P. Molella argues, speaking specifically of Giedion's abstract musings on science and art, discrete disciplines can engage with similar ideas without developing identical outcomes: "Historians of art and culture have perhaps limited themselves by being too rigid in their criteria for such linkages and restricting their search to one-to-one correspondences between scientific and artistic ideas. In fact, mutual influences between science and culture almost always occur in the more fluid context of metaphor, often through a lingua franca transcending the frontiers between science and art."[45] The point here is not to align architecture with science against animation's art, but rather to bridge the irreducible gap between architecture and animation: the former is constrained by the laws of physics even as it negotiates new ways to construct and understand space within those constraints; the latter is not, and its experiments

with space will therefore bear different fruit than those of modern architecture. Molella offers a way to compare apples and oranges, to respect the structural incommensurability of these two fields even as we place them in conversation with each other and find them saying the same thing in different words.[46]

Architecture thus could not do what *Flebus* did, even as it attempted to redefine space; what it could do, however, was use color to animate space, albeit in ways subtly different from those of Pintoff's animation. In the mid-1950s, Rodney Walker entered this conversation with the Walker Residence, completed in 1959. Best known for his work in the Case Study House Program (Nos. 16, 17, and 18), Walker is associated with the use of natural wood, large panes of glass, fluorescent shelf and tube lighting, and open floor plans, but the house he designed for himself is perhaps most interesting for its spatial deployment of color.[47] The house's most striking feature is its stained concrete floor, a vibrant, mottled green throughout the interior (save for the kitchen, which is a paler mint green with a tighter, more regular pattern). Complemented by the presence of natural wood fixtures, red brick along the walls, and a band of bright, light blue paint circling the interior between the wood fixtures and the ceiling, the house's color scheme recreates the chromatic impact of the Ojai Valley above which the house is situated: green earth and blue sky with a wooded area in between. The exterior walls, made entirely of glass, intensify the impact of this color scheme by allowing a visual continuity with the outside world. But the Walker Residence is doing more with its color than bringing the inside out and the outside in (about which more below): his use of color fields takes advantage of the glass windows to create an unusual interplay of form and color inside the house.

Most notably, the blue band circling the upper wall of the house's interior challenges the functional logic of the wall in various ways. The Walker Residence's irregular roofline gives the strip of color an unstable shape that constantly widens and narrows as it meets the rising and falling ceiling. Sometimes it occupies enough space to seem like the dominant portion of the wall, while other times it is barely a sliver, eclipsed by brick or wood. In some places, such as the eat-in kitchen, built-in shelving units and cabinetry give the impression of sitting in front of the wall, and the only exposed portion of the wall behind is the blue band at its greatest width, circling the top of the kitchen—that is, the blue band seems to be the wall itself, a continuous plane that is interrupted by the presence of furnishings but presumably extends behind them to reach the floor. In the living room and bedroom, in contrast,

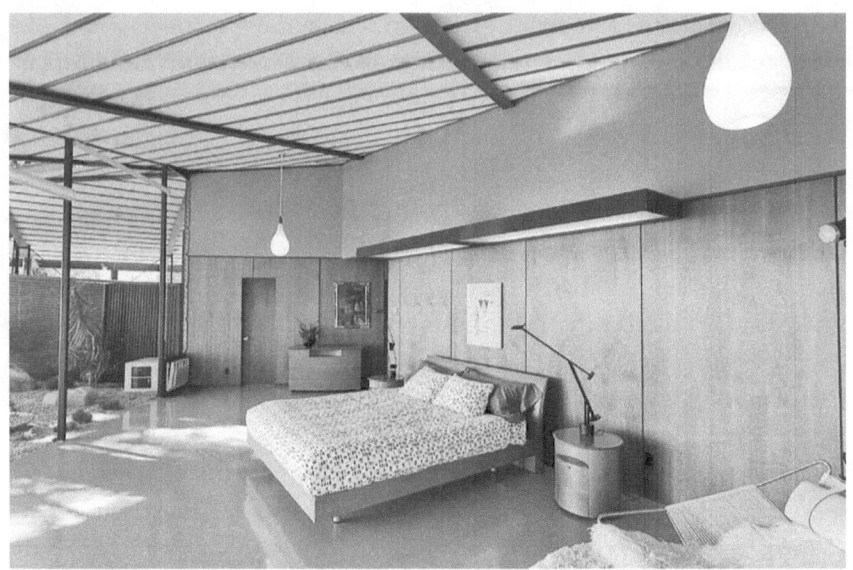

Walker Residence. Photograph © Elizabeth Daniels, 2013.

the blue band shares wall space with wood paneling, giving the impression of a two-tone arrangement in which the wood paneling is the wall and the blue band is a decorative strip running along the top. This alternation complicates the blue band's architectural function, rendering it sometimes wall, sometimes accessory to the wall. The unstable band's fluid relationship to the wall captures the cartoon's capacity for metamorphosis, its ability to be both one thing and something else at the same time, a tail and a question mark, a solid wall and a decorative flourish. Lacking *Flebus*'s capability to literally reshape space during the progression of its narrative, the Walker Residence courts this spatial uncertainty in its own way, still activated by perceptual experience though not, as in the cartoon, visibly caught in the act of transformation.

The unstable architectural function of this design element becomes especially clear when the house is viewed from the outside or from the open area of the living room. As mentioned above, the house's exterior walls consist of floor-to-ceiling glass, allowing a visual communication between the interior and the exterior. This phenomenon is not unique to the Walker Residence; in fact, it is a determining trait of midcentury modern architecture in many of its American manifestations.[48] What is noteworthy, however, is the use of color within the house to interact with color outside—for the Walker

Residence actively employs transparency (or the notion thereof) as a means to a chromatic end, engaging architecture and its surroundings in an interplay of color fields. In providing color with an architectural function, Walker simultaneously promotes the oft-maligned decorative impulse within the modernist hierarchy and expands our understanding of what counts as an architectural function, enlisting the decorative color field in architecture's work of creating and structuring space.

Given the transparency of the exterior walls, the interior walls are visible as freestanding planes within the space of the house, and the blue band thus momentarily confounds the eye, mimicking the color of the sky and thereby producing a false sense of transparency through the use of opaque patches of color. In a glass house already so penetrated by the color of the outside world, these glimpses of painted blue often sit next to an unimpeded view of the real sky, allowing the painted color field to bleed into the natural world. The transformative effect lends to objectively existing nature an added resonance as a color field like those inside the house, roping the nonbuilt environment into the house's carefully designed abstract chromatic play. It also, like *Flebus* and its constantly shifting red rectangle, brings two widely disparate planes of depth—here, the nearness of the wall and the endless distance of the atmosphere—into one plane of vision, simultaneously bringing the sky close and pushing the visual dimensions of the house outward into infinite extension. This depends, of course, on a clear day—another instance of the utopianism underpinning modernist thought—yet under overcast conditions, the blue band perhaps carries out even more interesting work, existing as a patch of sun-brightened "sky" within the blockage of cloud cover, containing within the house a visual illusion of something beyond the clouds outside and overhead, a nearby window to a faraway space. The green-stained concrete floor, of course, enables a similar dialogue between the floor inside and the natural world outside—and again, its utopian function renders this effect seasonal, though the color scheme of the house ensures that, indoors at least, it was always summer for the Walkers.

Seasonal, even hourly changes in color were also on the mind of another architect in the 1950s. In *Survival through Design,* Richard Neutra links architectural color with spatial perception, declaring, "It is obvious how much our space, which is a product of our physiological make-up, appears affected by color choice in design."[49] Traditional architecture's central chromatic problem, for Neutra, is static color, color that offers an endless experience of an unchanging stimulus, and his stakes are not low: "If man-made

color is to play its part as an aid to survival in a fully urbanized environment, it is imperative first of all to minimize static effects and rigid color arrangement."[50] For Neutra, psychological health was the bedrock of a well-adjusted modern society, and modern life had thus far been developing in ways inimical to this health by neglecting the importance of the senses. Responsible architectural design was thus a protective mechanism for a delicate human sensorium, carefully curating visual and environmental stimulus to most beneficially harmonize with our organic selves. Bad design, at its worst, was actively harmful. In light of these investments, failure to surmount the problem of static color would render an architectural space, "physiologically speaking, unfit" and would induce "the ordeal of exposure to monotonously sustained color effects"—Eisenstein's "grey, grey, grey."[51] What the human eye needed, then, was variation in color, periodic renewals of chromatic stimulation to prevent the enclosed space from becoming stifling, suffocating. (Compare this to the International Style dictum, "If architecture is not to resemble billboards, color should be both technically and psychologically permanent.")[52] Neutra offers many solutions, and true to the modernist spirit, some belong to the realm of (then) science fiction, such as his admittedly "rather utopian" proposal for "an endless light organ, producing rheostatically controlled variations in illuminative intensities and color" that would "be planned to play refreshingly on opaque and translucent surfaces, on surfaces selected to absorb or to reflect light rays."[53]

Other solutions, however, are both simpler and more strictly architectural in nature. The juxtaposition of contrasting colors, Neutra argues, creates tensions in the eye that produce stimulation. The glass exterior wall, a central element of the ethos of transparency characterizing modernist architecture, also expands the possibilities of color effects in the home and office. The Walker Residence provides one example of the chromatic possibilities enabled by large floor-to-ceiling windows, allowing painted and stained interiors to interact with natural color outside. However, Neutra supplies another, deceptively simple color effect of glass walls and windows: "If we are limited in our interiors to permanently applied color coatings, we must reduce their harmful effects on the nervous system by giving these interiors as much as possible the benefit of the natural changes of illumination outdoors."[54] In other words, if a rheostatically controlled endless light organ was not yet on the menu of consumer culture, picture windows and glass walls could at least allow the static color of painted walls to change in brightness and intensity with the rising and setting of the sun and the vagaries of the weather.

This attempt to keep color moving, to animate it, is a subtle, metaphorical form of metamorphosis that modern architecture employed to keep pace with a modern sensorium attuned to movement and change. Unlike animation's ability to directly reshape objects and spaces—turning color fields into walls, and flatness into depth, and buildings into nebulous, floating spaces—architecture could provide constantly changing visual experiences of a static space by opening itself up to the outside force of light and manipulating light's chromatic properties through its arrangement of its own materials and textures. Like Eisenstein, architects diagnosed modern life with a stultifying grayness, and both architecture and animation provided a similar solution set to this overarching problem: to set color in motion, and to animate space by rendering it ambiguous and fluid.

CHROMATIC SPACE: ADVANCING AND RECEDING COLOR

Constantly morphing color is one way to ensure a sense of movement, but color need not change to define and manipulate space, and midcentury modernism's emphasis on visual perception brought to the fore another way in which color could animate architectural spaces. In *Language of Vision,* Kepes devotes ample space to the exploration of color. Like Léger and Eisenstein, he advocates for an experience of color as an independent force, observing, "When one sees colors, unhampered by the notion that they reside in the objects, one's sensory reaction has overtones which originate in one's understanding of light as the basic condition of life."[55] Unshackled from their objects, colors are free to move according to the dictates of ocular perception, determined by the varying distances at which different colors can come to a focus on the retina. Kepes's science, here as elsewhere, is imprecise: "For this and some other intricate physiological reasons," he hurries, "hue, brightness, and saturation in their dynamic interrelationship in the visual field are perceived as advancing, receding, or circulating, or they appear to be of different weights—falling or floating."[56] Likewise, and citing Eisenstein's work on color theory, Moholy-Nagy claims, "The lens of the eye does not focus equally upon all hues. Red makes the eye 'far-sighted,' by causing the lens to grow thicker. This action will give red a nearer position than blue which causes the eye to grow 'near-sighted' as it flattens the lens," a property that explains "how color is able to change size or show receding and advancing values, producing stereometric and space values."[57]

In architecture, Neutra invokes the same principle, arguing that "only monochromatic light—that is, light of one color and wave length—can be fully focused on at one moment by the lens of the eye." Other colors being perceived at the same time, he notes, will fall into focus in front of or behind the retina, seeming either to advance toward the spectator or to recede into the background. He concludes with his above-mentioned observation, "It is obvious how much our space, which is a product of our physiological makeup, appears affected by color choice in design."[58] Animators as well seemed aware of the spatial implications of color choice in design. Describing these choices in the production notes for *The Tell-Tale Heart* (1953), Charles Daggett explains: "Color, editorial structure, and linear composition were designed almost to recede from the audience as the curtain falls."[59] The film's closing image, a semiabstract rendering of a set of buildings receding toward a vanishing point, is cast in blue tones with white accents, in line with Neutra's example of "cool" colors appearing to recede when the eye focuses on white.[60] The result is a film that seems to be retreating from both the viewer and the protagonist, a madman who has been imprisoned, watching the world leave him behind.

If *Flebus* and Walker House use color to render space unstable, constantly reforming itself in the spectator's eye, the prospect of advancing and receding colors further develops modernist design's ability to reproduce the perceptual effects of movement from still materials. Here is Neutra on color and the animation generated by disparate ocular focal lengths:

> But the situation here becomes also more complicated when, for example, colors are added in one or the other way. They will incite changes of focus as the eye turns to them, owing to the physiological impossibility of responding with an equal lens accommodation to a variety of color stimuli. The ocular muscles are in such a case repeatedly innervated for successive focusings, as if the eye were following a moving object. And so a motor phenomenon is produced in the eye itself, although the outer objects are really fixed. In such a case internal stimuli bring forth a cortical response, as if external motion had been evidenced.[61]

The true repository of motion is therefore in the mind's eye, not the outer world. The sensation of movement trumps the literal presence of movement.

This animating property of color finds an idealized expression in the "Care-free Homes" of the late 1950s, a project funded by Alcoa, Inc. (an abbreviation of Aluminum Company of America) and rolled out to the

public in 1957. Designed by Charles M. Goodman, these homes constituted an appeal to the American public in the hopes of opening up a new market. As Alcoa's brochure for the homes boasts, "In these pages, you'll see why Alcoa Care-free Home is remarkably free from the burdens of household chores and upkeep, yet rich in charm and distinction. You'll learn how aluminum was brought to prominence as the most Care-free of building materials by 30 years of Alcoa research and development. You'll see how it combines harmoniously with wood, plastics, and fabrics to launch a new era of easy living amid heart-warming beauty." Simultaneously acknowledging and mystifying the less-than-romantic reputation of aluminum, that basest of base metals, Alcoa turns its typical nondomestic use into a mark of its freshness: "Many of these products were pioneered in the exacting fields of commercial and industrial applications. Others are completely new uses of aluminum's exciting advantages."[62] By framing aluminum as the result of decades of scientific research oriented toward more demanding uses, and by identifying domestic ease as the ultimate practical application of that research, Alcoa positions its Care-free Home as the future of modern living, a tangible, inhabitable experiment in better living through technology.

One element of the homes is decidedly impractical, however, at least according to the cold logic of industrial metals. Sold fully furnished, Alcoa's homes sport a distinctive color palette: exterior panels, window grillwork, and doors in purple, aquamarine, and gold—all aluminum, naturally—with these colors replicated on interior partitions as well, and joined by blue, white, black, and green panels on cabinetry. It is tempting to read this color scheme as compensatory overkill on Alcoa's part, a delirious attempt to "lend gay informality along with the practicality of easy cleaning" to their signature material.[63] "Gay," "informal," "heart-warming," and "exciting," among other selling points, constitute the linguistic arsenal of Alcoa's charm offensive on behalf of aluminum, brightening up its dull industrial taint and imbuing it with a sense of whimsy more appropriate to the midcentury home. While trumpeting the home's unique spaciousness and its by now requisite open floor plan, the brochure stops short of enlisting Goodman's use of color in his spatial design, opting instead to fashion color as a complement to bright, happy living; the home's spatial properties are contained solely within its blueprint and its glass walls. But in the context of modern architecture and design's interest in color perception, the Care-free Home's signature color styling nevertheless finds a spatial resonance, opening up a new sense of mobility within its rigid aluminum walls.

Seen from the outside, the Care-free Home resembles any other midcentury ranch house: a single-story structure with a long roofline and wide eaves. The difference is chromatic: this house's aluminum surfaces offer a dramatic departure from the visual experience of the typical suburban façade. The strong horizontal emphasis of the ranch home demands a similarly horizontal gaze, rendering the aluminum paneling and grillwork a series of vertical color fields experienced in sequence. This recalls Neutra's dictum, "Colors should set each other off refreshingly, not only in space, side by side, but also in time, one stimulation following another," as well as *Flebus*'s own use of vertical color fields that are experienced, as all animation is experienced, in time and with one stimulation following another.[64] When viewed in this manner, midcentury design's "motor phenomenon" is indeed activated, trading on the advancing and receding properties of color to set the exterior walls of the home in motion. Paired with the warm, light-colored wooden structural supports, the vibrant purple and yellow panels reach outward toward the spectator with varying intensities, particularly in their contrast with the floor-to-ceiling windows between them. The windows' blue grillwork, belonging to the part of the spectrum that recedes from the spectator's gaze, pull in the opposite direction, imbuing the façade with a dynamism that complicates the spatial notion of a continuous surface.

The animation of the home's exterior is a result not merely of advancing "warm" and receding "cool" colors, but also of the transparency of the glass, which enables a temporary gaze into depth that the panels prohibit. In this way, the Care-free Home stands apart not only from the suburban ranch house but also from the other trend marking midcentury domestic design: the glass house and the picture window. Goodman's color play may thus be reconsidered as a matter of penetration: the gaze briefly penetrates the space of the house through the windows, then is rebuffed, bounced back by the brightness of the purple and yellow aluminum, only to be offered another glimpse beyond through the next window. Here, the aluminum panels are interruptions, staccato rejoinders to vision seeking extension into deep space. This alternation of extension and repulsion creates a rhythm, a kind of Morse code of vision, the dots and dashes of the thin wooden posts and the wider aluminum panels inducing varied intensities of advancing color blocking the viewer's penetrating gaze through the windows, forcing the refocusing of the eyes in which Neutra locates the perception of motion. Or, alternately considered, the blue-laced windows provide rhythmic dropouts from the house's otherwise forward-moving chromatic momentum. Here, architecture recapitulates modern

animation's dilemma: how to make the flat surface, whether a hand-drawn film frame or a house façade, express depth and fullness.

The interior of Goodman's model, extensively photographed in the brochure, features monochromatic furniture of all hues, ensuring that no vantage point is without the push and pull of competing color values. Perhaps most striking in this regard is the shelving unit built into the partition separating the family room from the kitchen, a split-level structure featuring two rows of cabinets, one above and one below an open space looking onto the kitchen. Each row is split into four equal bays of four distinct colors: powder blue, white, lime green, and black. In Neutra's optics, "The eye is not 'color-corrected.' Thus only monochromatic light—that is, light of one color and wave length—can be fully focused at one moment by the lens of the eye."[65] The shelving unit thus provides four possible areas of focus, and depending on which cabinet occupies the center of ocular attention, the other cabinets fall into line either in front of or behind the retina; that is, they either appear to advance toward the eye or recede from it. Outlined by black, that most recessive of colors, the cabinets are granted autonomy from each other, highlighting their activities as freestanding color fields. The asymmetrical distribution of these color fields (running left to right on the top and right to left on the bottom) ensures that the eye is constantly negotiating competing color values with competing forward and backward movements, "as if the eye were following a moving object."[66] This chromatic mutability provides precisely the self-renewing color relations that midcentury designers positioned as an antidote to the static, suffocating environments of poorly designed homes, setting color fields in motion by harnessing their forward and backward movement in the spectator's vision.

In this respect as well, animation's approach parallels that of architecture. The use of advancing and receding color fields to structure space marks modern animation across the board, but Gene Deitch's *Pump Trouble,* a 1954 film produced by UPA-NY for the American Heart Association to educate audiences on the symptoms and warning signs of heart disease, offers a particularly striking example. In the film, protagonist Cordell Pump convinces himself he is at death's door following a brief episode of chest pains. The diagnosis, after much hand-wringing and gun-jumping on the part of our paranoid patient, is merely a panic attack brought on by Pump's wrongheaded certainty that he was born with a bum ticker, itself the result of his mother's medical misinformation. (The figure of the overbearing woman driving men to various forms of neurosis is depressingly common in this period—an index

Pump Trouble (Gene Deitch, 1954).

of the lighthearted misogynist simmer that would come to a full boil in 1960's *Psycho*.)[67] As is perhaps fitting for a cartoon about a man *in extremis,* Deitch ratchets up the play with color and space characterizing modern animation, creating an expressionist universe that visualizes Pump's troubled state.

Pump's visit to the doctor's office, for instance, presents the audience with an unmodulated yellow color field, marked only by a pale green door at the "back" of the room—or rather, in the upper right quadrant of the frame. As in many modern cartoons, *Pump Trouble*'s rooms have no wall or floor lines; however, here the placement of the characters within the color field highlights the perspectival play by which these cartoons establish their sense of space. The cool, mint-green color of the door confers a sense of distance upon it, particularly in contrast with the vibrancy of the yellow surrounding it. This spatial conceit is common to modern animation (recall, in the previous chapter, UPA animator Bill Hurtz's invocation of "a doorway in a room with no boundaries"), and as with *Flebus* above, it encourages the creation of spatial qualities—in this case, a floor line—within blank fields of color.

However, by introducing the figure of the doctor in the foreground of this shot, *Pump Trouble* complicates these spatial qualities. In Neutra's example

of a schoolhouse chalkboard, "whenever the eye focuses on a white mark made on a green chalk board . . . it acts as though it were myopic to the green color: the image of the green surface falls into focus *in front* of the retina. This makes the green seem to recede into a 'background.'"[68] In *Pump Trouble,* Pump is Neutra's "white mark," sending the green rectangle behind him farther off into the distance, while the yellow area (another warm color, like Neutra's red) comes forward. But as an illustration, the doctor's appearance provides a more definite sense of *how* it comes forward: his presence at the front of the frame enables the eye to draw a set of lines from him to Pump, creating a vanishing point located within the green rectangle. With these perspectival relations in place, the yellow field advances toward the viewer not *en masse* as a thick, undifferentiated field, as in the earlier frames of the shot, but as a floor and a wall defined by lines of force radiating from the corners of the green door, reaching out to envelop the doctor and giving him a visual sense of place within the unmodulated yellow field. By instilling a perspectival framework for the yellow field's forward movement, *Pump Trouble* manufactures horizontality and verticality within a single blank color field, sending these visual phenomena forward toward the figure of the doctor and toward the front of the screen. Such perceptual movement is aided by the abstraction of the cartoon's style, privileging the play of color, shape, and line over representational properties and enabling the spectator to experience the relations between them as formal elements.

LEADING THE EYE: EMANATION AND DIRECTIONAL VECTORS

Color was not the only method architects and animators used to destabilize space and set it in motion. The simple line was capable of its own animating properties in visual theories of the postwar period, whether as a directional vector or as an element of a bounded shape. In *Space, Time, and Architecture,* Giedion argues that twentieth-century architecture offers a new "space-time conception," "a hitherto unknown interpenetration of inner and outer space and an interpenetration of different levels . . . which has forced the incorporation of movement as an inseparable element of architecture." This movement is a direct effect of a building's material properties, Giedion observes: "Shapes, surfaces, and planes do not merely model interior space. They operate just as strongly, far beyond the confines of their actual measured dimensions, as

constituent elements of volumes standing freely in the open." For Giedion, the "operations" of these "space-emanating qualities of free-standing buildings" thus animate both inside and outside, as the material ingredients of architecture not only channel George Howe's "flowing space" but also emanate their own space. That is, they visually *produce* space from within their own forms and radiate it outward in relation to other forms in the surrounding environment.[69]

Seminal midcentury visual theorist Rudolf Arnheim, turning the perceptual philosophies of his 1950s work squarely toward architecture in his 1977 book *The Dynamics of Architectural Form,* agrees: "It may seem paradoxical that space has a perceptual presence of its own, even though it is not explicitly constructed by the builder and does not appear among the objects constituting the inventory of the visual image. But it is quite common for visual percepts to contain more than what is given in the physical stimulus pattern."[70] That is, architectural forms are not merely the metal, wood, and glass constituting their structures; they are also "generators of fields of forces that spread through the surrounding space." We see not only the building, but the forces the building mobilizes, as "space is now pervaded by vectors."[71] Empty space is thus filled in by a fluid network sensed by the eye, perceptible even though it is not part of the visible world.

It is worth pointing out that for Arnheim, this movement is not necessarily a part of conscious apprehension. "The man in the street," he notes, "is even less likely [than is the architect] to be aware of the dynamism of perceptual objects, although it always has some influence on his visual world."[72] Rather than asserting itself to plain sight, this mobile space rests on sheer biological and physiological perception. Speaking of the human experience of interior space, he observes that the occupant of a room "constitutes a focal center from which vectors issue radially and fill the empty space with his presence. The hollow volume is perceived as an amplification and extension of the human focus."[73] The perceiving human is thus at the center of a network of forces generated by the immobile materials of architecture, and these forces are understood relationally; the moving human turns the enclosing interior into a cat's cradle, in which one shift in position changes the balance of all the parts. This subtle, not-quite-seen animation of space resonates with Neutra's abovementioned concept of "physiological space, with its strong directional accents," which is likewise anchored in unconscious perception. For Neutra, "the world, at least as we view and sense it, can have no hub unless it is the little ego itself."[74]

In other words, the human eye lies at the center of the visual forces that architecture sets in motion; Giedion's space-emanations, Arnheim's vectors, and Neutra's directional accents all arrange themselves for the benefit of the viewer, without whom they do not exist. This understanding of space borrows from the philosophical conundrum of the tree falling in the forest, but here midcentury architectural design gives a resounding answer. Arnheim declares: "Physically, a line on paper is indeed a dead thing, and so is the edge, profile, or surface separating a building from the surrounding space. The perceptual images of these lines, edges, or surfaces, however, are products of the nervous system, and as such are the highly dynamic resultants of the antagonistic forces I am trying to describe."[75]

It is fitting that Arnheim compares the profile of a building to a line on paper, given modern animation's adoption of a similar understanding of space. Hints of this new spatial orientation appear in a letter from Daggett to MoMA curator Douglas MacAgy, in an effort to explain the studio's aesthetic principles and working methods in advance of the 1955 exhibition at the museum. Speaking of the line on paper (or on celluloid, as it were), Daggett notes: "Cartoon production makes the use of drawn line a mechanical necessity—and UPA's inventiveness with line has become a recognizable aspect of our work. The line varies, and it *expresses.* Sometimes the nervous agonized blotted lines of David Stone Martin, sometimes the spontaneity of Dufy; or the suave calligraphic brush-line of old Persian miniatures; but never just a wire fence around a drawn form. Line as well as color can become a figure of speech."[76] Never just a fence around a form, the line does more than contain or define: it speaks to the viewer, assumes her presence and has something to say, conjures itself for her and makes itself heard by her. The animated line will communicate; the tree falling in the forest will be heard. Most importantly, it is active. It agonizes; it is spontaneous or suave. Noteworthy here are Daggett's references to the active lines of painters, that is, artists working in a medium that is not animated. UPA cartoons explicitly imbue their lines with this "inanimate" form of activity, engendering a sense of movement unrelated to, or in addition to, the movement of their twelve frames per second. In this way, UPA's lines escape status as dead things, the same way the profile of a building comes alive: by expressing, by emanating beyond their material form and becoming animated in the perception of the spectator.

In fact, some cartoons of this period make literal Arnheim's and Giedion's ideas of a space pervaded by vectors and emanations. For example, in *Gerald McBoing Boing on Planet Moo* (1956), an impromptu trip to outer space

reveals a firmament shot through with vectors, a watercolor blue background covered with lines of white and dark blue. While baldly sketched stars also appear in the sky, these lines do not emanate from them, and are thus not meant to represent beams of light; the stars exist independently of the lines that occasionally pass through them. In their tendency to travel in groups and to radiate outward from invisible sources, these lines rather indicate vastness itself, making visible the prospect of an unknown void permeated by forces beyond human comprehension. They form a network within which both Earth and Planet Moo are suspended, and with which they interact. In one shot, Planet Moo even seems to interrupt the vectors, placing it, like Arnheim's buildings, within an active empty space defined by the relations of the visible objects in it.

Postwar architecture calls to mind another attempt to visually negotiate a relationship with the vastness of surrounding space. Perhaps the most famous of these attempts are Eero Saarinen's airport terminals, the TWA Flight Center at JFK International Airport, designed in 1956, and the main terminal at Virginia's Dulles International Airport, designed in 1958. Both terminals sport inverted rooflines that curve upward from a low point in the center, creating a vector that continues out and up beyond the dimensions of the roofs themselves. If the earlier TWA roof actually resembles a bird's wings, injecting an external referent into architectural form, the later Dulles terminal merely visualizes the concept of flight, simply encoding an upward sweep into the concrete materials of the building itself. The walls of the Dulles terminal, sloping outward as they rise to meet the roof, add a second vector, doubling the building's upward-and-outward thrust into the sky. As architectural historian Alastair Gordon notes, "Saarinen wanted the architecture of his terminal to be a 'place of movement and of transition,' he wrote. 'We wanted an uplift.'"[77]

This drive toward "uplift" makes sense for airports, involving architecture in a metaphorical play with the business conducted there, but the architectural approximation of liftoff did not remain so thematically constrained. The midcentury trend of "googie architecture," a style of popular modernism marked by bright colors, butterfly roofs, and a space-age sensibility, colonized ordinary environments such as coffee shops and gas stations in the postwar era, turning them into upward-reaching buildings whose rooflines swept the gaze into the sky above. The googie style creates a visual sense of lightness and liftoff, not into the sky, as with airports, but into outer space itself, a realm alluded to by shapes recalling flying saucers and galactic formations.

Yet even these social spaces suggest a kind of transience that aligns them with the conceptual signature of the airport: they are nodes in larger processes of travel, places where people stop briefly en route to other places, and their perceptual mobility thus still partakes in the airport's metaphorical rootlessness. More noteworthy in midcentury architecture is the presence of the butterfly roof in home construction, most commonly associated with the Palm Springs modernism of William Krisel, who began using the design in 1957. Here even domestic space partakes in midcentury architecture's drive toward liftoff, capping its permanent, stable environment—not a place of travel but a destination, the place where travel stops—with forms that radiate upward and outward into the sky overhead. These vectors, extending across public and private realms, arcing upward and projecting outward from their architectural sources, radiate away from the upper corners of their material platforms, entering the network of mobile spatial relations dramatized in *Gerald McBoing Boing on Planet Moo*.

Liftoff is not the only vector-based animation in modernist architecture; horizontals and verticals, the constituent elements of the dreaded modernist "box," are equally capable of setting buildings in motion. We may find this sense of movement in, to take a famous example, the domestic architecture of Neutra himself. His 1956 Chuey House features all the elements we associate with modern architecture: dramatic angles, stripped-down geometric forms, stark horizontals and verticals. Neutra puts these elements into motion, constructing what architecture historian Sylvia Lavin calls "boxes whose walls and planes dynamically slip and slide as if moved by some unseen energy source."[78] Here the "box" of the house is exceeded by the architecture composing it, partly by a faux-cantilevered roof but more notably by a horizontal supporting beam that, once it reaches beyond the confines of the house, supports nothing. Instead, it carries its outward motion into the surrounding environment; exterior space is thereby roped into architectural composition by this projecting beam. Encompassing open space, it turns empty air into a visual extension of the floor-to-ceiling windows that make up the transparent box of the living room. The house thus appears to contain more planes than the architectural materials actually provide, carrying the dimensions of the house beyond its material presence. The border of the reflecting pool continues the beam's outward movement after the beam itself ends in a strong vertical, while the water reflects the geometry of the house, effectively doubling the forward and backward thrusts of the beam and the rooflines toward the vanishing point. Through this visual radiation of finite

Richard Neutra, Chuey House. Photograph by Julius Shulman, 1960. © J. Paul Getty Trust. Getty Research Institute, Los Angeles (2004.R.10)

architecture into the open space surrounding it, Neutra animates his house on a perceptual level, channeling space through and around its vertical and horizontal lines.

The limited animation of UPA's cartoons channels and animates space in a way similar to, though also in exaggeration of, Neutra's construction. Freed from the responsibility of creating architectural structures that can physi-

Gerald McBoing Boing (Bobe Cannon, 1950).

cally hold together, the modern cartoon can pick up modernist spatial principles and run wild with them. The studio's most celebrated short, the 1950 film *Gerald McBoing Boing,* demonstrates this architectural animation in a brief but celebrated moment in which Gerald, after being reprimanded by his father, sadly climbs the stairs to his room. Composed of two color fields of maroon and pink, the background exaggerates the spatial dimensions of the house without directly showing them. Aside from an irregular patch of wallpaper and a floating blue doorway hinting at architecturally impossible floor lines, there is no indication of walls, corners, or seams of any kind. Even the staircase is merely a jagged, staircase-shaped polygon without individual steps. However, the strong diagonal vector of this polygon, swamped in a sea of undifferentiated maroon "house," makes the staircase, and poor Gerald McCloy's torturous hike up it, seem interminable, while the canted angles pair compositional elegance with expressionist despair.

This approach to representing space recalls Giedion's "space-emanating volumes" that extend beyond their physical dimensions to reshape and define the areas surrounding them. Through such manipulation of color and line, *Gerald McBoing Boing* makes movement out of still backgrounds; shapes and

planes "emanate" space, alternately receding from and advancing toward the viewer, their forceful angles running away with the space they purportedly depict. The spectator must construct the house's architecture at the moment of perception, creating perpendicular angles and vertical and horizontal planes where none objectively exist. The bounded space of the frame, like the physical form of the building, is thus secondary to the spatial relationships created among the abstract elements of its design. Here, animation's movement makes perhaps its closest pass to that of architecture's metaphorical movement, its abstract forms not literally moving (the only thing moving here is Gerald's tiny figure) but rather offering the illusion of motion.

Significantly, both of the above examples rely on the presence of a camera and its particular placement to generate their animation effects. And indeed, a view of the same segment of Chuey House, shifted slightly to the left to emphasize the rectilinear geometry of the frame rather than the dramatic diagonals captured by Julius Shulman in his famous photograph, reveals a calmer, quieter home, still partaking in the emanation of planes and the extension of directional vectors but appearing more at rest, less animated. Instead of Lavin's planes "dynamically slip[ping] and slid[ing] as if moved by some unseen energy source," we have what Siegbert Langner of the Hochschule für Bildende Kunst in Dresden calls "an open, space-radiating architecture which blends perfectly with the landscape," a "purely geometric arrangement of rooms which continues onto the outdoor areas, while the landscape, in its original, unaltered state, is brought into the interior of the house."[79] The same building, depending on the angle of view, produces a different sensation of movement within its constituent parts, sometimes reaching out and pulling space into itself, other times serenely opening itself to surrounding space and radiating out into it. The same could be said of *Gerald McBoing Boing*. Without the canted angle and an optical viewpoint designed to emphasize the staircase's diagonal thrust, would the spectator perceive such dynamism in the McCloy home?

To ask this question is to overlook both the premise of midcentury notions of spatial perception and the status of modern architecture in the period. If, as Arnheim argues, architectural planes and forms exert their forces in relation to other objects in the visual field, and if, as Neutra argues, the hub of space is "the little ego itself," then the variability of architectural activity based on position is the whole point, a feature and not a bug. Architecture's ability to provide different experiences of movement is the property that allows it to claim its own brand of metamorphosis, a key element of anima-

tion itself. Midcentury modernism's conspicuous engagement with this ability flips the switch that sets architecture in motion in new and startling ways. And as architecture theorist Beatriz Colomina observes, modern architecture "has become known almost always through photography and the printed media. This presupposes a transformation of the site of architectural production—no longer exclusively located on the construction site, but more and more displaced into the rather immaterial sites of architectural publications, exhibitions, journals."[80] We should add to this the site of popular magazines as well, such as *Life* magazine's 1949 "Glamourized Houses" spread,[81] where Shulman's photography reached mass audiences, and advertising media such as Alcoa's Care-free Home brochure—and, of course, midcentury cartoons.

As architectural modernism found mass exposure in the newly booming postwar home market and in endlessly reforming downtowns, definitions of American architecture were contested not merely in trade journals and gallery spaces, and certainly not merely on the lots on which the constructions stood. Architecture was experienced by way of images designed to bring modernism to those who were not yet living right in the middle of it. This is perhaps another allegiance between architecture and animation during the period: the ocular angles from which they were understood were in many cases already determined, chosen to showcase the strongest visual forces at work in their abstract elements. For many spectators, architecture and animation were both experienced via the medium of photographic film, with perspectives and movements governed by an expert's design sense, painstakingly arranged to generate the maximum sense of movement in a viewer's perceptual apprehension.

INVISIBLE ARCHITECTURE: TRANSPARENCY AND SPACE

As Chuey House and Walker House make clear, an essential element of vector-based movement in midcentury architecture is its ability to push the inside out and bring the outside in. This interpenetration of inside and outside could be literal, as in Neutra's extended support beams that enlarge the footprint of the house beyond the dimensions of its enclosure, or it could be perceptual, created by glass walls enabling views of nature through the house and reflecting pools that visually replicate the home's interior in its exterior.

The perceptual sense of interpenetration rests on a final fundamental element of midcentury modernism's engagement with vision: the use of transparency to extend sightlines and place the architectural interior in communication with the exterior. Returning to Neutra's observation on the human sensorium as the center of modern space, we may find another link to animation's practices during the period: discussing the motor phenomenon of the eye, he concludes, "Outer and inner worlds are confused, flow into each other; they are really one—an ancient truth."[82] Importantly, the reciprocal relationship described here is between the interior and exterior of the *human*, a border-crossing that, for Neutra, was to be replicated in the design of human living space in order to enable the most seamless flow, the fullest expression of his "ancient truth" by way of a visually integrated life.

UPA head John Hubley shared Neutra's faith in this traffic between inner and outer, complete with its metaphysical resonances. In "Beyond Pigs and Bunnies," his 1975 sequel to "Animation Learns a New Language," he observes: "I can see the day when characters will be conceived and defined beyond the ordinary outer visual aspects as we presently know them. At any given moment we will see also a portrayal of two or three of the dramatically relevant inner facets of the character and, at the same moment, the nonvisual aspects of the environment."[83] His subsequent discussion makes clear that he is referring to the use of drawn animation to make the invisible movements of the inner human spirit—hunger, loneliness, anguish—visible in its exterior form, condensing inside and outside onto a single surface. Surprisingly, Kepes himself provides a meeting place for these two ideas in a 1972 interview, in which he discusses his onetime plans for an animated film of his own, a retelling of "The Emperor's New Clothes" as a response to the Nazi regime, in which "I used every soldier as a transparent head, having the helmet inside rather than outside, and the whole idea was to crucify dictatorship, and to show fakes in life."[84] By employing transparency, the artist, whether an architect or an animator, can merge inside and outside, make the inner world visible in the outer, and in the process reveal fundamental truths.

However, if modern animation and modern architecture were philosophically aligned on transparency, their employment of it in their finished forms diverges in striking ways. More than with color, line, or shape, transparency's realization in these two media run on parallel, but rarely intersecting, trajectories. With numerous homologies but no clean translations, the visual solutions generated by animated and architectural transparency are thus productive case studies in sympathetic modes of representation working with

fundamentally different materials. Animation in particular seeks a radical experimentation with transparency, seemingly observing architecture's testing of the limits of the physical world and deciding instead to turn those limits inside out. UPA cartoons repeatedly imagine new forms of transparency that are specifically denied to architecture, in some ways functioning as a clearinghouse for the utopian rhetoric of architects and designers whose dreams were too far ahead of contemporary technology and materials. But in other ways, animation's version of transparency veers off from architecture's fantasies in doubly fantastical directions, conjuring a relationship of inside to outside that overturns the very definitions of the words themselves.

In its most basic, glass-walled sense, transparency was indispensable to an animated architecture. By opening up the closed structure to the outside world, Gropius argues, "Sections of the infinite outdoor space become part of an architectural space composition which does not stop at the enclosing walls, as in past periods, but is carried beyond the building into the surroundings. Space seems to be in motion."[85] The interpenetration of inside and outside enables the building to be more than merely itself and instead a part of an "architectural space composition," an arrangement of forms and forces that extend beyond material boundaries. Historian Roland Marchand points out the importance of this dynamism in everyday life in the postwar era: "Picture windows and other expanses of glass accentuated the idea of a free-flowing continuity of space and mood between indoors and outdoors. Population pressure and high costs had imposed limitations in the postwar suburban search for spaciousness. In response the ranch house nurtured illusions of open continuous space and freedom."[86] This "illusion," manifesting in the cramped occupant's perception rather than in her direct environment, enlists transparency in the same kind of animation as color and vector, a metaphorical outward movement that rests on vision to make itself felt.

Yet where Gropius finds in transparency a descriptive theory of space, and Marchand a historical response to cultural and economic forces, Moholy-Nagy finds a springboard for a utopian fantasy of a fully transparent world populated by architecture that is not only invisible, but insubstantial as well. Projecting into the future, he imagines an architecture in which "the roof [would] be supported by pressed air columns; limitless open space could be provided without impairing movement or sight."[87] Containing tabletops and chairs resting on pillars of the same substanceless substance, this air-based architecture would effect a seamless integration between inside and outside that raises Giedion's new "space-time conception" to a near-absurd degree.

Discussing the Crystal Palace and Mies van der Rohe's glass skyscraper design for the 1921 Friedrichstrasse Skyscraper Project, Moholy-Nagy imagines the logical endpoint of such innovation: "In combination with a bare steel construction a transparent apartment can be built.... If [Mies's] model should one day be realized the transparent structure would appear as a gigantic soap bubble, plainly showing the deviation from the heavy solid mass of the Pantheon."[88] For him, this transparency would meld inside and outside into one experiential whole, reuniting humankind with nature through design's engagement with vision. In a spunky discussion of "monumental windbags," architecture critic Reyner Banham elaborates on this experience via inflatable architecture: "The beauty of that simple wind-bag was the directness and continuity of its response. Every slight change of state inside or out—even a heated conversation—brought compensating movement in the skin ... by direct variation of curvature under balance of pressures. For the human occupant it was a kind of partnership relation with the enclosing membrane, each going independently but sympathetically about its business."[89]

Moreover, to turn architecture into a soap bubble or a curtain of air is to render it not only transparent to the eye, but potentially permeable to the body as well. And as Alastair Gordon notes, architecture did indeed flirt with this possibility. Describing Walther Prokosch's Northwest Airlines Terminal at JFK International Airport, he says: "From the land side, the terminal was entered through a hundred-foot-wide opening that was protected from the elements by an invisible curtain of warm air blown through nozzles in the floor."[90] While a far cry from a column of air capable of supporting a roof, it is nevertheless an indication that Moholy-Nagy's dream of a weightless, immaterial architecture was not merely a figment of his own mind. In the meantime, as Gropius suggests, glass fills the gap: "Its sparkling insubstantiality, and the way it seems to float between wall and wall imponderably as the air, adds a note of gaiety to our modern homes."[91] That Gropius is so concerned with "gaiety," much as Alcoa's Care-free Home sought "gay informality" and Eisenstein sought "triumphant joy" in Disney animation, links modern architecture to the whimsy of cartoons in a way that is at odds with its reputation for severity and joylessness.[92]

The laws of physics stood in the way of Moholy-Nagy's architecture of air; however, the designers and animators at UPA faced no such strictures. If in the former's utopian imaginings "open space could be provided without impairing movement or sight," UPA's cartoons could dramatize exactly such

Christopher Crumpet's Playmate (Bobe Cannon, 1955): a tri-color room.

a scenario, eliminating visual barriers within the home and creating an architecture in which *all* of the house is visible at once, an extreme rendition of the open-floor plan. In *Christopher Crumpet's Playmate,* the 1955 sequel to *Christopher Crumpet* (1953), invisibility is thematized within the narrative. Christopher, who in the series's first installation was able to transform himself into a chicken, has here developed an imaginary friendship with an elephant. When it turns out that the elephant is not in fact imaginary but merely invisible, hijinks ensue, including a family trip on the new house pet's back through the Crumpet home. Instead of passing through discrete rooms, the Crumpets simply float out of one color field and into another, with the contents of each "room" visible across the nonexistent physical boundaries separating them. The placement of objects within the rooms, and their perspectival renderings orienting them toward separate vanishing points, indicate separate spaces with walls between them, yet the spectator is as unbound by this architecture as are its inhabitants: both movement and sight are wholly unimpaired by this insubstantial architecture, as invisible as a soap bubble and as permeable as a curtain of air.

In line with Moholy-Nagy's disappearing architecture, Neutra's homes show a tendency toward disappearance, famous for their seamless integration into their surroundings. In her discussion of Neutra's domestic American modernism, architecture historian Gwendolyn Wright observes that his glass-walled structures "dematerializ[e] into their surroundings," a hallmark of his attempt to "affect illusions of infinite space," to offer a domestic

experience of the outdoors as part of the home.[93] In many of his homes, as discussed above, this phenomenon is accentuated by the presence of floor-to-ceiling glass walls, blurring the boundary between the home's interior and exterior and extending vision *through* the envelope of the house. In fact, the reflective capability of the glass walls suggests that not only does Neutra's transparent façade not limit vision; it actually *expands* it by superimposing the view ahead and the reflection of the view behind onto one transparent screen. The "interruption" of the house allows the viewer to see more of the outside world than would be possible without it. A similar illusion of expanded vision characterizes Walker House's play with transparency, in which views of the interior of the house through the glass façade place sky-blue color fields next to the blue sky, offering the experience of vision passing through the architecture even as it is in fact encountering an opaque wall. Likewise, as Beatriz Colomina observes of the Eames House, "The house dissolved itself in a play of reflections, restless images that immediately caught the eye of the world."[94] These reflections and their restless play suggest a house in motion by multiplying and bending perspectives, offering simultaneous views of incommensurable spaces.

The Tell-Tale Heart (1953) engages with this dematerialization of architecture as well, here again carrying the illusion further than physics will allow. Adapting Edgar Allan Poe's story about an unstable lodger who murders his landlord, the short dramatizes the disappearance of architecture as a reflection of changing mental states. Directly after the protagonist, driven to madness by the presence of the elderly landlord in the cluttered, ramshackle house they share, commits the murder, the claustrophobic house becomes transparent, its floor a freestanding platform floating in a foreboding, cloudy sky. The shutters, once attached to a solid wall, now stand starkly silhouetted against the nighttime, the sole obstacle between the protagonist's vision and the outside world. Fittingly, given midcentury modernism's investment in transparency as a cure for the cramped human sensorium, the madman's release is visually experienced as the disappearance of architecture and the extension of vision into infinity. As the protagonist's mind settles, the walls return. However, in the penultimate scene of the film, as police officers search for signs of foul play in the landlord's disappearance, the walls disappear again, this time becoming a dark blue color field, leaving staircases, doorframes, and arches standing in empty space. The interior of the house has become transparent, mimicking the protagonist's erstwhile visual freedom but ultimately mocking it by enclosing the transparent space of the house in an unearthly

Gerald McBoing Boing (Bobe Cannon, 1950).

blue shell, presaging his impending dissolution and capture. Accordingly, the final shot of the film is the obstructed view from a madman's cell, the small, barred window denying any sense of transparency.

This is simple enough, but the modern cartoon's relationship with transparency is often something more complicated, and more vexing. While it is accurate to say that architecture disappears in UPA cartoons—in most of them, wall and floor lines are absent, and objects float in empty color fields— the question of what replaces it is fraught with paradox and impossibility. For instance, in *Gerald McBoing Boing,* the family living room is a blank, beige color field with a window suspended in midair, its location in the top half of the frame the only indication that it is on a wall and not on the floor. The view through the window is cast in the same beige, giving the impression of a transparent wall penetrated by the color of the outside world. But the wall is not transparent: through the window, we see trees, themselves the same color as the interior of the home and the atmosphere outside, save for light green circles hastily superimposed over the outlines of the treetops. So while architecture is indeed invisible in *Gerald McBoing Boing,* its invisibility does not grant a view beyond itself, at least not exactly, and not in the way

Moholy-Nagy envisioned. If in the real world invisibility and transparency are conceptually synonymous, or at the very least produce the same effect on vision, it appears that the opposite is true in animation.

If modern architecture starts with raw materials in the physical world and attempts to build the most visually open environment possible, modern animation finds itself in a slightly different position. Starting from absolute nothingness, modern animation also attempts to build the most visually open environment possible, but its handicap is that it still must build an environment of *some* sort. There is no preexisting world to which its architecture must give access by relaxing its delineation of space. Rather, it must erect visual barriers in order to delineate space at all, because to represent a transparent architecture otherwise means to fill the frame with infinite evidence of the outside world as proof of transparency. This visual clutter would defeat the purpose of the minimalist modernism the midcentury cartoon champions—what art historian Bruce Jenkins calls "the radically simplified haptic space of UPA cartoons."[95] In this sense, modern animation approaches architecture's transparency from the other side; in seeking to represent an invisible architecture, it must obstruct vision, deny the view into infinite space that invisible architecture by definition provides. Its illusion of transparency and invisibility thus rests on a paradox.

The culprit in this confusion is the color field, an abstract form that functions differently on the picture plane than it does when imposed upon a material object. In *Language of Vision,* Kepes establishes the difference between the three-dimensional visual field and the two-dimensional picture plane, explaining, "The frame of reference shifts from the more general spatial direction of the spectator to the new background of the picture field—to the four borders and the two dimensions. An entirely new frame of reference is created, a world with new laws formed out of the new relations."[96] In *Gerald McBoing Boing,* for example, the unified color scheme—the interior wall seeming to be penetrated by the color of the exterior world—works against transparency even as it flirts with invisibility. The reduction to abstract form carried out by midcentury architecture, when placed next to the midcentury cartoon, reveals itself as incomplete, an approximation: a three-dimensional structure built out of solid materials and existing in space reaches a limit that animation need not obey. The modern cartoon can walk the line between abstraction and representation in ways that confound real-world perception, taking the overlapping categories of "invisible" and "transparent" in built architecture and rendering them antagonists in the animated cartoon.

That said, one place where we might again find consonance between transparency in architecture and animation, or even a shared development of ideals, lies in the treatment of the human body within the built environment. Returning to Neutra's demand for a constantly shifting, renewing color palette to prevent the suffocation of the human sensorium amid static visual forms, the importance of transparency becomes, so to speak, clear: "Large expanses of glass aid a visually conceived plan of space for living; they add to its chances of yielding comfort, lasting over the stretches of time."[97] For the passage of light throughout the day to animate chromatic surfaces within the home, a transparent façade is a necessity, and the discussion of comfort, along with Neutra's placement of the eye and mind at the center of multidirectional, modern space, emphasizes the body as the locus of architectural activity.

Moholy-Nagy takes this conceit one step further, arguing in *Painting, Photography, Film*, "Penetration of the body with light is one of the greatest visual experiences."[98] If Neutra's design program is about the exposure of the body to changes in light, Moholy-Nagy transfers the responsibility of transparency from architecture to the body itself: light mustn't merely penetrate architecture to play upon the body, but rather must keep going to penetrate the body itself. Transparency thus becomes not merely an architectural imperative, but a human imperative as well; the logic of the building is mapped onto its inhabitant, who is changed by her encounter with architecture. Likewise, design historian Michael Golec argues that Kepes's new language of vision "theorized a new society predicated on the refinement of vision at the expense of the corporeal, the material," a process that entailed "releasing the eye from the material body."[99] That is, the dematerialization of the body is central to Kepes's utopian visual cure-all for the ills of modern life, a dematerialization that is equally central to Moholy-Nagy's image of "penetration of the body with light."

Animation repeatedly enacts this dematerialization of the body through the transparency of its human figures. In *The Rise of Duton Lang* (1955), a soirée congratulating the eponymous character on his miraculous weight loss is represented as a gathering of transparent people whose outlines prove permeable and whose insubstantial corporeal presences give way to the all-powerful assertiveness of the color field. The human body in this cartoon is impenetrable to certain objects: dinnerware, tables, and, strangely, other people are not visible through the outlines of Lang's transparent celebrants. However, the seemingly random composition of color fields in the frame cut through human forms, often bisecting bodies and rendering them in some color-block combination of white, blue, and aquamarine. Light penetrates

The Rise of Duton Lang (Osmond Evans, 1955).

the body, offering what is indeed a great visual experience, striking in its representation of the human body as shot through with color, impenetrable to other humans and the markers of the material world but thrown open to the activity of light and color. That this experience is visualized in the context of a party seems to corroborate Moholy-Nagy's declaration, offering up the transparent body as a joyous adaptation to modern design principles.

Gerald McBoing Boing's Symphony (1953) does not share *Duton Lang*'s reticence, rendering its human figures as totally transparent, their outlines overlapping with each other and revealing the world beyond through their basic shapes. Remarkable in this case is a scene occurring in front of a dramatically elongated hallway, represented in alternating bands of red and white stretching back toward an exaggerated vanishing point. The vectors created by the dramatic lines, coupled with the visual syncopation of the rhythmically alternating colors, carry forward to the front of the frame, visually strengthened by their penetration of the human forms in the foreground. Here, not only does light penetrate bodies, but vectors penetrate them as well, roping the human occupants of architecture into the animated play set into motion by the building's employment of color and line.

This animation of the body by placing it into an already animated visual system was also a part of architectural practice at the time. Quoting G. E. Kidder-Smith on airport design, Alastair Gordon notes "a significant shift in perception," one that rested on transparency for its bodily effect on the spectator: "'As soon as one arrives one feels that this is an airport and no other

transportation service,' he wrote. 'One is architecturally, indeed physically, projected onto the field and made a part of its excitement, for no solid wall ever rises between the passenger and his aerial transportation.'"[100] In this formulation, transparency allows the body to be made immaterial, to be projected along the vectors set in motion by architectural form. This is perhaps the endpoint of architectural transparency: light penetrates not only the building, setting it in motion, but also the body inside the building, animating it in ways beyond muscular capacity for movement. Architecture can *move* its occupant, can animate the body in ways that it cannot animate itself, enabled by the visual phenomenon of transparency. Light trumps matter, and building and body dissolve in the play of visual forces. Here again animation literalizes architecture's metaphor, representing not only its spaces but also its characters as direct, visible expressions of these abstract architectural ideas.

THE CARTOON AS LABORATORY

Through the use of free color, advancing and receding color, vectors and emanation, and transparency, architecture and animation partook in midcentury modernism's engagement with the human sensorium, attempting to craft new ways to habituate vision to changing ideas of modern space. For Kepes, the new "language of vision" was intimately tied to architecture: "To grasp spatial relationships and orient oneself in a metropolis of today, among the intricate dimensions of streets, subways, elevated, and skyscrapers, requires a new way of seeing."[101] Moholy-Nagy argues that the new architecture involves the creation of space, what he calls "articulated space relations," a new approach to architecture and the image that would enable "the cultivation of vision and other senses."[102] Design historian Oliver I. A. Botar elaborates on what this means, calling it "an attempt by Moholy-Nagy to transcend 'art' (or at least as 'art' had been traditionally understood), and to arrange, rather, for *situations* in which people could experience and develop both their physical and sensory capacities. Moholy-Nagy would famously come to refer to this sensory expansion as 'New Vision.'"[103] In *Survival through Design,* Neutra provides a manual for arranging these situations predicated on an understanding of a multidirectional space "with strong directional accents" and "the little ego itself" as its hub.[104] And Arnheim advocates an understanding of space as alive and responsive to the visual presence of objects, arguing, "Space has a perceptual presence of its own, even though it is not explicitly

constructed by the builder and does not appear among the objects constituting the inventory of the visual image."[105] Together, they posit a theory of architectural space as mobile and relational, and of human perception as in need of an upgrade by way of art.

What these interrelated approaches add up to is a deliberate instability of architectural form, an approach well suited to the medium-specific properties of animation and its use of metamorphosis. Architecture metaphorically partakes in this practice of metamorphosis, seeking ways to animate its inanimate materials through an appeal to the properties of visual perception. Colors leap out at the eye, lines carry it in various directions, and transparent materials encourage its extension into infinite space even as it remains in one place. Film scholar Aylish Wood offers another way to talk about this kind of spatial play: "space as both certain and uncertain." For Wood, "Space is perceived in terms of stasis when it is certain." In cases of uncertainty, however, "Different experiences of a given spatial organization reconfigure space, forcing the re-discovery that what is mapped out through familiarity is only one dimension of a multiplicity of possibilities," a process she calls "transformation."[106] If the buildings discussed above do not actually move, they are nevertheless always in transformation, never presenting a stable image to the outside world. This architectural animation, dependent not on the literal movement of its constituent materials but rather on the work of the spectator's eye, is also at work in UPA's superficially still aesthetic, which routinely intermixes foreground and background, complicating the viewer's certainty of the cartoon's spatial dimensions. The result of this thinking is the concept of a user-generated architecture, enabling the occupant to create her own spaces within a structure based on her placement in relation to forms and objects—and on her visual capacities. The therapeutic compensation for the dislocations of the postwar era would be achieved via the reeducation of vision, and animation was a prime vehicle for this sensorial tinkering.

In 1953, the same year Eames showed his students *The Four Poster*, UPA released *Christopher Crumpet*, a seven-minute theatrical short that illustrates Wood's uncertain space as well as modern architecture's user-generated space. Here UPA's stylistic markers reach apotheosis, the zero degree of mid-century animation style. Instead of solid humanoid shapes, characters are mere outlines; instead of cycling between poses, characters often merely slide across the screen; and most suggestively, instead of boldly colored backgrounds, *Christopher Crumpet* takes place against a plain white field. The family home is visually almost nonexistent, represented at most by a door

Christopher Crumpet (Bobe Cannon, 1953): the impossible indoor/outdoor space.

hovering on one side of the frame. The Crumpets navigate hallways and rooms that are not visibly there but are signified merely by the characters' multidirectional progress through empty space. To move from the easy chair to the front door, by all appearances a straight shot within a single room, they take a circuitous route that leads them up and down, left and right across the empty screen. What at first seemed a screen-sized living room is revealed to be two distinct spaces separated by the twists and turns of an invisible architecture. Mr. and Mrs. Crumpet in a sense precede the space they occupy, creating it for the spectator through their movements.

If the Crumpets' progress through the empty frame of their "house" calls their domestic architecture into being as they clarify its dimensions by moving through it, their home itself occasionally resists this clarification. In one scene, exiting the front door, they disappear momentarily, only to reappear through another door, this time emerging into their backyard; the impossible territory between these two doors, neither inside nor outside—or both at the same time—recalls Wood's uncertain space that is always in transformation. The Crumpet home is the ultimate in modularity, its absurdly flexible design the conceptual destination of prefab architecture's starting point. In

Christopher Crumpet, architecture literally shapes itself according to the dictates of space use, going so far as to wait to exist until it is called into being by the passage of its occupants. By remaining uncertain, the cartoon's space endlessly transforms itself without even appearing visibly onscreen.

But what do cartoons gain by entering the conversations among design and architecture professionals? As discussed in the previous (and the next) chapter, UPA's founders saw in animation the potential to express abstract concepts and to illustrate complex processes in an intuitively intelligible way to a large audience of laypeople—and in so doing, to redefine what animation is and how it works. The studio's desire to experiment with spatial representation and abstraction enabled not just a new style of animation, but also a new *kind* of animation that expands well beyond the supposed limits of "limited animation" and its budget-directed lack of movement. This animation depends on activating the stationary elements of the image in the spectator's eye by, as we have seen, experimenting with the perceptual properties of color, line, and transparency. This, then, is a form of motion over and above the projected image's twenty-four frames per second and its animating illusion of the persistence of vision, and a form of animation that we may find in the supposedly stationary elements of modern architecture as well.

As Neutra, Moholy-Nagy, and Kepes are teaching a new generation of architects and designers to deliver humankind from a colorless, suffocating modernity of its own making, UPA positions animation as part of the solution. Their cartoons take part in the burgeoning postwar attempt to wrangle flowing space and to enable people to live comfortably in it—as well as in the burgeoning postwar consumer market attempting to advertise and sell those objects of comfort, be they decorations, furnishings, or modernist homes. Moreover, it strikes out in its own directions, often reaching points beyond where architecture could reach (and sometimes veering off into its own fantastical territories) by visibly representing the chromatic play, the powerful vectors, and the spatial interpenetration that architects and designers, bound to the laws of physics, sought but had not yet found a way to achieve. Making architecture's spatial metaphors literal, modern animation in effect becomes a cinematic laboratory of architectural theory in motion; it shows us the world modern architects imagined was all around us, if only we could see it.

THREE

Condensed Works

COMMUNICATION IN GRAPHIC DESIGN AND
THE MODERN CARTOON

SOMETIME IN THE 1940S, ALVIN LUSTIG DESIGNED a bookplate for John Hubley. Lustig, a well-known graphic designer during the period, is perhaps best known for the iconic book covers he designed for publisher New Directions' "New Classics" series between 1941 and 1952. Translating literary classics by Tennessee Williams, Franz Kafka, James Joyce, Arthur Rimbaud, Henry James, Ezra Pound, Charles Baudelaire, and Gertrude Stein, among others, into concise, abstract visual images, Lustig established his primacy on the American design scene.[1] It is not an exaggeration to say that when Americans read major works of modernist literature at midcentury, their exposure was filtered through Lustig's designs. That Hubley would seek him out to design his personal bookplate—an abstract and geometric, almost architectural, composition in black, maroon, and gold—suggests an affinity between UPA's creative director and one of the most famous emissaries of midcentury modernist graphic design.

And this is not the only point of affinity. In 1947, UPA cofounder Stephen Bosustow commissioned Lustig to redesign the studio's logo. The three ovals, each in a primary color and each containing a letter of the studio's initials, ran on UPA's theatrical cartoons and was featured on their letterhead and publicity materials. This was not a random assignment; Lustig was a high-powered designer working in advertising, textile design, and storefront branding at midcentury. He taught at Black Mountain College, founded in North Carolina by Bauhaus émigré Josef Albers, and at Yale, the first university in the United States to offer a degree in graphic design. Given UPA's modernist bent, it made sense to have his stamp on the studio's public branding, and given Hubley's own aesthetic commitments, Lustig's design was a perfect image to have pasted in each of Hubley's books. That both Hubley

and Bosustow sought out Lustig for personal and professional commissions suggests UPA's strong engagement with the field of graphic design, and points to an understanding of the animation studio as being enmeshed in a design discourse that was in great ferment during the postwar period. Lustig's trademark, particularly on display in his book covers, was his ability to assess a large body of information and to distill it into a representation that was stark, simple, and arresting. This practice, the bread and butter of midcentury graphic design, resonated with UPA not just as a matter of style, but as a matter of communicative ethos, and it points to a way in which both graphic design and animation in the postwar era sought the clear, direct conveyance of essential information in a reduced, abstract form. Across these two disciplines, the question of condensation was paramount: how to pack the most information into each image, how to communicate as much as possible to the viewer in the shortest amount of time, and how to devise a new visual language capable of rendering the newest discoveries of a scientific age to the general population in an intelligible form. In this chapter I explore the ways in which this design principle shaped the form of graphic design alongside the ways in which it shaped the form of, and more importantly, the ways in which it was extended and developed in, the visual language of animation.

However, while condensation was a key design principle of midcentury modernism, the word carries various meanings, all of which are related facets of this central concept, and all of which appear in the analysis of visual texts below. Condensation in some cases implies "compression," as in the condensation of large amounts of information into small images, employing the language of the infographic to render a large and unwieldy body of data easily digestible. In addition, compression refers to the superimposition of images, compressing two images into one to enact a form of "simultaneous seeing" of two things at once.[2] It can also include temporal and spatial compression, the squeezing of the time frame of an atomic, astronomical, or historical process to render it visible not only for the sake of practicality—who can spare literal eons to witness the formation of a galaxy?—but also for the larger goal of expanding the limits of vision itself. The human eye, unaided, cannot take in long, far-flung, slow-moving processes that range freely throughout time and space, but graphic design and animation can render these processes in a visual form that enables the eye to partake in events beyond its physical apprehension through compression and condensation.

There is also condensation as "distillation," which, rather than compressing, or squeezing, an outsized body of information into a manageably sized

visual container, separates out the most valuable elements of a phenomenon or concept and presents them on their own. This process appears in modern design's and animation's tendencies to strip representation down to essentials and to make meaning out of simplicity: the most minimalist outline of a figure in *Gerald McBoing Boing*, the most pared down and unadorned shape to stand in for a more complex form in Alvin Lustig's cover design for Tennessee Williams's *A Streetcar Named Desire*. By removing the most important elements of a concept or process from the larger, more diffuse contexts, narratives, and bodies of information in which they are dissolved, distillation through design extracts the "pure" materials, so to speak, so that they can be seen and apprehended in their condensed form.

And finally, condensation implies "solidification, concretization." Like water vapor condensing into droplets, graphic design and animation sought methods for the condensation of abstract, invisible information into concrete representations visibly located in time and space. Complex concepts that happen beyond the thresholds of human perception can be made to submit to that very perception through the alchemy of design thought, transmuting idea into form. This process often manifests in terms of the visual metaphor, but as I show below, graphic design and animation developed many other methods of direct visualization through their use of condensation. Here, then, condensation is the making visible of the invisible, giving material presence to the microscopic, the conceptual, the ethereal, and the infinite.

These meanings are linked by a common concern: how to render complex, often theoretically advanced or esoteric ideas into a visible form that the layperson can understand, and how to do so in a way that is quick, efficient, and easily grasped regardless of divergent levels of literacy or education. Under the rubric of condensation, therefore, graphic design and animation attempted to open up new avenues of communication in various directions, in all of them seeking a more powerful means of expressing information visually. This chapter is devoted to an analysis of these means, a close, detailed inventory of the working of this multifaceted condensation through the innovations in modern animation and graphic design.

First, however, condensation carries with it one final, or perhaps preceding, valence, one that is important in the context of graphic design's and animation's attempts to make the most of their powers of communication, yet seems like an odd fit here: Freudian condensation. In Freud's psychoanalytical theories—particularly those of dreams and jokes—condensation is one of the main engines driving the unconscious processes underlying human

activity and behavior. Numerous scholars have used Freud's theories to better understand the inner workings of cartoons,[3] but my interest in Freud here lies in the ways in which his notion of condensation, particularly as found in dreams, can help us to more fully understand the processes of visual condensation at work in graphic design and animation at midcentury.

To place these three fields in dialogue is neither a perverse exercise in theoretical application nor a combative revision of film theory's use of psychoanalysis. Rather, as graphic design and animation moved toward the development of new modes of visual communication aimed at direct and visceral understanding, many of the implications of the condensation these two media employed find suggestive echoes in Freud's own dream-work theories. Exploring these echoes, I argue, provides a powerful tool for untangling the design language being developed concurrently by midcentury graphic design and cartoons. If Freud's writings have given us several cues in the interpretation of filmic images more broadly, his writings on condensation prove particularly valuable in establishing a clear understanding of animation's articulations of condensation as a design principle.

This, then, is not a chapter about Freud; it is a chapter about condensation, in which Freud's ideas have something to add to the definitions and discourses of condensation developed by graphic designers and animators in the postwar era. While the preceding chapters have made clear modern animation's pedagogical commitment to a new visual language aligned with design theorists such as György Kepes and László Moholy-Nagy, the present chapter will focus on animation's engagements and resonances with questions being asked by graphic designers across the profession, exploring the ways in which vision was conceived and enlisted in a utopian project of mass communication. Designers viewed their work as an "extension of language ... that synthesis of art and science now urgently demanded by contemporary life."[4] Lofty ideals of communication became the lingua franca of graphic designers as they met at increasingly common national and international conferences and extended the scope of their concerns beyond two-dimensional images to encompass the future of society and the fate of the human spirit. At the center of these conversations was vision—not just passive seeing, but *vision:* how it works, how it's failing, how to capture its attention, and how to fix it. As designer Will Burtin argues, "In designing we must realise that steadily changing conditions confront us, to which we can adjust ourselves only by ... understanding the mechanics of vision."[5]

This chapter delves into these conversations among graphic designers, following the wartime and postwar debates and position statements in leading trade journals *Graphis* and *Print,* which serve as an index of design thinking at midcentury. These discussions fall into place alongside currents in modern animation. John Hubley's writings resonate strongly with the rhetoric of *Graphis* and *Print,* as do archival documents surrounding Saul Bass's film title sequences as well as notes and correspondence from UPA's archives. And more centrally, close analysis of the products of various animation studios of the period bear out the impact of this shared rhetoric. As graphic design approached the modern cartoon aesthetic, and as the modern cartoon adopted the language of graphic design, the fields in many ways merged. The line between the two is thus blurry and often simply not there. In many ways, animation functions as a subset of graphic design—the branch of graphic design that moves—and in other ways graphic design is sometimes figured as animation waiting to burst into motion. Across these differing configurations, the key idea pulling them together is *condensation,* the fundamental design principle underlying the new forms of visual expression these two media undertook together. Graphic design and animation thus contribute to a set of pedagogical postwar discourses that mutually inform each other and that determined the visual images the American public saw in their magazines, in their movie theaters, on their television screens, in their museums—in short, if the designers were right, anywhere they looked in a world increasingly focused on visual communication.

CONDENSATION: DEFINITIONS, THEORIES, AND USES

In his 1975 article "Beyond Pigs and Bunnies," former UPA head John Hubley identifies metamorphosis as the key to animation's medium specificity. "A dynamic transformation of symbol becomes possible that intensifies and heightens the dramatic content," he argues. "The fleeing cat, running at extremely high speeds, assumes the shape and sound of an airplane. It is this symbolic condensation of a transformation of energy that I consider to be the primary property of animation. By abstracting and purifying a representation of an object-organism, an artist creates his equivalent of a writer's word."[6] While the insistence on metamorphosis is a common refrain in animation

theory, Hubley's use of *condensation* as a synonym strikes a more curious note, as does his invocation of the "writer's word," an appeal to animation as a system of linguistic communication. These terms echo his earlier description, in the 1946 article "Animation Learns a New Language," of animation's "quality of compression, of *continuous* change in terms of visual images," as the source of animation's unique communicative abilities, the seat of its status as "a new visual language."[7]

Hubley is not alone, however, in identifying condensation as a peculiar property of animation. Paul Wells likewise mentions condensation as a key component of animation's central features, among a host of other traits: "metamorphosis; synecdoche; condensation; symbol and metaphor; penetration, sound, etc."[8] In his earlier work, 1998's *Understanding Animation,* the term's definition is surprisingly limited, and more importantly, wholly temporal, confined mainly to "the elliptical cut and comic elision," processes that are presumably shared by all modes of film production.[9] By 2002's *Animation and America,* Wells's idea of condensation has shifted to something more visual, "the maximum of suggestion in the minimum of imagery," and in 2007's *Basics Animation 01: Scriptwriting,* he elaborates on this definition: "Each animated story or expression effectively 'condenses' and compresses resonant visual representations and motifs, and focuses purely on the detail that will enhance the narrative form . . . preferring the intensity of suggestion in visual composition and design."[10] This sentiment lines up with UPA publicity director Charles Daggett's assessment of *Gerald McBoing Boing,* which he describes as "marked by an utter simplicity of background, character delineation and movement—a simplicity most necessary in telling the simple, touching story of a little boy who is a strange one in a strange world."[11]

However, it is one thing to employ simplicity in a simple story, and quite another to employ simplicity across the board. UPA's house style, as I have argued, is marked by an extreme simplification in almost all of its films. Moreover, as UPA's house style became, broadly speaking, the dominant style in American animation in the 1950s and 1960s, this growing simplification becomes part of a larger history, resonating outward into other areas of culture. If UPA shares concerns of order with Precisionism, and of movement with modern architecture, the question of condensation brings it into the orbit of graphic design, a field with which UPA was outspokenly aligned. UPA cofounder Zack Schwartz declared, "Our camera isn't a motion-picture camera. Our camera is closer to a printing press," calling for "a world of graphic expression and symbolism which we had not used" in the early

years.¹² The cartoon, for Schwartz, was animated graphic design, not drawn cinema. As Hubley stated, animation could function like "the writer's word," a means of visual communication that worked like a language. This idea—Kepes's "language of vision"—circulated throughout the burgeoning graphic design profession at midcentury, at the very moment that the profession placed itself at the center of American life and its everyday processes. Visual communication, and the forms of condensation that enabled it, thus spanned both popular animation and graphic design, becoming a powerful presence well beyond the boundaries of their originary fields.

The midcentury designer, under the influence of Kepes and Moholy-Nagy—and in the androcentric language of the movement—viewed himself as a "visual interpreter," emphasizing "his unique role as communicator, link, interpreter, and inspirer" between the worlds of the artistic, the scientific, and the social in the service of expanding humankind's visual vocabulary.¹³ For Will Burtin, a fellow pre-WWII émigré from Germany, "Graphics can play an important role in extending human vision by demonstrating a new reality to which the uninitiated as yet have no key. The need is now imperative for clarifying the universe rather than allowing it to remain a puzzle or a subjective projection of the individual artist's personality. In this clarifying process graphic presentation deals also with a class of problems in which the task is to compress a whole field of reality into a single, powerful image, instantly recognized by its composite, associative, impressionistic elements."¹⁴ The compression described here, relying on "a single, powerful image," aligns with Hubley's description of condensation, relying on "abstracting and purifying a representation of an object-organism." Both turn the image into language by making the world smaller, simpler, more comprehensible.

Likewise, at the 1955 Aspen Design Conference, an annual meeting of the leading minds in the design and visual communication fields, George D. Culler observed, "Change is our environment; we must learn how to grow flexibly and creatively in relation to it. This is perhaps the greatest design challenge of all time."¹⁵ In invoking change as the hallmark of the modern condition, Culler unwittingly echoes Hubley and Schwartz above, who referred to "*continuous* change in terms of visual images" as a way for animation to help mass audiences understand abstract concepts. Tellingly, they called this "compression." Meanwhile, three years later at Aspen's 1958 conference, E. A. Gutkind asked, "How does our world look today? Excitingly hopeful and at the same time dangerously frustrating. . . . The new feeling of space which has not yet been condensed into a clearly definable idea of space

is everywhere at work."[16] In the rhetoric of both animation and graphic design, condensation is a prerequisite for understanding. The world is without form, and void; it must undergo condensation to become an *idea*. At midcentury, graphic design and animation employ condensation to render concepts visible, to make them understandable as "definable ideas" by first turning them into images.

Helpful in the illumination of this process is Sigmund Freud, whose presence on the American scene reached its peak at midcentury. While historians date the onset of Freud's influence on American psychotherapy to the early 1920s, the postwar era saw psychoanalysis's widespread penetration into popular consciousness, due to both Hollywood's fascination with its emotional dynamics and the advertising industry's fervent embrace of the unconscious as a means of manipulation.[17] American studies scholar Lawrence Samuel calls psychoanalysis "an almost standard part of the American experience" in the postwar era, describing its impact as "becoming more central to everyday life in America and familiar to a cross-section of the nation's population," largely serving the middle class but extended to working-class populations as well through a small number of low-cost and free psychoanalytic services.[18] Postwar cartoons in particular featured the psychoanalyst prominently—invariably with an Austrian accent as a nod to Freud himself. In UPA's filmography, a scheming wife hires Dr. I. Ego to diagnose her unicorn-spotting husband in *The Unicorn in the Garden,* while *The Jaywalker's* Milton Muffet visits the couch to break himself of his jaywalking addiction. Elsewhere in the modern cartoon, *Flebus* offers a vision of therapy in which both protagonist and antagonist are declared neurotic by a wonk-eyed psychoanalyst, poking fun at both the perceived loopiness of the psychoanalytic project and the seemingly ubiquitous neurosis of modern life.

Freud's own notion of condensation is seminal to understandings of both dreams and jokes, two areas of experience deeply embedded in the cartoon. But Freudian condensation is even more thoroughly entwined with animation and graphic design than this superficial sharing of terminology would suggest. Condensation, for Freud, is the first step in the dream's ultimate purpose: "transforming thoughts into visual images."[19] That is, as in animation and design, for Freud abstract concepts must be condensed before they can be seen and therefore known. The resonance of Freud's idea of dreams as a visual language—he refers to dream content as "a pictographic script" and compares dream-images appearing in sequence to letters forming a syllable—with those of modern design in general, and with Kepes's own work in par-

ticular, speaks to the relationship between these two conceptualizations of condensation at two different moments in history, and suggests the usefulness of bringing the former to bear on the latter.[20]

In contrast to Freud, who views condensation as part of the internal drama of the human psyche, Kepes finds the ultimate expression of his theoretical ideas outside the self, in advertising—so much so that he closes *Language of Vision* with an appeal to the possibilities inherent in the medium. "All these findings came to focus in the practical tasks of contemporary advertising art," he concludes. "It belonged to its very nature to be contemporary and forceful, and it could be so only through the use of the new dynamic visual idioms." Advertising posters "could train the eye, and thus the mind, with the necessary discipline of seeing beyond the surface of visible things, to recognize and enjoy values necessary for an integrated life."[21] If Kepes seems here to be more concerned with the outer world than Freud does, a short passage in *Print* magazine, excerpted from an essay in his 1956 anthology *The New Landscape in Art and Science,* suggests an almost Freudian interest in interiority when he says that modern painters "have established stations along the road to a new vision of the world around us. They are the optical specialists who enable us to become aware of what lies slumbering within us, can be awakened by us ourselves."[22] This unification of "the world around us" and "what lies slumbering within us," both reachable by a newly developed visual language and a new sensorium retrained to comprehend it, constructs a bridge between the inner and outer spaces of the unconscious and the external world. And if modernist painting had already established its way stations, for Kepes advertising and graphic design were responsible for finishing that roadwork.

This is not to say that graphic designers and animators were picking up Freud for ideological purposes or were interested in fashioning themselves as emissaries of Freudian ideas in their postwar moment; rather, Freudian theory acts here as a parallel discourse running alongside this rhetorical modernism's ideal of a universal visual language these two groups of artists sought. Various elements of Freud's contributions to psychology appear in the content of postwar cartoons—neurosis, repression, hysteria, the Oedipus complex, to name a few—but it is his notion of condensation that is both most generative and most underplayed. There are no cartoons *about* condensation; rather, the process of condensation determines the visual form of the cartoons of UPA and its fellow travelers, even though neither animators nor designers professed interest in Freudian condensation. The condensation

under discussion in Hubley and Schwartz's writings and in the pages of *Print* and *Graphis* is of a different order, independent yet inextricably linked. It is not merely that we can't think about condensation without thinking about Freud (though I would argue we can't); it is that Freud's notion of condensation, and his development of the concept as a major determinant of the dream as a form of visualization, can elucidate the ways in which condensation as a tool of visualization in graphic design and the modern cartoon does its work.

The concept of condensation originated in Freud's work on dreams in 1900. As Freud defines it, "The first achievement of the dream-work is condensation. By that we understand the fact that the manifest dream has a smaller content than the latent one, and is thus an abbreviated translation of it.... Condensation is brought about (1) by the total omission of certain latent elements, (2) by only a fragment of some complexes in the latent dream passing over into the manifest one and (3) by latent elements which have something in common being combined and fused into a single unity in the manifest dream."[23] The dream-work condenses dream thoughts both to save mental energy—it is much easier to represent one amalgam than two separate people, for instance—and to disguise the true identities or meanings of the objects represented in the dream, lest their meanings make their way to the surface and upset the conscious mind. Rather than let these meanings make themselves known, Freud suggests, "The dream-work puts these thoughts into another form, and it is a strange and incomprehensible fact that in making this translation (this rendering, as it were, into another script or language) these methods of merging or combining are brought into use."[24]

The relevance of dreams here is twofold. First, as Freud points out in "The Claims of Psycho-Analysis to Scientific Interest," "It is generally agreed that dream-interpretation is the foundation stone of psycho-analytic work and that its findings constitute the most important contribution made by psychoanalysis to psychology."[25] The insights into the processes of condensation and displacement would from here spiral outward into new understandings of jokes, hysterical episodes, nervous tics, and even such ordinary experiences as malapropisms—the famous Freudian slip—and forgetting.[26] In this way, the process of condensation underpinning all of these incidents is figured as one of the central elements in the work of the unconscious. Interestingly, Freud also argues in "Claims" that the dream-work "brings to our notice novel processes such as 'condensation' (of ideas) and 'displacement' (of psychical emphasis from one idea to another), processes which we have never come across at all in our waking life, or only as the basis of what are known as

'errors in thought.'"[27] Yet as we will see below, graphic design and animation are perhaps places where we can in fact come across this condensation in waking life, at least graphic design and animation as they were widely practiced in the postwar era, when Freud's ideas were reaching the American public on a mass scale.

And second, the sites of Freud's most in-depth work on condensation—dreams and jokes—place cartoons in a privileged position for observing midcentury modernism's condensation in action.[28] The bond between cartoons and humor is strong and well established, perhaps indelible; equally well developed is the association of animation with magic and fantasy.[29] Freud locates the dream and the joke at opposite ends of a spectrum of sociality: "A dream is a completely asocial mental product; it has nothing to communicate to anyone else.... A joke, on the other hand, is the most social of all the mental functions that aim at a yield of pleasure."[30] Dreams, as pure visualizations of repressed wishes, bypass language—indeed, bypass intelligibility—in their quest to turn irrational thoughts into sensory images, while jokes employ wordplay and linguistic tricks to amuse others. But cartoons, by visually staging humor in a pointedly fantastical, dreamlike space, occupy a middle ground between these two poles, seasoning the communal experience of commonly understood jokes with a dash of the irrational and bringing the irrational space of private fantasy out into the shared public space of the theater.[31] Cartoons offer the experience of sociality *through* the sensory experience of irrational images, drawing an animated line across Freud's conceptual gap.

Moreover, Freud's formulation begs the question, why is visualization asocial? Or rather, why does the asocial trade in visualization while the social uses words? For Freud, condensation, as part of the dream-work, serves to impede communication, to prevent the material of repressed thoughts from reaching consciousness in an intelligible manner.[32] Yet as we have seen, midcentury graphic designers and animators viewed condensation in a very different way, as a means to *enhance* communication and understanding, to make abstract ideas reach consciousness more intelligibly. Put simply, Freud did not account for a form of visual condensation that has a social, communicative function.[33] At midcentury, however, this is precisely the combination of attributes graphic design identified as its holy grail: the common thread running through Kepes's work, Moholy-Nagy's work, and the work of the graphic designers featured and published in the profession's leading trade journals is the pressing need for a social visualization, a way to visualize concepts and communicate them as widely and efficiently as possible.

These two opposing conceptions of condensation are not entirely at odds, though. As Freud observes, "In spite of all this ambiguity, it is fair to say that the productions of the dream-work, which, it must be remembered, *are not made with the intention of being understood,* present no greater difficulties to their translators than do the ancient hieroglyphic scripts to those who seek to read them."[34] That is, while condensation in the unconscious exists in part to thwart conscious understanding, the condensed concepts may still be understood—rather easily, Freud points out—if one knows how to speak the language of condensation. Lacking fluency in this language, he argues, the dreamer experiences dreams as "ingenious and amusing because the direct and easiest pathway to the expression of their thoughts is barred: they are forced into being so" by employing what he calls "the indirect method of representation."[35] A fluent analyst, on the other hand, is perfectly capable of unpacking the condensed message, tying the dream's visual representations back to their repressed referents in the memory. That is, psychoanalytical knowledge can "un-condense" condensed material, rendering it intelligible.

Animation and graphic design, however, have privileged access to this "direct and easiest pathway," engaging in representation that is not indirect but direct. As Hubley notes, in animation "our understanding of the process as a whole is experienced directly and immediately."[36] Strangely, though, this direct experience is achieved through what Hubley calls "compression" and later "condensation." In dreams the direct route is barred and in animation the direct route is finally opened; in each case, the culprit is condensation. How is this possible? One answer lies in *Language of Vision,* and in Kepes's belief that art and design could function as a form of democratic visual education, in effect teaching the masses the new language of vision by disseminating examples throughout art, architecture, design, and advertising—and, in UPA's case, cartoons. It is true that animation can show things "directly" in a way that is not possible in any other medium, but for midcentury modernist designers and animators, just as for Freud, that language had first to be taught. If Freud attempted to systematize the wilderness of the mental field, identifying the processes that made dream images unintelligible and offering strategies for analysts to decode them, Kepes did the same for the chaos of the visual field, systematizing elements of form and color and offering graphic designers and artists—and, it bears repeating, animators—strategies to use them more legibly in their own work so that spectators would eventually begin to adopt these same strategies in their daily lives. Lawrence Samuel's description of psychoanalysis's ultimate benefit, "its way of looking at the

world and ability to see the entire landscape," resonates with the expanded field of vision at the core of graphic design's mission to cultivate a new way of seeing, to retrain the eye to perceive the new spatial relations of the modern world.[37] Proper design principles would teach people to un-condense visual material just as psychoanalysis would teach its adherents how to un-condense dreams.

Another, better answer begins with Freud's above-quoted assertion that dreams "have nothing to communicate to anyone else" and that they are therefore fundamentally asocial. However, dreams still do communicate—in fact, they communicate desperately, though the channel of communication does not extend beyond the boundaries of the individual. As a furtive radio signal from a temporarily unguarded unconscious, the dream is warped by the interference of condensation and displacement, which seek to prevent the signal from reaching its destination intact. However, Freud's own analysis shows that these condensations aren't *lies*, and these "dream-distortions" do far more than merely cover up the truth; in fact, they create new ideas, forge links between seemingly disparate objects (think of the dense semiotic network traced between Dora's grandmother's pearl earrings, droplets of semen, and white flowers, or the composite figures who literalize commonalities between two different people),[38] and give visual form to abstract linkages, emotions, and anxieties. In essence, dreams communicate powerfully, and they offer a new way of seeing, concretely representing the connectedness of things and seeing through to the heart of truths that the conscious mind would rather not admit. In their condensation, Freud's dreams take an immense body of memory, history, familial tensions, repressed emotions, and unconscious associations and render them in compact, simplified visual form. Like graphic design, they employ condensation to visualize concepts that cannot be visualized by any other means.

What these two conceptions of condensation share, then, is the prospect of a powerful means of communication that is at odds with traditional representations of reality. Both visualize the invisible by first condensing material and then rendering it in visual form, but a visual form that looks strange, either in its narrative abstraction and lack of logic, as in dreams, or in its visual abstraction and lack of adherence to the appearance of the natural world, as in midcentury design. Writing about George Giusti, an Italian graphic designer and fellow émigré to the United States like Kepes and Moholy-Nagy, *Graphis*'s Georgine Oeri highlights the qualities that make him one of the period's paramount designers: "The ability to present realities and to simplify

forms down to an explicit minimum, backed by the will to a sensuous and almost obvious distinctness ... springs from the imaginative power—strengthened, it is true, by a Latin sense of form—for embodying the unseen. Giusti is taken up with the discovery of pictures for things that are not accessible to the normal visual powers of the human eye."[39] It is worth noting that this super-ocular vision is not merely Oeri's personal hobbyhorse; writing about microphotography a year earlier, designer Max Bill praised artist Hans Haffenrichter for "enabl[ing] us to visualise things that are otherwise inaccessible to the human eye,"[40] and in 1960 *Graphis* ran an article entitled "Beyond Human Vision," illustrating the centrality of this idea to the field.[41]

Picking up on these trends, Oeri singles out the ethos of the age: "The tendencies of artistic presentation in our own day could perhaps be summed up by saying that new media of expression are being created for human realities which are not primarily visual but have to be given picture-form for an age which is primarily attuned to visual experience."[42] Visual artist L. Fritz Gruber's 1949 article "Design for Music" specifically appeals to the longstanding question of visualizing music, expounding on modernism's unique ability "to give a body to the bodiless and abstract, to pin down a roving tune in two dimensions."[43] Tellingly, in this process, "words of description or explanation must respectfully retire."[44] This prescription, invoking written language only to banish it to the hinterlands of artistic expression, suggests an alternative, a new kind of language capable of mediating perception in Oeri's age of visual experience. UPA, implicated in this search for such a language through "Animation Learns a New Language," outspokenly carries forward this charge, as does Kepes in *Language of Vision*. For all of these disparate figures, condensation *is* visualization, whether it is Freud's condensation of multiple unconscious urges into one image, Gruber's condensation of ethereal music into two graphic dimensions, or Hubley's condensation of complex and invisible processes into simple geometric forms. To paraphrase Hubley and Schwartz, it is a particular type of visualization that breaks with representing what we *see* in order to represent what we *know*, in a compressed, abstracted form intended to capture essences and draw connections between them.[45]

In terms of technique, UPA's most lasting contribution to animation is its development of limited animation. By using fewer frames per second, repeating frames, and animating only parts of frames, the cash-strapped studio pushed the assembly-line practice of studio animation to its efficient extreme, inaugurating a style of cartoon that increased the spectator's share of the burden of creating perceptual movement. For all the artistic motivation

behind limited animation—the invocation of graphic design language, the engagement with the rhetoric of architecture, the cultivation of new forms of motion within the animated frame (see chapter 2)—it would be foolish to deny the budgetary constraints that gave these innovations their particular form. As Hubley himself admitted, "There's no substitute for full animation."[46] What this budgetary limitation of the animation process ultimately entails is condensation: a concentration of movement to one particular part of the frame, a compression of twenty-four frames' worth of motion into twelve, a reduction of the full range of a gesture and its bodily reverberations to only its most prominent movements. The tendency is toward economy, toward reusing, repurposing, and repeating.

For Freud, condensation serves the same purpose: it is at bottom a budgetary concern, designed to save not money but rather mental energy. He repeatedly describes condensation in terms of economy, a process that gathers the dream-thoughts and streamlines their contents, lowering the psychic cost of representation. "Although condensation makes dreams obscure," he observes, "it does not give one the impression of being an effect of the dream-censorship. It seems traceable rather to some mechanical or economic factor, but in any case the censorship profits by it."[47] Elsewhere he argues, "It is often possible in this way to achieve quite a remarkable amount of condensation in the content of a dream; I can save myself the need for giving a direct representation of very complicated circumstances relating to one person, if I can find another person to whom some of these circumstances apply equally."[48] This economy, directed toward the most efficient and cost-effective means of representation, reuses and repurposes components, building the dream out of the smallest amount of materials; it is the unconscious mind's attempt at limited animation. Moreover, as in animation, this budgetary restriction generates a unique aesthetic form, the bizarre and disorienting narrative, spatial, and temporal compressions that compose the "house style" of the dream. The dream and the limited-animation cartoon thus share a fundamental question in their production, one with deep ramifications for their final appearance: What is the cheapest way to produce this representation? What is the most economically efficient way to communicate this material visually?

Yet if condensation emerges from an economic impulse, its ultimate achievement is its communicative strength; if the unconscious is a cheapskate, it is also savvy in its frugality. As Freud notes, "The greatest intensity is shown by those elements of a dream on whose formation the greatest

amount of condensation has been expended."[49] In other words, when the dreaming mind seeks to get more bang for its buck, it is condensation that provides the bang. This is true of animation as well; limited animation, while aiming to be cheap and efficient, turns this efficiency into sheer communicative *power*, and this power is not an accidental byproduct, but rather the fruit of graphic design theory, which figures as its *raison d'être* the most widely powerful visual expression of a concept or an idea. Significantly, and as mentioned above, graphic design thinking locates this expression in a realm beyond vision, thereby making its task the devising of a new visual language to give form to something the senses cannot apprehend on their own.[50] Burtin and Lessing, discussing "the suppleness of graphic presentation in dealing with ideas" in a spread on astrophysics published in *Fortune,* phrase it thus: "A patch of sky is shown as it appears in the camera's naked eye, then as seen through filters, on special photographic plates, and with the aid of infra-red light, then as it would appear in its true colors without the limitations of human optics—demonstrating the extra-sensatory reality of science."[51] This "extra-sensatory reality," a reality that is not available to us without the intervention of graphic design, is communicated through the "new visual language" at the heart of midcentury modernist design principles. It shifts our common understanding of animation as a "fantasy space," encouraging us to consider what exactly is being fantasized. If cartoons are a space of imaginative possibility, where cats can become airplanes and Droopy the Dog can multiply and teleport at will, they are also a space of *perceptual* possibility, where the limits of vision can be tested and expanded, offering new visual experiences of space and movement, and new expressions of invisible knowledge condensed into visible forms.

This capacity of animation is particularly visible in contrast with live-action cinema. While live-action training and educational films were common during World War II, Burtin and Lessing address a potential drawback for the medium in their account of an Air Force training manual designed to teach recruits about the anatomy of their firearms. Signaling the need for efficiency, they remark: "Consequently, the message had to be direct and swiftly to the point. A movie was considered for this purpose, but tests proved that movies had poor memory value in terms of detail, even upon repeated showings." The solution was "a loose-leaf manual form ... retaining as much as possible of cinematic techniques" but allowing for an improved "almost cinematic flow."[52] The desire to harness cinema's capabilities is clearly displayed in this attempt to asymptotically approach cinema without actually employing it; the sticking

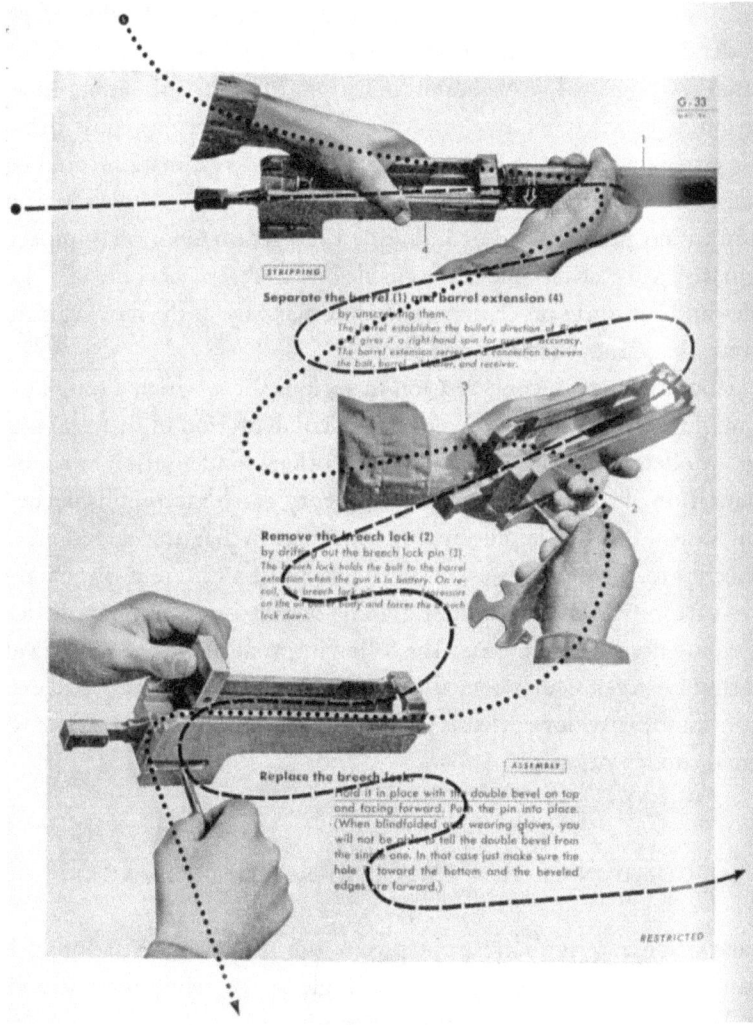

U.S. Army Air Force training manual (Will Burtin and Laurence Lessing).

point here seems to be an equally powerful desire to retain some elements of the diagram alongside those of film.[53] Burtin and Lessing are clear about what cinema contributes: story. The most effective design "must integrate all the elements of illustration, typography, photography, color, surface texture, ink, and printing itself in space, on paper, with the international logic of good prose."[54] By invoking prose, the authors hint at a narrative dimension that good graphic design should provide, and by specifying that it must be "on

paper," they rule out live-action cinema and its reality effect, which captures every detail of the profilmic environment and thus resists the condensation required for powerful visual communication. Modern animation, however, foregrounds its status as drawings on a flat surface even as those drawings unfold within a cinematic narrative. Done properly, animation could rescue audiences from the tedium of diagram-based training films, which "contained no humor, no personalized or intensified image, no emotional impact, no imaginative association of ideas to enable one to retain its content."[55] Just as Hubley and Schwartz proclaimed, the ideal marriage of the moving film and the static diagram is the animated cartoon.

Cartoons engage in condensation in various ways, which a rough taxonomy might classify into four major types: condensation of material into an image, condensation of images onto each other, condensation of time, and condensation of space. Each of these, in theory, can be accomplished by live-action cinema as well, but modern animation has developed its own approaches to these processes, orienting them in a different direction that carries cartoons into the realm of graphic design—moving graphic design, but graphic design nonetheless. The following analyses take Schwartz at his word that UPA's camera is not a film camera but a printing press, and explore the communicative power that is unleashed when this printing press engages in visual condensation.

CONDENSATION OF MATERIAL INTO IMAGES

Perhaps graphic design's most outspoken aim is the condensation of large amounts of intellectual material into a single image, rendering it in a visual language developed for maximum communicative efficiency. As Burtin and Lessing observe, "Whenever a mere recitation of facts is insufficient, too time-consuming or unclear to the reader, and an accented visual organization is imposed on them, design is the result."[56] This is condensation in its most basic sense of distilling a large body of knowledge into a simplified, easily apprehended form, and it is in line with Schwartz and Hubley's mission for UPA, whose animation style "occurred because of the need to present objective information in human terms."[57] In some cases these "human terms" are taken literally, as when abstract concepts are condensed and visualized in human form in animated cartoons. For example, in *The Brotherhood of Man*, one of the studio's earliest films, commissioned by the United Auto Workers

in 1945, the collection of suspicions, fears, and hostilities driving racism are given form as a translucent humanoid figure that lives within each flesh-and-blood person. In localizing these attitudes within a human figure, the cartoon simplifies the causes of racism itself, attributing them to an inner demon with a physical presence rather than to a complex web of cultural anxieties and historical inheritances, rendering it easier both to understand and to master. Likewise, the 1949 short *Big Tim,* a promotional film for the Timken roller bearing company, concretizes the concept of friction as a green gangster chewing on a cigar in order to illustrate the dangers of operating trains without proper equipment to eliminate resistance. Nowhere in the short is friction explained scientifically, nor are the workings of bearings themselves; rather, the sheer fact of visualizing friction as a character with a narrative function acts as a substitute for understanding, conveying only the most essential and minimal concept of friction's activity—narrated here as "Kid Friction's heavy hand lockin' up them old-style bearings."

This practice of personification as a form of visualization was widespread.[58] From the depiction of chlorophyll as a bright green chef in *Our Mr. Sun* (1956) to the personification of subatomic particles as cartoon soldiers marching in formation in *The Strange Case of the Cosmic Rays* (1957) (both part of the Bell Laboratory Science Series directed by Frank Capra and animated by UPA veteran Bill Hurtz), abstract concepts receive human form as a means of explanation. *The Strange Case* draws out interesting tensions in this practice of representation, highlighting animation's powers of visualization and communication. As gravitons are introduced as the first class of elementary particle-soldiers, the voice-over narration admits: "This graviton has never been pinned down or observed in any way." Next, the photons debut along with the statement, "Unlike the graviton, this photon has been measured and directly observed." Here, visualization is not merely a question of simplifying technical concepts for the layperson: even scientists cannot see the graviton, yet animation can render it as visible as the photon for both audiences, bridging the divide between visible (to science) and invisible through the power of animated condensation. Finally, the ranks of as-yet-unnamed pi mesons appear, shown not as human forms but rather as a series of question marks. It is only when they are named, as part of a spoken history of their discovery, that they transform into marching soldiers like the other two types of particle. Their discovery coincides with their cartoon visualization; knowing and seeing are figured as the same act, enabled solely through animation's properties of condensation.

The specific nature of midcentury design is more apparent in the practice of distilling complex, formless concepts into simple forms and shapes. Most famous in this respect is graphic designer Alvin Lustig, who is responsible for the abovementioned colorful, geometric cover designs of the New Directions paperbacks in the 1940s. In a *Graphis* profile of the designer, commentator C. F. O. Clarke describes his approach: "The task, as he conceived it, was to find a series of symbols that could rapidly summarize the spirit of each book and give it an appropriate visual form."[59] This spirit, as revealed in another profile in *Print* by New Directions founder James Laughlin, is not strictly related to the book's content, but rather to the "author's creative drive";[60] that is, Lustig's goal is to represent not the narrative, but something more fundamental and more diffuse. Burrowing down below the level of narrative, Lustig aims to represent the book's core, which encapsulates not only subject matter but also tone, style, and other elements of an intangible authorial essence. As Clarke puts it, "In all Lustig's jackets the approach is indirect, but through its sincerity and compression has more imaginative power than direct illustration could achieve."[61] The abstract labyrinth of *The Longest Journey*, the black-and-white expressionist stick figures of *A Streetcar Named Desire*, and the line-radiating amoebae of *The Flowers of Evil* are, through graphic design's powers of condensation and compression, *more* direct than direct representation could be, enabling the viewer to see through to the heart of things, to what lies beneath the bare content.

Compare this to animator Chuck Jones's *Now Hear This*, which employs graphic forms in an attempt to represent sound visually. Though released in 1962, the Warner Bros. short is the fruit of aesthetic exploration dating back to Jones's 1946 *Hollywood Quarterly* article "Music and the Animated Cartoon," in which he calls for a more sophisticated use of sound. Like Hubley and Schwartz, Jones frames his preferred developments as a matter of faithfulness to the unique capacities of animation, arguing: "I believe that a deeper understanding of the aesthetic and cultural possibilities of the medium can serve to broaden its usage and increase its popularity." Also like his UPA compatriots, his stakes are not low: the ramifications for animation's cultural and political "toddling stage" have been enhanced by wartime applications, but have a long way to go before cartoons can make "profound statements about anything."[62] Developing theories about appropriate cartoon sound, Jones devotes the most space and creativity to his section on "abstract or absolute" sound, in which he devises abstract visual analogs for sounds such as "tackety" and "goloomb" (harsh, jagged zigzags), and "oooooooooomp" and

"pooooooooooo-o-" (rounded, cloudlike shapes). Despite the cuteness of the sounds he chooses to illustrate, Jones positions these visualizations as the key to animation's "maturity," identifying the biggest threat to the medium as the underestimation of its capabilities.[63]

In 1962, then, Jones gets a chance to test out his 1946 theory through a dialogue-free narrative about a man who mistakenly begins using one of Satan's horns as an ear trumpet. Auditory hijinks ensue, and each disorienting, disruptive, or just plain dreadful sound is given abstract visual form through animation. In many ways, *Now Hear This* is a devilish resurrection of early modernist visual music experiments, Oskar Fischinger possessed by the spirit of Looney Tunes; it ventures into abstraction without entirely sacrificing plot and character (though the nameless character's plot is vanishingly thin, more of a conceit than a full-bodied story). The cartoon plays extensively with space, poking fun at convention by establishing spatial relationships with the barest of lines and repeatedly overturning them in a series of visual jokes, but the real fireworks are reserved for Jones's sonic experiments. A sharp, reverberating *boing* is visualized as a rapidly expanding, bright orange polygon; a car horn is a frenetically vibrating collection of sharply angled blue lines; a telephone's ring is a geometrically arranged series of flashing red circles; a heartbeat is a red diamond that flattens to a line between pulses. In perhaps the most lively sequence, the auditory chaos of a passing train is represented as an epileptic freakout, a graphic riot of color and shape that includes a receding red circle surrounded by short arcs, a yellow frame with jagged black lines, a white screen with radiating rectangular forms in bright green, and a rapidly advancing pink rectangle that overwhelms the frame and then leaves a different color in its wake when it recedes, repeating this movement to create a dizzying alternation of background colors. This method of visualizing the invisible enacts a form of condensation different from Lustig's, transmuting sound across sensory boundaries, congealing an ethereal, unseeable substance and rendering it bounded and located in space, like pulling a gas out of the atmosphere and condensing it to a liquid or solid state.[64]

Finally, animation condenses information into a smaller image by combining two separate ideas into one visualized thing. In the dream-work, Freud calls these visualizations "composite structures," the creation of which is "foremost among the characteristics which so often lend dreams a fantastic appearance, for it introduces into the content of the dreams elements which could never have been objects of actual perception."[65] For Freud, this is a

Now Hear This (Chuck Jones, 1962).

matter of both economy and censorship: condensing two real people or objects into one dream figure saves mental energy, and as a bonus it prevents the dreamer from understanding the true identity of the person or object being dreamed about. In animation, however, this form of condensation in which something is two things at once works in the opposite way, in favor of streamlined communication and direct presentation of abstract concepts. For example, when *Brotherhood of Man* presents a composite home, a half-and-half structure made of an American house and a Chinese house, and shows people passing from one side to the other, it is presenting, in a very simple way, animation's ability to condense two separate things into one image. This condensation allows them to function together and bear a new meaning to the spectator, here one of cultural unity in which national and ethnic differences are visually smoothed over and united.

This is a simple example, but the cartoon can perform more complex processes of condensation as well, one that enables the communication Hubley and Schwartz identify as animation's province. Again, this works both in unison and at odds with Freud's condensation, in which, as he notes, the unconscious looks for similarities between two elements in order to combine

The Strange Case of the Cosmic Rays (Frank Capra and Bill Hurtz, 1957).

them into a third, "compromise idea." He notes, "In the dream-content this third element represents both its components; and it is as a consequence of its originating in this way that it so frequently has various contradictory characteristics."[66] These contradictory elements, whether they are a screaming librarian's head shaped like a steam whistle in *Destination Earth* (1956) or Nelly Bly's intertwined arms containing properties of both arms and snakes in *Rooty Toot Toot* (1952), fuse two ideas into Freud's images "which could never have been objects of perception," fantastical representations that show us things we could not otherwise see.[67] They are, like Burtin and Lessing's abovementioned "extra-sensory reality" beyond "the limitations of human optics,"[68] something truer than a straightforward representation can offer, or at least something more transparently communicative, conveying an idea in their combination that is more immediate than the sums of their parts.

Wells is right to refer to "metaphor" as one of animation's medium-specific capabilities.[69] These examples are of course visual metaphors enabled by animation's distance from photographic representation. But they are more than that, or perhaps it is more precise to say that animation's specific deployment of the larger category of metaphor functions by way of visual condensation, in

a way that more closely resembles Freud's dream-condensation than any other process. In *The Strange Case of the Cosmic Rays,* cartoon atoms are flicked from the sun in a dramatization of cosmic rays bouncing off magnetic fields and striking Earth. As an illustration of physicist Enrico Fermi's metaphor of this phenomenon as a game of badminton, Hurtz's animation condenses two ideas, the magnetic field and the badminton player, into one figure. Groups of concentric freeform shapes with badminton rackets face each other light years apart, and we watch them bat top-hatted and caped atoms across the galaxy. It is difficult to think of an image more illustrative of Freud's "fantastic appearances" outside the realm of visual perception. Surprisingly, graphic design–oriented animation employs dream logic to do the very thing dream logic exists to prevent: efficient, clear communication of complex ideas.

CONDENSATION OF IMAGES ONTO EACH OTHER

Another form of condensation involves condensing images onto each other, not into one figure, person, or object, but into a "double exposure" image marked by superimposition and preserving the identities of both source elements. In *Vision in Motion,* Moholy-Nagy calls this mode of vision "simultaneous seeing by means of superimpositions."[70] Freud deals with this form of condensation as well; in fact, he groups it with other forms when he says that dream-thoughts "are compressed, condensed, superimposed on one another, and so on."[71] Yet superimposition remains a special case, one that signifies a failure of condensation to finish its job: "If the objects which are to be condensed into a single unity are much too incongruous ... the process of unification into a single image may be said to have failed. The two representations are superimposed and produce something in the nature of a contest between the two visual images."[72] In this condensation, the dream image reveals the similarities of the two representations in the places where they line up, while the irreconcilable differences show in the places of disjuncture where the two representations are visible on top of, or through, each other. Visible superimposition is thus incomplete condensation, an image that retains its rough edges and fails to be two things at once. In design, however, condensation by superimposition serves different ends, marking not a failure but a conscious aesthetic decision with a communicative purpose.

For instance, in the 1958 *Graphis* article "Visual Presentation—A Challenge to the Designer," commentator Stanley Roberts analyzes the

graphic work of Austrian-American designer Richard Erdoes. All of his images display the style of the modern cartoon, but one in particular stands out, a field of simplified house-shapes overlaid by what appear to be a series of black scribbles. The caption reads, "For a self-promotion slide film of McCann-Erickson Advertising Agency, depicting the rise and importance of their TV department."[73] The houses, made of colored paper and layered densely atop each other to give the scene an appearance of flatness, present the unified image of a town or neighborhood. The scribbles, in the context of the caption, are clearly television antennae; however, they do not attach to the homes in any uniform way. Though many emerge from rooflines, others seem to float over the scene, and the harsh, jagged, black scribbles of the antennae clash with the simple, clean lines and colors of the houses they purportedly serve. The ultimate effect is of superimposition, of two different images sandwiched together rather than one unified image. The meaning communicated by this superimposition is not "for every home, a television"—this would be signaled by a more "successful" (in Freud's terms) condensation of the two ideas: ordered buildings, each with its own antenna. Rather, the meaning communicated is the absolute interpenetration and interdependence of home and television, in which the town or neighborhood depicted exists within and is suffused by the media miasma of television waves—a vastly more profound cultural change than the mere presence of a TV set in each home. This specific concept is enabled by, and perhaps could only be represented by, condensation by way of superimposition. By the time of the 1962 roundup of graphic design in *Graphis*'s annual "Art Directors Club of Los Angeles" series, the importance of superimposition as a design tool had become clear. The introductory text identifies the logic of the selections as "display[ing] a professional capacity to communicate"; of the seven pieces reproduced in the opening spread, three were superimpositions.[74] This language of communication—extending human vision, revealing a truer world than the one available to human perception—permeated the design scene during and after World War II, and superimposition was one of the methods artists and designers used to achieve it.

Likewise, the Precisionist standard-bearer Charles Sheeler merged his semiabstract aesthetic with a new layering technique, replicating the photographic double exposure in his painting. In his work from the late 1940s and 1950s, Sheeler continues to paint urban space and machinery in his trademark nondescriptive color, but their superimposition onto each other carries out a vastly different project than Precisionism's search for structure and

order. In paintings such as *Manchester* (1949), *Counterpoint* (1949), *Windows* (1952), *New England Irrelevancies* (1953), and *Ore into Iron* (1953), two different images meet, projected onto each other without fusing into one single image; the result is a mind-boggling interplay of lines and shapes that art historian Mark Rawlinson calls "impossible spaces" and that offer an extrasensory perception at the threshold of a dream.[75] Many commentators frame this practice as a gesture of pure aesthetics and self-referentiality, "an art about art, in which the search for the beautiful—defined as timeless, nameless, still form—took precedence" or "a parodic play on the language of criticism."[76] However, in conjunction with developments in graphic design and their resonance with Freud's impossible conflations, this superimposition participates in the condensation of multiple views, and it also plays out in the territory of imagination and fantasy, animation's province.[77]

In animation, Hubley was also invested in Moholy-Nagy's "simultaneous seeing." In "Beyond Pigs and Bunnies" he argues, "The legacies of the multiple-vision cubist approach to heighten the reality of the environment are apparent and invaluable." This approach can allow animators to visualize "*non*visual, unseen aspects related to the environment" such as "air temperature, the molecular or atomic structures of surrounding objects; the processes of growth and decay, the influences of the ravages of past history." If cubism, known for its rigorous theoretical practice of condensing multiple images onto one picture plane, allowed for a fuller view of the object seen from many angles and perspectives, animation could import those representational insights into its own practice. Hubley calls for just such an adoption, urging, "We must push the monodimensional graphic limits of the drawn image into a time-space multi-leveled realization."[78] This, then, is what superimposition offers: not the streamlined condensation of two ideas into one seamless image, but the "multileveled realization" of representing two planes of time-space simultaneously.

We may find this process at work in UPA's Poe adaptation, *The Tell-Tale Heart*. Aside from a few shock-motivated smash cuts, transitions between shots are extended cross-fades, occasionally persisting for so long that they become superimposed scenes unto themselves. In one of the film's tenser moments, five separate shots linger over each other: three views of a ticking clock (a full-length shot, a close-up of the clock face, and an abstract view of the swinging pendulum); a long shot of the old man sitting in his room, his shadow nightmarishly lengthening; and a view of stairs elsewhere in the house. Fading in and out of each other, the film's various shots become floating images in the narrator's stream of mad consciousness, capturing the

The Tell-Tale Heart (Ted Parmelee, 1953).

peculiar time-space of the lunatic by supplanting linear reasoning with a jumbled, all-over visual logic in which boundaries are meaningless and discrete objects and places fall together into a paranoid conspiracy theory.[79] In keeping with the conceit of a madman's vision, *The Tell-Tale Heart* overlays views of the external world with the narrator's tormented inner visions: abstract networks of lines emerge from and multiply over a shot of the old man's tormenting eye, and when the steady drip of spilled water convinces the narrator that the old man's heart is still beating audibly under the floorboards, a visual representation of a falling water droplet is superimposed over a series of shots of the house and the policemen visiting it. This is a telling use of superimposition. If for Freud visible superimposition is the mark of incomplete condensation, then *The Tell-Tale Heart* employs excessive, baroque superimposition to express the further failure of one man's psychological mechanisms.

To be sure, this is a form of superimposition that is theoretically available to all kinds of filmmaking, and early modernist avant-garde cinema took advantage of double exposure in films such as Fernand Léger's *Ballet Mécanique* (1924) and Dziga Vertov's *Man with a Movie Camera* (1929), and

especially in French Impressionism. Hollywood cinema as well used elaborate superimposition in montage sequences designed to efficiently convey the passage of time. However, it is unlikely that *The Tell-Tale Heart*'s five-layer image would be legible in live-action, without the cartoon's recourse to visual simplification. UPA's house style and its condensational innovation here are inextricably intertwined.

Animation can achieve superimposition in another way, one that engages even further with Hubley's "time-space multileveled realization." Central to animation's communicative power is its capacity for metamorphosis. The language of change, and even more so of dynamism, suffuses midcentury design thought. Kepes's *Language of Vision* ultimately proposes a search for "a dynamic iconography," an approach to art that will "release and bring into social action the dynamic forces of visual imagery" within a world of constant change.[80] Moholy-Nagy's *Vision in Motion* defines planning for the postwar era as "the projective dynamics of our visionary faculties."[81] Georgine Oeri refers to "the seed of movement in the leap of the mind bridging two concepts" in a discussion of the stationary objects in display windows.[82] It is no accident that Hubley's example in "Beyond Pigs and Bunnies" is what it is—a cat running so fast that it metamorphoses into an airplane. Hubley's concern with dynamism extends back to his article with Schwartz, where they identify animation's special ability, which is to "represent, by means of the *dynamic* graphic symbol, the entire process, each stage or degree of development."[83] It is worth nothing that while the others quoted here are discussing still images and unmoving objects, Hubley and Schwartz are being literal: if midcentury design really wants to capture dynamism and change, midcentury design is going to have to move. Animation's movement, and its capacity to visualize change within its fantasy space, can link concepts in a purely visual way.

Unlike design, animation can employ metamorphosis to carry out superimposition *in time,* repairing Freud's "failed" condensation by engaging the cartoon form in a process of visible becoming. In metamorphosis, the connection of two ideas is no longer marred by "a contest between the two visual images"; rather, that contest becomes a relay race. For Freud, superimposition creates "a composite structure with a comparatively distinct nucleus, accompanied by a number of less distinct features."[84] These less distinct features, crowding the image and rendering it unfocused and visibly superimposed, nevertheless share the kernel of similarity (and clarity) that Freud identifies as a "nucleus." However, when one object metamorphoses into another in animation, these two different states that do not line up in the stationary

image become separated by time, yet are still unified by the nucleus of the object itself: the cat was first a cat, and then it was an airplane, but regardless of these two differences of physical state, it is still one thing, its identity preserved by the unifying thread that metamorphosis weaves through these two moments in time. The two images do not compete, but rather stand at either end of a process of change.

For Hubley and Schwartz, this process of change is precisely what animation contributes to the enterprise of communication. "The dynamics of changing symbols," they argue, "—ballots turning into guns, books to poison, plowshares to swords, children changing to soldiers, soldiers to graves— can carry a visual potency as clear as the growth of a seed into a plant. Our understanding of the process as a whole is experienced directly and immediately."[85] If graphic design can condense two separate ideas into one image, thereby highlighting a similarity between the two, animation can give that condensation a direction, a sense of causality: not two things that are similar, but one thing taking on the characteristics of another thing, even if only for a moment. Animation can provide a narrative dimension, Burtin and Lessing's "logic of good prose," experienced in time as prose is also experienced. As Hubley and Schwartz put it, "One person is being protected by another, and for a moment the protector animates up into a proud knight and charger... and then the whole image animates down again into its original form."[86] This is a revelation that occurs in the time-space dimension Hubley theorizes, within the spatial boundaries of the frame and its depicted world, but also across the time of the moving image.

In John Sutherland's petroleum-industry promotional film *Destination Earth*, as the narrator explains that refineries produce the oil used for lubricating machines, a haphazard collection of oil and grease containers fills the screen. As the voice-over declares that these oils and greases "keep the wheels turning in America," the containers rotate away from the front of the frame to reveal their undersides, which metamorphose into simple circles. Bands appear between them, and some of the circles become spinning gears, transforming the previous image into the inner workings of a machine. Delving further into the scientific literature, the narrator explains that this oil "is made up of billions of tiny molecules," and concurrently the gears transform into brightly colored circles, the revolving bands reducing to straight black lines—and suddenly we are looking at a diagram of a molecule. The voice-over commentary is almost redundant: we have seen the containers become the gears of a machine, and the gears become molecules. This is a visual

language, functioning by chains of association and visual logic, and unfolding in time as one image changes into another. The circles, remaining in the same place, form Freud's nuclei, the parts of the image that are successfully condensed and therefore maintain clarity in the combination of the three images. However, by drawing out these images in time rather than condensing them upon each other within one moment, animation ensures that the differences between them do not compete, but instead are allowed to transition visually, forming a thoroughly communicative image informed by ideas of causality and change.

In 1961, Saul Bass dramatized animation's function as a visual language, employing this kind of superimposition to showcase the communicative power and versatility of the medium. His opening titles to the late-night talk show *P.M. East* begin with a setting sun; as the screen fades to black, small white squares wink into existence throughout the bottom half of the screen. As these abstract shapes congregate in clusters, it becomes apparent that they are forming a semiabstract representation of an urban skyline. Gradually, the white squares overtake the entire screen, filling it entirely to form a white-on-black grid, after which random squares revert to blackness one by one. In another gradual transformation, the remaining white squares reveal the letters of the show's title, signaling the end of the opening sequence. Here, the theoretical process described above—abstract form harnessed by graphic design and animation to become a unique visual language—is allegorized in the content of the images. Abstract forms (white squares) become a graphic image (a skyline), and that graphic image then becomes language (the words of the title). The white squares constitute the thread that connects each iteration of the image, the nucleus that persists as one configuration supplants another over time. Laid atop each other, these separate configurations would be illegible, their parts in contest with each other; given movement by animation, they metamorphose seamlessly, communicating not only the thematic material of the show, but also the power of animation as a visual language.

CONDENSATION OF TIME WITHIN THE IMAGE

Condensation is active on another register as well, one that condenses not information or images, but time. In relating the story of a dreamer who dreamed an entire scenario about being beheaded during the French Revolution in the time it took for a real board to fall on his real neck, Freud

addresses the question "whether and how it was possible for a dreamer to compress such an apparently superabundant quantity of material into the short period elapsing between his perceiving the rousing stimulus and his waking."[87] The condensation, or compression, here is not strictly speaking visual; it is not the direct translation of ideational content into visual form. However, its effects on the temporal properties of image and story are important for thinking about design's and animation's own approaches to condensing time. In the dream, Freud argues, "the dream-work possesses the advantage of accelerating our thought-processes to a remarkable degree."[88] A closer look at some leading design and cartoon experiments of the postwar era shows a similar investment in acceleration, compressing story time into smaller and smaller frames, and in ways that are only possible through the innovations in visual language being developed by designers and animators alike.

A particularly notable experiment in cartoon time took place in 1952, in Irving Reis's *The Four Poster*, a live-action marital drama featuring animated interstitial sequences by UPA. To be sure, the combination of live-action and animation was not new to the cinema,[89] but *The Four Poster* employed the visual language of the modern cartoon in a way that challenges notions of film temporality. In eight distinct live-action scenes, the 103-minute film dramatizes eight moments in the marriage of its two protagonists, John and Abby, covering over forty years between their wedding and their deaths, from 1890 to the 1930s. Between each of these live-action scenes, a short animated sequence directed by John Hubley provides connective tissue, linking one live-action moment to the next within the film's chronology. These interstitial segments cover large expanses of narrative time, enabling the unitary, self-contained live-action scenes to function as interrelated moments despite the intervening years of offscreen time—in each of these scenes the characters are visibly older than in the previous one, the actors sporting makeup and graying hair to carry them from early adulthood to old age. In entrusting these vast expanses of time to Hubley and his animators, Reis offered UPA an opportunity to merge the field of animated cartooning with that of graphic design within the context of a mainstream Hollywood film, and to test animation's unique capacity to condense time.

UPA artists' experimental aims, tied with their interest in mass communication and in revising the form of the Hollywood cartoon, find in *The Four Poster* an ideal venue for pushing the limits of animation's possibilities. The film's episodic structure sets a compelling challenge for the animated segments: if each relatively lengthy live-action scene covers a single moment in

its protagonists' lives, with no narrative ellipsis, then each animated scene, though markedly shorter, must cover vast swaths of time, carrying the spectator along the narrative stream in which the live-action scenes are isolated islands. Not that this challenge had never faced filmmakers before; live-action films had already developed montage sequences to represent passing time, and animation had long since perfected, say, the dotted-line-on-a-map approach to compressing space and travel time. But UPA's approach does not partake in either of these preexisting solutions. Instead, Hubley's scenes in *The Four Poster* attempt to harness the insights of graphic design to condense large amounts of narrative information into simple visual forms, and to communicate a new visual experience of time and space. The extreme contrast between the live action and the animation renders UPA's innovations all the more noticeable. The live-action scenes, focusing so intently on the real-time unfolding of eight pivotal moments, engage in narrative at the micro level, while the animated scenes romp through the wide-open fields of macronarrative, and Hubley takes advantage of this freedom to indulge his allegiance to the cartoon as graphic design.

For its part, graphic design was also looking for ways to condense time in its images. In 1950, the Container Corporation—an organization at the forefront of design innovation at midcentury thanks largely to the efforts of its CEO (and key patron of Moholy-Nagy's New Bauhaus), Walter Paepcke—published a piece in *Graphis* outlining its design philosophy.[90] Entitled "Good Design—An Important Function of Management," the article also includes examples of the Container Corporation's best work, specifically the work of Egbert Jacobson, the company's art director. One of the images, a mural in the conference room at Chicago's Lake Shore Mill painted by Katherine O'Brien, is described as "a symbolic expression of the work of the mill," and tellingly, it employs the same semiabstract and clean-lined, simplified forms of the modern cartoon.[91] In it, all steps of the mill's process are depicted as occurring simultaneously. A suited figure with a clock for a head even occupies pride of place at the top center of the mural to signify the importance of well-managed time to the operations painted below. The entire piece has the feel of a diagram, with flowing lines and color fields connecting different stages of the process, all the while masquerading as factory material, such as pipes and conveyor belts. This simplified form, in which realistic representation gives way to simple, sharply drawn form, enables a clear view of a meticulously scheduled, multistep operation in one single image, condensing numerous activities precisely located in time into a mural that flat-

Mural at the Container Corporation's Lake Shore Mill in Chicago. © WestRock Company.

tens these different moments through condensation. A circle motif repeats across the mural, unifying the various positions in the manufacturing chain and bringing each separate moment into a coherently designed "now" of the perceived image. Through design, the Container Corporation mural condenses the time of its operations, and this "good design," billed as "an important function of management," suggests the managerial power of modern graphics to render all parts of a complex process visible at once, easily overseen and easily directed.

Equally, if not more, at the forefront of design innovation at midcentury is Saul Bass, the Hollywood-aligned artist who famously "described himself as 'visual communicator' rather than graphic designer."[92] While perhaps most famous for his film titles (more on those in a moment) and his corporate identity design, his work in film posters is also relevant to a discussion of condensation as visual communication in graphic design. Commentary on Bass invariably pinpoints his powers of distillation, as in design historian Jeremy Aynsley's assessment, "His skill was in finding elegant, robust and immediate symbols, often distinctive pictographs, which distilled complex meaning."[93] Likewise, media scholar Georg Stanitzek refers to the ways in which Bass "found ways to symbolically represent each film, respectively, as a concise sign, almost a logo itself."[94] And it is true that this talent for visual condensation and concision both defines Bass's film work and extends beyond it to his work designing logos for major corporations in the 1950s and 1960s. However, in his 1953 article "Film Advertising," Bass himself describes it in terms both more specific and more revealing: "Here he [the film designer] deals with the unique problem of projecting the quality of a basically visual communication in one form (the film), into a visual communication in

another form (the advertisement). One of the more interesting facets of this transformation involves the condensation of the time of perusal from that of hours, on the one hand, to seconds, on the other."[95] A film poster must contain the entire film in its own text, compressing the time span of the entire narrative into one image that can be visually apprehended instantly. Whether the crooked, blocklike arm of *The Man with the Golden Arm* (1955) or the dismembered human body of *Anatomy of a Murder* (1959), Bass's film "logos"—which circulated not merely as posters but also as advertising images, lobby cards, and letterheads, among other industrial uses—functioned as a *temporal* condensation, shortening the experience of the film for those who looked at the designs.

Bass designed for animation as well, and is perhaps best known for his credits sequences for major Hollywood live-action films. In *Graphis,* designer and typographer Raymond Gid refers to Bass's work as "integrated with cinematographic vision," and he specifically points out the fact that "generous use is made of the picture's third dimension, which is time."[96] Bass's engagement with time is most visible in his animation work; it is one thing to see a film poster that condenses the time of the film to a mere second by the use of visual metaphor, but another entirely to tell a narrative in miniature, condensing not just the themes or the concept of the film, but its events as they unfold in time. It is precisely this that Bass accomplishes in his closing titles for *Around the World in 80 Days* (1956), referred to in his in-house title description as "a condensed recapitulation, in animated form, of the preceding three hours of film."[97]

Most interesting about Bass's approach to this temporal condensation is that his research for the *Around the World* sequence consisted of locating advertising images of products from the mid-1800s. His files for the film contain pictures of umbrellas, shoes, and gadgets in woodcut style, which he used as inspiration for the closing titles.[98] That is, in designing his condensed rendition of the film's narrative, he drew not from photographs but from already simplified representations of them, designed from the outset to communicate efficiently to the wider public as advertisements. As with the Container Corporation's mural, condensation of time is enabled by simplified, condensed forms. And yet movement here is key to Bass's innovation. In his writings about *The Man with the Golden Arm,* he credits his work in animation on the simple premise of movement: "And my work on film began here. At one point, having created the symbol, Otto [Preminger] and I looked at each other and said: 'Why not put it at the head of the film and make it move?' And zaaap!!! I was launched on my parallel career as a filmmaker!"[99]

This focus on movement and animation is neither arbitrary nor a lark. In the program for *The Searching Eye,* a cinematic treatise on vision and creativity produced for the 1964 World's Fair, Bass writes, "Their chosen subject, as the title suggests, was the 'art of seeing' in the broadest definition of 'seeing'—observation, perception, and animation."[100] Animation *is a kind of seeing,* a direct descendant of Moholy-Nagy's vision in motion. In fact, as a student at Moholy-Nagy's Institute of Design, Bass worked closely with Kepes, and the two designers' influence is clear in the notes for Bass's 1968 film *Why Man Creates,* also about creativity across human history. On an early draft of the film's script, a section entitled "CREATIVE IDEAS" is supplemented by Bass's own handwritten notes, which read, "Creative *vision.* New *vision.*"[101] Here Bass clarifies his use of the term *vision,* which extends beyond the generic use of the term in creative discourse as an artist's preoccupation or method; more importantly, it one-ups Moholy-Nagy's and Kepes's interest in dynamism and movement, describing animation as a fundamental component of seeing itself, of equal stature with observation and perception.

The Four Poster uses its animation to achieve a similar condensation of time, though it aims for a broader reach. For instance, in one interstitial sequence, Hubley takes one minute of remarkably abstract animation to deal with the entirety of World War I. Dialing up animation's powers of metonymy, he uses the shapes of military helmets bouncing across the screen to represent armies, abstract starburst shapes to signify explosions, and, in perhaps his most abstract gesture in this scene, horizontal lines to connote gunfire. This condensation distills large, complex events into simple shapes that bear their meaning in their geometric form. With no human figures onscreen and no recognizable location or event, we understand that World War I has happened and John and Abby's son has been killed. Hubley and Schwartz stake this particular territory for animation in contrast to photography—or, one assumes, live-action cinema. For them, the photographic image "represents a *specific* aspect of reality in very real terms"; they use the example of a photograph of a man being executed by a fascist government, the specificity of which enables us to intellectually grasp the abstraction of fascism. Conversely, "with animation, this process is reversed. Instead of an implied understanding resulting from the vicarious experience of a specific situation, animation represents the *general* idea directly. The audience experiences an understanding of the whole situation."[102] This contrast, according to which photography can merely render an aspect of something while animation is capable of representing a conceptual whole, hinges on a condensation of time:

not only is the general experience of war represented through condensed images, but also the historical experience of World War I is condensed into one single minute, sandwiched between two live-action scenes that present more specific, bounded, real-time episodes.

However, animation's capacity to manipulate time runs deeper than this. All kinds of filmmaking have developed ways to condense time. As Burtin argues, "In motion pictures, time can be condensed (one year = one minute) or stretched (one second = one hour), and the visual image (space) can develop from realism to illusions of astonishing depth and dexterity."[103] Live-action cinema uses slow frame rates to create fast motion during projection, and montage sequences denoting the passing of time through overlapping shots and dissolves had been in use for decades before *The Four Poster*. But animation accomplishes the passage of condensed time differently, by enabling large amounts of time to pass in squashed real time, so to speak. Rather than manipulating the image through speed changes or editing—techniques that work upon the filmstrip either in production or postproduction—animation can render large swaths of time in the profilmic image. *The Four Poster* offers an example of this kind of animated temporality in one of its interstitial scenes, in which the camera zooms out of the apartment window of the live-action couple, presents a cartoon sequence, and then zooms back into the window for another live-action scene.

In this interstitial scene, narrative time is subject to multiple forms of visual condensation. Rather than employing montage to signal passing time, Hubley and his animators opt for a simple pan, parlaying animation's knack for metamorphosis into a remarkable temporal compression. Gliding rightward from our protagonist couple's window, we see buildings appear in chunks, rising in new formations around a series of traditional, preexisting buildings. Notably, we watch two steel-frame structures assemble themselves, marking the passage into a new phase of architectural history when steel internal skeletons replaced load-bearing stone and brick walls in urban construction practice. After this signaling of not just the passage of time but also an architectural changing of the guard, we see a bridge stretch into existence, and again, the animated narrative compresses a large span of time, expressing not just the movement of vehicles across the bridge but also the transition of technological generations. Led by a bicycle, a horse-drawn carriage metamorphoses into an early automobile, and the automobile behind it streamlines itself into a sleeker, less boxy convertible. Suddenly the bridge is swarming with cars, and we understand that we are now in the automobile age. In one twenty-second

The Four Poster (Irving Reis, 1952), animated interstitials by John Hubley.

shot we observe the end of an era and the beginning of a new one. Hubley caps off this temporal experimentation with a winking admission of his game: as the camera pans leftward back to the window, it becomes nighttime, a playful gesture that condenses two impossible narrative time frames onto each other: years of technological and architectural expansion on one hand, and a single day on the other. As with Bass's posters, the viewer's moment of perception is an encounter with a radically condensed narrative time.

This pan maneuver might seem idiosyncratic, a quirk of *The Four Poster* rather than a genuine development in animated time. Yet the technique appears across animation of the postwar period, the pan—or rather, the illusion of a pan simulated by the cartoonist's drawings—capturing temporal progression as it moves across the cartoon world. In Gene Deitch's *Wings for Roger Windsock* (1947), produced for the Jam Handy Organization, a rightward pan follows an airplane across the sky as it transforms from an early biplane through the various stages of technological development, ending at the contemporary jet aircraft. Later in the film, a single pan provides an aerial view across a minimalist landscape as oil derricks wink into existence, a metropolis materializes, and industrial architecture spreads across the terrain, all within

the space of a single shot. Similarly, in John Sutherland's U.S. Steel–produced *Rhapsody of Steel* (1959), a leftward pan follows a car driving through empty space, continuing its movement as the car is swallowed up by rapidly proliferating office buildings and skyscrapers, offering a visual testament to the transformative power of steel. This shot condenses the temporality of a moving car and that of industrial urbanization into one frame, presenting the impossibly rapid passage of time while preserving the real-time illusion of the single, uninterrupted take moving at a normal, undoctored speed. Even Disney got into the game, his 1952 film *The Little House* dramatizing architectural expansion as houses pop up in a slow-moving panning shot. These instances of the representation of passing time trouble the promise of cinema's uninterrupted take, that it preserves temporality within its borders. Animation's ability to condense time within a single shot offers a new experience of time, one enabled by condensation and compression.

This new experience provides a new configuration of space and time, perhaps analogous to Hubley's call for "a time-space multileveled realization."[104] The passage through space becomes an indicator of passing time—not only the passing time of the camera, but the accelerated, condensed time of the image as well. In Freud, time is spatialized. In "Revision of the Theory of Dreams," he observes: "In general, indeed, where it is possible, the dream-work changes temporal relations into spatial ones and represents them as such." For example, "Dreams represent the relation of frequency by a multiplication of similar things."[105] Seeing five representations of one's father in a room together, for instance, thus signifies that the paternal event being dreamed about happened five times. This spatialization of time, in which a temporal or historical process is expressed as a matter of spatial configuration, is likewise evident in the above cartoons, though in a different form: if in dreams frequency is given form as multiplication (or, as Freud also argues, remoteness in time is signaled by a figure witnessed from far away), in these simulated panning shots, historical progression is represented as movement. Time becomes spatialized, expressed through directly visible relations enabled by animation.[106]

The Four Poster is thus not alone in this form of temporal experimentation, though it does foreground it by virtue of its format. By exercising maximum contrast with the intimate, real-time live-action scenes, Hubley positions the animated interstitial scenes as representations of history, reaching out to refer to large cultural and historical shifts and events by way of abstraction and condensation. Like Hubley's example of the execution photograph, *The Four Poster*'s live-action scenes record aspects of life—fragments of a

couple's life together, conversations they are having at a specific time in a specific place. Meanwhile, the animation enables the spectator to witness the invisible processes of historical change, processes that the film camera cannot capture because they are too large, too wide-ranging, taking too long to unfold and expanding too far to be taken in by a single photographic view. To return to Hubley and Schwartz's article, in animation, "Processes we know we can now see."[107]

CONDENSATION OF SPACE AND SCALE

Freud's insight that dream logic turns time into space escaped the realm of psychology and entered the lexicon of graphic design at midcentury. In "Beyond Human Vision," scientist and futurologist Herbert W. Franke discusses the challenge of visualizing the invisible, especially the microscopic. He notes, "Often enough we are not dealing with spatial projections at all, but with quite different elements which we have to translate into terms of space—such as times or frequencies. . . . The result is always a visual structure, a picture in a new and wider sense."[108] These "new and wider" pictures were of keen interest to designers in the postwar period, thanks to new scientific discoveries about the nature of the world around us, particularly the discovery of the atom—an invisible world lying just beneath our own, waiting to be visualized for the public to bring them up to speed on the true nature of the universe.

Burtin and Lessing lay out the challenge facing graphic designers after the war; for them, science had adopted and adapted to new methods of understanding space, and was busily making new discoveries about it. The arts, meanwhile, "have not kept pace with the revolutionary concepts and abstractions of the new physics." The artist's new task, in keeping with this new physics, is no easy feat, consisting as it does of "bringing into human consciousness the new realities of relativistic physics, atomic structure, and their interrelations in such phenomena as cosmic radiation, atomic reactions, genetics and the like." The result was to be "a greatly extended visual consciousness."[109] For Burtin and Lessing (as for the modernist architects of the period), the new language of vision was deeply embedded in matters of space, and it was to take its cues from science.

Ten years later, by the time of the 1958 Aspen Design Conference, this interest was so widespread that the editors of *Print* declared, in their roundup of the conference proceedings, "*Expansion* was a recurrent theme at the

conference. Some designers, taking their cue from trends in dwelling patterns, feel that this expanding space is an important factor to be considered in two-dimensional representations."[110] E. A. Gutkind's above-cited discussion of "the new feeling of space which has not yet been condensed into a clearly definable idea of space is everywhere at work" placed emphasis on design's current "widening out, a new awareness of spatial relations, an urge to emerge from a stale isolation."[111] Notably, multimedium artist Claire Falkenstein connected this new feeling of space to, well, space: "Miss Falkenstein links our increasing awareness of astronomical space with the graphic dimension," remarking, rather poetically, "'A void, aggressive and frightening, expands into the universe.'"[112] The editors conclude their assessment of the graphic design profession by observing dryly, "Graphic artists had their work cut out for them at the conference: increasing responsibilities in this world and spatial awareness of the universe falls to their lot—a considerable lot."[113]

Animation as well was interested in teasing out these new spatial notions—recall Bill Hurtz's search for novel ways of suggesting space in *Gerald McBoing Boing*, creating a "vast hall" out of a few lines and a color field, or Bobe Cannon's famous decision to have characters "dissolve" from one side of the frame to another as a new method of movement through space[114]—and it is safe to say that many animators working in the modern style would have agreed with *Print*'s assertion of expanding space's importance to two-dimensional representations. And science as well seems to have resonated with animated filmmakers of the period. Frank Capra's *Our Mr. Sun* and *The Strange Case of the Cosmic Rays* explored the vast reaches of outer space and *The Unchained Goddess* (1958) covered weather systems, while his *Hemo the Magnificent* (1957) illustrated the likewise foreign land of the human circulatory system. At Disney, *Our Friend the Atom* (1957) explained atomic physics, while John Sutherland Studios' *A is for Atom* (1953) delved into the details of nuclear energy and the periodic table. Animation, it seems, proved itself a good fit for visual representations of abstract scientific theories and invisible natural, physical, and biological forces. Most importantly, animation proved itself adept at "condensing" space, both in Burtin's sense of the term, rendering new spatial ideas understandable in simple visual terms, and in Freud's sense of compressing large amounts of space into the smaller space of the frame and superimposing different views of space into one image.

One way modern animation deals with space is fairly straightforward: in UPA's *Brotherhood of Man,* the protagonist imagines the world of the future, which the voice-over tells us is "steadily shrinking." The cartoon presents the

top half of a globe, and we watch North and South America drift eastward while Europe and Africa approach from the other side of the frame. This is direct, literal condensation of space, the world visibly shrinking before our eyes, enabled by animation's metamorphic capabilities. But there are more interesting and complex methods of spatial condensation at work in midcentury animation, extending the insights of Cubism to engage in a more radical play with space and its representation. Hubley, as noted above, declared his allegiance to Cubism in "Beyond Pigs and Bunnies," evincing an interest not merely in its look, but in its theoretical insights as well. He extols "the multiple-vision cubist approach" as a way of showing different sides of an object.[115] Hubley is particularly interested in representing the interior and exterior of a figure, its physical appearance as well as the invisible processes going on inside. However, in modern cartoons we may find another extension of Cubist thought: if Cubism's innovations rest on the condensation of different perspectives, different sides of the object onto a single, two-dimensional picture plane, animation engages in a sort of Cubism-plus—not just different angles of view, but different distances as well, different spatial scales condensed into one image.

In Creative Arts Studio's *The Spy from Mars!* (1958), for instance, a car drives into a bottle of booze, sloshes around until it's good and soused, and then shoots out like a cork, ready to jeopardize the lives of other drivers on the road. In Transfilm's *Energetically Yours* (1957), a boat surfs on the jet of water emerging from a whale's blowhole; the camera first pans up until the whale is no longer in the frame, and then pans back down, where we see that the jet of water is now a jet of oil spurting out of an oil derrick. And in *A Is for Atom*, the activities of atomic particles are presented to us in the form of a small man in a suit with a top hat perched atop a nucleus and its orbiting electrons. These examples might be written off as mere sight gags, cute jokes owing their existence to animation's fantasy space, but they are also lighthearted versions of a practice that often reaches for more profound transformations of space and more intriguing condensations of spatial scale.

Often these transformations involve maps and other simplified representations of space. John Sutherland's *It's Everybody's Business* (1954), in dramatizing the British colonists' departure from England and arrival in America, seamlessly transitions from a map of the Atlantic Ocean to a more naturalistic (though by no means actually naturalistic) rendition of a storm at sea, then back to a map. Although the British coastline is represented at a reasonable (cartoon-reasonable) scale, populated as it is with citizens and their homes,

the storm segment of the scene dwarfs the boat by placing it among one giant, thickly outlined cloud and a personified sun that is bigger than the boat itself, which floats on a white scribble of waves over a dark blue color field; conversely, as the ship emerges from the storm and the American continent slides into view, the background reveals itself as all map. North and South America are tiny, each continent not much bigger than the boat headed toward its shores. This transformation, from ordinary space, to dreadful expansion at the mercy of the elements, and finally to serenely ordered and manageably compressed cartography, visually expresses the colonial project of leaving a familiar home and braving the wild seas in order to master a land that is only known in the abstract. These shifting relations of human mastery over the globe, and over nature, are rendered visible precisely through these manipulations of scale, and their condensation into a single, surreal passage across the Atlantic unifies these aspects of the British/American experience.

In print, graphic designers found expressive power in this play with scale as well. Perhaps the most famous of the practitioners of this spatial experimentation—besides Moholy-Nagy and his 1920s photomontages—is Herbert Bayer, who worked with industrial giants such as the Container Corporation and General Electric to provide visualizations of these companies' concerns to the public. In an article about his work, Sigfried Giedion discussed Bayer's engagement with "the changes in the relations of the continents brought by the shrinkage of distances in our era," noting that in one particular exhibition for the Museum of Modern Art, "Bayer could work to his heart's content with cosmic dimensions, spheres in space, cords to represent connections, and with the magic of maps."[116] That these issues would make Bayer's heart content is clear across the breadth of his work, which is perhaps most striking for its persistent condensation of vastly different spatial scales into his advertising images.

His booklet "Electronics—A New Science for a New World," produced for General Electric in 1942, is particularly forceful in this regard. On the cover, two hands grip what appears to be a giant spark plug studded with miniature Earths, holding it up to the sky where atoms circulate like stars. Condensing these extreme spatial scales—the human, the microscopic, and the planetary—into one photomontage, Bayer poignantly and powerfully visualizes humankind's position in the universe during the heady days of World War II. Planets and atoms cohabitating in the sky is a common motif running throughout the booklet. Conversely, a singular and surprising image is the one entitled "This Electronic World," which features a baby sitting on

a curved surface (the crust of a tiny Earth?), looking out into the universe, where a galaxy, an atom, a butterfly, and a starfish float around his head, all the same size. On the ground next to him are three roses, a fern, an unidentifiable piece of machinery, and a pair of geometric diagrams, again roughly the same size. The democratization and equalization of so many different fields—the microscopic and the macroscopic, the planetary and the galactic, the underwater and the astronomical, the natural and the mechanical, the visible and the invisible—is accomplished by collapsing their vast spatial differences into one uniform plane, making them the same size and placing them in the same image. The effect is to celebrate the possibilities unleashed by an age of scientific discoveries, a conviction that everything once unknown is now not only at our fingertips, but equally knowable, equally visible, and equally close to our grasp.

Likewise, in 1955 Erik Nitsche designed a series of posters for General Dynamics entitled *Atoms for Peace,* intended to convey the company's work at the first International Atomic Energy Conference. As design critic Suzanne Barrey notes, "General Dynamics' problem however was singular: as builders of the first atomic submarine . . . security measures allowed little to be shown. In the absence of actual atomic products therefore, a symbolic expression of General Dynamics' corporate mission was needed."[117] The ostensible content of the posters—what the company does—had to remain invisible. Nitsche's solution to communicate the incommunicable is, again, the condensation of space, and of spatial scales, into single images. A submarine shoots out of a nautilus shell with a globe at the center of its spiral; a wind flow chart is superimposed over an Erlenmeyer flask containing a functioning weather system; a globe, broken up into pieces, is overlaid with the travel paths of an airplane and a submarine. In each of these posters, vast differences of space are obliterated by the condensational power of the image, conveying not the nuts and bolts of what General Dynamics does, but rather the conceptual mechanics of what it does.

A Is for Atom condenses space with a similar grandiosity, superimposing the atomic and the planetary and, more interestingly, varying the spatial dimensions of the human alongside these other scales. In perhaps one of the most bafflingly disturbing introductions in cinematic history, a massive human figure, the "answer to a dream as old as Man himself, a giant of limitless power at Man's command," emerges from a mushroom cloud and grows in size until he towers over the globe. The personification of atomic power, this behemoth is the humanoid representative of the atom, which is to be the subject of the

rest of the film. In explaining the origin of all things in the humble atom, *A Is for Atom* presents everyday objects of all sizes—"ships and shoes and sealing wax [!] and cabbages and kings" as well as atoms themselves—in a swirling array in which everything is roughly the same size. Traditional notions of perspective, which would establish distances between these seemingly equal-sized objects based on their real-life referents, fall away in the swirl, these various distances collapsed and condensed by the animation.

Later in the film, the narration describes the coalescence of "industry, labor, science, and the military" around the plan of a nuclear reactor. First the plan materializes in the middle of the frame, a blueprint for a building capable of housing atomic operations. One by one, in their own quadrants, visual representations of the four cultural institutions materialize around the plan: the ships and trucks of the manufacturing sector; a phalanx of human workers; a collection of books and scientific tools—including atoms; and an array of soldiers. Again, there is no attempt to maintain the relative sizes of any of these objects; they are all equal in size and arranged in keeping with an overall pattern that condenses various spatial dimensions into a single one for the sake of a well-ordered image. What is conveyed is the power of these institutions and organizations, their ability to manage a massive project in an orderly and uniform fashion. And since this is an abstract concept, its visual concretization is the uniform deployment of far-flung, widely different things as interchangeable widgets in a grand design. The image conquers space, rendering the invisible visible through the condensation of scale.

In "Integration," Burtin explains what is at stake in this investment in scale. "Man in design is both—a measure and a measurer," he declares. "The dimensions of his hands, his eyes, his entire body should be seen in relationship to the scale, shape, and volume of anything surrounding him, and directed at him." That is, "Man" is not a solid, unchangeable mass: "His scale and focus change continuously as he studies, grows and develops."[118] As a pronouncement of the place of humankind in the universe, this is obviously metaphorical. As our knowledge of things accumulates and shifts, we understand ourselves in strange and new positions relative to the objects, environments, and phenomena surrounding us. But translated into graphic design and animation, these changes in relationship become literal and, more importantly, can be *seen* by anyone instead of merely known by experts. The visual language of midcentury modernism is a mode of communication that words cannot perform; they can only indirectly and abstractly convey humankind's place in the universe. Design and cartoons, however, can turn these

A Is for Atom (Carl Urbano, 1953).

new relationships into visible reality, a direct experience of epistemological upheaval expressed by a new language invented to capture it.

The preliminary notes on the 1955 UPA exhibition at the Museum of Modern Art are unintentionally revealing about space and distance in the modern cartoon. Describing the studio's aesthetic, they note: "[UPA] uses scale (metaphorically, as when a man feels small or big he becomes so; spatially, as in diminishing perspective—not a UPA invention, but especially effective in UPA because of the elimination of inessentials in the scene)."[119] That is, as with the condensation of time, the simplification of form is a prerequisite to a uniquely communicative condensation of scale. In his discussion of microphotography, Franke hints at a reason for this: "And these worlds have a remarkable feature—their graphic fascination. They obey shaping laws that are unknown on a macroscopic plane. The principles of organic construction are replaced by geometry. These forms are a genuine expression of our age."[120] These simplified, geometric forms, then, though they in many ways stem from modern art, take over popular aesthetics at midcentury because they speak to emerging understandings of microscopic worlds around us.

The merging of the microscopic and the macroscopic through animation design is strikingly evident in the 1956 UPA short *Gerald McBoing! Boing! on Planet Moo*.[121] Franke's microscopic imagery, all intersecting lines and fragile geometric patterns, come to life in the vision of outer space devised for the cartoon's backdrop. The astronomical void is here represented as a densely intersecting network of lines and starburst shapes, all abstract geometry with little physical material undergirding it, save for a few errant planets and little Gerald McCloy in his spaceship. Even interior scenes are shot through with patterns of thin lines, suggesting a vision of space in which the microscopic is always present, always visible. In the cartoon's most nakedly atom-age moment, an alien planet is figured unmistakably as an atom, into which our heroes barely miss crashing. This coexistence of the microscopic and the macroscopic, as central to *Planet Moo*'s aesthetic as it is to Franke and Bayer's notion of contemporary design practice, configures UPA's style as the gateway to a new vision, adapting the geometry of microphotography to the entire visible world. Space is condensed, blurring outer space and inner space, the visible and the invisible, into one meticulously designed world. Widely opposing spatial scales collapse and coexist, communicating the advancing knowledge and shifting relationships of a new age.

CODA: *FUDGET'S BUDGET*

UPA's 1954 short *Fudget's Budget* strikes a strange note in the studio's already strange oeuvre. The story of a family trying to live on a budget (the title is not at all figurative), it takes the style of the modern cartoon to a place almost as stark as—though much more colorful than—that of *Christopher Crumpet*. But where *Crumpet*'s visual play was best described in terms of architecture, *Fudget's Budget*'s approach engages more with metaphor and the ability of an image to communicate multiple ideas at one time. The Fudgets' world is overlaid with a fine-lined grid, interspersed with the occasional thick line—the background is essentially ledger paper, indicating the structuring power of finances in this family's daily life. Carrying out their day-to-day activities amid this constant visual reminder of frugality and budgetary strain, they act out a cautionary tale for Americans adjusting to a freshly booming consumer society, stressing the importance of discipline, bargain-hunting, and delayed gratification.

In light of the developments outlined above, this film is a marvel of animated condensation. Its style hinges on an absolute, almost absurd economy

of means, with the minimum amount of material being used to signify any given part of the narrative world. Beginning with stark, streamlined outlines for every object, including the Fudgets themselves, the film moves from there in the direction of greater visual frugality. There are no rooms, no doors, no walls; characters merely disappear arbitrarily behind lines in the gridded pattern of the frame. When the narrator mentions the cost of a new picket fence, that cost is given direct visual expression: the boards composing the fence are not straight lines, but rather elongated dollar signs, the same dollar sign that stands in for the house's television antenna, signifying both their material identities and their cost to the family. Other visual condensations abound: a loan shark is depicted as an actual shark; the "sinking ship" of the Fudget household metamorphoses into an actual ship; the "storm" of unexpected and mounting expenses hijacks the narrative as an actual storm. These condensations of two ideas into one image provide the cartoon with a dreamlike urgency, in which the image visually expresses a repressed, formless anxiety—here, about the Fudgets' cost of living.

In fact, the material informing this narrative world is so compressed that everything is quite literally flat: when characters and objects turn sideways, they become straight lines. More interestingly, transitions between scenes are marked by these lines lifting off from the ground and swirling around each other, forming an abstract pattern that condenses passing time while keeping the principal actors on the screen. In another instance of temporal economizing, Mrs. Fudget navigates her house by "popping" from one floor—or rather, one segment of the frame, since again there are no drawn floors—to another, eliding narrative time while preserving the real time of an unchanging shot.

Fudget's Budget also condenses various spatial scales, and different levels of the narrative world, upon each other. If the film accentuates its two-dimensionality through the presentation of an ostentatiously flat world, it also hints at the presence of a z-axis: when those characters turn sideways and become lines, their two-dimensionality visibly rotates like a spinning coin, now extending backward into space. This third dimension is likewise indicated by the moments when one of the Fudgets disappears behind one of their background lines. It is there, yet not there; this paradox of flatness versus depth is, in essence, a condensation of two spatial configurations into one image, uneasily sharing the frame and jostling for prominence over the course of the film. Similar paradoxes abound: the Fudget home is bigger on the inside than it is on the outside, as we see when elder child Junior passes through a shot of the house in cross-section, disappearing behind the house's

thick outer edge. And in another shot during the Fudgets' dark night on the financial high seas, a trip to the bank to deplete the family's savings account is inverted when the teller's window floats over to the family ship—two incontrovertibly separate spaces share the frame, interacting on a single plane of spatial condensation.

These manipulations of space are punctuated by the occasional intrusion of an emissary from a world even more removed from the Fudget's spatiality: the space of the narrator. For most of the film, the narrator's voice sits comfortably with the action onscreen, following the common cartoon practice of pairing voice-over commentary with animated image. However, at certain "teachable moments," the red outline of a human profile materializes on the side of the screen, several times larger than the titular characters. Offering ill-tempered skepticism and smug, I-told-you-so asides, this face directly questions the narrator, and receives direct responses. Emerging from outside of the filmic world, he nevertheless visibly shares the frame with the onscreen characters, not as another figure in that world but as a giant, disembodied face all of out of proportion to his surroundings. These two worlds, represented as two spatial scales—we may recall Freud's assertion that things far away in the past, for example a story about a family who overcame their financial woes, are visualized as being farther away in space, dwarfed by representations of the here and now, which is the time of the narrator—are superimposed upon each other, condensed upon each other and sharing the frame, even while not sharing narrative space.

Yet superimposition also plays a more meaningful, conceptual role in *Fudget's Budget*. The thematic importance of the account ledger superimposed over the entire Fudget household is readily apparent. What happens in a moment of utter financial collapse, however, is more complex. As the narrator waggishly informs us that "George and Irene Fudget awoke within their expanded budget to find it falling down about their necks, and their warm and friendly shelter was all out of kelter," the thick lines of the Fudgets' bedroom grid bend and warp, leaving only the regularity of the thinner, finer lines to uphold the financial structure. The following image, an external shot of the Fudgets trying in vain to shore up their collapsing home, shows the twisted outline of a house in thick lines superimposed over the thin lines, which preserve the erstwhile outline of the structurally intact home. This superimposition, enacting Freud's idea of the "nucleus"—here, the home—that unites two separate images even as they fail to line up entirely to cohere into one, carries profound meaning in its ill fit: even as the physical structure

Fudget's Budget (Bobe Cannon, 1954).

of the everyday falls apart, the tyranny of finance maintains its rule. The Fudget household may be collapsing, but its budget-induced logic of frugality and strict discipline isn't going anywhere.

Although the film does not engage with graphic design's obsession with scientific progress and the communication of new discoveries about the universe, it nevertheless uses the same aesthetic procedures to visualize its own everyday concerns. And while it is true that it does not express or clarify a new scientific reality, it does express and clarify a new cultural reality. As the transition from wartime thrift to postwar largesse brought on the new phenomenon of consumer culture, and the new identity category of the consumer citizen shifted conceptions of the self and its place in society, *Fudget's Budget* visualizes the abstract and invisible forces that accompanied this massive social change.[122] It may not be a visualization of emerging truths about humankind's evolving place in the infinite universe or the submicroscopic atomic world, but it is an equally powerful use of condensation to visualize emerging truths about humankind's place in shifting relations of capital, economics, and selfhood that characterized the postwar era.

FOUR

The Design Gaze

CARTOON LOGIC IN HOLLYWOOD CINEMA
AND THE AVANT-GARDE

ON MARCH 20, 1964, BLAKE EDWARDS'S MYSTERY farce *The Pink Panther* premiered in American theaters, offering spectators the first adventure of many featuring the bumbling Inspector Clouseau, played by Peter Sellers. In its UPA-style animated opening title sequence, the film introduced audiences to the Pink Panther, a character entirely unrelated to the live-action narrative, the title of which refers merely to a purloined diamond. Much to the delight of the animators—and to the frustration of the film's stars—the Pink Panther proved more popular than any of the actual characters that followed: in early screenings, exhibitors reportedly had to stop their projectors to allow the enthusiastic audience response to subside before continuing with the show. Executives at United Artists were not blind to the phenomenon; shortly after the premiere, they asked creators Friz Freleng and David DePatie for a free-standing six-minute short starring their feline hero. The result, *The Pink Phink,* ran before Billy Wilder's *Kiss Me, Stupid* and netted the animated short an Academy Award and an opening spot on all of United Artists' major releases in early 1965, not to mention marquee billing for its eponymous character alongside the accompanying feature films. A contract with UA for monthly theatrical installments was not far behind.

Accounting for the sheer sense of fun involved in the spectacle of a pink cat sabotaging the graphically abstract opening titles in order to leave his pawprints on the proceedings, the runaway success of *The Pink Panther*'s opening sequence nevertheless suggests a continuing audience desire for UPA-style visual modernism. By 1964, when UPA's legacy was well established and its influence was still determining the form of popular animation both in the United States and abroad, *The Pink Panther*'s eponymous mascot symbolized the good taste associated with midcentury modernism. Sporting

a monocle and an elegant cigarette holder, surrounded by simplified lines and bold colors, he simultaneously embodies and sends up the sophistication sought by the middle class's love affair with modern design. While segmented from the main feature, then, these animated opening titles, alongside those famously crafted by Saul Bass, identify a point of modernism's infiltration into the otherwise classical model of live-action Hollywood cinema.

In fact, throughout the postwar era animation circulated in ever wider reception contexts, engaging in a cross-pollination not only with art, architecture, and graphic design, but with cinema more broadly considered. Cartoons are typically aligned in historical descriptions with "the movies," as the short-form appetizer before the main course of the feature—or in an animated opening titles sequence, as in *The Pink Panther*—but they circulated throughout American film culture in numerous other ways that force us to rethink the cartoon's status in relation to film as a medium. To be sure, cartoons premiered alongside Hollywood films in theaters across the country, and this chapter explores new ways to conceive of this relationship; however, it explores other, more surprising configurations of animation and live-action cinema as well. As midcentury modernism developed as a cultural force, animation was exhibited in highbrow avant-garde cinemas, at MoMA as part of the increasing acceptance of film as art, and perhaps most importantly, at conferences where designers met to brainstorm solutions to the problems plaguing modern life through, among other approaches, the analysis of film.

As Lynn Spigel notes, at the 1959 meeting of the International Design Conference in Aspen, films of all kinds showed alongside one another, not separated by genre or levels of prestige, but rather as equally compelling examples of "various aspects of film form." These screenings "included everything from animated experimental shorts like [Norman] McLaren's *Penpoint Percussion and Dots* (1951) to experimental filmmaker Maya Deren's *At Land* (1944) to Stanley Kubrick's feature *Paths of Glory* (1957) to French and British television commercials."[1] Of note here is the intermingling of animation, avant-garde film, and the mainstream Hollywood feature. UPA director Ted Parmelee spoke at the 1954 Aspen conference, which suggests the cartoon's specific relevance to designers as a model of moving graphic design. The presence of other kinds of film on the roster five years later indicates the openness of midcentury modernists to all branches of film practice as offering potential design solutions to the changes in modern ways of life in the postwar era.[2] In its incursions into Hollywood and avant-garde filmmaking, the modernism of UPA and Kepes, of Neutra and *Graphis*—in short, the

modernism of this book—found its way into American film culture in ways that our new understanding of modern animation can help us untangle. That is to say, midcentury modernism's impact on cinema does not begin and end with animation; live-action cinema also engaged with the design principles undergirding the postwar cartoon.

In many cases, the results were stylistically similar to UPA's output, with live-action adopting the visual forms prevalent in modern animation. In others, however, the design principles underlying animated form produced different results when transferred to the photographic representation of the movies. This chapter, then, is an account of the moments when the logic of design seeped into the greater film culture of postwar America, sometimes offering a model of a live-action cartoon, though not always, and never completely. These points of intersection allow us to view film's full engagement with midcentury modernism and offer an alternative to more common definitions of postwar cinematic modernism as a descendant of modernist literature and theater, an alternative that is primarily visual rather than narrative.[3] They also help clarify the ways in which cinema of the period becomes wrapped up in midcentury design's rhetorical modernism, opening a path to considering the *usefulness* of popular and experimental film.

As modern design occupied an increasing share of the postwar marketplace, the circulation of animation alongside other branches of film practice became a matter of broad public experience rather than one confined to the rarefied locales of galleries, conferences, and specialized exhibitors. In *TV by Design: Modern Art and the Rise of Network Television,* Spigel charts the involvement of the major television networks in matters of cultural education, particularly in matters of art and design. One of the new medium's efforts to garner cultural legitimacy was the practice of showing movies on TV, and particularly by the early 1960s, art cinema shared airtime on American television with old Hollywood classics.[4] The avant-garde found purchase here as well; Spigel cites a 1967 *Art Direction* poll in which advertising executives "saw the application of art and experimental film techniques as the most important trend of the decade."[5] Televised Hollywood movies, European art films, and commercials laced with arthouse and avant-garde techniques mingled in American living rooms across the country alongside the more canonical offerings of TV—and most importantly, they all came embedded in an interface of modern design. Spigel notes, "Early television audiences saw variety shows, soap operas, sitcoms, dramas, news, and commercials packaged within a distinctly modern graphic look designed by some

of the nation's leading graphic artists and scenic designers. Modern graphic design, as well as modern stage and set design, accompanied a good portion of the daily schedule. Modern design was indeed crucial to the visual culture of television."[6]

If design was thus in some ways the vehicle uniting these various forms of filmic production in a televised space, I would like to extend this notion out of the living room and into the films themselves, following a distinctly midcentury modernist thread running through Hollywood and the avant-garde. Here again Kepes's influence is paramount. In a 1972 interview, he considers his interwar tenure at the New Bauhaus and its postwar legacy, observing: "On looking back, I know that almost every teaching in this country, is based upon, on at least, in a certain aspect of it, what we introduced, in Chicago, in this year or two years.... In fact, the term, Visual Design, I introduced, because we had to have a name for it and it was not design and not art."[7] A touch self-aggrandizing, sure, yet it points to a notion of design, or something greater than design, that, as in Spigel's analysis of design in television, subtends many different media forms.

The first three chapters have provided a lens through which to view animation's contribution to the visual culture of midcentury America, highlighting the cartoon's engagement with larger design questions circulating both within professional conversations and in the public sphere. This chapter's shift to live-action cinema suggests another shift, one with greater implications for film studies as a discipline. I have argued for a new understanding of the cartoon as a partner in a widespread search for design solutions to increasingly prominent problems of vision, space, and communication in American culture. In exploring the manifestations of these solutions in other, more firmly embedded areas of film practice, I thus propose a shift in our thinking of film studies writ large, a way of focusing on the designed image that brings the theoretical work of animation into contact with the workings of cinema more broadly in the postwar era.

As animation gained cultural legitimacy, it became a place to which artists, architects, and designers began to look for solutions to overarching design problems, as this book has thus far established. And as cartoons also entered a larger conversation with live-action cinema, this cultural legitimacy made them a source for further cinematic explorations of the cartoon's play with form and space. If, as I have argued, the modern cartoon is fundamentally a cinematic expression of modern design, here postwar film as a whole begins to resonate with this design impulse, positioning animation as a key

to understanding changes in film culture and film style. In this chapter, therefore, big-budget crowd pleasers sit uncomfortably next to artisanal 16mm films; a musical-western hybrid and an experiment in optical printing rub elbows; *D.O.A.* and *Christopher Crumpet* wink at each other from across the room. Taken together, they reveal that the influence of midcentury modernism on American film culture extends beyond animation, reaching feelers outward into other genres and film forms. In each of the sections that follow, I explore the points of contact between modern animation and live-action cinema, with a particular focus on the ways in which these intersections offer a new way of thinking about what makes these cinematic practices modernist. Discussions of modernism are by no means new to any of these branches of live-action cinema; however, I argue that modern animation's design strategies provide another model of how modernism took shape in postwar cinema more broadly.

GAZES, SPECTATORS, AND MEDIUMS

Ultimately, what links these various forms of live-action cinema at the center of postwar American film culture is design. And what activates the thread running through these forms of cinema is, as in the theory at work in modern animation and design, the activity of the spectator's eye. Here the question of the gaze becomes paramount, and it offers an analytical tool for understanding the manifestations of the modern design impulse in live-action cinema. More specifically, I propose a particular gaze that is enabled by films being screened in this midcentury moment. Media theorists have dealt with various gazes, ways of being a spectator in front of a screen, from Jan Campbell's invocation of a "phenomenological gaze" to Frederic Jameson's critique of the "painterly gaze" and, of course, Laura Mulvey's development of the "male gaze."[8] More recently, film scholar Martin Lefebvre has theorized a "landscape gaze," a way of viewing cinema that brings the landscape to the center of spectatorial attention despite the presence of a narrative dimension, turning mere setting or background into the primary object of attention.[9]

That the landscape gaze focuses specifically on *landscape* at the expense of story or action is of less concern here than is the particular way in which Lefebvre formulates the work of this gaze (though insofar as it privileges an engagement with the representation of space and form over an engagement

with matters of narrative, it shares some intellectual DNA with the project at hand). He explains:

> After four centuries of development, landscape today constitutes a cultural habit and a sensibility revealing itself not only in our capacity to see real landscapes *in situ,* but also in our capacity to bring a "landscaping gaze" to bear on images that do not immediately derive from the genre (e.g., obviously, filmic images). In these cases, it is the cultural context that makes it possible to direct the "landscape gaze" onto the narrative spaces of fiction films despite the absence of strategies or intentions to make them autonomous.... Landscape appears when, rather than following the action, I turn my gaze toward space and contemplate it in and of itself.[10]

For Lefebvre, a filmic image does not have to be trying to function as a landscape in order to function as one; it merely has to exist in a reception environment in which people are familiar with and interested in the landscape as an artistic tradition. The spectator will do the rest.

Lefebvre's "landscape gaze" opens the way for another method of viewing cinema, what I will call the "design gaze." As Spigel has shown, the widespread, television-assisted penetration of modern design into the American consciousness after World War II created "a new visual culture," what she calls "a quotidian form of postwar modernism, showing the public how to enjoy new trends in the visual arts as an everyday national pastime."[11] For Lefebvre, and for the landscape gaze, "the first condition is elsewhere, in the spectator's gaze, which is to say, in their cultural knowledge and their sensibility."[12] In postwar America, then, the conditions were in place to view cinema through a design gaze, one in tune with the cultural knowledge and sensibility percolating through a freshly modernism-oriented middle class that was seeing "Good Design" everywhere it looked.[13] This gaze may also be seen as the fruition of Kepes and Moholy-Nagy's goal of "a reorientation of all our faculties" toward a mode of vision more capable of withstanding the upheavals of the twentieth century.[14] I take seriously Lefebvre's invocation of a visual dimension of the filmic image that exists to greater or lesser degrees on a production level and yet advances and recedes "according to the uses that we make of the film." In the analyses below I make deliberate use of the design elements in various films and, to repurpose Lefebvre, "turn my gaze toward design and contemplate it in and of itself" in live-action cinema.[15]

In outlining a mode of spectatorship that privileges the surface of the image over the narrative of the film, the design gaze also intersects with a broader

theoretical tradition aligned variously with semiotics, with psychology, and with excess. In "The Third Meaning," structuralist luminary Roland Barthes outlines a mode of film analysis that privileges the individual frame, scouring the isolated image for elements that rupture the cohesive narrative whole. This slippery dimension he calls "the obtuse meaning," as opposed to the "obvious meaning" of the film's story and its historical and sociological dimensions.[16] When these moments occur—and for Barthes, they exist in some places and not in others, though the placement is decidedly personal—the spectator is liberated from the dominant meaning of the film and freed to construct another kind of meaning, shadowy, associative, and outside of the intended signification of the text. Remove the spectator from the flow of the narrative, and the spectator is gifted with greater options for thought and experience.

This idea has generated much thought among film theorists on the place of the spectator in the filmgoing experience. For example, Kristin Thompson's concept of "excess" builds out Barthes's observations into a model of film criticism that seeks points of weakness to help unravel a film's drive toward narrative unity. She argues, "A film displays a struggle by the unifying structures to 'contain' the diverse elements that make up its whole system. Motivation is the primary tool by which the work makes its own devices seem reasonable. At that point where motivation fails, excess begins."[17] A film wants to be a seamlessly crafted contraption of setup and payoff, every piece held together by the logic of Chekhov's gun. But it is also composed of textures, gestures, background objects, line readings, facial expressions, and other ungovernable elements that simply *are,* and these eruptions of the aleatory are focus points for attention to excess. Everything unruly, every quirk that cannot be subsumed into the overall pattern of the film's desired narrative functioning, is excess, and each is a jumping-off point for the spectator's freedom to explore and to think (and see) independently. Similarly, Robert Ray develops the idea of "fetishism as research strategy," an analytical method that, following Barthes in another way, prizes the stilled film frame. Glossing Barthes, he observes: "If the movies' relentless unrolling prevents your noticing anything except the narratively underlined details, the only response is to stop the film."[18] And when you do, everything the film wanted you to breeze by snaps into focus, and from there the spectator is freed to draw whatever associations she chooses between those objects and the larger symbolic lexicon of art, culture, and history.[19]

Both of these theories advocate a spectatorship practice that, as Barthes observes, "frustrates meaning," denying the film the power of directing all of

its details toward the single-minded march to its narrative climax.[20] At bottom, all of these approaches—not just those of Thompson and Ray, but of Barthes and Lefebvre as well—take a pointedly adversarial stance toward cinema, carving out a space for spectatorial play within the well-crafted apparatus of industrial cinema by prioritizing the vagaries of the image over the intended progression of narrative. Yes, the film *wants* the spectator to follow its rhythms, but the spectator is free to look elsewhere, to understand differently, to poke her finger in the eye of a narrative drive that wants to enfold her in its onward flow. There is an ideological dimension to this, especially when talking about Hollywood cinema: to disrupt the spectator's immersion in the narrative is to demote the narrative's naturalized drives toward monogamous romance, the securing of social and moral goods, and the reassertion of norms encapsulated by the happy ending. Put differently, these "look where you want to look" theories of spectatorship, at their core, are about doing violence to the ideological work of cinematic narrative by breaking apart the unified whole of the film. (Not for nothing does Barthes call the third meaning a "disruptive force.")[21]

While the design gaze also prizes a focus on the visual elements of the film's surface—backgrounds, color compositions, odd arrangements of shapes—over the depth of narrative, there is a key difference here. The above theories wish to fragment the film in order to reduce its overwhelming power over the spectator, to enable her to look where the film does not wish her to look. Conversely, UPA cartoons, and the design-inflected live-action films that are the subject of this chapter, actively solicit a gaze that lingers over the surface of the frame and its formal elements. There is no tension between the film's demands upon the spectator and, say, the abstract forms of *Gerald McBoing Boing* or an MGM musical; the surface of the film is *part of* the unified whole. The design gaze, then, does not disrupt the orderly, cohesive unfolding of a film narrative. If anything, as an outgrowth of Spigel's midcentury visual culture, and in "showing the public how to enjoy new trends in the visual arts as an everyday national pastime," it enfolds the functioning of cinema into larger design discourses in this period.[22]

In a sense, the design gaze may resonate more with Elie Faure's cineplastics. In his dream of a plastic cinema, he rhapsodizes: "That the starting point of the art of the moving picture is in plastics, seems to be beyond all doubt. To whatever form of expression, as yet scarcely suspected, it may lead us, it is by volumes, arabesques, gestures, attitudes, relationships, associations, contrasts and passages of tones—the whole animated and insensibly modified

from one fraction of a second to another—that it will impress our sensibility and act on our intelligence by the intermediation of our eyes."[23] The overwhelmingly sensory impact of cinema in this formulation calls attention to the compositional elements of the film frame and to the perceptual experience of *watching* a film, of seeing its forms unfold on the screen as a moving visual image. Moreover, the emphasis on plastics resonates with *Language of Vision,* where Kepes's overriding concern is also the plastics of the image. He observes, "The ultimate aim of plastic organization is a structure of movement that dictates the direction and the progression toward ever new spatial relationships until the experience achieves its fullest spatial saturation. As new relationships progressively unfold, the spatial integration of the image gains momentum until it finds final clarification in the plastic image as a whole."[24] For both Faure and Kepes, the potential of these plastic wholes, unified in their parts, is to enable a similar wholeness and union in the audience. This is not—as in the third meaning, or excess—about the aleatory. Note how Kepes's language replicates the idea of "dictat[ing] the direction and progression" of the art experience, in a way similar to Thompson's and Ray's descriptions of narrative. Here, the spectator is still being driven; she is merely being driven toward "fullest spatial saturation," as opposed to, say, the climax of the plot. The focus remains the unified experience of film, just of a different kind. As Faure predicts, "Cineplastics will doubtless be the spiritual ornament sought for in this period—the play that this new society will find most useful in developing in the crowd the sense of confidence, of harmony, of cohesion."[25]

Wrapped up in this notion of a unified assemblage of plastic wholes that can likewise unify its audience is a central point about the ideological dimensions of the design gaze. Throughout this book, I have argued that UPA cartoons sought to teach a particular way of looking, not just at themselves, but at the world beyond. I have also argued that UPA animation is best seen as a mediator of wartime and postwar aesthetic and ideological change, caught up in the entrée of modern design into larger institutions and markets. The design gaze, then, mobilizes these lessons and uses them to see how other branches of cinema were also participating in the postwar project of bringing modern design—and with it, its utopian perceptual impulses—to the masses. It therefore does not represent the same ideological challenge as those that wish to break up the film's unified force to enable individual meaning-making. In fact, as part of an overarching ideological project stemming from the New Bauhaus and its attempts to fashion a new mode of seeing in postwar

America at various institutional levels, the design gaze might be better seen as a *tool* of this burgeoning postwar ideology. Recall Robert Genter's designation of a "rhetorical modernism" at midcentury that aimed to convince mass audiences of its benefits through pedagogy and persuasion. The design gaze might be how one sees after having been taught and persuaded.

Also at issue in this chapter is the relationship between animation and film. Popularly, animation has been cordoned off as a genre of film, and often a debased one (best to say nothing here at all of the widespread "children's media" assumption). Media theorist Lev Manovich, sneering at this condescension, outlines the mainstream belief in "cinema's bastard relative, its supplement and shadow—animation. Twentieth-century animation became a depository for nineteenth-century moving-image techniques left behind by cinema."[26] In this history, Manovich explains, "the opposition between the styles of animation and cinema defined the culture of the moving image in the twentieth century. Animation foregrounds its artificial character, openly admitting that its images are mere representations. Its visual language is more aligned to the graphic than to the photographic," while "in contrast, cinema works hard to erase any traces of its own production process, including any indication that the images that we see could have been constructed rather than simply recorded."[27] There is indeed some value to this story; this book has made numerous references to the freedom animation finds in being unburdened by photographic indexicality in its representations of fictional worlds.

Yet Manovich's account is one of animation's revenge in the digital era, when cinema reveals the empty space behind the curtain: "And pixels, regardless of their origin, can be easily altered, substituted for one another, and so on. Live-action footage is thus reduced to just another graphic, no different than images created manually." Even here, there is more than a whiff of a declensionist narrative; to be "reduced to just another graphic" is to utterly devalue the graphic, and while Manovich says this with tongue in cheek, it still stings. The image one is of animation finally managing to pull film down into its gutter. But he immediately opens up a better way of thinking through the animation/live-action relationship and the value of the graphic: "If live-action footage were left intact in traditional filmmaking, now it functions as raw material for further compositing, animating, and morphing. As a result, while retaining the visual realism unique to the photographic process, film obtains a plasticity that was previously only possible in painting or animation."[28] Here again plasticity returns as a positive value, an expression of the flexibility and visual power of the filmic image, no matter how it was

produced. My only complaint is one of timelines. As this chapter argues, the live-action image was *always* plastic, not rendered plastic when digitality ruptured the trustworthiness of the indexical image.[29]

This debate often oscillates between two historical poles: pre-cinema on one hand, where animation emerges from a series of optical toys such as the zoopraxiscope and the phenakistoscope, and on the other, digital cinema, where live-action film is revealed to give up the ghost of indexicality and to be just one more kind of animation. What, then, of the midcentury moment? It is perhaps not as critical a moment for debates about medium-specificity in cinema: rather than categories in turmoil, the period is marked by the American Bauhaus ethos of ruthless interdisciplinarity, of multimedia exhibitions, and of films airing on television and screening on loops in museums. But for this very reason, the question of what exactly *is* animation is activated. I confess to a certain measure of conscientious objection in this debate; I am far less interested in where the borders between mediums lie than in what happens when they are crossed. It is clear that we do not know with absolute certainty what animation is—nor, in my view, should we. Animation historian Donald Crafton describes animation's true expansiveness: "To reiterate, *animation* is more than a technique. Owing to the vestiges of its semantic past as a word bound up with the mysteries of life, the breath of God and such, it carries a lot of transcendental baggage."[30] Risking mysticism, I think that to eschew the narrative structure on which popular media is built and to invest in the power of the plastic elements of the visual frame does require a small but worthwhile leap of faith. To do so is to ask, what do visual images do to us? This question is at the heart of midcentury modernism's exploration of vision, and to wall off various mediums from each other is to hinder the viability of that question.

As we will see in this chapter, Hollywood musicals and avant-garde passion projects (and even, briefly, film noir) connect with one another via a shared design language, and one driving force of this argument is that our categories for branches of cinema do not precisely work the way we would like them to. In part, this reflects an interdisciplinary approach that steps outside film studies to view cinema askance, allowing various kinds of moving-image media to commingle without strict territoriality. Manovich says, "Born from animation, cinema pushed animation to its periphery, only in the end to become one particular case of animation."[31] Conversely, Crafton says, "I remain intrigued but skeptical of the arguments that film is a subset of animation. My objections to the genealogy that animation begat cinema

are that it may be largely semantics, deploying disingenuous definitions of animation and cinema."[32] I, dropping arms, side with animation scholars André Gaudreault and Philippe Gauthier, who boldly declare, "Is it not a fact, in some respects, that *animation is kinematography and kinematography is animation?*"[33] But I would add to that question, is it not also possible that both are caught up in theories and practices of design? In this sense, it is worth revisiting one of Manovich's above-quoted claims, that "[animation's] visual language is more aligned to the graphic than to the photographic." What happens when we view both animation and live-action cinema as varying instances of design? That is the question around which this chapter revolves, and it is the basis for my advancement of the design gaze, which inclines toward the plastic dimensions of the filmic image, whether drawn or photographed. To place animation at the center of this gaze is to acknowledge that modern animation gives us nothing *but* design to look at; it demands that we look at the design of the film's surface. If we view this gesture as part of UPA's rhetorical modernism, the thing the studio wants to teach us, then we may take the combined lessons of the first three chapters on animation and turn them toward cinema as a larger category, and view films as design objects circulating together in the same networks as modern architecture, graphic design, and cartoons.

RED WALLS AND *RED GARTERS:* HOLLYWOOD CINEMA AND CHROMATIC SPACE

As the *Pink Panther* anecdote that opens this chapter attests, modernist animation migrated from its "warm-up" status of the prefeature cartoon short to something closer to a part of the feature film itself, often under the guise of the opening titles sequence. This infiltration of animation's modernism into the realm of the live-action Hollywood movie is perhaps the starkest example of animation's influence in Hollywood, but the particular modernism circulating through the design scene entered popular cinema in other ways as well, challenging our conception of modernism's place alongside the mainstream styles of postwar American film. The "classical Hollywood cinema" of the 1930s to the early 1960s has tended to function as modernism's "other," the tradition-bound aesthetic conservatism against which modernism rebelled, but scholars have conceptualized a potential Hollywood modernism in various ways.

One method relies on the film industry's relations with progressive political organizations in the interwar years, aligning Hollywood's political modernism with the fortunes of the U.S. Popular Front. For instance, in the aptly titled *Hollywood Modernism,* historian Saverio Giovaccini identifies what he terms a "democratic modernism" influenced by political ideas emerging from intellectual circles on both coasts of the nation. Here, "Hollywood's cinema promised the construction of a democratic modernism, a common language, able to promote modernity while maintaining a commitment to democracy as well as the political and intellectual engagement of the masses."[34] It is worth noting that for Giovaccini, this democratic modernism is resolutely not experimental or alienating to a mass audience; in fact, it "often, though not always, took the form of social realism."[35] Likewise, film scholar Chris Robé finds in 1930s progressive Hollywood circles the desire "to prove once and for all that modernism was not the sole province of cultural elites but could serve both political and aesthetic revolutionary ends for mainstream audiences."[36] From an art historical perspective, Erika Doss traces the history of modernist painter Thomas Hart Benton's 1937 *Life* magazine–commissioned mural *Hollywood,* linking its modernism to its celebration of "the movie industry's workplace consolidation of productivity and collectivity."[37] In these formulations, Hollywood modernism stands as an explicitly political movement taking advantage of a progressive cultural moment to disseminate revolutionary (and thus modernist) ideas to a wider audience. It is perhaps unsurprising that these definitions of modernism consider the phenomenon to have splintered and collapsed after World War II, in the wake of the Red Scare.

Literary scholars, meanwhile, in line with conceptions of modernism in European art cinema, have linked cinematic modernism in Hollywood to literary modernism. David Trotter, for example, charts the intersections between modernist literary heavyweights such as Joyce, Woolf, and Eliot and their American cinematic contemporaries, D. W. Griffith and Charlie Chaplin.[38] From another perspective, Tom Cerasulo follows authors as they make their way into the Hollywood machine, exploring literary modernism's industrial contact with the movies, particularly through the figure of Nathanael West.[39] Expanding beyond these boundaries into the terrain of the senses, film historian Miriam Hansen's seminal contribution to the history of cinematic modernism, "The Mass Production of the Senses: Classical Cinema as Vernacular Modernism," comes significantly closer to my general project, overturning the opposition between classicism and modernism.

Referring to classical Hollywood cinema as "an international modernist idiom on a mass basis," one that ultimately constituted "the single most inclusive cultural horizon in which the traumatic effects of modernity were reflected, rejected or disavowed, transmuted or negotiated," Hansen positions the cinema as modernist because technologically modern, reproducing for audiences the massive sensory shifts caused by modernity itself.[40]

Hollywood modernism, then, is either a political phenomenon applying to films produced by progressive intellectuals, or a literary phenomenon informing and informed by high modernism, or, à la Hansen, a sensory phenomenon induced by any engagement with the inherently modern technology of the cinema, most effectively through the widespread and transnational reception of Hollywood's global distribution (or even, as musicologist Peter Franklin has argued, a property of films' musical scores).[41] What Hollywood modernism is not, in any of these models, is a visual phenomenon occurring in connection with an interdisciplinary design movement characterizing the most popular forms of postwar animation and capturing an increasing amount of the public's gaze at midcentury.

However, Hollywood's connections with this movement are clear and manifold, and experimentation with modernist design principles determines live-action cinematic form in many places in popular American cinema's catalogue. In *Designing Dreams,* architecture and design curator Donald Albrecht charts the incursion of modern design into Hollywood films across the 1920s and 1930s, positioning them as forums in which innovations in architecture and design were disseminated to the wider American public.[42] He notes, "If the movies of this period did not actually initiate design trends, they did provide conspicuously attractive settings for their scenarios, and, more important, anticipated and virtually defined for the general public modern architectural trends then only barely perceptible on the design horizon."[43] This is a model of cinema as showroom, displaying modern objects to a freshly modernizing society. In a similar vein, film historian Lucy Fischer's *Designing Women* explores the penetration of Art Deco style into Hollywood in the same period, especially as it inflects representations of women. Here, narrative, set design, and fashion link femininity with consumerism via the medium of popular film.[44]

As chronicles of the presence of modern design in Hollywood cinema in the 1920s and 1930s, these studies provide a compelling model for thinking through historical points of contact between these two fields. However, what they both find is a different kind of engagement than the one we see in

midcentury cinema. Albrecht and Fischer discuss the emergence of modernist objects in the mise-en-scène—streamlined set design, Knoll sofas, Deco-inspired costumes, modernist architecture onscreen. That is, in this earlier period cinema is showing us things that are modernist, but they seem to be shown to us in a relatively classical mode. In other words, the modernism is *profilmic:* it's there on the soundstage, equally modern whether one is in the studio for the filming or in the theater for the screening. By contrast, UPA animation invokes modernism in the image itself. In fact, the settings of the cartoons discussed thus far are often pointedly *not*-modernist. While we find expansive modernist experimentation with spatial representation in *Gerald McBoing Boing,* for example, the McCloy home is pointedly Victorian in style; consider as well the rickety premodern decay of the old man's house in *The Tell-Tale Heart* (see figures on page 99 and page 141). Instead, the modernist exists in the *filmic,* in how these nonmodern spaces are represented. In a way, this is the obverse of the dynamic Albrecht and Fischer find in the cinema of the 1920s and 1930s—classical "sets" and classical fashion, but modernist in the very form of the film frame, the film as a composed image. By reducing the outer world to abstraction, this design-based style is able to render the whole world modern, regardless of the lingering physicality of past eras. And by activating the design gaze, these cartoons therefore prime the spectator's eye not to see modern things, but to see things modernly.

This is also true of significant strains of live-action cinema at midcentury. While Saul Bass's animated opening credits sequences certainly smuggled modern design into Hollywood, his titles for Alfred Hitchcock's *Vertigo* (1958), superimposing abstract geometric patterns on a real eye, provide a moment where live action meets modernist animation in real time. In fact, the merger of graphic designer and sometime animator Saul Bass and experimental filmmaker John Whitney within the space of a major studio film points to the interpenetration of animation, design, the avant-garde, and mainstream cinematic practice. The traffic of directors such as Frank Tashlin between animation and live action points to another point of infiltration of the cartoon into live-action Hollywood cinema. Meanwhile, as I discuss below, George Marshall's 1954 musical-western hybrid *Red Garters* reduces film sets to such a degree of minimalism that the screen becomes a blank color field, such that a *Variety* reviewer was prompted to describe it as "a live-action UPA cartoon."[45] In these ways and, as we shall see below, many others, Hollywood partook in a modernism found not in its literary sensibility or its political engagement, but in its visual form itself, employing the

design principles characterizing midcentury modernism and coming ever closer to the stylistic developments of the cartoon.

One of the clearest ways in which modern animation's aesthetic practices resonated with Hollywood cinema is through the use of visual abstraction. Following the definition of a visual cinematic modernism established in the previous chapters, we may identify a few key traits: the reduction of form to a simplified geometry of lines and shapes and the use of bold, often nondescriptive color in flat fields. These forms of abstraction, so central to both midcentury design and the development of the modern cartoon, often lend a cartoon aesthetic to the live-action cinema in which they appear, particularly as they manifest in genres such as the Hollywood musical. Elsewhere, these techniques result in something more austere, a simplified, pared-down visual style stripped of the cartoon's whimsy, in line with a more "serious" expression of modern design principles. But in both cases, they show a continuity between modern design and film form that offers evidence of a shared modernism tying the various branches of film practice together.

A good place to begin identifying a cartoon aesthetic in the movies is the Hollywood musical, for numerous reasons. Albrecht highlights the musical's natural fit with modern design, observing, "Modern décor was a particularly appropriate backdrop for their [Paramount, RKO, and MGM] society comedies and dramas and lavish fairy-tale musicals."[46] Fischer likewise traces the links between Art Deco's style and its specific suitability for the musical.[47] We still see hints of modern décor foregrounded in postwar musicals. In Vincente Minnelli's 1951 film *An American in Paris,* for example, the number "'S Wonderful" plays out in large part against a Parisian exterior wall festooned with pointedly modernist posters advertising Perrier, Gerline soap, and Marie Claire stockings, so closely arranged that they become a collage in front of which Gene Kelly and Georges Guétary sing and dance. This is a recurring trope, one we also see in Stanley Donen's 1957 *Funny Face,* where Audrey Hepburn and Fred Astaire conspicuously pause during a walk-and-talk before slowly resuming, allowing the camera to highlight two giant posters on the wall behind them. These examples fit the established practice of Hollywood cinema showing modern things, and specifically modern in the style of the postwar cartoon. However, there are other reasons to link the musical and the modern cartoon that take us deeper into film form and structure.

As an "interlude" between larger narrative segments, the musical number partakes in the liberties available to the short-form "prelude" of the cartoon.

In both cases, the self-contained nature of the segment opens up a space of fantasy in which traditional rules, whether of storytelling, plausibility, or physics, are suspended in favor of an enhanced, more pleasurably anarchic aesthetic experience. The rupturing of narrative continuity for the spectacle of the musical number instills a level of reflexivity that the cartoon also shares, offering a privileged moment for the design gaze to make sense of the visual field. Moreover, derived from stage performances, the principles of set construction and design are free to stray from the dictates of realism to a greater degree than in many other genres, and significantly, the particular departure from realism in postwar musicals often moves in the direction of the modern cartoon.

The musicals of Vincente Minnelli, whose above-mentioned poster-strewn *An American in Paris* was but one film that engaged with midcentury modernism, are a case in point. Across his musical numbers is a more sustained exploration of modernism that manifests in a few ways. Film scholar James Naremore has located Minnelli's modernism in, among other things, his tendency to borrow forms from modern art and merge them with the everyday and the vernacular, creating "a form that was neither high nor low, neither conservative nor vanguardist, but a relatively up-market synthesis of two cultures—one of them aristocratic and European, the other populist and American."[48] In some places the borrowing from modern art is explicit, as in the *"American in Paris* Ballet" number, where Gene Kelly dances through a whirlwind survey of French painting, including Van Gogh, Rousseau, Toulouse-Lautrec, and—in the vein of UPA's own MoMA-sponsored cartoon short *The Invisible Moustache of Raoul Dufy*—Dufy's 1933 painting *La Place de la Concorde*. Here, the backgrounds are painted to resemble the semiabstract painting styles of the European masters, another instance of including modern objects in the mise-en-scène—though a more complex one, as the world of the film *becomes* a modernist painting for that moment. Elsewhere, however, the film's style turns modern in a way more in line with the stylistic innovations of UPA.

Minnelli's 1953 film *The Band Wagon* also features sets that are painted in a semiabstract form, but in a way that is less directly traceable to a specific artistic referent. In the "That's Entertainment" number, for example, Fred Astaire, Jack Buchanan, Nanette Fabray, and Oscar Levant perform in front of a disassembled stage set that is painted in bright, solid colors and reduced detail, allowing the live-action characters to frolic through swaths of cartoonish representation, even as the real-world soundstage beyond the sets offers a

The Band Wagon (Vincente Minnelli, 1953), "Triplets."

detailed contrast to the imagery in the foreground. The flatness on display here, then, is that not merely of the designs painted on the sets, but also of the sets themselves, thin wooden slats that are revealed in their lack of depth throughout the number. This play with flatness and space is perhaps more one-note than the kind of spatial representation at the center of UPA's modernist experimentation, but it does hint at a visual ethos that celebrates the flatness of the image—as stage set or as drawing—rather than attempting to mimic the three-dimensionality of illusionistic cinema. Later, the "La Femme Rouge" number offers an equally abstract-representational background, again narratively couched as a stage set. Perhaps the strongest eruption of cartoon form in the film, however, belongs to "Triplets," in which Astaire, Buchanan, and Fabray dance in baby costumes in front of a stark, stylized background that conceptually resembles a child's drawing, but upon closer inspection seems more akin to Stuart Davis–inflected UPA cartoons.

Owing to such indulgences in exaggeration and stylization, the heightened spectacles of musical numbers have arguably always partaken in a sense of whimsy and reverie that we might call "cartoonish," but one particular musical in the postwar era stands out in the directness of its appeal to the

look of the cartoon.[49] In *Singin' in the Rain,* Gene Kelly and Stanley Donen's 1952 showbiz musical satirizing the corruption of Hollywood during the coming of sound, the visual style of the numbers is brightly colorful—not unusual for the genre—but also in some places pointedly hand-drawn, capturing the exaggerated, free-wheeling stylization of a UPA short. In the much-lauded "Broadway Melody" sequence, a necessity in the stage musical—painted sets representing the musical's world—becomes a phantasmagorical exercise in abstraction on film, dispensing with realism in favor of visible brushstrokes, ostentatious flatness, and blank color fields. Notably, this sequence, in the words of protagonist Don Lockwood (Gene Kelly), is "for the modern part of the picture," "the picture" referring to a new version of *The Dancing Cavalier,* a silent film under production being reworked for sound. "Modern" in plot terms refers to one of these updates, specifically a contemporary scene to contrast with the period setting of the rest of the film. However, it is also, visually speaking, the most modern, and modernist, part of the film *Singin' in the Rain.*

Dramatizing the arrival of Lockwood's "hoofer" on Broadway and his ensuing rise in the world of the stage musical, "Broadway Melody" opens with Lockwood on a small platform in a cavernous, otherwise nondelineated sound studio festooned with the telltale marquee signs of Broadway playhouses. As a crowd rushes into the studio, completing the picture of a bustling New York City, the film shifts to more specific locations: Penn Station, a row of casting agents' doors, a nightclub. Each of these locales is painted in a pointedly unrealistic style, noteworthy even within the context of stage-inspired Broadway musicals. Specifically, the style is unrealistic in the manner of a modern cartoon. As in UPA's departures from realistic representation, perspective lines are warped and skewed, signage is written in crooked and obviously handwritten scrawls, and the right angles of everyday architecture are replaced by curves, ovoids, and wobbling, irregular lines of inconsistent thickness and an almost drunken lack of direction. Detail is reduced to a minimum in favor of boldly colored shapes merely suggesting real-world referents. The backgrounds look so thoroughly cartoonish that it comes as a shock when doors actually open, revealing a functional architecture underneath the stylization.

In the nightclub, den of Cyd Charisse's *femme fatale,* this reduction intensifies, often placing Don in front of a bare, minimally textured red color field with the occasional line painted on it to represent a door or, incongruously, a metal pipe or a radiator (this indicated by a squiggly gray line near the

Singin' in the Rain (Stanley Donen and Gene Kelly, 1952), "Broadway Melody."

floor). Perhaps most strikingly, light itself is painted onto the set, an innovation unnecessary even in the most barely furnished of stage musicals, never mind the lavishly budgeted arena of the MGM musical. This is of course not unprecedented; think of the darkly lit storm clouds painted on the cavernous backdrop in the "Pirate Ballet" number in Minnelli's 1948 *The Pirate,* or indeed the exterior soundstage set of any number showing the sky. The difference here is the immediacy of the lit object: not a cloud, which cannot be physically imported into the studio, but a fixture hanging over a table—an actual table, mind you—whose simple nature as an everyday object calls attention to the stylistic decision to paint its light abstractly instead. Hazy patches of white outlined by orange and progressively deepening into the red of the rest of the room indicate the glare of lights where none are actually present. "Ceiling mounted" fixtures are painted on the walls, with flocks of stylized yellow crescents underneath to indicate the light emanating from them. Here, a live-action film is employing animation's means of representing space, depicting the play of light by painting simplified forms on a two-dimensional surface rather than actively placing and manipulating light itself. This aggressive, pointedly artificial flatness operates as the inverse of

Singin' in the Rain (Stanley Donen and Gene Kelly, 1952), "Broadway Melody."

UPA's creation of depth through the arrangement of flat shapes. Here, *Singin' in the Rain* creates flatness through the arrangement of its three-dimensional space.

It is worth noting that in all of the musicals mentioned above, the abstract spaces and cartoonish representational strategies are tightly contained and cordoned off from the film's "real world," existing purely for the moments of spectacle enabled by the song break. Whether through the narrative device of a diegetic stage show, as in *The Band Wagon,* or of an interior psychological space—fantasy, reverie, memory—as in *An American in Paris* and *Singin' in the Rain,* moments of modern design in these films are located in a fictionalized elsewhere that is subordinate to, or at the very least outside of, the real world that reasserts itself the moment the dancing stops. In this hierarchy, we have the alternating solicitation and repulsion of the design gaze; outside of the modernist song-and-dance numbers, we witness thoroughly classical cinema.

Consider instead—and again—*Funny Face,* a thoroughly modern romance set in the fashion world of Paris. More specifically, consider the opening "Think Pink" scene, which similarly employs the spectacular nature of the musical number for design-based purposes, but in a slightly different

Funny Face (Stanley Donen, 1957), "Think Pink."

way. Here, the eruption of full-on graphic design into the film—including a brief glimmer of true-blue (or true-pink?)[50] animation when a model swirls a lively ribbon of toothpaste into cartoon curlicues that glow with independent, hand-drawn life—plays with the surface of the frame in a way that the other films don't. As various figures enter the frame, often simply winking into existence against a blank black or white background, they confuse the space they occupy. What sometimes appears to be an empty soundstage becomes an abstract void in which dancers and high-divers, all dressed in pink, float in their own quadrants; a seemingly open—if strangely empty—space becomes fragmented, flattened, like a page of a magazine. It is no longer a three-dimensional world that people navigate, but rather a graphic space operating outside the laws of physics. The catch is that it is actually happening within the framework of the narrative, rather than occupying the pointedly artificial spaces of the previously discussed films. No stage set, no fantasy; this is happening right in the *Quality* magazine office.

This is not the only blurring of the line between modernist form in the musical number and the otherwise realist depictions of the interstitial scenes. In another scene in the film, Hepburn and Astaire musically romance each other in a darkroom, the red light washing the entire frame in a red glow. This play with monochromatic color fields also participates in the modernist

experimentation we find in UPA animation and beyond, but again sutures it to the real world outside the privileged space of the musical number. Yet even here, we must not forget that we are in a film that is *about* modern design: fashion, photography, the graphic design of the magazine spread. In this way, the visual experimentation is authorized by the modernness of the surroundings—note the absence of modernist stylings in, say, Jo's (Hepburn's) antiquarian bookstore.

It is, I argue, in Paramount's 1954 musical *Red Garters* that the modern design of the musical reaches its cartoonish apotheosis. Like *Singin' in the Rain,* this film satirizes Hollywood, but it does so by merging with that most unmodern of genres: the western. However, If *Singin' in the Rain* flirts with cartoon modernism in its "Broadway Melody" sequence, *Red Garters* goes both further and broader with the conceit, reducing its backgrounds to absolutely blank color fields—no texture, no painted-on accessories—and extending this practice across the entire running time of the film. Many reviews at the time focused on these backgrounds, referring to the film's "stylized, unrealistic props set against backgrounds of vivid gold and red Technicolor" and declaring, "Through sheer dramatic presentation of appointments in pastel colors and in stylized sets, 'Red Garters' has a powerful visual punch."[51] Getting more specific in addressing its use of nondescriptive color, the *Chicago Daily Tribune* review praised the film's "eye taking backgrounds. Some of the sets offer saffron sands and skies, showing tall grey trees with silvery leaves; other scenes contrast a brilliant cobalt blue with dead white. All of them are interesting."[52] In seeking a point of comparison, Bosley Crowther described the film's "frankly artificial décor" as "the sort of scant, symbolic scenery that is familiar to the stage."[53] However, some critics saw in the film's backgrounds the influence not of the stage, but of graphic design; the *Los Angeles Times* review observed, "Pictorially it will seem to most eyes more like a colored postcard than anything else."[54]

Only one reviewer, however, compared the film to animation, in *Variety*: "Actually, about the closest description of the look worn by the picture would be that it resembles a live-action UPA cartoon. This is particularly true of its seeming flatness, in the use of only suggestions of scenery and props, and in the monotones of its colorings. Props, colors, and action are so arranged as to try for an illusion of depth without 3D."[55] This "illusion of depth without 3D" is precisely the spatial dynamic UPA sought with its design-based visual style, as opposed to the multiplane camera's actual engagement with the third dimension to create depth in the filmic image. The *Hollywood Reporter*'s

Red Garters (George Marshall, 1954), "Brave Man."

review is likewise telling, referring to "the impressionistic backgrounds soon becoming realities to the eye, yet achieving an aura of fantasy that is in keeping with the caricature mood of the piece."[56] Fantasy and caricature, two terms closely aligned with discussions of animation's unique properties, also characterize the visual approach in *Red Garters*.

The film's visual style is, in fact, remarkably similar to that of *Gerald McBoing Boing*, all flat color fields with window frames and doors floating in empty space, symbolizing objects rather than representing them fully. The use of nondescriptive color pushes the western-musical into the realm of the cartoon, a play with color and spatial representation that recalls UPA's methods of expanding depth through two-dimensional planes. In the "Brave Man" scene, set in a minimally furnished bedroom, two window frames hang suspended against a sky-blue color field, each angled differently to give the impression of belonging to two perpendicular walls. As in UPA's *Christopher Crumpet's Playmate* (see chapter 2), these reduced, simplified forms create space out of pure color, their orientation toward different vanishing points creating architecture in the spectator's eye. In the absence of wall lines, directional vectors simulate them out of empty, brightly colored air. Likewise, the

Red Garters (George Marshall, 1954), "Meet a Happy Guy."

"Meet a Happy Guy" scene, unfolding on a stairwell, resembles nothing so much as UPA's *The Tell-Tale Heart,* doorframes and banisters rising up into blue nothingness, constructing a transparent architecture generated by the movements of the human actors through the otherwise unmarked, empty space. Here, as in *Singin' in the Rain,* Hollywood cinema uses color fields in particular ways to delineate space. If these stylistic practices of set construction, historically speaking, can be traced back to the stage, aesthetically speaking they belong right alongside the modern cartoon, both of them carrying out visually similar experiments in flatness and depth.[57]

If the modern cartoon uses flat forms to create perceptual sensations of depth, live-action cinema, working in three-dimensional shooting space as opposed to animation's two-dimensional cel, bears a more complicated relationship to these questions of spatial representation. Anchored to the real world in a way that cartoons are not, live-action cinema must deal with the contrast between design and photography that animation freely avoids. The use of color fields *reduces* depth in *Singin' in the Rain;* Gene Kelly and Cyd Charisse's rounded bodies and balletic movements, modeled by shadow and extending backward and forward in space, starkly contrast with the

ostentatiously flat backgrounds and give the impression of real people navigating a flat, cartoon world. Conversely, in *Red Garters* the use of color fields opens space up, directing it outward by establishing directional vectors with minimally rendered props, dramatizing modern architecture's methods of animating space in a fashion complementary to that of the cartoon. Here, the flesh-and-blood actors seem to activate a space that expands around them, rooms being generated by the passage of real bodies through them—"a live-action UPA cartoon" indeed. This, then, is the true function of the cartoonish in the live-action Hollywood film, and the way in which the design gaze can do its work: *Red Garters* does not so much (or does not only) *look* like a cartoon; more importantly, it *works* like a cartoon, at the level of the visual surface of the frame. It obliges the spectator's eye to carry out exactly the practices the rhetorical modernism of midcentury design is aiming to teach, in all of the mediums in which it does its work.

In the musical, a genre historically linked to the cartoon, Hollywood engaged in the kind of spatial experimentation that midcentury cartoons were busily carrying out in their own design practices. Using color to delineate space and to call into question its stability as a defined three-dimensional environment, live-action and animated cinema both played games with perception, smuggling midcentury design philosophies of space and vision onto American screens under the cover of lighthearted spectacle and whimsical entertainment. Yet this experimentation took place in the more sober realms of film culture as well. As we shall see, the hallowed chambers of the avant-garde were themselves no stranger to the modern cartoon, nor to its particular form of visual modernism.

MACHINES FOR DANCING: AVANT-GARDE CINEMA AND MOBILE ABSTRACTION

As animation gained credibility in the postwar years due to its increasing presence on television screens among discursive markers of right-thinking middle-class taste, its fingerprints on the visual styles of major Hollywood releases, and contemporary critics' linkages of the form with art, it also gained prominence in more rarefied circles. The Museum of Modern Art's 1955 exhibit devoted to modern animation, *UPA: Form in the Animated Cartoon*, offers one point of intersection between animation and the intimidating, exclusive environs of serious culture. High culture bestowed even

further stamps of approval on the work being carried out at the studio, acknowledging the aesthetic dialogues taking place between the cartoon and the more esoteric practices of independent filmmakers. More specifically, UPA's aesthetic approach resonated with developments occurring in the postwar avant-garde, which was itself encountering a new artistic environment at midcentury, spurred by the availability of newer, cheaper, more portable filmmaking technologies. Here, as in the Hollywood musical, we may find traces of the design-oriented modernism of postwar animation, and thus a new sense of the kinds of modernism at work in the American avant-garde.

In the historiography of the American postwar avant-garde, another definition of cinematic modernism reigns, one involving notions of medium-specificity, an attention to the physicality of film as a material object, and a turn toward surrealism, mysticism, and personal expression. Film scholar James Peterson, for instance, refers to "the Modernist effort to destroy the illusionism of art," in which "[Stan] Brakhage and the Structural filmmakers do not suppress the material nature of the film strip in the way that films with understandable images do. Instead these filmmakers *examine* the status of the film object."[58] For Peterson, this modernism surfaces in the avant-garde cinema as "expressions of purity, such as unmediated views of subjectivity or open displays of the essential features of the medium."[59] It is perhaps telling that one of Peterson's touchstones for this definition of modernism in avant-garde cinema is Clement Greenberg, onetime champion of Abstract Expressionist painting and devoted antagonist of kitsch the world over.[60] And Peterson is not alone in linking the American avant-garde to Abstract Expressionism; seminal historians of the period repeatedly link the two movements, including Annette Michelson and P. Adams Sitney, who declares, "The preoccupations of the American avant-garde film-makers coincide with those of our post-Romantic poets and Abstract Expressionist painters."[61]

Yet as I argued in chapter 1, there is another midcentury modernism that diverges from the Abstract Expressionist model, one that recalls an earlier moment in American modernism marked by Precisionism, a more geometrical, ordered, and representational sort of abstraction. This is not to say that the link between the postwar avant-garde and Abstract Expressionism is false. The links between, for instance, action painting and the lyrical film are quite apparent, and Brakhage and Jackson Pollock are cut from the same aesthetic cloth. It is rather to say that we may find another dimension of postwar experimental film practice that is in dialogue with the strain of

modernism outlined in the previous three chapters, one that is closer to modern animation in its aesthetic and closer to modern design in its goals. Charles and Ray Eames, perhaps the best-known practitioners of midcentury modern design, produced both experimental films and modernist cartoons. However, the links between design, animation, and experimental film are not always so idiosyncratic. As Lev Manovich notes, "one of the major impulses in all avant-garde filmmaking from Léger to Godard was to combine the cinematic, the painterly, and the graphic."[62] The merger of the modern cartoon and the avant-garde occurred on a more widespread level.

The main location of this merger lies in two American film societies that emerged after World War II: San Francisco's Art in Cinema, founded by Frank Stauffacher and Richard Foster under the auspices of the San Francisco Museum of Art in 1946, and New York City's Cinema 16, founded by Amos and Marcia Vogel the following year.[63] Formed to provide both an outlet for filmmakers working outside of the Hollywood system (and outside of the Hollywood style) and an education for audiences eager for a different kind of engagement with cinema, these film societies trafficked in various kinds of filmmaking: socially conscious documentaries, silent classics, industrial and scientific films, imported art films, and, perhaps most important to their reputations and legacies, experimental and avant-garde film. During this period, the center of gravity of the international experimental scene shifted to the United States, where avant-garde heavyweights such as Maya Deren, Kenneth Anger, Hy Hirsh, Shirley Clarke, Jonas Mekas, and Stan Vanderbeek, among many others, defined the concerns of a generation of experimental filmmakers.[64]

Amid the high seriousness of these societies and their self-presentations—which included ambitions of "building up a well informed public, exigent and aware, where artistic quality is concerned" and "greater international and interracial understanding and tolerance"[65]—it is perhaps mildly surprising that both organizations featured repeated engagements with UPA. Cinema 16 hosted an annual screening of the studio's most recent shorts, which their Fall 1954/Spring 1955 program identifies as "one of Cinema 16's most popular features."[66] This is not mere marketing copy; a 1953 survey of the society's membership named *The Unicorn in the Garden* the top choice in a popularity contest.[67] While the program announcement of the first showing in the spring of 1951 referred to "United Productions of America ... whose outstanding films promise to revolutionize the American cartoon field," the matter was settled a mere six months later, when the editorial copy was changed to read, "... who are revolutionizing the American cartoon field," a

designation that remained in all future announcements of the UPA program.[68]

Art in Cinema, meanwhile, invited UPA founder Stephen Bosustow to speak about "the group that created an entirely new animated film" and to show some of the studio's most famous shorts in May 1954 for a series entitled "Aspects of the American Film: The Work of Fifteen Directors."[69] Additionally, they dug deep into the studio's nontheatrical catalogue, showing in 1947 the previous year's training film *Flat Hatting,* produced to be shown not to general audience, but to U.S Naval recruits.[70] Stauffacher even attempted to put Maya Deren and John Hubley in touch, saying in a letter to Deren, "He has done some interesting [films] himself and we are going to include them on our ANIMATED FILM AS AN ART FORM program. You might write to him if you are interested, although I know that you are more interested yourself in imaginative reality."[71] "Imaginative reality" seems to allude to Deren's work in live action rather than animation, but Stauffacher's assumption of some kind of common interest between Deren and Hubley draws a compelling line between modern animation and the most avant-garde of the American avant-garde. In a 1992 interview, experimental filmmaker Jordan Belson claimed: "In many ways abstract films were the 'cartoons' of art film programs"—but in fact it seems that *cartoons* were the cartoons of art film programs.[72]

Yet there is some significant aesthetic overlap in the visual styles of the cartoons and the art films showing on these art film programs. If modern animation's engagement with modern design wanted to develop a modern vision, postwar avant-garde filmmaking was equally concerned with explorations of vision. Its solutions signal a shared process of learning and exploration taking place in cultural organizations like Art in Cinema and Cinema 16, and a shared investment in the questions of vision and modernity circulating throughout the design world. By focusing on abstraction, color, and shape as a means of working through the technological, spatial, and social developments of the mid–twentieth century, experimental film entered the conversation already in full swing between animators and designers.

This modern vision becomes acutely symbolized in Pat O'Neill's avant-garde film *7362* (1965–1967), in which footage of oil rigs and dancers is manipulated through high-contrast printing to become ceaselessly metamorphosing, intersecting, and intertwining Rorschach blots of abstract form and color. Film historian Malcolm Le Grice places O'Neill within the West Coast tradition of the postwar avant-garde, of which he observes, "The

motive in West Coast work is graphic, the creation of abstract visual elements and manipulation of colour and rhythm." O'Neill's films, he argues, "tend to retain a basically graphic character—a complex form of image montage or combination separating the resultant image from its source and procedure."[73] Le Grice is not wrong; *7362* is overwhelmingly graphic, and over the course of the film's nine minutes, the clear images of machinery and human bodies are indeed stripped of their real-world reference to become brightly colored shapes pulsating in and out of each other. However, rather than the subsiding of representation in favor of abstraction, it is precisely this tension between the two that gives the film its visual and conceptual charge. Tellingly, avant-garde filmmaker David Curtis places the film in a lineage of modernist animation, observing, " *7362* begins as an 'absolute' film in Richter's and Ruttman's sense—pure circles of light bounce on the black screens. They establish not only the rhythm of the film but the terms in which the subsequent brilliant colour images ... should be viewed."[74] However, if the film *begins* in this mode, its departure is equally significant, and this departure places the film in its contemporary moment alongside the design theories of Kepes and Moholy-Nagy. Even as the forms that begin as oil pumps and dancing bodies gradually surrender to abstraction, the memory of what they were informs the film's point; seen through the lens of *Vision in Motion*'s call for a better balance between technology and the human, *7362* thus becomes an exemplar of the midcentury modernist impulse to repair the rifts between the two through reduction to abstract form.[75] As these two types of imagery in O'Neill's film submit to the logic of shape and color, they merge into indistinguishable similarity, finding a visual union through abstraction that echoes the American Bauhaus's own solutions to postwar America's plight.

In a similar vein, Shirley Clarke's 1958 experimental film *Bridges-Go-Round* couples O'Neill's engagement with questions of color, form, and vision with an exploration of space, transparency, and directional vectors similar to the spatial play of UPA. Carrying out a thorough re-visioning of the external world, *Bridges-Go-Round* employs both abstraction and superimposition to set architecture in motion through an engagement with the bridges over New York Harbor, including the Brooklyn Bridge. In what film scholar David E. James calls "a short visual dance," Clarke often reduces the architecture of these bridges to high-contrast black-and-white linework or simple black silhouette, then tints the film stock to produce bold, brightly colored fields as a backdrop to the "dancing" of the bridges generated by the movement of her camera.[76] Superficially, the technique resembles that of *Red*

7362 (Pat O'Neill, 1965–1967).

Garters, with solid lines on blank color fields. However, where *Red Garters* uses its lines to establish a coherent spatiality, *Bridges-Go-Round* does the opposite, reducing the image to line and color to create a sense of spacelessness, cutting off the bridges from their terrestrial anchors and sending them careening through chromatic space. The interwoven criss-cross patterns of struts and support beams twist around each other against empty fields of red, yellow, purple, and lime green, sometimes doubling up to form a two-layered composition of black lines on vivid colors. Assembled from leftover footage from a State Department–funded project aimed at documenting the American way of life, the imagery of *Bridges-Go-Round* does in fact capture the American way of life, but in a decidedly oblique way, one more oriented toward the visual culture introduced by television, animation, and modern design.

Swirling around the bridges in a series of aerial shots, the original footage repurposed for Clarke's avant-garde experiment clearly offered majestic, sweeping views of American ingenuity and architectural know-how, as well as kinetic shots filmed from a car traveling along the Brooklyn Bridge and more prosaic, static shots of fast-moving traffic. By reducing this footage to

Bridges-Go-Round (Shirley Clarke, 1958).

simplified abstract form, Clark focuses specifically on the movement of lines and shapes rather than on the bridges as architectural feats. The result, James's "dance," becomes something more than that, what Curtis calls "a study of the patterns made by bridges in space, their massive power, and the *particular quality of motion that is given to bridges when moving in relation to them.*"[77] This motion takes many forms, particularly as understood alongside Moholy-Nagy's various definitions of his central concept of vision in motion, which include "seeing while moving" and "seeing moving objects either in reality or in forms of visual representation. . . . The spectator, stimulated by the specific means of rendering, recreates mentally and emotionally the original motion."[78] *Bridges-Go-Round* satisfies both of these definitions. It fulfills the first not only by the mere fact of the moving camera's sweep across the bridges, but also in Clarke's own intervention of editing these movements, placing them alongside each other in time (and, in the case of her superimpositions, in space) to create a new experience of planned movement, organized into a visual dance. The second, the mental re-creation of movement in the experience of Clarke's representation, rests on the same premises of abstract form informing modern animation and architecture. Strong

directional vectors lead backward to vanishing points and forward out of the frame in the original shots; when doubled by superimposition, they merge into a complex network of directional forces that animate the silhouetted shapes in a perceptual motion over and above the motion conferred by the moving camera. If modern architecture and animation use immobile components to generate motion in the eye of the spectator, *Bridges-Go-Round* adds to this dynamic the actual movement of cameras mounted on helicopters and cars.

That said, for Moholy-Nagy, vision in motion is also "simultaneous grasp," which "instantaneously integrates and transmutes single elements into a coherent whole."[79] Clarke's superimpositions of the bridge footage combine with her practice of optical printing in surprising ways. In many shots, two separate views of the bridges enter the frame from opposite sides, hovering in an unstable float before gradually converging at the center of the frame. The two separate images realign into a single new one, the two networks of lines congealing into a full-screen abstract form. This simultaneous registration of two separate images gives the viewer two discrete things to watch until they merge, a visual shift that relies on abstraction for its eventual union. Throughout the film, the inanimate is animated: stable architecture becomes an autonomous, dancing body through the combined methods of modern design, merging the reduction to abstract form, superimposition, and the generation of movement in the spectator's eye to breathe life into cold, hard iron. Employing techniques used throughout various fields of artistic production, including architecture, animation, and graphic design, *Bridges-Go-Round* is a thoroughly designed engagement with the modern world, offering new modes of vision and new ways of understanding the world through that vision.

NIGHT VISIONS: WILLIAM KLEIN, THE LIGHT-SPACE MODULATOR, AND FILM NOIR

Near the end of *The Band Wagon,* in a sequence called "Girl Hunt Ballet," Fred Astaire wanders into a film noir. It's a jarring moment, not only because the vivid color scheme of the rest of the film suddenly leaches out into black-and-white cinematography, but also because we watch the musical briefly merge with a genre that could not seem to be further away if it tried. What becomes clear, however, is that no matter how opposed they are to each other

The Band Wagon (Vincente Minnelli, 1953), "Girl Hunt."

thematically, they belong together *visually*. The same process of abstraction that we see in so many other musical numbers—the flattening of the represented world, the reduction of the scene to simplified blocks of color, the stylized artificiality of the proceedings—is alive and well here, and this visual approach draws a line between the musical and the film noir. As Astaire, in full noir detective gear, recites a Spillane-esque interior monologue, he stands in front of an emptied-out cityscape in which the barest forms of buildings are suggested by blocks of light representing windows, urban space reduced to simple geometry. What stands out here—to the design gaze, at least—is a sense of dematerialization, a world made insubstantial and transparent, isolated forms hanging in the blackness of night.

This is all, of course, very noir. Discussing Edward Dmytryk's 1944 noir *Murder My Sweet*, film and architecture scholar Edward Dimendberg describes a similar scene: "Simultaneously dematerialized and encircled by the night, valorized yet presented as tawdry and insubstantial, this illuminated city also suggests the perceptual modality of the automobile."[80] It is hard not to hear in this echoes of Moholy-Nagy's "vision in motion," a rationale for a new design language brought about by the increasing mobility of an automobile culture

and the constantly speeding eye that it conjures. And for good reason: *Vision in Motion* is the source of the chapter's epigraph, and Dimendberg's exploration of the film noir here is premised on the notion of "centrifugal space," an urban fabric that is stretching outward and emptying out due to the geographical effects of a burgeoning car culture in midcentury America. And he is right; the emptying out of the city is one of the prime determinants of noir's seedy, desperate, back-alley feel. However, I would like to think about this dematerialization another way: in terms not of motion, but of light. To do so, we must take our own detour and examine a film that melds avant-garde practice with a noirish design sensibility: William Klein's *Broadway by Light* (1958).

William Klein's strange place in postwar artistic culture straddles design, animation, art cinema, and experimental film. His position at the nexus of these various currents makes him a compelling case study for the cross-fertilization of design, animation, and cinema in American film culture. Moreover, his biographical and conceptual connections to Kepes and Moholy-Nagy offer a way to put his own stylistic practices into conversation with other fields concurrently feeling the influence of these two designers, providing new contexts for such seminal Hollywood phenomena as film noir and Marvin the Martian. Unlikely bedfellows, to be sure, but then, the design principles developed in midcentury animation and percolating through live-action cinema make for a big bed, and this particular union, I believe, allows for revelatory readings of old favorites.

A photojournalist and fashion photographer, Klein made documentary and experimental films, as well as a body of art films in the 1960s, including *Who Are You, Polly Maggoo?* (1966) and *Mr. Freedom* (1969). Born in the United States but living in France, Klein is perhaps best known for bringing an American influence to the art cinema as art director of Louis Malle's *Zazie dans le Métro* (1960), a quasi-Surrealist, madcap romp through the streets of Paris directed by New Wave filmmaker Louis Malle and released in the U.S. in 1961.[81] The Austin Film Society's director of programming Chale Nafus points out, "Philippe Colin, first assistant director on *Zazie*, had written a study of Tex Avery's work, and Malle asked him to write a list of gags found in the Tom & Jerry cartoons."[82] This Avery/M-G-M sensibility has often led the film to be described as a live-action cartoon, marked by fast-motion cinematography, trick editing, and gag-loaded chase scenes. Klein, as art director and visual consultant, brought to the film distorting fisheye lenses and a bright, exaggerated color scheme that help create the feel of an animated film within *Zazie*'s live-action mise-en-scène.

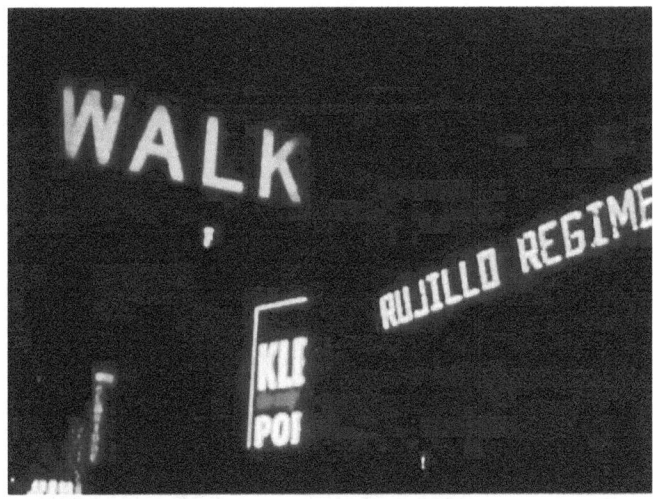

Broadway by Light (William Klein, 1958).

Yet Klein's connection with animation runs deeper, and into less literal territory. As a photographer and avant-garde filmmaker, Klein explored the visual environment of New York City in the mid-1950s, resulting in perhaps his most famous publication, *New York: 1954–1955,* as well as a lesser-known but more suggestive experimental film titled *Broadway by Light* (1958). The film captures the lights encrusting the buildings of Broadway, flashing, traveling, and constantly animated as they advertise the products of their sponsors or the goings-on within the buildings they adorn. Using high-contrast cinematography, Klein reduces the visual field to multicolored light, rendering the architectural supports of these lights invisible, an undifferentiated black background. Blinking words and icons thus hang suspended in air, pure projections of light unmoored to the physical environment of the city, sometimes even overlapping in postproduction superimposition (recalling, incidentally or not, the opening of *Singin' in the Rain*'s "Broadway Medley" sequence with its Broadway lights suspended and overlapping in midair). It is only when the sun rises over the Manhattan skyline that New York as a material location becomes visible, and it suffers by comparison to what has come before; it is sad, visually crowded, dead. The previous evening's lights, an animated galaxy within reach floating in empty space and offering illusions of depth and infinity, give way to buildings obstructing views of other buildings, closing off the infinite expansion of nighttime and replacing it with a sea of dingy earth tones and prisonlike scaffolding. In *Broadway by*

Light, light is linked with freedom and life, figured as a societal survival mechanism in an opening preamble: "The Americans have invented jazz to console themselves about death, the star to console themselves about women. To console themselves about night, they have invented Broadway."[83] More importantly, this illusion of life depends on the removal of excess (and unpleasant) visual information and the reduction of the built environment to lines of light and spots of color, the transformation of an overstuffed and unpleasant visual surround to simplified design.

That Klein would present this view of New York City is unsurprising given his outspoken investment in the prevailing principles of midcentury design. As David Campany observes, "Back in the darkroom he explored pure light, form and materials. It was a self-education guided by László Moholy-Nagy's book *Vision in Motion* and György Kepes' *The New Landscape.*"[84] In many ways, *Broadway by Light* is Klein's completion of proposed projects occupying Kepes during the war years. Art historian Judith Wechsler recounts a story in which the United States Army commissioned Kepes's Institute of Design to devise a system of urban camouflage. Kepes flew over Chicago, constructing a plan to suspend cables of lights over Lake Michigan in order to "dislocate the night landmarks" of the city, hoping to confuse enemy planes about the true layout of the city so that they would drop their bombs into the water rather than onto Chicago itself.[85] This "orchestration of the urban nightscape," a nightscape that is categorically, geographically different from the dayscape, finds a filmic echo in Klein's film, in which the spatial experience of New York at night is utterly irreconcilable with the vision of the daytime city that closes out the film.[86]

As in *Broadway by Light,* the idea of light without material supports animated much of midcentury design thought. The representation of urban space as dematerialized light is also central to the modern cartoon, as in the minimalist rendering of skyscrapers as yellow rectangles within a frame-wide purple polygon in *Mister Magoo's Christmas Carol* (1962). In reducing the urban surround to abstract form, it seems the walls are the first thing to go, dispensable in light of, well, light. Kepes saw this coming in 1944; in *Language of Vision,* he writes, "Buildings that were modelled under the sun into a clear sculptural form, under the simultaneously acting artificial light-sources lose their three-dimensional quality. Contours are obscured. The light spots, coming from inside and outside simultaneously, and the fusion of luminosity and chiaroscuro, break up the solid form as the measuring unit of space."[87]

That is, in the face of the visual experience of light, material form recedes, disintegrates. Design historian Michael Golec went so far as to claim that Kepes's entire model of vision rests not only on a dematerialization of the world, but on a concomitant dematerialization of the self into a floating, disembodied eye.[88] Modern design need not go quite that far for everyone, however. For Moholy-Nagy, the plastic manipulation of light at the expense of its material supports was a matter that could be addressed not in the erasure of the body, but rather in the cinema. In *Vision in Motion* he argues: "The film stage of the future will be conceived as a structure for the production of motion, light, and shadow effects either with skeleton constructions or walls, planes, surfaces and textures for absorption and reflection, for the organized distribution of light. Such a scenic concept—not 'background'—will be a tool for vision in motion rather than a setting for sentimental naturalism."[89] In short, the physical objects in the profilmic scene are merely there to create plays of light and shadow; this light and shadow, not the stuff it illuminates, is to be the film.

In 1930 Moholy-Nagy brought just such a vision to light with his sculptural work *Light Prop for an Electric Stage (Light-Space Modulator)*. A collection of rotating, perforated discs and rods made of glass and metal, the *Modulator* was intended for use on the stage as a means of creating elaborate effects of light and shadow. As the discs and rods revolved and rotated, light from bulbs installed behind them would alternately pass through, be blocked by, or reflect off of the moving surfaces. Key to the whole enterprise was the fact that the sculpture was not the point; the light show it produced was. Here, as in the case of *Broadway by Light,* material form provides an excuse for light effects to happen, receding into invisibility in the face of the play of colored beams of light and shadow. This privileging of light at the expense of matter carried forward into Moholy-Nagy's teaching at the New Bauhaus and his writing, visible throughout *Vision in Motion*. (It is perhaps no coincidence that in 1948, when *Looney Tunes* villain Marvin the Martian made his premiere, his main means of mayhem was the suspiciously Moholian "Illudium Q-36 Explosive Space Modulator." In reality a stick of dynamite, its objective is to blow up Earth in order to secure Marvin's unobstructed view of Venus, again advocating dematerialization in favor of the passage of light.)[90] Following this theorization of the play of light and shadow as the primary objective of cinematic art, we may perhaps draw a line back to that most distinctive Hollywood form, the film noir.[91]

László Moholy-Nagy, *Light Prop for an Electric Stage (Light-Space Modulator)*. © Estate of László Moholy-Nagy / Artists Rights Society (ARS), New York.

A reevaluation of noir in light of the cartoon is perhaps not as unlikely as it first sounds. Linking animation and noir, film scholar Richard Thompson observes: "And cartoon images, like *film noir*, and good surrealism, occupy our attention for their flashy virtuosity while on another level they slowly corrode away the legs of rational conceptions of the world."[92] To be sure, Thompson's "rational conceptions" are about things such as order, morality, justice, institutions—rational conceptions about how the world works. However, we may also view noir as corroding away the legs of rational *visual* conceptions of the world, putting in their place a conception that resonates with modern design. The distinctive "look" of noir has been traced back

(rightly, in my view) to various sources, paramount among them German Expressionism, but also French poetic realism, Italian neorealism, American city painting, and Abstract Expressionism.[93] Roughly, noir's visual signature includes such stylistic traits as black-and-white cinematography, a heavy use of chiaroscuro, low and canted angles, and long shots isolating characters within forbidding environments. These traits have clear antecedents in the film and art practices mentioned above, but they also, put together, add up to a common tendency to compose a frame that can be quite readily read with a design gaze as an abstract arrangement of line and shape, light and shadow.

Film scholar Patrick Keating refers to the lighting challenges noir presented to cinematographers: "When the shadows get too dark, they stand to violate a number of other conventions: creating flat planes of blackness that betray the illusion of roundness, obscuring information that is important to the narrative, or producing strong contrasts that destroy the star's glamour."[94] Keating discusses these possibilities as failures in the filmmaking process—but removed from the discourse of classical form and viewed instead in the framework of the design gaze, we may view the film noir as offering the same kind of abstraction found in the modern cartoon and other design-oriented fields. In this sense, one of the defining phenomena of midcentury Hollywood cinema lines up with the midcentury modernism spreading across other areas of American cultural production. Consider noir's famous use of the silhouette: Leonard and Susan framed against the smoke-filled beam of a spotlight in *The Big Combo* (1955); the black, oddly insectile figure on crutches confronting the spectator in the opening of *Double Indemnity* (1944); detective Bradford Galt lurking in the dark of his office while a thief ransacks the adjoining room in *The Dark Corner* (1946). These aren't betrayals of the illusion of roundness; they are a deliberate courting of flatness and a deliberate obscuring of information—or rather, as in the avant-garde *Bridges-Go-Round,* a reduction of visual information to a simple outline filled in with solid color, much in the form of a modern cartoon.

Noir's play with light and shadow bears an even closer relationship to this midcentury modernism, one that resonates with Moholy-Nagy's *Light-Space Modulator* (and even with Marvin the Martian's Space Modulator, though perhaps only in its destructive intent) as a means of crafting a cinema made of light rather than of objects. In their abstraction of the visible world, UPA's pointedly unrealistic cartoons dematerialize that world—it is no coincidence that realism is often modified by the phrase "flesh-and-blood." Reducing the

Double Indemnity (Billy Wilder, 1944).

complex physical world to line, shape, and color, modern animation in a sense transforms things into light—or rather, foregrounds their status as patterns of light on a screen in a way that a naturalist approach aims to obscure—making luminous fields of vibrant color out of the visual material of the everyday world. Film noir's signature venetian blinds, patterned and backlit screens, and tightly focused shafts of light piercing otherwise dark spaces likewise place an emphasis on the arrangement and movement of light and shadow at the expense of the objects producing them.

To return to *Double Indemnity,* for example, whatever thematic and symbolic purpose is fulfilled by the oppressive bars of shadow cast by the venetian blinds in Phyllis Dietrichson's house, from the perspective of the design gaze we are not seeing the shadow of venetian blinds. The blinds are merely a flimsy excuse for a composition in light and dark, the intricacy and severity of the shadows so exaggerated that it would be ridiculous to claim this as an instance of motivated lighting. Similarly, in the climactic chase sequence of Rudolph Maté's 1949 noir *D.O.A.,* a long shot of an upper-floor landing becomes an exercise in shadowcasting, the ornate ironwork of the railing

D.O.A. (Rudolph Maté, 1949).

forming the highlight of the scene, no matter what existential extremity protagonist Frank Bigelow is experiencing in the moment. These paradigmatic noir images define the film form, and even their less elaborate and less famous counterparts engage in this kind of visual play. As mentioned above, the heavy hand of German Expressionism is a clear antecedent for this mode of representation, but it is not the only explanation. The construction of film sets for the express purpose of casting light and shadow is also linked to noir's contemporary design environment.

Noir's sets are, in this context, not descriptive or representational, not even symbolic or expressionist; they are Moholy-Nagy's "skeleton constructions or walls, planes, surfaces and textures for absorption and reflection, for the organized distribution of light." They are the *Light-Space Modulator* given cinematic form. Film noir, as the mainstreaming of Moholy-Nagy's installation art, thus smuggles this particular strain of design-based modernism into the heart of classical Hollywood. In his epilogue, Albrecht positions noir as the end of modernist design in Hollywood: "During the 1940s ... modern décor virtually disappeared from the movies," he argues. Noir "was

an unsuitable vehicle for the modernist aesthetic of the previous decade. The film noir's favorite theme of entrapment within a closed society ran counter to modernism's connotations of spatial openness, social mobility, and escape, while its cinematography explored dark and menacing shadows, reversing the modernist's manipulations of brilliant light."[95] While it may be true that noir does not work for the modernist aesthetic of the 1930s, it *does* work for the modernist aesthetic of its own decades. Albrecht is right that noir does not feature modern décor—nor did the musicals explored in this chapter. But if modernist décor disappeared from the movies, modernist visual language filled the vacuum left behind. Yes, the film noir lacks the utopian dreams of modern design, lacks all hope for a better world; however, I would argue that noir is very much characterized by "the modernist's manipulations of brilliant light." There is simply less of it. And in the oppressive shadow of the film noir, there is the dark twin of Moholy-Nagy's light-filled, air-walled buildings, his transparency and insubstantiality of matter. The physical world recedes and light, shape, pattern, and composition—that is, design—takes over. We may therefore find in film noir another instance of the modernism found throughout this chapter in not only Hollywood musicals, but also the midcentury avant-garde, as well as, of course, the cartoon, where this modernism was worked out in its fullest form.

Tying together all of these various branches of cinematic practice, the principles, concerns, and visual approaches of modern design extended their roots into postwar filmmaking writ large, illustrating the diverse impact of midcentury animation's particular expression of modernism on American cinema. To put this differently, there is another modernism in the postwar cinema, and it is explicitly visual. It connects the medium of cinema not to literature and drama, but to design, and to the visual experiments and explorations of the modernism we find in Kepes, Moholy-Nagy, and UPA. To view cinema as a participant in this interdisciplinary modernism is to rethink its relationship to animation. For film studies, animation is both essential to the discipline's self-understanding and a marker of how thoroughly it is enmeshed in the concerns of design. Far from being "cinema's bastard relative, its supplement and shadow," then, animation is the avatar of a modernism that spread throughout the visual and spatial arts in the postwar era.[96] Esther Leslie wryly observes, "Cartoon trash could cast the most curious and fantastic lights."[97] One of the places animation may cast some light is on film, and without it, a significant part of its history remains dim.

USEFUL ANIMATION? RHETORICAL MODERNISM AND THE PEDAGOGICAL IMPULSE

Ultimately, in charting the points of contact between animation, live-action Hollywood cinema, and the avant-garde, we find a particular sense of purpose, a pedagogical impulse that brings all of these forms into the orbit of another category central to film studies: useful cinema. It may seem perverse to advocate for the presence of Gerald McBoing Boing and Mr. Magoo in the ranks of useful cinema—a term generally reserved for sponsored films, industrial training and educational films, advertisements, and other "nontheatrical" or "nonentertainment" cinema—but it is worth remembering that UPA began as a sponsored film outfit. Years before Gerald, Magoo, or even their early Fox and Crow duo, the studio made industrial and military training films, commercials, and other films with a strictly utilitarian bent, and they continued making advertisements during their theatrical peak. In this context, John Hubley and Zack Schwartz's 1946 article so central to this study, "Animation Learns a New Language," is a powerful manifesto of useful animation: how to use the medium to communicate, to visualize, to teach. Their entrée into theatrical entertainment shorts may have been an accident of politics and economics; however, as this book has argued, the strategies of usefulness and visual education at the core of UPA's early films did not evaporate when the studio began releasing films with Columbia in 1948. It is therefore worthwhile to think about UPA and its stylistic innovations in terms of their pedagogical capabilities. In so doing, we might follow that useful potential so clearly on display in their cartoons into the live-action cinema as well, finding echoes of useful cinema in the very "other" against which the category is defined. Film historians Haidee Wasson and Charles R. Acland note, "Cinema has also been *useful,* at times involved more with functionality than with beauty, to employ the familiar Kantian dichotomy."[98] But what do we do when cinema, as with UPA animation, is useful precisely *because* of its beauty, or at least its primary aesthetic qualities?

The literature on useful cinema is in fact quite open regarding the ways in which a film can be useful, and film scholars have argued for using the designation beyond the obvious slam-dunks of an industrial or military training film. For example, film historian Eric Shaefer connects the term to exploitation cinema, finding in the genre a pedagogical appeal based not only on the flimsy "medical" frameworks used to justify titillating sexual material, but also on

grounds of moral education. Even if the lessons were lost on those simply looking for a cheap thrill, he argues, "for others who hoped to at least begin to attain a modest amount of knowledge about sex, venereal diseases, drug use, and other difficult subjects, for many years they served as an introductory lesson at a time when such information was difficult to find."[99] Meanwhile, media historian Lee Grieveson explores the Ford Motor Company's use of cinema to foster a sense of civic consciousness, "work[ing] in particular to visually articulate principles of political economy and to shape historical consciousness."[100] Both of these scholars frame an educational cinema that teaches not skills or procedures, but rather ways of being in the world. This widened scope of the purview of educational cinema thus enfolds the larger design project in which UPA was enmeshed: teaching new ways of *seeing* the world.

In his analysis of the efficiency-training motion study films of Frank and Lillian Gilbreth, film historian Scott Curtis remarks upon the films' dual function: "I submit that they do two kinds [of work]: productive and promotional.... They demonstrate a process while promoting that process as 'the one best way,' much like all sponsored films. Here, however, the process they document (the worker assembling something) is not the primary product. Instead, the product is the process of filming, or the image of efficiency that the documentation represents. In other words, Gilbreth was not promoting any specific process that he filmed so much as the films themselves as a process."[101] To oversimplify Curtis, the content of the film is not the point; rather, the form is the point. The way the film works is more important than the thing the film shows, because the way the film works reveals something new we can do with the medium, and something new it can teach us about the modern world. In this formulation, the useful film is asking to be seen in a particular way, and that is one of the most useful things about it.

The design gaze has a similar valence, and it is in the context of useful cinema that it perhaps differentiates itself from other models of film analysis. After all, to prioritize the surface of the frame over the narrative of a film is basic formalism. However, the design gaze is mobilized at a specific historical moment when a specific design rhetoric is circulating throughout American culture, and the formal elements of the frame are gathering around a central idea: a rapidly expanding design culture is trying to systematize a new language of vision, and it is using film—among other mediums—to do it. The design gaze watches the image for precisely those dynamics of the image that participate in the larger conversation of postwar design. This is what is pedagogical about the modern cartoon, and about the musical, the film noir, and

the avant-garde film. The particular modernism they share is, to return to Robert Genter's idea, a rhetorical modernism that makes an argument and imparts a lesson of vision. In this sense, it doesn't matter that the films' primary purpose is entertainment. They teach as they entertain, and this is a powerful statement of their usefulness.

Speaking of a factory recruiting film from 1914, film scholars Vinzenz Hediger and Patrick Vonderau quote an in-house postscreening assessment that concludes of the factory workers, "They flocked to be entertained. But they went away persuaded."[102] We might say of the audiences of these strikingly modernist films across the spectrum of midcentury American film culture, "They flocked to be entertained. But they went away exposed to a new and quintessentially modern form of vision." In a moment when a Bauhaus-inspired design scene mobilized the arts to update and retrain the public's way of seeing—and therefore being in—the world, the films that partook in that design language of necessity echoed that rhetorical imperative. It is clear that, in the case of UPA, the artists meant for that rhetorical imperative to be there; even when they moved from training films to commercial theatrical films, they were still making training films. It is for this reason that the animation studio offers such a clear view of a widespread and interdisciplinary design culture in the postwar era. It sits at the center of a web of influences: John Hubley gives new UPA animators Kepes's *Language of Vision;* Charles Eames teaches UPA films in his architecture and design courses; Alvin Lustig designs John Hubley's bookplate and the UPA logo. By using UPA as the high point from which to survey the rest of American film culture, we can therefore see how far this web extends, and how far the visual rhetoric of modern design shifts the workings of cinema more broadly. This is not to say that Vincente Minnelli wanted to use his musical numbers to teach the American public abstract design theory; it is, however, to say that when he picked up the visual language of midcentury modernism and crafted his stylized scenes, he repeated those lessons, tweaked them according to his own aesthetic impulses, and in so doing passed them on to a public who just flocked to be entertained. In this way, the soft utopianism of György Kepes and László Moholy-Nagy, of Sigfried Giedion and Richard Neutra, of Saul Bass and Herbert Bayer, of Zack Schwartz and John Hubley, circulated throughout the most popular artform of the postwar era. Whether they wanted to or not, the movies picked up the rhetoric of midcentury design, and in so doing, they became useful.

Conclusion

IN AUGUST 2005, CARTOON NETWORK BEGAN AIRING an updated version of *Gerald McBoing Boing*, a 30-minute series featuring two 11-minute shorts and starring a new-and-improved Gerald McCloy. Already a significant departure from UPA's unsuccessful *The Boing Boing Show* (1956–1958), the studio's first foray into television that used Gerald as an emcee for various experimental shorts entirely unrelated to the show's titular hero, the 2005 *Gerald McBoing Boing* puts Gerald front and center, along with a pair of sidekicks and a dog named Burp, who—get this—burps. While the show's animation features similarly sparse and geometric backgrounds that hew closely to the original style, human figures in the shorts are more fully rendered, with blushed cheeks and slight color differentiation for hair. It is by no means naturalistic, yet is still more solid and more detailed, particularly in comparison to the transparent extras in the 1950s cartoons such as *Gerald McBoing Boing's Symphony*. But perhaps the most striking difference is the show's treatment of Gerald's peculiar affliction, which here renders him a superhero of sorts. He still speaks in sound effects (in fact, his signature "boing!" is the exact effect from the 1950 UPA short), but in this revamped version the noises he makes produce fantastical results. For instance, in an Arabian Nights–themed adventure, when Gerald needs to move more quickly on a flying carpet in order to rescue one of his two sidekicks from entrapment in a nefarious genie's lamp, he makes the sound of an engine with his magical mouth, and a real engine appears on the carpet, turbocharging it and thereby saving the day. The show ran for two seasons, ending in November 2007.

This updating brings a mid-twentieth-century figure into the media landscape of the early twenty-first, where the superhero has been enjoying a

cultural "moment" across media forms. Yet there is something else at work in Gerald's revival, a phenomenon already on the minds of UPA's artists in their own time. As Charles Daggett observed of his studio's ethos, "But always, each picture must make a point while it follows a narrative; and this editorial point of view (consistent in the work from story-planning, design and drawing and painting, even the use of the animation camera) is responsible for the basic difference and forward motion of UPA. Other studios have failed to grasp this, and have nevertheless tried to imitate the visual appearance of our films on the screen, very much the way a small child puts on grown-up clothes that don't fit. Never a very successful masquerade, because the body isn't there."[1] The 2005 *Gerald McBoing Boing*'s decision to transform Gerald's speech disorder from a modern affliction to a magical power weakens this "point of view," this about-ness that, as I have argued, drove UPA's midcentury style. If in 1950 Gerald's boing-boing was a response to the technological overreach of the postwar era, in 2005 it would seem to be merely a funny noise that makes mischief and works wonders; it is masquerade without body, one more in the seemingly endless parade of Hollywood remakes, sequels, and prequels. However, if I have spent this book arguing that the modernist impulse survives in the transmission of style even in the absence of directly stated intent, it is disingenuous to claim that there is nothing behind this new iteration of Gerald McBoing Boing and his linguistic misadventures.

And our contemporary media climate would suggest that there *is* something going on here. From the romanticizing nostalgia of *Mad Men* (2007–2015) and its meticulous resurrection of Danish Modern interior design and period fashion (and its various knockoffs, such as 2011's ill-fated *Pan-Am*) to the nostalgia-puncturing nightmare of *American Horror Story: Asylum* (2012–2013) and its vicious exposure of the sexism and racism of the same historical era; from magazines such as *Dwell* and their fetishization of spare, minimalist architecture and décor to the explosion of homemade midcentury mod housewares on amateur sites such as Etsy; from the revival of suburban housewife chic to the streamlined, "Good Design" braggadocio of Apple and Design Within Reach, midcentury modernism is making a comeback in our current century. On the one hand, we may explain midcentury modernism's return as Jameson's postmodernism at work, in which "the producers of culture have nowhere to turn but to the past: the imitation of dead styles, speech through all the masks and voices stored up in the imaginary museum of a now global culture."[2] Here the return of *Gerald McBoing Boing*

takes part in a slick reappropriation of the 1950s, joining *Desperate Housewives* (2004–2012) and *Mad Men* in a moment when the kitschified lifestyles of the postwar era can be tried on by anyone interested in a little bit of nostalgia and stylistic pastiche. The Organization Man's brown liquors in crystal decanters and designer lowball glasses mingle with contemporary craft beers at house parties; roller derby athletes sport polka-dot A-line dresses, Bettie Page cuts, and sleeve tattoos outside of the rink; and anything can be sold for double the price on Craigslist if the modifier "Eames-era" is attached. Removed from their cultural, scientific, and aesthetic contexts, the visual innovations of the atomic age return as empty style, put on with an ironic wink and a wistful nostalgia.

Yet the resurgence of midcentury modernism is not merely a consumer phenomenon; in academic and artistic circles, Kepes and Moholy-Nagy are experiencing a new prominence as well. Reinhold Martin's 2003 book *The Organizational Complex* was an early salvo in the crusade to reevaluate Kepes's and Moholy-Nagy's places in the pantheon of midcentury modernism.[3] In 2006 London's Tate Modern opened its exhibit *Albers and Moholy-Nagy: From the Bauhaus to the New World*, and 2012 saw the opening of the Kepes Institute, Museum, and Cultural Center in Eger, Hungary; and Manitoba's Institute of Contemporary Art opened an exhibit entitled *Sensing the Future: Moholy-Nagy, Media, and the Arts* on March 8, 2014. In October 2018, Northwestern University's Block Museum opened an exhibition on Morton and Millie Goldsholl, a husband-and-wife design team who studied under Moholy and Kepes at the School of Design in the early 1940s and practiced as Goldsholl Design Associates through the 1970s. This revival of the reputations of two of the central figures of postwar modernism in the museum and the academy raises another explanation that begs taking midcentury modernism's return more seriously. If this book has argued that in the postwar era modernism attempted to retool vision to assuage cultural anxieties, what cultural function might this simplified, streamlined style be serving in the twenty-first century? If this semiabstract, geometrical mode of representation surfaced as Precisionism in the 1910s and 1920s, and as midcentury modernism in the 1950s, ought we to consider this new eruption another iteration of the same visual impulse? And if so, to what is it responding?

And questions remain in the postwar era as well. This book has focused on the utopian dreams of a core group of midcentury modernists and the ways in which their ideas took shape across various media; in essence, it has looked at the ways in which design theory acquired visible and material form.

More work remains to be done in understanding the dimensions of this midcentury modernism as a project of retraining vision, particularly on the reception end of this transaction. I have no investment in claiming that Kepes's and Moholy-Nagy's ideas "worked," that is, that they actually succeeded in changing the mode of vision of an entire multicultural society; if pressed, I would quite comfortably be willing to say that they did not. All utopias fail, but my interest here lies in the blueprints and the forms they engendered rather than in the lived experience of the results. I have focused on midcentury modernism's efforts to craft a new language of vision, but how did the proposed recipients of this visual education experience this project? Lynn Spigel has shown that audiences partook of midcentury modernism as an exercise in consumer taste and cultural uplift, a practice encouraged by television networks and the corporations and museums with which they partnered.[4] This argument certainly lines up with the advertising rhetoric of "better living through good design" and "labor-saving devices" that often accompanied the rollout of modernist objects. Did the Aspen Design Conference conversations and the Kepesian theories, the high-minded rhetoric about modern visuality and "new feeling[s] of space," about condensation and expansion, about the merging of art and science, survive the translation to the language of consumer culture?[5] Did people care about the revolutionary sensory experiences they were having? Were they having them at all?

Moreover, as I have mentioned, it is not enough to say "people," because midcentury modernism was in many ways a middle-class phenomenon largely invented by men for the benefit of a nebulously described universal "Man." If the question "Did it *work?*" is relevant to the general efficacy of the movement, it is even more so to the question of the American Dream's "others," whose relationship to the postwar economic boom and the avalanche of Good Design it brought in its wake was very different. The utopian rhetoric of a gradually democratizing society engendered by a new and modern vision takes on, as I have discussed, troubling authoritarian overtones of control and coercion even as it attempts to knit free individuals together into a peaceful postwar society. Points of encounter between the various cultures and subcultures of the midcentury period, on the one hand, and the project of midcentury modernism specifically framed as an education of vision, on the other, offer a fruitful avenue of further research.

And all of this is to say nothing of animation itself. This book has argued for a consideration of the modern cartoon as a partner in a multimedia design project built on new theories of vision and communication, elevating the

status of animation from an appropriator of cultural trends to a driver of design innovation. The general consensus in animation history remains a narrative in which UPA broke the cartoon mold and changed the face of American animation in the 1950s and 1960s, after which television cartoons stole limited animation to make the cheap, assembly-line pablum of Hanna-Barbera programs, thus spelling the end of animation as a creative force for decades to come.[6] A reevaluation of the work of the television cartoon is long overdue, and the theoretical and historical work laid out here may provide a direction for such research. If, as I have argued, the educational and rhetorical impulses of UPA's earlier sponsored films survive in their entertainment fare, and if the design spirit consciously crafted in harmony with Kepes's "language of vision" theories survives in other studios working with a similar style if not necessarily with a similar intent, then what happens when UPA's modernism moves to the small screen? We could say, as many animation historians have, that it disappears. However, I believe animation studies would benefit from a determination to take the television cartoon seriously as a visual form. How does the "fallen" midcentury modernism of the Saturday morning cartoon interact with a cultural environment in which modernism gradually fades as the 1960s give way to the 1970s? What does it mean to have this remnant of midcentury design, an echo of a utopian scheme for an educated vision and an improved population that uses it to see more clearly, subsisting in a world that has moved on to other concerns? And even more simply, how does the animation style of the Saturday morning cartoon innovate upon the highbrow UPA model? All of these explorations would offer a happy alternative to our present account of decline.

Meanwhile, the spirit of the modern cartoon, like other elements of midcentury modernism, is experiencing a revival in the twenty-first century. If animated theatrical features remain in line with the long-standing Disney model of "the illusion of life," nearly perfected by the digital magic of PIXAR and Dreamworks, the rise of internet distribution has proved a boon for artisanal and independent animated shorts that recapture UPA's tension between budget-directed simplicity and designerly elegance. Blogs such as Amid Amidi's *Cartoon Brew* and Mark Mayerson's *Mayerson on Animation* bring together an international spread of contemporary animation, much of it showing a return to hand-drawn styles that recall UPA's investment in the cartoon as a conspicuously and openly drawn medium rather than as an outgrowth of, or accessory to, live-action cinema. (We can also add to the stylistic stable Flash animation and other digital techniques that trade on

simplified graphic forms in ways that were technologically unavailable in the postwar era.) In so doing, these new cartoons have brought animation and design closer together than they have been since the period under examination in this book. There is, to be sure, an equal amount to say—and being said—about this particular moment in animation history as there is about the postwar era, and as in the case of midcentury modernism, I believe design is a useful lens to analyze contemporary animation as well.

The convergence of artisanal animation and easily accessible production and streaming technologies also offers a fruitful avenue for thinking about digitality. As routine mechanisms of life and sociality are increasingly filtered through the interfaces of computer screens and smart phones, more and more of our daily lives are brought into contact with animation—an animation that, following contemporary trends, recalls midcentury styles of reduction and simplification of the image. I would like to think that my interdisciplinary approach here has legs and can circulate more broadly. There has been much discussion of digital animation in terms of mapping and cartography. How might a midcentury perspective of spatiality and visual style inflect our understandings of animated locational technologies and the communicative logics of, for example, Google Maps? How might we place utopian rhetorics of simplification against the increasing capabilities of digital animation to render the world in minute detail?

Ultimately, and perhaps most importantly, in this book I have endeavored to carry out a research program that is ruthlessly interdisciplinary, bringing together animation, art, architecture, graphic design, and live-action cinema, with no respect for any hierarchies of value or importance among them. In this I take a cue from Giuliana Bruno, who argues, "Corroding disciplinary boundaries, architecture and film should find their common terrain, even on institutional grounds: one can only imagine what interesting cultural practices would emerge if the field of cinema studies could find an institutional working place within schools of architecture rather than in the literary 'locations' that have traditionally housed it and served as a point of reference."[7] I like the forthright aggression of "corroding disciplinary boundaries," and more than that, I like the idea of film studies programs setting up shop in various departments across the arts and humanities. If, for Bruno, the key point of contact is between film and architecture, to my mind it is film and design. Moreover, to enable such transdisciplinary contacts may help to expand the boundaries of animation studies as a discipline that is related to film, but that is also a part of a much broader dialogue. I would like to believe

that the present work has shown how animation interacts with fields well beyond film studies, and that it has loosened the ties that bind animation to cinema. At the same time, I hope also that I have demonstrated how film studies *needs* animation, not as a means of rounding out its generic profile, but as an independent medium that helps us understand its connections with other fields in the visual and spatial arts. Above all, it is my hope that this book offers a basis from which to explore the questions raised above, and a methodology that will prove productive in the answering of them.

NOTES

INTRODUCTION

1. *Magoo's Puddle Jumper, Gerald McBoing Boing on Planet Moo,* and *The Jaywalker.* UPA was also nominated in 1948 for *Robin Hoodlum* and in 1949 for *The Magic Fluke,* but they lost to MGM's *The Little Orphan* and Warner Brothers' *For Scent-imental Reasons.*

2. Fred Hift, "'McBoing Boing' Sounds Off with a Bang, Bang," *New York Times,* January 14, 1951.

3. Richard L. Coe, "10 Best Films of the Year," *Washington Post,* December 23, 1951; "You Must Meet Gerald McBoing-Boing for He's Too Scrumptious for Words," *Times of India,* April 20, 1951, respectively.

4. For instance, Philip K. Scheuer calls *Gerald* "the most original and truly modern cartoon in years," while Walter W. Lee Jr. credits the studio with "a stream of fresh modern entertainment." Philip K. Scheuer, "'Never a Dull Moment' Comedy of Ranch Life," *Los Angeles Times,* March 10, 1951; Walter W. Lee Jr., "UPA," *Pendulum* 2, no. 3 (Spring 1953): 44, respectively.

5. See Amid Amidi, *Cartoon Modern: Style and Design in Fifties Animation* (San Francisco: Chronicle Books, 2006); Norman M. Klein, *Seven Minutes: The Life and Death of the American Animated Cartoon* (London; New York: Verso Books, 1993); Georgine Oeri, "UPA: A New Dimension for the Comic Strip," *Graphis* 9, no. 50 (1953): 470–479; Paul Wells, *Animation and America* (Edinburgh: Edinburgh University Press, 2002).

6. See David Bordwell, *Narration in the Fiction Film* (Madison: University of Wisconsin Press, 1985); Robert Phillip Kolker, *The Altering Eye: Contemporary International Cinema* (Cambridge: Open Book, 2009); András Bálint Kovács, *Screening Modernism: European Art Cinema, 1950–1980* (Chicago: University of Chicago Press, 2007).

7. See Adam Abraham, *When Magoo Flew: The Rise and Fall of Animation Studio UPA* (Middletown: Wesleyan University Press, 2012); Amidi, *Cartoon Modern;* Michael Barrier, *Hollywood Cartoons: American Animation in Its Golden Age* (New

York: Oxford University Press, 1999), esp. chap. 13; Klein, *Seven Minutes,* esp. chap. 22; Wells, *Animation and America,* 63–67.

8. The strike revolved around a union membership dispute and unrest over raises and bonuses, with the Screen Cartoonists Guild positioned against Walt Disney; it lasted for two months. For a full account, see Barrier, *Hollywood Cartoons,* 279–285, 306–309.

9. Their first cartoon together, the 1944 campaign short *Hell-Bent for Election,* campaigned for FDR's reelection.

10. Bosustow bought them out, and they went on to found the Zack-David Corporation, which was quickly renamed Tempo Films. See Abraham, *When Magoo Flew,* 124, for the full, if brief, story.

11. Amidi, *Cartoon Modern,* 112.

12. In a 2010 interview, animator Gene Deitch outlines the process of moving from UPA to the Jam Handy Organization: "At UPA in Hollywood, surrounded by titans, I was assured that I could possibly make director within ten years, but here was a chance, in a studio still in the animation stone age, to flash my UPA reflected glory and fake my way into an immediate director's slot. . . . The final film, with its simplified UPAish style, was an internal sensation, and I was launched in 1949 as a genuine animation director and soon to be chief of the JHO animation department" ("Cartoon Brew TV #24: *Building Friends for Business* [1949]," *Cartoon Brew,* www.cartoonbrew.com/brewtv/buildingfriends-23417.html).

13. See Amidi, *Cartoon Modern.*

14. John Hubley and Zachary Schwartz, "Animation Learns a New Language," *Hollywood Quarterly* 1, no. 4 (1946): 360–363.

15. Jennifer Wicke, "Appreciation, Depreciation: Modernism's Speculative Bubble," *Modernism/Modernity* 8, no. 3 (2001): 400.

16. For a discussion of the ideological imperatives for simplification that bypassed economic concerns, see Klein, *Seven Minutes,* 209.

17. However, that is a standard which most animation does not bother to meet; even Disney, the king of full animation, reportedly averaged eighteen frames per second, which looks good enough to the naked eye. See, for example, Thomas LaMarre, *The Anime Machine: A Media Theory of Animation* (Minneapolis: University of Minnesota Press, 2009), 74.

18. Before this became common practice in the brutal economic space of television animation, the clearest example of this kind of animation would be UPA's *Jamaica Daddy* (1957), a musical cartoon in which sequences of action consist of two drawings alternating back and forth—perhaps the most limited of limited animation.

19. Many Disney animators, particularly during the Depression, were classically trained artists who turned to cartooning in the absence of work in the fine arts; straight academic realism, for many of them, was not what they signed up for in art school. For an account of Disney animators' frustration toward the studio's relentless pursuit of the illusion of life, see Barrier, *Hollywood Cartoons,* 506–507.

20. John D. Ford, "An Interview with John and Faith Hubley," in *The American Animated Cartoon: A Critical Anthology*, ed. Danny Peary and Gerald Peary (New York: Dutton, 1980), 187.

21. For various explanations of the newness of the midcentury moment, see Robert H. Bremner and Gary W. Reichard, eds., *Reshaping America: Society and Institutions, 1945–1960* (Columbus: Ohio State University Press, 1982); Lizabeth Cohen, *A Consumer's Republic: The Politics of Mass Consumption in Postwar America* (New York: Knopf, 2003); George H. Marcus, *Design in the Fifties: When Everyone Went Modern* (New York: Prestel, 1998); Lynn Spigel, *Make Room for TV: Television and the Family Ideal in Postwar America* (Chicago: University of Chicago Press, 1992); Carroll W. Pursell, *Technology in Postwar America: A History* (New York: Columbia University Press, 2007); Sigfried Giedion, *Mechanization Takes Command: A Contribution to Anonymous History* (New York: Oxford University Press, 1948); David E. Nye, *American Technological Sublime* (Cambridge, MA: MIT Press, 1994); Robert Bruegmann, *Sprawl: A Compact History* (Chicago: University of Chicago Press, 2005); Dolores Hayden, *Building Suburbia: Green Fields and Urban Growth, 1820–2000* (New York: Pantheon Books, 2003); W. T. Lhamon, *Deliberate Speed: The Origins of a Cultural Style in the American 1950s* (Washington: Smithsonian Institution Press, 1990); William Hollingsworth Whyte, *The Organization Man* (New York: Simon & Schuster, 1956); Joanne J. Meyerowitz, ed., *Not June Cleaver: Women and Gender in Postwar America, 1945–1960* (Philadelphia: Temple University Press, 1994); Howard Zinn, *Postwar America: 1945–1971* (Indianapolis: Bobbs-Merrill, 1973).

22. For fuller discussions of these arguments, see Lhamon, *Deliberate Speed*; Daniel Joseph Singal, "Towards a Definition of American Modernism," *American Quarterly* 39, no. 1 (Spring 1987): 7–26; Matei Calinescu, *Five Faces of Modernity: Modernism, Avant-Garde, Decadence, Kitsch, Postmodernism* (Durham, NC: Duke University Press, 1987).

23. Reinhold Martin, *The Organizational Complex: Architecture, Media, and Corporate Space* (Cambridge, MA: MIT Press, 2003), 7. See also Jonathan Crary, *Techniques of the Observer: On Vision and Modernity in the Nineteenth Century* (Cambridge, MA: MIT Press, 1990).

24. For more on these intersections, see Orit Halpern, *Beautiful Data: A History of Vision and Reason since 1945* (Durham, NC: Duke University Press, 2014); John Harwood, *The Interface: IBM and the Transformation of Corporate Design, 1945–1976* (Minneapolis: University of Minnesota Press, 2011); Justus Nieland, "Midcentury Futurisms: Expanded Cinema, Design, and the Modernist Sensorium," *Affirmations: Of the Modern* 2, no. 1 (Winter 2014): 46–84; and Fred Turner, *The Democratic Surround: Multimedia and American Liberalism from World War II to the Psychedelic Sixties* (Chicago: University of Chicago Press, 2013).

25. See Gene Youngblood, *Expanded Cinema* (New York: Dutton, 1970).

26. Lynn Spigel, *TV by Design: Modern Art and the Rise of Network Television* (Chicago: University of Chicago Press, 2008), 23.

27. Ibid., 106. In fact, graphic designer John Halas suggests an even stronger link between television and the new design styles at midcentury: "Television, with its limiting size and tone range, provides a natural trend towards simplification and abstract characterization.... Consequently, some of the most imaginative uses of sound, visual ideas, graphic design and animation are created in such TV films" (Halas, "Graphic Design in Television," *Graphis* 15, no. 86 [December 1959]: 490).

28. Spigel, *TV by Design*, 304n11.

29. Miriam Hansen, "The Mass Production of the Senses: Classical Cinema as Vernacular Modernism," *Modernism/Modernity* 6, no. 2 (April 1999): 60.

30. Robert Genter, *Late Modernism: Art, Culture, and Politics in Cold War America* (Philadelphia: University of Pennsylvania Press, 2010).

31. See Genter's intro for full discussion. In my understanding, "high modernism" might align with, say, Adorno and Horkheimer and their attack on the culture industries, whereas "romantic modernism" might align with Abstract Expressionism and the first-person techniques of a certain branch of the postwar American avant-garde cinema.

32. Here is perhaps one reason for this particular midcentury modernism's departure from Abstract Expressionism, which focuses on visible brushstrokes and other physical evidence of the hand of the artist as an expression of inner states, as opposed to the more scientific, planned, design-based modernism of Kepes and Moholy-Nagy.

33. In fact, as mentioned above, UPA only entered the entertainment market when their client base for sponsored films began to pull away from the left-leaning animation house during the anticommunist paranoia of the Cold War. In this sense, the shift from rhetoric to entertainment was made under duress.

34. Genter, *Late Modernism*, 4.

35. Nieland, "Midcentury Futurisms," 63.

36. See, for example, David Bordwell, *On the History of Film Style* (Cambridge, MA: Harvard University Press, 1997), esp. chap. 5.

37. The body of literature on cinema and turn-of-the-century modernity is vast; for further reading on these new experiences of time, speed, sensation, and cinema, see especially the seminal anthology edited by Leo Charney and Vanessa Schwartz, *Cinema and the Invention of Modern Life* (Berkeley: University of California Press, 1995); also Ben Singer, *Melodrama and Modernity: Early Sensational Cinema and Its Contexts* (New York: Columbia University Press, 2001), esp. chap. 4; Mary Ann Doane, *The Emergence of Cinematic Time: Modernity, Contingency, the Archive* (Cambridge, MA: Harvard University Press, 2003); and Lucy Fisher, "'The Shock of the New': Electrification, Urbanization, Illumination, and the Cinema," in *Cinema and Modernity*, ed. Murray Pomerance (New Brunswick, NJ: Rutgers University Press, 2006), 19–37.

38. Nieland, "Midcentury Futurisms," 78 and 75, respectively.

39. Halpern, *Beautiful Data*, 17.

40. Spigel, *TV by Design*, 11.

41. Both emigrated to the United States in 1937, Kepes at Moholy's invitation.

42. For a full, expansively documented history, see Margret Kentgens-Craig, *The Bauhaus and America: First Contacts, 1919–1936* (Cambridge, MA: MIT Press, 1999).

43. Their most famous students include Kevin Lynch, Harry Callahan, Saul Bass, and Alvin Lustig.

44. Elsa Kula, "Institute of Design," *Print* 14, no. 1 (February 1960): 51. Likewise, Michael Golec identifies *Language of Vision* as "the most important book of the 1940s and 1950s on the problems of sense perception and expression in contemporary art and design" (Golec, "Natural History of a Disembodied Eye: The Structure of György Kepes's *Language of Vision*," *Design Issues* 18, no. 2 [January 2002]: 3). Masaru Katsumi reflects on the reach of these books even to Japan, where "young designers studied basic works like *Language of Vision* by Gyorgy Kepes and *Vision in Motion* by Moholy-Nagy. Selfawareness [*sic*] among designers grew by leaps and bounds and a gathering interest in society as a whole led to the emergence of various new ideas" (Katsumi, "Young Japanese Designers," *Graphis* 19, no. 102 [April 1962]: 453).

45. Martin, *Organizational Complex*, 72–73.

46. The second book was Vsevolod Pudovkin's *Film Acting*. Deitch continues, " Everything I've ever done was fortified by these two books and what Hub taught me" (Deitch, "Roll the Credits! 11: John Hubley," *GeneDeitchCredits,* 2011, http://genedeitchcredits .com/roll-the-credits/chapter-11---john-hubley-"it's-got-to-be-about-something).

47. Kepes: "Machines, motor cars, streetcars, elevated trains, aeroplanes, flickering-light displays, shop windows, became common features of the contemporary scene. Together with the new richness of light-effects from artificial light sources, the increased dimension of the landscape with the skyscrapers and their intricate inner spatial order above, and the subways underneath, they gave an incomparably greater speed and density to the light stimulations reaching the eye than any previous visual environment had ever presented" (György Kepes, *Language of Vision* [Chicago: Theobald, 1944], 130).

48. As Spigel notes, this is "a continuation of—rather than a break with—earlier forms of modernism" (Spigel, *TV by Design,* 11). However, for Kepes and Moholy, this continuation was also an intensification, reaching a breaking point in the postwar era.

49. Jan van der Marck, "Kepes as Painter," in *The MIT Years, 1945–1977,* by György Kepes (Cambridge, MA: MIT Press, 1978), 22.

50. See the opening anecdote in chapter 2 of Orit Halpern's *Beautiful Data* for a discussion of the centrality of mobile vision to Kepes's visual theory.

51. Kepes, *Language of Vision,* 67.

52. Halpern, *Beautiful Data*, 14.

53. László Moholy-Nagy, *Vision in Motion* (Chicago: Theobald, 1947), 58.

54. Kepes, *Language of Vision,* 176.

55. In a 1972 interview looking back on *Language of Vision,* Kepes notes, "And when I have to think about it, scaffolding the whys or scaffolding the motives for my interest in visual art and visual expression, I suddenly recall some of the ideas that I gained from the Gestalt psychologists" (György Kepes, Oral History

Interview with Robert Brown, Transcript, March 7, 1972, 20–21, György Kepes Papers, Archives of American Art, Smithsonian Institution). For a primary text in this line of thought, see Rudolf Arnheim, *Art and Visual Perception: A Psychology of the Creative Eye—The New Version* (Berkeley: University of California Press, 1974), originally published in 1954.

56. Moholy-Nagy, *Vision in Motion*, 21.

57. Kepes, Interview with Robert Brown, 4. We may also find evidence of this line of thought in Kepes's *Vision + Value* books, a series of six anthologies released in 1965–1966 that brought together luminaries from film, graphic design, art, architecture, anthropology, history, physics, biology, urban planning, and sociology, to name merely a few of the fields involved in the enterprise. Each volume organized articles from these fields around common themes, such as "the nature of art and motion" or "the man-made object."

58. Moholy-Nagy, *Vision in Motion*, 7.

59. Nieland, "Midcentury Futurisms," 47–48.

60. Turner, *Democratic Surround*, 2–3.

61. In addition to Turner, see John R. Blakinger, "The Aesthetics of Collaboration: Complicity and Conversion at MIT's Center for Advanced Visual Studies," *Tate Papers* 25 (Spring 2016), www.tate.org.uk/research/publications/tate-papers/25/aesthetics-of-collaboration; and Robin Schuldenfrei, "Assimilating Unease: Moholy-Nagy and the Wartime/Postwar Bauhaus in Chicago," in *Atomic Dwelling: Anxiety, Domesticity, and Postwar Architecture*, ed. Schuldenfrei (London: Routledge, 2012), 87–126.

62. Turner, *Democratic Surround*, 6.

63. Blakinger, "Aesthetics of Collaboration," para. 46; Schuldenfrei traces government entanglements back even further, to the activity of the new Bauhaus during World War II.

64. Nieland, "Midcentury Futurisms," 62.

65. See Abraham, *When Magoo Flew*, 63–66, for a full account of the film's genesis and production.

66. Turner, *Democratic Surround*, 78.

67. Schuldenfrei, "Assimilating Unease," 104.

68. Reinhold Martin, "Organicism's Other," *Grey Room* 4 (Summer 2001): 42–43.

69. Blakinger, "The Aesthetics of Collaboration"; see the sections "Collaboration as Conversion," paras. 42–52, and "Kepes's Faith," paras. 72–84.

70. Ibid., para. 84.

71. Schuldenfrei, "Assimilating Unease," 89.

72. Ibid., 114. Schuldenfrei also points out the rapidity with which Moholy made this shift: "It is striking how the exigencies of the circumstances in which he found himself in America, and the very anxiety that this new situation generated, carried him almost overnight from a left-leaning artistic milieu to American government collaborations and very pragmatic assistance to his new country" (89).

73. Nieland, "Midcentury Futurisms," 83.

74. See Pat McGilligan and Faith Hubley, "Faith Hubley: An Interview," *Film Quarterly* 42, no. 2 (Winter 1988–1989): 2–18, esp. 8–9. For the larger context of UPA's position in blacklist-era Hollywood, see Abraham, *When Magoo Flew,* chap. 6; and Barrier, *Hollywood Cartoons,* 533–535. Larry Ceplair and Steven Englund also mention UPA's role (under their earlier moniker, United Film Productions) in the drama of the Red Scare in *The Inquisition in Hollywood: Politics in the Film Community, 1930–1960* (Berkeley: University of California Press, 1983), 196.

CHAPTER ONE

1. "UPA Exhibition at MoMA: Preliminary Notes," n.d., Early Museum History III.26.b, Museum of Modern Art Archives, New York.

2. "Material for the UPA Exhibition at the Museum of Modern Art," May 9, 1955, 3, Early Museum History III.26.b, Museum of Modern Art Archives, New York.

3. Charles Daggett, "Letter to Mr. Douglas MacAgy," February 5, 1954, 2, Early Museum History III.26.b, Museum of Modern Art Archives, New York.

4. Animation historian Amid Amidi, for instance, notes, "[Television] audiences were unable to understand UPA's visual eclecticism, which came quite often at the expense of storytelling, humor, and characterization." See Amidi, *Cartoon Modern,* 146.

5. Hubley and Schwartz, "Animation Learns a New Language."

6. That said, animation historian Michael Barrier's identification of the Disney strikers as, in part, out-of-work art students frustrated by their inability to put their educations to use at the tradition-bound studio, coupled with UPA's direct reference to other schools of modernist art, suggests that the UPA cartoonists might have had at least a passing acquaintance with Precisionism. See Barrier, *Hollywood Cartoons,* 506.

7. For more on this moment in American art history, see Wanda M. Corn, *The Great American Thing: Modern Art and National Identity, 1915–1935* (Berkeley: University of California Press, 1999); and Francis V. O'Connor, ed., *Art for the Millions: Essays from the 1930s by Artists and Administrators of the WPA Federal Art Project* (Greenwich, CT: New York Graphic Society, 1973).

8. While MoMA director Alfred H. Barr Jr. reportedly used the term *Precisionist* to describe Sheeler, Demuth, and their fellow travelers in a 1927 lecture, the term didn't stick until decades later. For a thorough account of the development of the art-historical vocabulary on Precisionism, see Gail Stavitsky, "Reordering Reality: Precisionist Directions in American Art, 1915–1941," in *Precisionism in America, 1915–1941: Reordering Reality,* ed. Stavitsky (New York: Harry N. Abrams, in association with the Montclair Art Museum, 1994), 12–39.

9. Martin Friedman, *The Precisionist View in American Art* (Minneapolis: Walker Art Center, 1960), 14.

10. Stavitsky, "Reordering Reality," 35.

11. Quoted ibid., 32.

12. Quoted ibid., 22.

13. Louis Lozowick, "The Americanization of Art," in *Modern Art in the USA: Issues and Controversies of the 20th Century*, ed. Patricia Hills (Upper Saddle River, NJ: Prentice Hall, 2001), 49.

14. Friedman, *Precisionist View in American Art*, 22.

15. Ibid., 12.

16. See Matthew Baigell, "American Art and National Identity: The 1920s," *Arts Magazine* 61, no. 6 (February 1987): 48–55; Sharon Corwin, "Picturing Efficiency: Precisionism, Scientific Management, and the Effacement of Labor," *Representations*, no. 84 (November 2003): 139–165; Barbara Zabel, "Louis Lozowick and Urban Optimism of the 1920s," *Archives of American Art Journal* 14, no. 2 (April 1974): 17–21. For more on Taylor, the Gilbreths, and their development of scientific management generally, see Daniel Nelson, *Frederick W. Taylor and the Rise of Scientific Management* (Madison: University of Wisconsin Press, 1980); Samuel Haber, *Efficiency and Uplift: Scientific Management in the Progressive Era, 1890–1920* (Chicago: University of Chicago Press, 1964).

17. Lozowick, "Americanization of Art," 49–50.

18. Stavitsky, "Reordering Reality," 34.

19. Friedman, *Precisionist View in American Art*, 12.

20. M. Mannes, "Niles Spencer: Painter of Simplicities," *Creative Art*, no. 100 (July 1930): 59.

21. Stavitsky, "Reordering Reality," 35.

22. See, for instance, John Heilpern, "Ralston Crawford's Gift of Selection," *Aperture*, no. 92 (Fall 1983): 66–75; Gail Stavitsky, "The 1930s Paintings of Francis Criss," *American Art Review* 14, no. 2 (March–April 2002). Also, David A. Gerstner makes extensive use of excerpts from an oral history with Charles Sheeler in which he discusses his view on and use of selective realism in *Manly Arts: Masculinity and Nation in Early American Cinema* (Durham, NC: Duke University Press, 2006), esp. chap. 4.

23. Lozowick, "Americanization of Art," 49.

24. Stavitsky, "Reordering Reality," 35.

25. From his famous quote, "Modernity is the transient, the fleeting, the contingent; it is one half of art, the other being the eternal and the immovable." Charles Baudelaire, "The Painter of Modern Life," in *Selected Writings on Art and Artists*, ed. and trans. P. E. Charvet (Cambridge: Cambridge University Press, 1981), 403.

26. Stavitsky, "Reordering Reality," 35.

27. Diane Kelder, "Stuart Davis and Modernism: An Overview," in *Stuart Davis: American Painter*, ed. Lowery Stokes Sims (New York: Metropolitan Museum of Art, distributed by Harry N. Abrams, 1991), 23.

28. Barrier, *Hollywood Cartoons*, 537.

29. Amidi, *Cartoon Modern*, 112.

30. Hubley and Schwartz, "Animation Learns a New Language," 363.

31. This is often the argument advanced about the 1950 cartoon *Gerald McBoing Boing*; see, for instance, Amidi, *Cartoon Modern*, 133 ("in many ways the quintes-

sential UPA film"); and Klein, *Seven Minutes,* 236 ("in many ways the quintessential UPA product"). *Gerald's* reputation, while richly deserved, obscures the fact that it was not UPA's most representative cartoon, but merely its most famous, and its first widespread critical success. Part of my objective in this book is to return some oxygen to UPA's other films—as well as to films produced by their contemporaries working in similar styles—both as an acknowledgment of the diversity of form at the heart of the revolution in the postwar American cartoon and as a means of more fully probing the cartoon's multifarious engagement with modernity at midcentury.

32. See, for instance, Amidi, *Cartoon Modern,* 10; Jeremy G. Butler, *Television: Critical Methods and Applications,* 3rd ed (New York: Routledge, 2006), 356.

33. Friedman, *Precisionist View in American Art,* 22.

34. Esther Leslie, *Hollywood Flatlands: Animation, Critical Theory, and the Avant-Garde* (London: Verso Books, 2002), 293; Klein, *Seven Minutes,* 230; Amidi, *Cartoon Modern,* 115, respectively.

35. Stavitsky, "Reordering Reality," 35.

36. Quoted in Amidi, *Cartoon Modern,* 133.

37. "UPA Exhibition at MOMA: Preliminary Notes," 2.

38. Barrier, *Hollywood Cartoons,* 506.

39. Howard Rieder, "Memories of Mr. Magoo," *Cinema Journal* 8, no. 2 (December 1969): 19.

40. Corwin, "Picturing Efficiency" 154; Milton W. Brown, "Cubist-Realism: An American Style," *Marsyas* 3, no. 5 (1943–1945): 158, respectively.

41. Klein, *Seven Minutes,* 237; Barrier, *Hollywood Cartoons,* 528, respectively.

42. Quoted in Charles Daggett, "About 'Gerald McBoing-Boing,'" n.d., 2, Early Museum History III.26.a, Museum of Modern Art Archives, New York.

43. Talk of static forms runs through Gail Stavitsky's "Reordering Reality," both in her words and in those of the contemporary critics she quotes throughout the essay. The underlying stillness also subtends common critical assessments of the style as architectonic and structural (read: immobile, like architecture) and as cold and clinical (read: dead, like rigor mortis).

44. Barbara Rose, *American Art since 1900* (New York: Praeger, 1975), 83; Klein, *Seven Minutes,* 237, respectively.

45. For the most concentrated expression of this idea, see Arnheim, *Art and Visual Perception.*

46. As Sigfried Giedion wrote in his 1944 introduction, "This book seems to be addressed to the young generation which must rebuild America" (Kepes, *Language of Vision,* 8).

47. Charles Sheeler, letter to the editor, *Art in America,* 1955, ser. 2: Correspondence 1937–1966, Box 1, Folder 16, Charles Sheeler Papers, Smithsonian Institution Archives of American Art, Washington, DC.

48. This is especially the case insofar as Kepes reportedly hated Abstract Expressionism; Reinhold Martin quotes him as describing the artistic movement thus: " ... paintings and sculptures shaped with idioms in tune with the twilight spirit that created them: surfaces that are moldy, broken, corroded, ragged, dripping;

brush strokes executed with the sloppy brutality of cornered men" (Martin, "Organicism's Other," 43).

49. Kepes, *Language of Vision,* 67 and 68, respectively.

50. Ibid., 165.

51. Merrill Schleier, *The Skyscraper in American Art, 1890–1931* (Ann Arbor, MI: UMI Research Press, 1986), 104.

52. Lozowick, "Americanization of Art," 50.

53. Stavitsky, "Reordering Reality," 35.

54. Here his Bauhaus origins show themselves, continuing the school's quest for a practical *Gesamtkunstwerk* that would span all areas of human production.

55. Art critic Samuel M. Kootz, quoted in Stavitsky, "Reordering Reality," 24.

56. For a fuller account of Precisionist spin-offs in the 1930s, see ibid., esp. 24–30; Zabel, "Louis Lozowick and Urban Optimism."

57. Stavitsky, "Reordering Reality," 25. She quotes art curators Holger Cahill and Edith Halpert: "To me it is almost a logical follow-up of the so-called immaculate school which includes men like Sheeler, Spencer, etc."

58. Karen Wilkin, *Stuart Davis* (New York: Abbeville Press, 1987), 15–16.

59. Friedman, *Precisionist View in American Art,* 44.

60. For perhaps the boldest expression of this argument, see Rick Stewart, "Charles Sheeler, William Carlos Williams, and Precisionism: A Redefinition," *Arts Magazine* 58, no. 3 (November 1983): 100–114, which argues for Sheeler as "the sole true Precisionist." Likewise, R. Scott Harnsberger, bibliographer of scholarly work on Precisionism, calls Sheeler "perhaps the artist who best represents the quintessential Precisionist" in Harnsberger, *Ten Precisionist Artists: Annotated Bibliographies* (Westport, CT: Greenwood Press, 1992), 229. See also Milton W. Brown, *American Painting, from the Armory Show to the Depression* (Princeton, NJ: Princeton University Press, 1955). For a rare challenge to this argument, see Susan Fillin-Yeh, "Charles Sheeler: Industry, Fashion, and the Vanguard," *Arts Magazine* 54, no. 6 (February 1980): 154–158, in which she marks Sheeler as departing from the work of other Precisionists by virtue of his use of photorealism.

61. For a seminal exposition of this "generational" model, see Friedman, *Precisionist View in American Art.* Some accounts also discuss Morton Schamberg as a sort of "pre-precisionist" linking the Precisionists to earlier French modernism. See Stavitsky, "Reordering Reality"; Jan Thompson, "Picabia and His Influence on Art," *Art Journal* 39, no. 1 (Fall 1979): 14–21.

62. In this I follow art historian Karen Tsujimoto, whose account of Precisionism is refreshingly open-ended: "No one artist was responsible for establishing the Precisionist style. Rather, it evolved from a simultaneous interest by these painters in urban and industrial themes" (Tsujimoto, *Images of America: Precisionist Painting and Modern Photography* [Seattle: University of Washington Press, 1982], 21). See also Richard Guy Wilson, *The Machine Age in America, 1918–1941* (New York: Brooklyn Museum in association with Harry N. Abrams, 1986), esp. 218–219, where he calls Precisionism "not, properly speaking, an avant-garde movement but rather a label devised by art historians for a visual style common among some American

painters responding to the machine." More broadly speaking, I also take a cue from András Bálint Kovács, *Screening Modernism,* whose definition of postwar cinematic modernism likewise employs the buffet model of singular choices picked from a set of available stylistic options, which I see at work in this modernism writ large.

63. Stavitsky, "Reordering Reality," 28. Quote from art critic Helen Appleton Read.

64. A series of paintings in which Davis "nailed an electric fan, a rubber glove and an eggbeater to a table and used it as my exclusive subject matter for a year." See Karen Wilkin, "'Becoming a Modern Artist': The 1920s," in Sims (ed.), *Stuart Davis,* 45–55, esp. 52 (above quote); Wilkin, *Stuart Davis,* 104–106.

65. These complex and highly technical theoretical systems are not terribly on-point in this book; for a thorough discussion of Davis's more esoteric principles, see John R. Lane, *Stuart Davis: Art and Art Theory* (Brooklyn, NY: Brooklyn Museum, 1978); John R. Lane, "Stuart Davis in the 1940s," in Sims (ed.), *Stuart Davis,* 70–81.

66. Diary excerpt in Diane Kelder, *Stuart Davis: Art and Theory, 1920–31* (New York: Pierpont Morgan Library, 2002), 36.

67. Quoted ibid..

68. Corwin, "Picturing Efficiency," 152. Her examination of these tensions focuses largely on a Marxist critique of labor, both artistic and capitalist. For a recent work in a similarly Marxist vein, see Andrew Hemingway, *The Mysticism of Money: Precisionist Painting and Machine Age America* (Pittsburgh, PA: Periscope, 2013).

69. Mark Rawlinson, "Charles Sheeler's Imprecise Precisionism," *Comparative American Studies* 2, no. 4 (November 2004): 483.

70. Friedman, *Precisionist View in American Art,* 44.

71. Ibid.

72. Wilkin, *Stuart Davis,* 16.

73. Stavitsky, "Reordering Reality," 25.

74. Brown, *American Painting,* 108.

75. Friedman, *Precisionist View in American Art,* 44.

76. Among other things, in 1954 Davis was invited by Eero Saarinen to design and paint a mural for the central dining hall at Drake University in Des Moines, Iowa; and in 1955, his design for a conference room mural at the United Nations was chosen, though it was never actually executed.

77. See Tsujimoto, *Images of America;* Henry M. Sayre, "American Vernacular: Objectivism, Precisionism, and the Aesthetics of the Machine," *Twentieth Century Literature* 35, no. 3 (December 1989): 310–342; Henry M. Sayre, *The Visual Text of William Carlos Williams* (Urbana: University of Illinois Press, 1983), esp. chap. 2.

78. Lane, "Stuart Davis in the 1940s," 72.

79. Quoted in Kelder, *Stuart Davis,* 36.

80. Kelder, "Stuart Davis and Modernism," 27.

81. Lane, "Stuart Davis in the 1940s," 72.

82. Quoted in Kelder, *Stuart Davis,* 28.

83. Ibid., 11.

84. Kepes, *Language of Vision,* 165.

85. Quoted in Ben Sidran, "The Jazz of Stuart Davis," in *Stuart Davis,* ed. Philip Rylands (Boston: Bulfinch, 1997), 14.

86. Diane Kelder, "Stuart Davis: Pragmatist of American Modernism," *Art Journal* 39, no. 1 (Fall 1979): 36.

87. Kelder, "Stuart Davis and Modernism," 30.

88. Quoted ibid., 27.

89. Kepes, *Language of Vision,* 17.

90. Quoted in Lane, "Stuart Davis in the 1940s," 71.

91. See Kepes, *Language of Vision,* 36, 139, as well as the section on receding and advancing colors in the following chapter of this book.

92. Ibid., 31.

93. Quoted in Kelder, *Stuart Davis,* 35.

94. Quoted in Lowery Stokes Sims, "Stuart Davis in the 1930s: A Search for Social Relevance in Abstract Art," in Sims (ed.), *Stuart Davis,* 61.

95. Kepes, *Language of Vision,* 13.

96. Cécile Whiting, *Antifascism in American Art* (New Haven, CT: Yale University Press, 1989), 97.

97. Sims, "Stuart Davis in the 1930s," 60.

98. Quoted in Kelder, "Stuart Davis and Modernism," 26; Kepes, *Language of Vision,* 14, respectively.

99. Kelder, "Stuart Davis and Modernism," 28.

100. Hubley and Schwartz, "Animation Learns a New Language," 360. Hubley also resurrects this phrase in his 1975 article "Beyond Pigs and Bunnies: The New Animator's Art," *American Scholar* 44, no. 2 (October 1975): 213–223.

101. For more, see Wells, *Animation and America,* chap. 2. Even the studio's two forays into modernist animation, *Melody* and *Toot, Whistle, Plunk and Boom,* were reportedly produced while Walt Disney was out of the country because his employees knew he would have interfered if he had been on-site; see Amidi, *Cartoon Modern,* 149.

102. Wells, *Animation and America,* 45.

103. In the next round, Hubley, in his 1973 article "Beyond Pigs and Bunnies," is again arguing for a return to symbolically charged graphic animation, this time in opposition not to a repressive Disney naturalism but to the cheapened, irresponsible appropriation of Hubley's own limited animation by television.

104. As design critic Georgine Oeri notes, "An educative element has remained behind even in the freest and most playful film creations of the [sic] UPA" (Oeri, "UPA," 470).

105. See, respectively, Barrier, *Hollywood Cartoons,* 515; and Amidi, *Cartoon Modern,* 8.

106. Barrier, *Hollywood Cartoons,* 526.

107. Hubley and Schwartz, "Animation Learns a New Language," 361.

108. Ibid., 360. For more on the war's specific contributions to the development of the American cartoon, see Karl Van Leuven, "The Animated Cartoon Goes To War," in *Writer's Congress: The Proceedings of the Conference Held in October 1943*

under the Sponsorship of the Hollywood Writers' Mobilization and the University of California (Berkeley: University of California Press, 1944), 112–121.

109. Hubley and Schwartz, "Animation Learns a New Language," 361, emphasis theirs. However, Franklin Thomas argues for the importance of entertainment and human interest in military training films in "The Cartoon and Training Films," in *Writer's Congress,* 133–137.

110. Kepes, *Language of Vision,* 201.

111. Nieland, "Midcentury Futurisms," 63.

112. Hubley and Schwartz, "Animation Learns a New Language," 362 and 361, respectively; emphasis theirs.

113. Turner, *Democratic Surround,* 10.

114. Kepes, Interview with Robert Brown, 21–22.

115. Hubley, "Beyond Pigs and Bunnies," 217.

116. Ibid., 219.

117. Kepes, *Language of Vision,* 221.

118. Schuldenfrei, "Assimilating Unease," 115. In her estimation, the role of modern design in the postwar era was "to produce designers who would assume social, technological, and economic responsibility in the postwar period—following in the footsteps of those who had designed during the war, both for it and for the time beyond it."

119. "Squash-and-stretch" refers to a style of character animation based on the maintenance of a consistent bodily volume, like a water balloon. According to Klein, *Seven Minutes,* this type of animation, which gives the figure a feeling of bouncy fleshiness, was a significant step in the transition from 1920s graphic animation to 1930s Disney-era naturalism aiming for the illusion of life (this argument runs throughout his book, particularly his chapters about the 1930s). "Centerline animation" is a part of this same process, referring to a character design based on circles and ovals, bisected down the center with features distributed symmetrically across these center lines, another nod toward naturalism.

120. Richard Thompson, "Meep Meep," in *Movies and Methods: An Anthology,* ed. Bill Nichols, vol. 1 (Berkeley: University of California Press, 1976), 126–135 (quote 128). This is perhaps merely a more nuanced and persuasive iteration of the widespread animation studies contention that the cartoon is always already self-referential and critical because the ability to challenge live-action illusionism is inherent to the medium. See, for instance, Paul Wells, *Animation: Genre and Authorship* (London: Wallflower, 2002); and Wells, *Animation and America,* esp. chap. 1.

121. Klein, *Seven Minutes,* 107. While UPA to a large degree moved cartoons away from the gag structure, films like *Gerald McBoing Boing* and the *Mr. Magoo* series indicate that the gag, while demoted within the studio's approach, was still present in their cartoon style.

122. David Fisher, "Two Premières: Disney and UPA," in *The American Animated Cartoon: A Critical Anthology,* ed. Danny Peary and Gerald Peary (New York: Dutton, 1980), 182.

123. Ibid.

124. Snippets of these interviews are scattered throughout Amidi's *Cartoon Modern,* most liberally in the introduction and the chapter on UPA.

125. Klein, *Seven Minutes,* 90.

126. For the full discussion, see ibid., 210–217.

127. Ibid., 233.

128. Ibid., 241.

129. See Tom Gunning, "The Cinema of Attractions: Early Film, Its Spectator, and the Avant-Garde," *Wide Angle* 8, nos. 3–4 (Fall 1986): 63–70; Hansen, "Mass Production of the Senses"; Ben Singer, "Modernity, Hyperstimulus, and the Rise of Popular Sensationalism," in Charney and Schwartz (eds.), *Cinema and the Invention of Modern Life,* 72–99.

130. See Jonathan Crary, *Suspensions of Perception: Attention, Spectacle, and Modern Culture* (Cambridge, MA: MIT Press, 1999). For discussions of animation and its effects on attention and retention, see Hubley and Schwartz, "Animation Learns a New Language"; and Thomas, "The Cartoon and Training Films."

131. Klein, *Seven Minutes,* 210.

132. Ibid., 204.

133. Leslie, *Hollywood Flatlands,* 299.

134. Wells, *Animation and America,* 45.

135. Leonard Spigelgass, "Indoctrination and the Training Film: Excerpts of the Discussion," in *Writer's Congress,* 129.

136. Quoted in Schuldenfrei, "Assimilating Unease," 114.

137. Quoted in Abraham, *When Magoo Flew,* 57.

138. Halas, "Graphic Design in Television," 490.

139. For more on UPA's television work, see Abraham, *When Magoo Flew,* chap. 8.

140. Spigel, *TV by Design,* 64.

141. Wells, *Animation and America,* 66–67, emphasis mine.

142. Rieder, "Memories of Mr. Magoo," 19.

143. Fisher, "Two Premières," 180.

144. Stavitsky, "Reordering Reality," 35.

145. Quoted in Sims, "Stuart Davis in the 1930s," 63.

146. Gene Deitch, "How to Succeed in Animation—Chapter 12: The UPA Experience," *Animation World Network,* www.awn.com/genedeitch/chapter-twelve-the-upa-experience.

147. Sims, "Stuart Davis in the 1930s," 63.

148. Nieland, "Midcentury Futurisms," 46–47.

149. Stavitsky, "Reordering Reality," 35.

150. For more on UPA narratives as cultural allegories, see Wells, *Animation and America.*, esp. chap. 3; Milton J. Rosenberg, "Mr. Magoo as Public Dream," *Quarterly of Film, Radio, and Television* 11, no. 4 (Summer 1957): 337–342; Fisher, "Two Premières."

151. Quoted in Stavitsky, "Reordering Reality," 23.

152. Kepes, *Language of Vision*, 129.
153. Hubley and Schwartz, "Animation Learns a New Language," 363.

CHAPTER TWO

1. Charles Eames and Ray Eames, *An Eames Anthology: Articles, Film Scripts, Interviews, Letters, Notes, Speeches* (New Haven, CT: Yale University Press, 2015), 123. For a full discussion of the course, see pp. 120–127.
2. Ibid., 126.
3. Ibid., 121.
4. Charles Eames, "Language of Vision: The Nuts and Bolts," *Bulletin of the American Academy of Arts and Sciences* 28, no. 1 (October 1974): 13–25.
5. Eames and Eames, *Eames Anthology*, 300.
6. Eames, "Language of Vision," 14.
7. Hubley and Schwartz, "Animation Learns a New Language," 360.
8. Lynn Spigel, "Back to the Drawing Board: Graphic Design and the Visual Environment of Television at Midcentury," *Cinema Journal* 55, no. 4 (Fall 2016): 41.
9. Donald Albrecht, "Design Is a Method of Action," in *The Work of Charles and Ray Eames: A Legacy of Invention*, ed. Donald Albrecht (New York: Harry N. Abrams in association with the Library of Congress and the Vitra Design Museum, 1997), 29.
10. Paul Schrader, "Poetry of Ideas: The Films of Charles Eames," *Film Quarterly* 23, no. 3 (Spring 1970): 9–10.
11. Hubley and Schwartz, "Animation Learns a New Language," 363.
12. Lucinda Kaukas Havenhand, "American Abstract Art and the Interior Design of Ray and Charles Eames," *Journal of Interior Design* 31, no. 2 (2006): 38.
13. It is worth noting that these theories were not the idiosyncratic pursuits of a few visionaries or crackpots. In *Building for Modern Man*, architect Thomas Creighton transcribes the various lectures given at a 1947 Princeton symposium of architects and designers looking for a common way forward in postwar America; *Space, Time, and Architecture, Vision in Motion,* and *Language of Vision* inform the conversation to a striking degree. See Thomas H. Creighton, ed., *Building for Modern Man: A Symposium* (Princeton, NJ: Princeton University Press, 1949).
14. For a discussion of their influence, see Arthur P. Molella, "Science Moderne: Sigfried Giedion's *Space, Time, and Architecture* and *Mechanization Takes Command*," *Technology and Culture* 43, no. 2 (April 2002): 374–389.
15. For a thorough exploration of the development of this modernist space in the late nineteenth century, see Brian Jacobson, *Studios before the System: Architecture, Technology, and the Emergence of Cinematic Space* (New York: Columbia University Press, 2015).
16. Moholy-Nagy, *Vision in Motion*, 268.
17. Ibid., 245. See Federico Neder, *Fuller Houses: R. Buckminster Fuller's Dymaxion Dwellings and Other Domestic Adventures* (Baden, Switz.: Lars Müller, 2008),

47–58. Elie Faure agrees: "I imagine that architecture will be the principal expression of this civilization, an architecture whose appearance may be difficult to define—perhaps it will be the industrial construction of our means of travel—ships, trains, automobiles and aeroplanes" (Faure, "The Art of Cineplastics," trans. Walter Pach, in *Screen Monographs I,* ed. Martin S. Dworkin [New York: Arno Press, 1970], 44).

18. Richard Neutra, *Survival through Design* (New York: Oxford University Press, 1954), 163.

19. George Howe, "Flowing Space: The Concept of Our Time," in Creighton (ed.), *Building for Modern Man,* 168.

20. Walter Gropius, *Scope of Total Architecture* (New York: Harper, 1955), 72.

21. In "Nine Points on Monumentality," Giedion and Fernand Leger imagine an architecture whose planes of reference are "animated" in a more literal, yet still illusory, sense: "During night hours, color and forms can be projected on vast surfaces. Such displays could be projected on buildings for purposes of publicity or propaganda. These buildings would have large plane surfaces planned for this purpose, surfaces which are non-existent today. Such big animated surfaces with the use of color and movement in a new spirit would offer unexplored fields to mural painters and sculptors" (Sigfried Giedion, *Architecture, You, and Me: The Diary of a Development* [Cambridge, MA: Harvard University Press, 1958], 50–51).

22. Giuliana Bruno, *Atlas of Emotion* (New York: Verso Books, 2002), 58; and Anne Friedberg, *The Virtual Window: From Alberti to Microsoft* (Cambridge, MA: MIT Press, 2006), 173, respectively.

23. Faure, "Art of Cineplastics," 24. This idea of cinema as architecture pervades the entire text; later he argues: "We may easily imagine an expanded cineplastic art which shall be no more than an architecture of the idea. . . . Only a great artist will be able to build edifices that are made and broken down and remade ceaselessly—by imperceptible passages of tone and modelling that are in themselves architecture at every moment—without our being able to seize the thousandth part of a second in which the transition takes place" (40).

24. Jacobson, *Studios before the System,* 77.

25. Anne Friedberg, *Window Shopping: Cinema and the Postmodern* (Berkeley: University of California Press, 1993).

26. For an exploration of the links between cinema, architecture, and cybernetics, see Martin, *Organizational Complex.*

27. See Olivier Lugon, "Dynamic Paths of Thought: Exhibition Design, Photography, and Circulation in the Work of Herbert Bayer," in *Cinema beyond Film: Media Epistemology in the Modern Era,* ed. François Albera and Maria Tortajada (Amsterdam: Amsterdam University Press, 2010), 117–144; Martin, *Organizational Complex;* Turner, *The Democratic Surround;* and Blakinger, "Aesthetics of Collaboration."

28. Jacobson, *Studios before the System,* 71.

29. J. P. Telotte, *Animating Space: From Mickey to Wall-E* (Lexington: University Press of Kentucky, 2010), 45 and 59, respectively.

30. Leslie, *Hollywood Flatlands,* 18–19.

31. Ibid., 299.

32. László Moholy-Nagy, *The New Vision, from Material to Architecture*, trans. Daphne M. Hoffmann (New York: Brewer, Warren & Putnam, 1932), 160.

33. Anneke Reens, "Modern Architecture Comes of Age," *Magazine of Art* 37, no. 3 (March 1944): 92.

34. Fred N. Severud, "The Values of Visual Education," in Creighton (ed.), *Building for Modern Man*, 116; Donald Appleyard, "Motion, Sequence, and the City," in *The Nature and Art of Motion*, ed. György Kepes (New York: G. Braziller, 1965), 189.

35. Henry Russell Hitchcock and Philip Johnson, *The International Style* (New York: Norton, 1966), 75.

36. Fernand Léger, "On Monumentality and Color," in Giedion, *Architecture, You, and Me*, 40–41.

37. Sergei Eisenstein, "From Lectures on Music and Colour in *Ivan the Terrible*," in *Eisenstein: Selected Works*, vol. 3: *1934–1947*, ed. Richard Taylor, trans. William Powell (Bloomington: Indiana University Press, 1988), 335.

38. Sergei Eisenstein, *Eisenstein on Disney*, ed. Jay Leyda, trans. Alan Upchurch (Calcutta: Seagull Books, 1986), 3–4.

39. Eisenstein, "From Lectures on Music and Colour," 335–336.

40. Moholy-Nagy, *Vision in Motion*, 168. Viking Eggeling was a Swedish avant-garde filmmaker who is perhaps best known for his 1924 film *Symphonie Diagonale*; German filmmaker Walter Ruttmann also made abstract animation in his *Lichtspiel: Opus* series of 1921–1925; Francis Picabia was a French avant-garde painter associated with Cubism and inspirational to Precisionism (see chapter 1); and Fernand Léger, another French painter, also adapted Cubism to a machine aesthetic.

41. "The first part of Disney's 'Fantasia' was such an attempt. Unfortunately it was later cut out of the film in the false belief that the public was not ready for it. The public here, as in so many other cases, is used as a scapegoat for the producers' own incapacity to sustain a genuinely artistic concept" (ibid.).

42. László Moholy-Nagy, *The New Vision and Abstract of an Artist*, trans. Daphne M. Hoffmann (New York: Wittenborn, Schultz, 1947), 72.

43. Charles Daggett, Letter to Mr. Douglas MacAgy, February 5, 1954, Early Museum History: Administrative Records, III.26.b, Museum of Modern Art Archives, New York, 1.

44. This idea of a "constellation" comes from Rudolf Arnheim: "In spite of what spontaneous perception indicates, space is in no way given by itself. It is created by a particular constellation of natural and man-made objects, to which the architect contributes. In the mind of the creator, user, or beholder, every architectural constellation establishes its own spatial framework" (Arnheim, *The Dynamics of Architectural Form* [Berkeley: University of California Press, 1977], 13).

45. Molella, "Science Moderne," 388.

46. Reinhold Martin also addresses the constellation of art, architecture, and science in a slightly different arrangement, referring to "architecture's own *techne*, suspended between art and science in the discourse of the period" (Martin, *Organizational Complex*, 19).

47. Well, if I'm being honest, it's probably most interesting because it is shaped like a triangle. But in this context, it is most interesting for its color. For a full spread of photographs of the house, see https://la.curbed.com/2013/1/25/10281150/touring-designer-rodney-walkers-transparent-house-in-ojai-now-with-1.

48. The poured concrete shells of the Brutalist style imported from England would be the major exception.

49. Neutra, *Survival through Design*, 180–181.

50. Ibid., 184. It should also be noted that while Neutra does single out the metropolis for particular rebuke, his notion of an "urbanized environment" involves the proliferation of human-made forms and technological advances reshaping sensation and experience in all homes, as well as offices, schools, etc. This idea, as opposed to the essential "organic" Neutra wishes to recapture, runs throughout but is particularly pronounced in the opening chapters.

51. Ibid., 185; and Eisenstein, *Eisenstein on Disney*, 3.

52. Hitchcock and Johnson, *The International Style*, 76.

53. Neutra, *Survival through Design*, 185. This invention bears a striking resemblance to Moholy-Nagy's 1930 sculptural work *Light-Space Modulator,* which uses various perforated, translucent, and transparent surfaces to project a shifting array of colored light on the wall behind it. For more on this concept, see Oliver A. I. Botar, "Taking the *Kunst* out of the *Gesamtkunstwerk:* Moholy-Nagy's Conception of the *Gesamtwerk,*" in *László Moholy-Nagy: The Art of Light* (Madrid, Spain: LA Fabrica, 2010), 159–168, and chapter 4 of this book.

54. Neutra, *Survival through Design*, 187.

55. Kepes, *Language of Vision*, 134.

56. Ibid., 139.

57. Moholy-Nagy, *Vision in Motion*, 155.

58. Neutra, *Survival through Design*, 180–181.

59. Charles Daggett, "Production Notes on 'The Tell Tale Heart'," n.d., Early Museum History: Administrative Records III.26.a, Museum of Modern Art Archives, New York, 4.

60. Neutra, *Survival through Design*, 180.

61. Ibid., 327.

62. Aluminum Company of America, "Alcoa Care-free Home," 1958, www.myalcoahome.com/brochures, 1, 3.

63. Ibid., 5.

64. Neutra, *Survival through Design*, 185.

65. Ibid., 180.

66. Ibid., 327.

67. In UPA's output, consider the clearest instance of this phenomenon, *The Unicorn in the Garden* (1953).

68. Neutra, *Survival through Design*, 180.

69. Giedeon, *Space, Time, and Architecture*, lvi, xlvii.

70. Arnheim, *Dynamics of Architectural Form*, 18.

71. Ibid., 69.

72. Ibid., 71.
73. Ibid., 96–97.
74. Neutra, *Survival through Design*, 163.
75. Arnheim, *Dynamics of Architectural Form*, 71.
76. Daggett, Letter to Mr. Douglas MacAgy, 1–2.
77. Alastair Gordon, *Naked Airport: A Cultural History of the World's Most Revolutionary Structure* (New York: Metropolitan Books, 2004), 199.
78. Sylvia Lavin, "Open the Box: Richard Neutra and the Psychology of the Domestic Environment," *Assemblage*, no. 40 (December 1999): 15.
79. Siegbert Langner, "Transcript of Opening Ceremonies, 'The Architecture of Richard Neutra': From International Style to California Modern, Bauhaus Archiv, Berlin," January 11, 1984, Museum of Modern Art Exhibition Records, 1980–1989, Cur 1333.18, Museum of Modern Art Archives, New York, 5.
80. Beatriz Colomina, *Privacy and Publicity: Modern Architecture as Mass Media* (Cambridge, MA: MIT Press, 1994), 14–15.
81. "Glamourized Houses," *Life*, April 11, 1949, 146–148.
82. Neutra, *Survival through Design*, 327.
83. Hubley, "Beyond Pigs and Bunnies," 219. This itself is a restatement of a more prosaic thought in "Animation Learns a New Language" (363): "It might then be advisable to use a combination of photography and animation, the photography to state the facts of outward appearance and the animation to illustrate the inner construction.... This kind of treatment creates a super-reality in which we are conscious of many aspects simultaneously."
84. Kepes, Interview with Robert Brown, 8. Kepes never made his film; however, UPA did adapt "The Emperor's New Clothes" in 1953.
85. Gropius, *Scope of Total Architecture*, 36–37.
86. Roland Marchand, "Visions of Classlessness, Quests for Dominion: American Popular Culture, 1945–1960," in *Reshaping America: Society and Institutions, 1945–1960*, ed. Robert H. Bremner and Gary W. Reichard (Columbus: Ohio State University Press, 1982), 167.
87. Moholy-Nagy, *Vision in Motion*, 104.
88. Ibid., 103.
89. Reyner Banham, "Monumental Windbags," in *The Inflatable Moment: Pneumatics and Protest in '68*, ed. Marc Dessauce (New York: Princeton Architectural Press, 1999), 33.
90. Gordon, *Naked Airport*, 196.
91. Walter Gropius, *The New Architecture and the Bauhaus* (Cambridge, MA: MIT Press, 1974), 29.
92. Eisenstein, *Eisenstein on Disney*, 4.
93. Gwendolyn Wright, *USA* (London: Reaktion Books, 2008), 169 and 171, respectively.
94. Beatriz Colomina, "Reflections on Eames House," in *The Work of Charles and Ray Eames: A Legacy of Invention*, ed. Donald Albrecht (New York: Harry N. Abrams in association with the Library of Congress and the Vitra Design Museum, 1997), 133.

95. Bruce Jenkins, "Making the Scene: West Coast Modernism and the Movies," in *Birth of the Cool: California Art, Design, and Culture at Midcentury*, ed. Elizabeth Armstrong (New York: Prestel Art, 2007), 112.

96. Kepes, *Language of Vision*, 19.

97. Neutra, *Survival through Design*, 187.

98. László Moholy-Nagy, *Painting, Photography, Film*, trans. Janet Seligman (London: Lund Humphries, 1969), 69.

99. Golec, "Natural History of a Disembodied Eye," 6 and 9, respectively.

100. Gordon, *Naked Airport*, 171.

101. Kepes, *Language of Vision*, 13–14.

102. Moholy-Nagy, *New Vision and Abstract of an Artist*, 59, and *The New Vision, from Material to Architecture*, 152, respectively.

103. Botar, "Taking the *Kunst* out of the *Gesamtkunstwerk*," 162.

104. Neutra, *Survival through Design*, 163.

105. Arnheim, *Dynamics of Architectural Form*, 18.

106. Aylish Wood, "Re-Animating Space," *Animation* 1, no. 2 (November 2006): 139.

CHAPTER THREE

1. In fact, Lustig is back in vogue, and as of 2013, literary press New Directions has released fifty of his most iconic covers as a set of postcards.

2. I adopt this term from Moholy-Nagy, who considered it one of the central features of his foundational goal of "vision in motion." Moholy-Nagy, *Vision in Motion*, 208.

3. See, for instance, Suzanne Buchan, "Theatrical Cartoon Comedy: From Animated Portmanteau to the *Risus Purus*," in *A Companion to Film Comedy*, ed. Andrew Horton and Joanna E. Rapf (London: Blackwell, 2013), 521–543; Robyn Ferrell, "Life-Threatening Life: Angela Carter and the Uncanny," in *The Illusion of Life: Essays on Animation,* ed. Alan Cholodenko (Sydney: Power Publications in association with the Australian Film Commission, 1991), 131–144; Nicholas Sammond, "'Who Dat Say Who Dat?': Racial Masquerade, Humor, and the Rise of American Animation," in *Funny Pictures: Animation and Comedy in Studio-Era Hollywood,* ed. Daniel Goldmark and Charlie Keil (Berkeley: University of California Press, 2011); Paul Wells, *Understanding Animation* (London ; New York: Routledge, 1998).

4. Will Burtin and L. P. Lessing, "Interrelations," *Graphis* 4, no. 22 (1948): 108.

5. Will Burtin, "Integration, the New Discipline in Design," *Graphis* 5, no. 27 (1949): 230.

6. Hubley, "Beyond Pigs and Bunnies," 217.

7. Hubley and Schwartz, "Animation Learns a New Language," 362 and 361, respectively.

8. Wells, *Animation and America*, 12.

9. Wells, *Understanding Animation*, 76.

10. *Paul Wells, *Basics Animation 01: Scriptwriting* (New York: AVA Publishing, 2007), 25.

11. Daggett, "About 'Gerald McBoing-Boing,'" 1.

12. Quoted in Abraham, *When Magoo Flew*, 32.

13. P. K. Thomajan, "George Guisti: Advertisements and Covers," *Graphis* 11, no. 59 (1955): 266; and Burtin, "Integration," 232, respectively.

14. Burtin and Lessing, "Interrelations," 111.

15. "International Design Conference: Aspen, Colorado, 1955," *Print* 9, no. 6 (August 1955): 31. For more on the history and importance of the Aspen conferences, see Sidney Hyman, *The Aspen Idea* (Norman: University of Oklahoma Press, 1975).

16. "Notes on the Future: Aspen Design Conference," *Print* 12, no. 2 (October 1958): 55.

17. For more on Freud's postwar reign, see Lawrence R. Samuel, *Freud on Madison Avenue: Motivation Research and Subliminal Advertising in America* (Philadelphia: University of Pennsylvania Press, 2010); Samuel, *Shrink: A Cultural History of Psychoanalysis in America* (Lincoln: University of Nebraska Press, 2013).

18. Samuel, *Shrink*, 100 and 99, respectively.

19. Sigmund Freud, *Introductory Lectures on Psycho-Analysis*, trans. James Strachey, vol. 15 of The Standard Edition of the Complete Psychological Works of Sigmund Freud (London: Hogarth Press and the Institute of Psycho-Analysis, 1953), 175.

20. Sigmund Freud, *The Interpretation of Dreams (First Part)*, trans. James Strachey, vol. 4 of The Standard Edition, 277; Freud, *Dora: An Analysis of a Case of Hysteria*, trans. James Strachey (New York: Simon & Schuster, 1997), 32, respectively.

21. Kepes, *Language of Vision*, 221.

22. György Kepes, "Excerpt from Kepes," *Print* 11, no. 1 (March 1957): 54.

23. Freud, *Introductory Lectures on Psycho-Analysis*, 171.

24. Ibid., 172.

25. Sigmund Freud, "The Claims of Psycho-Analysis to Scientific Interest," in *Totem and Taboo and Other Works*, trans. James Strachey, vol. 13 of The Standard Edition, 170.

26. See Sigmund Freud, *The Psychopathology of Everyday Life*, trans. James Strachey, vol. 6 of The Standard Edition.

27. Freud, "Claims of Psycho-Analysis," 170.

28. As he observes, "So far-reaching an agreement between the methods of the joke-work and those of the dream-work can scarcely be a matter of chance" (Sigmund Freud, *Jokes and Their Relation to the Unconscious*, trans. James Strachey [New York: Norton, 1963], 89).

29. For the bond between cartoons and humor, see particularly Goldmark and Keil (eds.), *Funny Pictures;* and Buchan, "Theatrical Cartoon Comedy." For cartoons and fantasy, see Barrier, *Hollywood Cartoons;* Jayne Pilling, ed., *Animating the Unconscious: Desire, Sexuality and Animation* (London: Wallflower, 2012); Telotte, *Animating Space;* and Wells, *Understanding Animation*. In addition, shifting from

fantasy but remaining well within imaginary space, Donald Crafton calls animation a "memory palace" (Crafton, *Shadow of a Mouse: Performance, Belief, and World-Making in Animation* [Berkeley: University of California Press, 2013], 7).

30. Freud, *Jokes and Their Relation to the Unconscious*, 179.

31. It is perhaps no coincidence that many of Winsor McCay's animation works, such as *Little Nemo in Slumberland* and *Dream of the Rarebit Fiend*, are framed as dreams or as night visitations.

32. While Freud identifies displacement as the primary impediment to communication and condensation as a matter of efficiency, it is clear that condensation impedes communication as well; consider his assertion, "Here we have the fact of 'compression' or 'condensation,' which has become familiar in the dream-work. It is this that is mainly responsible for the bewildering impression made on us by dreams, for nothing at all analogous to it is known to us in mental life that is normal and accessible to consciousness" (Freud, *The Interpretation of Dreams [Second Part]*, trans. James Strachey, vol. 5 of The Standard Edition, 595).

33. He does discuss visual jokes such as caricatures in *Jokes and Their Relation to the Unconscious*, but they are not framed as examples of condensation, which he limits to linguistic uses. For more on condensation and linguistic humor, see esp. 41–45.

34. Freud, *Interpretation of Dreams (Second Part)*, 341, emphasis his.

35. Freud, *Interpretation of Dreams (First Part)*, 298n. For more on Freud's indirect representation, see *Jokes and Their Relation to the Unconscious*, 74–89; and Freud, *Dora*, 9.

36. Hubley and Schwartz, "Animation Learns a New Language," 363.

37. Samuel, *Shrink*, xxvii. It also resonates with the architectural rhetoric of the period, oriented toward the expansion of vision and the cultivation of infinite views. See chapter 2 of this book.

38. Freud, *Dora*, 56–84.

39. Georgine Oeri, "George Giusti," *Graphis* 5, no. 26 (1949): 148.

40. Max Bill, "Graphic Art in the Atom World," *Graphis* 4, no. 21 (1948): 81.

41. Herbert W. Franke, "Beyond Human Vision," *Graphis* 16, no. 87 (January–February 1960): 76–81, 86–87.

42. Oeri, "George Giusti," 148.

43. L. Fritz Gruber, "Design for Music," *Graphis* 5, no. 25 (1949): 14. Here we may find a midcentury echo of animation's engagement with the concept of visual music, most famously carried out by Oskar Fischinger.

44. Ibid., 19.

45. Hubley and Schwartz, "Animation Learns a New Language," 362.

46. Quoted in Barrier, *Hollywood Cartoons*, 528.

47. Freud, *Introductory Lectures on Psycho-Analysis*, 173.

48. Freud, *Interpretation of Dreams (First Part)*, 321.

49. Ibid., 330. This is true of condensation in jokes as well: "All these techniques are dominated by a tendency to compression, or rather to saving. It all seems to be a question of economy" (Freud, *Jokes and Their Relation to the Unconscious*, 42).

50. This is not an unprecedented development in aesthetic thought; film scholar Malcolm Turvey has explored the ways in which classical film theorists Jean Epstein, Dziga Vertov, Béla Balász, and Sigfried Kracauer claimed an extraperceptual power for the cinema—a school of thought he terms "the revelationist tradition." See Turvey, *Doubting Vision: Film and the Revelationist Tradition* (New York: Oxford University Press, 2008). Indeed, when he remarks, "They compare the cinema to microscopes and telescopes, arguing that, like them, it is capable of revealing truths about reality that are invisible in the sense that the human eye is incapable of seeing them unaided due to its limitations" (4), he may as well be describing Hubley and Schwartz. And when he bemusedly observes, "And they conceive of it as an awesome, even miraculous power that, rather than extending the power of the human eye, escapes its limitations and thereby has the potential to bring about a fundamental change for the better in human existence" (6), his critique is equally applicable to Kepes, Moholy-Nagy, and the wider field of midcentury graphic design. Interestingly, Hubley and Schwartz's claim for this vision-enhancing property as the linchpin of animation's medium-specificity as against live-action cinema in many ways adopts the very same rhetoric used to support live-action cinema's medium-specificity as against all other art forms.

51. Burtin and Lessing, "Interrelations," 109.

52. Ibid., 108.

53. See also Hubley and Schwartz, "Animation Learns a New Language," for a discussion of the film-meets-diagram potentialites of animation.

54. Burtin and Lessing, "Interrelations," 108.

55. Hubley and Schwartz, "Animation Learns a New Language," 360.

56. Burtin and Lessing, "Interrelations," 108.

57. Hubley and Schwartz, "Animation Learns a New Language," 361.

58. And also, it is worth noting, extends as far back as does the invention and worship of gods. Perhaps not coincidentally, Bell Laboratories' scientific cartoons are suffused with religious imagery and rhetoric.

59. C. F. O. Clarke, "Alvin Lustig: Cover Designs," *Graphis* 4, no. 23 (1948): 242. We may perhaps see in this practice an echo, or a commercialization, of Otto Neurath's influential "isotype," an acronym for "International System Of Typographic Picture Education." For a thorough explication of his invention, see Neurath, *International Picture Language: The First Rules of Isotype* (London: K. Paul, Trench, Trubner & Co., 1936). Neurath intended isotype to be a visual language whose signs "have to be so simple that they may be put in lines like letters" (32–33). In his system, "the picture-maker has to be guided by the rules of education by the eye and to make a *selection of material which will give a certain teaching effect*" (29, emphasis his). While the emphasis on his language's internationalism is not a primary concern for the design thought discussed here, this explanation of a process of distillation and condensation resonates strongly with the concerns of the postwar design scene.

60. Quoted in Steven Heller, *Born Modern: The Life and Work of Alvin Lustig* (San Francisco: Chronicle Books, 2010), 50.

61. Clarke, "Alvin Lustig: Cover Designs," 244.

62. Chuck Jones, "Music and the Animated Cartoon," *Hollywood Quarterly* 1, no. 4 (July 1946): 364.

63. Ibid., 368–370.

64. A year later, Jones offered an encore of this performance with *The Dot and the Line: A Romance in Lower Mathematics,* an adaptation of Norton Juster's illustrated book of the same title. Here the abstract substance given visible form is not sound but mathematics, and on top of that it uses the geometric forms of mathematical concepts to illustrate emotions and bodily experiences—love, excitement, enthusiasm, even a hangover.

65. Freud, *Interpretation of Dreams (First Part),* 324.

66. Freud, *Psychopathology of Everyday Life,* 58–59.

67. They are also a resurgence of the "graphic animation" of the famous animation duo of the Fleischer Brothers as discussed in Klein, *Seven Minutes,* esp. chaps. 1 and 5.

68. Burtin and Lessing, "Interrelations," 109.

69. Wells, *Animation and America,* 12.

70. Moholy-Nagy, *Vision in Motion,* 208.

71. Freud, *Interpretation of Dreams (Second Part),* 493.

72. Freud, *Interpretation of Dreams (First Part),* 324. Interestingly, Freud here compares this to a drawing "in which a general concept is formed from a number of individual perceptual images," a description that comes awfully close to Muybridge's early chronophotographic experiments.

73. Stanley Roberts, "Visual Presentation—A Challenge to the Designer," *Graphis* 14, no. 79 (September–October 1958): 407.

74. E. W. Ted Poyser, "Art Directors Club of Los Angeles—A Selection from Three Annual Exhibitions," *Graphis* 18, no. 101 (May–June 1962): 304–305.

75. Mark Rawlinson, *Charles Sheeler: Modernism, Precisionism, and the Borders of Abstraction* (London: I. B. Tauris, 2007), 179.

76. Charles Brock, *Charles Sheeler: Across Media* (Berkeley: University of California Press, 2006), 137; and Rawlinson, *Charles Sheeler,* 175.

77. Live-action avant-garde cinema partook in this as well; see chapter 4 of this book for a discussion of Shirley Clarke's *Bridges-Go-Round* and Pat O'Neill's *7362.*

78. Hubley, "Beyond Pigs and Bunnies," 218–219, emphasis his.

79. Moreover, this shot condenses time within a single image, as Charles Daggett notes: "We established the old man in a long shot at the table on a bare stage that involved clocks and the swinging of pendulums. In less than a minute, we expressed seven days of waiting" (Daggett, "Production Notes on 'The Tell Tale Heart,'" 3).

80. Kepes, *Language of Vision,* 200–201.

81. Moholy-Nagy, *Vision in Motion,* 12.

82. Georgine Oeri, "The Display Window as a Sign of the Times," *Graphis* 4, no. 24 (1948): 406.

83. Hubley and Schwartz, "Animation Learns a New Language," 362, emphasis theirs.

84. Freud, *Interpretation of Dreams (First Part)*, 324.
85. Hubley and Schwartz, "Animation Learns a New Language," 363.
86. Ibid.
87. Freud, *Interpretation of Dreams (First Part)*, 27.
88. Freud, *Interpretation of Dreams (Second Part)*, 496.
89. The combination of live-action film and animation is a long-standing practice in animated films, perhaps even a foundational one in terms of the visible presence of the artist in early animation by J. Stuart Blackton and Winsor McCay. This hybrid film continued into the 1920s and 1930s with Fleischer's *Koko the Clown* and Disney's *Alice in Cartoonland* series, as well as a cycle of dual-media romps in the 1940s, including films such as Disney's *The Three Caballeros* (1944) and *Fun and Fancy Free* (1947) and Warner Bros.' *My Dream Is Yours* (1949).
90. Container Corporation of America, "Good Design—An Important Function of Management," *Graphis* 6, no. 30 (1950): 136–140, 201. For more on Paepcke's and the Container Corporation's influence on modern design, see James Sloan Allen, *The Romance of Commerce and Culture: Capitalism, Modernism, and the Chicago-Aspen Crusade for Cultural Reform* (Boulder: University Press of Colorado, 2002).
91. Container Corporation of America, "Good Design," 137.
92. Andreas A. Timmer, "Making the Ordinary Extra-Ordinary: The Film-Related Work of Saul Bass" (PhD diss., Columbia University, 1999), 27.
93. Jeremy Aynsley, *Pioneers of Modern Graphic Design: A Complete History* (London: Mitchell Beazley, 2004), 104.
94. Georg Stanitzek, "Reading the Title Sequence," *Cinema Journal* 48, no. 4 (Summer 2009): 54.
95. Saul Bass, "Film Advertising," *Graphis* 9, no. 48 (1953): 276.
96. Raymond Gid, "Saul Bass: New Film Titlings and Promotional Films," *Graphis* 19, no. 106 (1963): 150.
97. Saul Bass, "Around the World in 80 Days—Titles Research," n.d., Box 1A, f20, Margaret Herrick Library Special Collections: Saul Bass Papers.
98. Ibid.
99. Saul Bass, "The Man with the Golden Arm—Writings," n.d., Box 4A, f19, Margaret Herrick Library Special Collections: Saul Bass Papers.
100. Saul Bass, "The Searching Eye—Programs," n.d., 73, Box 10A, f31, Margaret Herrick Library Special Collections: Saul Bass Papers.
101. Saul Bass, "Why Man Creates—Script," n.d., Box 5, f3, Margaret Herrick Library Special Collections: Saul Bass Papers.
102. Hubley and Schwartz, "Animation Learns a New Language," 362.
103. Burtin, "Integration," 231.
104. Hubley, "Beyond Pigs and Bunnies," 219. See also Giedion's notion of "space-time" as the new ordering force of modern experience in Giedion, *Space, Time, and Architecture*.
105. Sigmund Freud, "Revision of the Theory of Dreams," in *New Introductory Lectures on Psycho-Analysis and Other Works,* trans. James Strachey, vol. 22 of The Standard Edition, 26 and 25, respectively.

106. Film theorist Mary Ann Doane has addressed the question of the spatialization of time, drawing a parallel between Freud's concept of the "Mystic Writing-Pad" and Étienne-Jules Marey's chronophotography as two models of storing—that is, visually representing—time through media. Particularly relevant here is her discussion of Marey's problem with superimposition—too many images condensed onto each other becoming illegible—and his solution: the reduction of the profilmic image to abstract form to minimize the blurring of superimposition and thus retain legibility. See Mary Ann Doane, "Temporality, Storage, Legibility: Freud, Marey, and the Cinema," *Critical Inquiry* 22, no. 2 (Winter 1996): esp. 327–332.

107. Schwartz and Hubley, "Animation Learns a New Language," 362.

108. Franke, "Beyond Human Vision," 86.

109. Burtin and Lessing, "Interrelations," 111.

110. "Notes on the Future: Aspen Design Conference," 56.

111. Quoted ibid., 55.

112. Ibid., 57.

113. Ibid.

114. Amidi, *Cartoon Modern*, 133 and 115, respectively.

115. Hubley, "Beyond Pigs and Bunnies," 219.

116. Sigfried Giedion, "Herbert Bayer and Advertising in the U.S.A.," *Graphis* 1, nos. 11–12 (Oct./Nov./Dec. 1945): 422.

117. Suzanne Barrey, "General Dynamics: The Graphic Face of a Dynamic Corporation," *Graphis* 14, no. 79 (September–October 1958): 421.

118. Burtin, "Integration," 230.

119. "UPA Exhibition at MoMA: Preliminary Notes," 2.

120. Franke, "Beyond Human Vision," 86.

121. See chapter 2 for an analysis of spatial relations in this short film more indebted to architectural theory.

122. For a discussion of the emergence of the postwar consumer citizen, see Cohen, *Consumer's Republic*.

CHAPTER FOUR

1. Spigel, *TV by Design*, 217.

2. Parmelee directed four UPA shorts, *The Emperor's New Clothes* (1953), *The Tell-Tale Heart* (1953), *The Man on the Flying Trapeze* (1954), and *Four Wheels No Brakes* (1955), and worked in the art department for various others.

3. For perhaps the fullest expression of this idea, see Kovács, *Screening Modernism*. In *The Altering Eye*, Robert Phillip Kolker focuses on questions of "form" and "the image," but he is more concerned with the ontological status of the image and with art cinema's stance toward the reality of the image than he is with its graphic composition.

4. Spigel, *TV by Design*, chap. 6, esp. 226–232.

5. Ibid., 220.

6. Ibid., 6–7.

7. György Kepes, Oral History Interview with Robert Brown, Transcript, March 7 and August 30, 1972, and January 11, 1973, 20–21, György Kepes Papers, Archives of American Art, Smithsonian Institution. Punctuation as in transcript.

8. See, respectively, Jan Campbell, *Film and Cinema Spectatorship: Melodrama and Mimesis* (Oxford: Polity Books, 2005); Fredric Jameson, "Transformations of the Image in Postmodernity," in *The Cultural Turn: Selected Writings on the Postmodern, 1983–1998* (London: Verso Books, 2009), 93–135; and Laura Mulvey, "Visual Pleasure and Narrative Cinema," *Screen* 16, no. 3 (1975): 6–18.

9. Martin Lefebvre, "Between Setting and Landscape in the Cinema," in *Landscape and Film* (New York: Routledge, 2006), 19–60.

10. Ibid., 48.

11. Spigel, *TV by Design,* 106 and 23, respectively.

12. Lefebvre, "Between Setting and Landscape," 51.

13. For more on the "Good Design" movement, see Edgar Kaufmann Jr., *Good Design: 5th Anniversary* (New York: Museum of Modern Art, 1954); and Mark Jarzombek, "'Good-Life Modernism and Beyond': The American House in the 1950s and 1960s," *Cornell Journal of Architecture* 4 (Fall 1990): 76–93, 208. We may also find evidence of this phenomenon in the studies of "good taste" that circulated in the period; see, for instance, Russell Lynes, *The Tastemakers* (New York: Harper, 1954).

14. Moholy-Nagy, *Vision in Motion,* 268. One wonders what Moholy-Nagy, who died in 1947, would have thought about television's introduction of modern art and design principles to wide swaths of the American public in the comfort of their own homes.

15. Lefebvre, "Between Setting and Landscape," 22.

16. See Roland Barthes, "The Third Meaning," in *Image–Music–Text,* trans. Stephen Heath (New York: Hill & Wang, 1977), 52–68.

17. Kristin Thompson, "The Concept of Cinematic Excess," *Cine-Tracts* 1, no. 2 (Summer 1977): 58.

18. Robert B. Ray, *The Avant-Garde Finds Andy Hardy* (Cambridge, MA: Harvard University Press, 1995), 103.

19. There is a resonance here with camp as well, another spectatorship practice that works to subvert the ideological drive of the Hollywood narrative—especially its obsession with heterosexual romance—by canonizing elements of surface, gesture, texture, and performance.

20. Laura Mulvey has posited another form of this spectatorship practice, outlining the positions of the "possessive spectator" and the "pensive spectator," both of whom gain a form of control over the film by being able to stop it and ruminate upon its stilled details. This control is born of the era of home video, especially digital media, which the spectator can readily pause to explore in a depth that the constant motion of the film does not allow. For more on this video- and DVD-specific theory, see *Death 24× a Second: Stillness and the Moving Image* (London: Reaktion Books, 2006), esp. chaps. 9 and 10.

21. Barthes, "Third Meaning," 58.
22. Spigel, *TV by Design*, 23.
23. Faure, "Art of Cineplastics," 29.
24. Kepes, *Language of Vision*, 52.
25. Faure, "Art of Cineplastics," 45. It is difficult to read this and not hear the appeals to democratic unity that Fred Turner, in *The Democratic Surround*, finds in midcentury design's own championing of plasticity in the postwar era.
26. Lev Manovich, *The Language of New Media* (Cambridge, MA: MIT Press, 2001), 298. We may also find a hint of this position in Karen Beckman's recent anthology *Animating Film Theory* (Durham, NC: Duke University Press, 2014), which fights for animation's place within the established canon of film theory.
27. Manovich, *Language of New Media*, 298.
28. Ibid., 300–301.
29. This is the essence of Elie Faure's 1926 argument about the potentialities of cinema in "The Art of Cineplastics."
30. Donald Crafton, "The Veiled Genealogies of Animation and Cinema," *Animation: An Interdisciplinary Journal* 6, no. 2 (2011): 106.
31. Manovich, *Language of New Media*, 302.
32. Crafton, "Veiled Genealogies of Animation," 94.
33. André Gaudreault and Philippe Gauthier, "Could Kinematography Be Animation and Animation Kinematography?" *Animation: An Interdisciplinary Journal* 6, no. 2 (2011): 88, emphasis in original.
34. Saverio Giovaccini, *Hollywood Modernism: Film and Politics in the Age of the New Deal* (Philadelphia: Temple University Press, 2001), 5.
35. Ibid., 2.
36. Chris Robé, *Left of Hollywood: Cinema, Modernism, and the Emergence of U.S. Radical Film Culture* (Austin: University of Texas Press, 2010), 80.
37. Erika Lee Doss, *Benton, Pollock, and the Politics of Modernism: From Regionalism to Abstract Expressionism* (Chicago: University of Chicago Press, 1991), 212.
38. David Trotter, *Cinema and Modernism* (Malden, MA: Blackwell, 2007).
39. Tom Cerasulo, *Authors Out Here: Fitzgerald, West, Parker, and Schulberg in Hollywood* (Columbia: University of South Carolina Press, 2010).
40. Hansen, "Mass Production of the Senses," 67 and 69, respectively.
41. Peter Franklin, *Seeing through Music: Gender and Modernism in Classic Hollywood Film Scores* (New York: Oxford University Press, 2011).
42. In a sense, this approach resembles that of Beatriz Colomina, who positions architectural photography as one of the primary ways in which average Americans, who could not afford modern architecture, experienced modern architecture; for more, see chapter 2 of this book.
43. Donald Albrecht, *Designing Dreams: Modern Architecture in the Movies* (Santa Monica, CA: Hennessey + Ingalls, 1986), 77.
44. Lucy Fischer, *Designing Women: Cinema, Art Deco, and the Female Form* (New York: Columbia University Press, 2003).

45. "Red Garters," *Variety,* February 1, 1954, Paramount Pictures Production Records, 163-f.9, Margaret Herrick Library, Beverly Hills, CA.

46. Albrecht, *Designing Dreams,* 78.

47. Fischer, *Designing Women,* chap. 5.

48. James Naremore, *The Films of Vincente Minnelli* (Cambridge: Cambridge University Press, 1993), 18.

49. A notable counterpoint here would be the 1930s musicals of Busby Berkeley, where human bodies are arranged, segmented, and repeated in order to create dazzling geometric spectacles, often through the use of direct overhead shots. The difference here is that there is nothing cartoonish on display; the visual modernism at work in this earlier iteration of musical modernism is not the postwar modernism of the cartoon, but the interwar modernism of the machine.

50. I apologize.

51. R. H. Gardner, "A New Kind of Western," *Baltimore Sun,* March 16, 1954; and Joe Pihodna, "On the Screen: 'Red Garters,'" *New York Herald Tribune,* March 27, 1954, respectively.

52. Mae Tinée, "'Red Garters' Western Has Snapping Fun," *Chicago Daily Tribune,* April 20, 1954.

53. Bosley Crowther, "Red Garters," *New York Times,* March 27, 1954.

54. Edwin Schallert, "'Red Garters' Valiantly Essays Western Satire," *Los Angeles Times,* February 10, 1954.

55. "Red Garters," *Variety.*

56. "Red Garters," *Hollywood Reporter,* February 1, 1954, Paramount Pictures Production Records, 163-f.9, Margaret Herrick Library, Beverly Hills, CA.

57. In fact, cartoonist Frank Tashlin both cowrote an early version of the script for and was slated to direct *Red Garters,* though his involvement in the finished product two years later is unclear. Roger Garcia notes that there were three different *Red Garters* projects in circulation in 1952 and that the resulting film, "as finally produced, used Tashlin's 'comedy-western-musical' concept"; he does not, however, mention the film's visual style. See Roger Garcia and Bernard Eisenschitz, eds., *Frank Tashlin* (Locarno: Éditions du Festival international du film de Locarno in collaboration with the British Film Institute, 1994), 229.

58. James Peterson, *Dreams of Chaos, Visions of Order: Understanding the American Avant-Garde Cinema* (Detroit: Wayne State University Press, 1994), 81.

59. Ibid., 180.

60. Ibid., esp. 85–90.

61. See, respectively, Annette Michelson, "Film and the Radical Aspiration," in *Film Culture Reader,* ed. P. Adams Sitney (New York: Praeger Publishers, 1970), 417–418; and P. Adams Sitney, *Visionary Film: The American Avant-Garde, 1943–2000,* 3rd ed (New York: Oxford University Press, 2002), xiii.

62. Manovich, *Language of New Media,* 306.

63. For exhaustive histories of these two organizations, see Scott MacDonald, ed., *Cinema 16: Documents toward a History of the Film Society* (Philadelphia: Temple University Press, 2002); and MacDonald, ed., *Art in Cinema: Documents toward*

a History of the Film Society, Wide Angle Books (Philadelphia: Temple University Press, 2006).

64. For fuller histories of this moment in avant-garde cinema, see the seminal histories by David Curtis, *Experimental Cinema: A Fifty-Year Evolution* (London: Studio Vista, 1971); Malcolm Le Grice, *Abstract Film and Beyond* (Cambridge, MA: MIT Press, 1977); Michael O'Pray, *Avant-Garde Film: Forms, Themes, and Passions* (London: Wallflower, 2003); and Sitney, *Visionary Film.*

65. MacDonald (ed.), *Art in Cinema,* 77; and MacDonald (ed.), *Cinema 16,* 6.

66. MacDonald (ed.), *Cinema 16,* 242.

67. Ibid., 213.

68. Ibid., 158 and 166, respectively.

69. MacDonald (ed.), *Art in Cinema,* 270.

70. Ibid., 5.

71. Ibid., 29.

72. Scott MacDonald, *A Critical Cinema 3: Interviews with Independent Filmmakers* (Berkeley: University of California Press, 1998), 68.

73. Le Grice, *Abstract Film and Beyond,* 114. For more on the West Coast style, particularly as it relates to animation, the avant-garde, and design, see Jenkins, "Making the Scene."

74. Curtis, *Experimental Cinema,* 163.

75. "The problem of our generation is to bring the intellectual and the emotional, the social and technological components into balanced play; to learn and see and feel them in relationship" (Moholy-Nagy, *Vision in Motion,* 12).

76. David E. James, "*The Sky Socialist:* Film as an Instrument of Thought, Cinema as an Augury," in *Optic Antics: The Cinema of Ken Jacobs,* ed. Michele Pierson, David E. James, and Paul Arthur (New York: Oxford University Press, 2011), 81.

77. Curtis, *Experimental Cinema,* 158. Emphasis his, but it serves my purposes nicely too.

78. Moholy-Nagy, *Vision in Motion,* 12.

79. Ibid.

80. Edward Dimendberg, *Film Noir and the Spaces of Modernity* (Cambridge, MA: Harvard University Press, 2004), 168.

81. Artist and curator David Campany links Klein to Fellini as well, and locates him within the mainstream of European modernism: "Klein was at the forefront of a new form as it developed out of *cinéma vérité* and alongside the *nouvelle vague*" (Campany, "William Klein's Way," in *William Klein: ABC,* by William Klein [New York: Harry N. Abrams, 2013], 7).

82. Chale Nafus, "*Zazie dans le Métro,*" www.austinfilm.org/essential-cinema/program-notes-zazie-dans-le-metro (accessed February 11, 2014; no longer available).

83. "Les Américains ont inventé le jazz pour se consoler de la mort, la star pour se consoler de la femme. Pour se consoler de la nuit, ils ont inventé Broadway." My translation.

84. Campany, "William Klein's Way," 4.

85. Judith Wechsler, "György Kepes," in *The MIT Years, 1945–1977*, by György Kepes (Cambridge, MA: MIT Press, 1978), 10.
86. Halpern, *Beautiful Data*, 97.
87. Kepes, *Language of Vision*, 154.
88. See Golec, "Natural History of a Disembodied Eye."
89. Moholy-Nagy, *Vision in Motion*, 272.
90. Many thanks to Oliver I. A. Botar for bringing this parallel to my attention.
91. Without wishing to overlook the debates about film *noir*'s status—genre? style? mode?—this book is not the place to settle the question; I confess to holding a radically catholic interpretation of the term. For the general outlines of the issue, see Raymond Borde and Étienne Chaumeton, *A Panorama of American Film Noir, 1941–1953* (San Francisco: City Lights Books, 2002); R. Barton Palmer, *Hollywood's Dark Cinema: The American Film Noir* (New York: Twayne, 1994); James Naremore, *More Than Night: Film Noir in Its Contexts*, updated and expanded ed. (Berkeley: University of California Press, 2008); and Alain Silver and James Ursini, eds., *Film Noir Reader*, 4th Limelight ed. (New York: Limelight Editions, 1998).
92. Thompson, "Meep Meep," 134. Relatedly, Borde and Chaumeton briefly link *noir* to the cartoon, but to Disney and Fleischer cartoons specifically, and only in terms of their "inexhaustible sadistic imagination," not their visual style; Borde and Chaumeton, *Panorama of American Film Noir*, 26.
93. See, for instance, Nicholas Christopher, *Somewhere in the Night: Film Noir and the American City* (New York: Free Press, 1997), 13–15; Borde and Chaumeton, *Panorama of American Film Noir*, 22–28; and Michael Leja, *Reframing Abstract Expressionism: Subjectivity and Painting in the 1940s* (New Haven, CT: Yale University Press, 1993), 319–323.
94. Patrick Keating, *Hollywood Lighting from the Silent Era to Film Noir* (New York: Columbia University Press, 2010), 247.
95. Albrecht, *Designing Dreams*, 167.
96. Manovich, *Language of New Media*, 298.
97. Leslie, *Hollywood Flatlands*, 299.
98. Haidee Wasson and Charles R. Acland, "Introduction: Utility and Cinema," in *Useful Cinema*, ed. Acland and Wasson (Durham, NC: Duke University Press, 2011), 2.
99. Eric Schaefer, "Exploitation as Education," in *Learning with the Lights Off: Educational Film in the United States*, ed. Devin Orgeron, Marsha Orgeron, and Dan Streible (Oxford: Oxford University Press, 2012), 334.
100. Lee Grieveson, "Visualizing Industrial Citizenship," in Orgeron, Orgeron, and Streible (eds), *Learning with the Lights Off*, 121.
101. Scott Curtis, "Images of Efficiency: The Films of Frank B. Gilbreth," in *Films That Work: Industrial Film and the Productivity of Media*, ed. Vinzenz Hediger and Patrick Vonderau (Amsterdam: Amsterdam University Press, 2009), 86–87.
102. Vinzenz Hediger and Patrick Vonderau, "Record, Rhetoric, Rationalization: Industrial Organization and Film," in Hediger and Vonderau (eds.), *Films That Work*, 43.

CONCLUSION

1. Daggett, Letter to Mr. Douglas MacAgy, 1.
2. Fredric Jameson, *Postmodernism; or, The Cultural Logic of Late Capitalism* (Durham, NC: Duke University Press, 1991), 17–18.
3. Martin, *Organizational Complex.*
4. Spigel, *TV by Design.*
5. "Notes on the Future: Aspen Design Conference," 55.
6. For examples of this argument, see Abraham, *When Magoo Flew;* Joe Adamson, "Chuck Jones Interviewed," in *The American Animated Cartoon: A Critical Anthology,* ed. Danny Peary and Gerald Peary (New York: Dutton, 1980), 140–141; Amidi, *Cartoon Modern;* Leonard Maltin, *Of Mice and Magic: A History of American Animated Cartoons* (New York: McGraw-Hill, 1980); Telotte, *Animating Space.*
7. Bruno, *Atlas of Emotion,* 70.

BIBLIOGRAPHY

ARCHIVAL COLLECTIONS

The Academy Film Archive, Los Angeles, CA.
The ASIFA-Hollywood Animation Archive. Burbank, CA.
The György Kepes Papers, 1909–2003, bulk 1935–1985. Archives of American Art, Smithsonian Institution, Washington, DC.
Early Museum History: Administrative Records, III.26. The Museum of Modern Art Archives, New York, NY.
The Museum of Modern Art Exhibition Records, 1980–1989, 1333. The Museum of Modern Art Archives, New York, NY.
Paramount Pictures Production Records. Coll. 215. Margaret Herrick Library, Academy of Motion Picture Arts and Sciences, Beverly Hills, CA.
Saul Bass Papers. Coll. 421. Margaret Herrick Library, Academy of Motion Picture Arts and Sciences, Beverly Hills, CA.
The UCLA Film and Television Archive. Los Angeles, CA.

PRIMARY AND SECONDARY PRINT SOURCES

Abraham, Adam. *When Magoo Flew: The Rise and Fall of Animation Studio UPA.* Middletown, CT: Wesleyan University Press, 2012.
Adamson, Joe. "Chuck Jones Interviewed." In *The American Animated Cartoon: A Critical Anthology*, edited by Gerald Peary and Danny Peary, 128–141. New York: E. P. Dutton, 1980.
Albrecht, Donald. *Designing Dreams: Modern Architecture in the Movies.* Santa Monica, CA: Hennessey + Ingalls, 1986.
———. "Design Is a Method of Action." In *The Work of Charles and Ray Eames: A Legacy of Invention,* edited by Donald Albrecht, 18–43. New York: Harry N. Abrams in association with the Library of Congress and the Vitra Design Museum, 1997.

Allen, James Sloan. *The Romance of Commerce and Culture: Capitalism, Modernism, and the Chicago-Aspen Crusade for Cultural Reform.* Boulder: University Press of Colorado, 2002.

Aluminum Company of America. "Alcoa Care-Free Home," 1958. www.myalcoahome.com/brochures.

Amidi, Amid. *Cartoon Modern: Style and Design in Fifties Animation.* San Francisco: Chronicle Books, 2006.

Appleyard, Donald. "Motion, Sequence, and the City." In *The Nature and Art of Motion,* edited by György Kepes, 176–192. New York: G. Braziller, 1965.

Arnheim, Rudolf. *Art and Visual Perception: A Psychology of the Creative Eye—The New Version.* Berkeley: University of California Press, 1974.

———. *The Dynamics of Architectural Form.* Berkeley: University of California Press, 1977.

Aynsley, Jeremy. *Pioneers of Modern Graphic Design: A Complete History.* London: Mitchell Beazley, 2004.

Baigell, Matthew. "American Art and National Identity: The 1920s." *Arts Magazine* 61, no. 6 (February 1987): 48–55.

Banham, Reyner. "Monumental Windbags." In *The Inflatable Moment: Pneumatics and Protest in '68,* edited by Marc Dessauce, 31–33. New York: Princeton Architectural Press, 1999.

Barrey, Suzanne. "General Dynamics: The Graphic Face of a Dynamic Corporation." *Graphis* 14, no. 79 (September–October 1958): 420–427.

Barrier, J. Michael. *Hollywood Cartoons: American Animation in Its Golden Age.* New York: Oxford University Press, 1999.

Barthes, Roland. "The Third Meaning." In *Image–Music–Text,* translated by Stephen Heath, 52–68. New York: Hill & Wang, 1977.

Bass, Saul. "Film Advertising." *Graphis* 9, no. 48 (1953): 276–281.

Baudelaire, Charles. *Selected Writings on Art and Artists.* Edited and translated by P. E. Charvet. Cambridge: Cambridge University Press, 1981.

Beckman, Karen, ed. *Animating Film Theory.* Durham, NC: Duke University Press, 2014.

Bill, Max. "Graphic Art in the Atom World." *Graphis* 4, no. 21 (1948): 80–84.

Blakinger, John R. "The Aesthetics of Collaboration: Complicity and Conversion at MIT's Center for Advanced Visual Studies." *Tate Papers* 25 (Spring 2016), www.tate.org.uk/research/publications/tate-papers/25/aesthetics-of-collaboration.

Borde, Raymond, and Étienne Chaumeton. *A Panorama of American Film Noir, 1941–1953.* San Francisco: City Lights Books, 2002.

Bordwell, David. *Narration in the Fiction Film.* Madison: University of Wisconsin Press, 1985.

———. *On the History of Film Style.* Cambridge, MA: Harvard University Press, 1997.

Botar, Oliver A. I. "Taking the *Kunst* out of the *Gesamtkunstwerk:* Moholy-Nagy's Conception of the *Gesamtwerk.*" In *László Moholy-Nagy: The Art of Light,* 159–168. Madrid, Spain: LA Fabrica, 2010.

Bremner, Robert H., and Gary W. Reichard, eds. *Reshaping America: Society and Institutions, 1945–1960.* Columbus: Ohio State University Press, 1982.

Brock, Charles. *Charles Sheeler: Across Media.* Berkeley: University of California Press, 2006.

Brown, Milton W. *American Painting, from the Armory Show to the Depression.* Princeton, NJ: Princeton University Press, 1955.

———. "Cubist-Realism: An American Style." *Marsyas* 3, no. 5 (1943–1945): 139–160.

Bruegmann, Robert. *Sprawl: A Compact History.* Chicago: University of Chicago Press, 2005.

Bruno, Giuliana. *Atlas of Emotion.* New York: Verso Books, 2002.

Buchan, Suzanne. "Theatrical Cartoon Comedy: From Animated Portmanteau to the *Risus Purus.*" In *A Companion to Film Comedy,* edited by Andrew Horton and Joanna E. Rapf, 521–543. London: Blackwell, 2013.

Burtin, Will. "Integration, the New Discipline in Design." *Graphis* 5, no. 27 (1949): 230–237.

Burtin, Will, and L. P. Lessing. "Interrelations." *Graphis* 4, no. 22 (1948): 108–117.

Butler, Jeremy G. *Television: Critical Methods and Applications.* 3rd ed. New York: Routledge, 2006.

Calinescu, Matei. *Five Faces of Modernity: Modernism, Avant-Garde, Decadence, Kitsch, Postmodernism.* Durham, NC: Duke University Press, 1987.

Campany, David. "William Klein's Way." In *William Klein: ABC,* by William Klein, 2–13. New York: Harry N. Abrams, 2013.

Campbell, Jan. *Film and Cinema Spectatorship: Melodrama and Mimesis.* Oxford: Polity Books, 2005.

"Cartoon Brew TV #24: *Building Friends for Business* (1949)." *Cartoon Brew,* www.cartoonbrew.com/brewtv/buildingfriends-23417.html.

Ceplair, Larry, and Steven Englund. *The Inquisition in Hollywood: Politics in the Film Community, 1930–1960.* Berkeley: University of California Press, 1983.

Cerasulo, Tom. *Authors Out Here: Fitzgerald, West, Parker, and Schulberg in Hollywood.* Columbia: University of South Carolina Press, 2010.

Charney, Leo, and Vanessa Schwartz, eds. *Cinema and the Invention of Modern Life.* Berkeley: University of California Press, 1995.

Christopher, Nicholas. *Somewhere in the Night: Film Noir and the American City.* New York: Free Press, 1997.

Clarke, C. F. O. "Alvin Lustig: Cover Designs." *Graphis* 4, no. 23 (1948): 242–246.

Cohen, Lizabeth. *A Consumer's Republic: The Politics of Mass Consumption in Postwar America.* New York: Knopf, 2003.

Colomina, Beatriz. *Privacy and Publicity: Modern Architecture as Mass Media.* Cambridge, MA: MIT Press, 1994.

———. "Reflections on Eames House." In *The Work of Charles and Ray Eames: A Legacy of Invention,* edited by Donald Albrecht, 126–149. New York: Harry N. Abrams in association with the Library of Congress and the Vitra Design Museum, 1997.

Container Corporation of America. "Good Design—An Important Function of Management." *Graphis* 6, no. 30 (1950): 136–140, 201.

Corn, Wanda M. *The Great American Thing: Modern Art and National Identity, 1915–1935.* Berkeley: University of California Press, 1999.

Corwin, Sharon. "Picturing Efficiency: Precisionism, Scientific Management, and the Effacement of Labor." *Representations,* no. 84 (November 2003): 139–165.

Crafton, Donald. *Shadow of a Mouse: Performance, Belief, and World-Making in Animation.* Berkeley: University of California Press, 2013.

———. "The Veiled Genealogies of Animation and Cinema." *Animation: An Interdisciplinary Journal* 6, no. 2 (2011): 93–110.

Crary, Jonathan. *Suspensions of Perception: Attention, Spectacle, and Modern Culture.* Cambridge, MA: MIT Press, 1999.

———. *Techniques of the Observer: On Vision and Modernity in the Nineteenth Century.* Cambridge, MA: MIT Press, 1990.

Creighton, Thomas, ed. *Building for Modern Man: A Symposium.* Princeton, NJ: Princeton University Press, 1949.

Curtis, David. *Experimental Cinema: A Fifty-Year Evolution.* London: Studio Vista, 1971.

Curtis, Scott. "Images of Efficiency: The Films of Frank B. Gilbreth." In *Films That Work: Industrial Film and the Productivity of Media,* edited by Vinzenz Hediger and Patrick Vonderau, 85–100. Amsterdam: Amsterdam University Press, 2009.

Deitch, Gene. "How to Succeed in Animation—Chapter 12: The UPA Experience." *Animation World Network,* www.awn.com/genedeitch/chapter-twelve-the-upa-experience.

———. "Roll the Credits! 11: John Hubley." *GeneDeitchCredits,* 2011, http://genedeitchcredits.com/roll-the-credits/chapter-11---john-hubley-"it's-got-to-be-about-something/.

Dimendberg, Edward. *Film Noir and the Spaces of Modernity.* Cambridge, MA: Harvard University Press, 2004.

Doane, Mary Ann. *The Emergence of Cinematic Time: Modernity, Contingency, the Archive.* Cambridge, MA: Harvard University Press, 2003.

———. "Temporality, Storage, Legibility: Freud, Marey, and the Cinema." *Critical Inquiry* 22, no. 2 (Winter 1996): 313–343.

Doss, Erika Lee. *Benton, Pollock, and the Politics of Modernism: From Regionalism to Abstract Expressionism.* Chicago: University of Chicago Press, 1991.

Eames, Charles. "Language of Vision: The Nuts and Bolts." *Bulletin of the American Academy of Arts and Sciences* 28, no. 1 (October 1974): 13–25.

Eames, Charles, and Ray Eames. *An Eames Anthology: Articles, Film Scripts, Interviews, Letters, Notes, Speeches.* Edited by Daniel Ostroff. New Haven, CT: Yale University Press, 2015.

Eisenstein, Sergei. *Eisenstein on Disney.* Edited by Jay Leyda; translated by Alan Upchurch. Calcutta: Seagull Books, 1986.

———. "From Lectures on Music and Colour in *Ivan the Terrible*." In *Eisenstein: Selected Works,* vol. 3: *1934–1947,* edited by Richard Taylor, translated by William Powell. Bloomington: Indiana University Press, 1988.

Faure, Elie. "The Art of Cineplastics." Translated by Walter Pach. In *Screen Monographs I,* edited by Martin S. Dworkin. New York: Arno Press, 1970.

Ferrell, Robyn. "Life-Threatening Life: Angela Carter and the Uncanny." In *The Illusion of Life: Essays on Animation,* edited by Alan Cholodenko, 131–144. Sydney: Power Publications in association with the Australian Film Commission, 1991.

Fillin-Yeh, Susan. "Charles Sheeler: Industry, Fashion, and the Vanguard." *Arts Magazine* 54, no. 6 (February 1980): 154–158.

Fisher, David. "Two Premières: Disney and UPA." In *The American Animated Cartoon: A Critical Anthology,* edited by Danny Peary and Gerald Peary, 178–182. New York: Dutton, 1980.

Fischer, Lucy. *Designing Women: Cinema, Art Deco, and the Female Form.* New York: Columbia University Press, 2003.

———. "'The Shock of the New': Electrification, Urbanization, Illumination, and the Cinema." In *Cinema and Modernity,* edited by Murray Pomerance, 19–37. New Brunswick, NJ: Rutgers University Press, 2006.

Ford, John D. "An Interview with John and Faith Hubley." In *The American Animated Cartoon: A Critical Anthology,* edited by Danny Peary and Gerald Peary, 183–191. New York: Dutton, 1980.

Franke, Herbert W. "Beyond Human Vision." *Graphis* 16, no. 87 (January–February 1960): 76–81, 86–87.

Franklin, Peter. *Seeing through Music: Gender and Modernism in Classic Hollywood Film Scores.* New York: Oxford University Press, 2011.

Freud, Sigmund. "The Claims of Psycho-Analysis to Scientific Interest." In *Totem and Taboo and Other Works,* translated by James Strachey, vol. 13 of The Standard Edition of the Complete Psychological Works of Sigmund Freud, 165–190. London: Hogarth Press and the Institute of Psycho-Analysis, 1953.

———. *Dora: An Analysis of a Case of Hysteria.* Translated by James Strachey. New York: Simon & Schuster, 1997.

———. *The Interpretation of Dreams (First Part).* Translated by James Strachey. Vol. 4 of The Standard Edition of the Complete Psychological Works of Sigmund Freud. London: Hogarth Press and the Institute of Psycho-Analysis, 1953.

———. *The Interpretation of Dreams (Second Part).* Translated by James Strachey. Vol. 5 of The Standard Edition of the Complete Psychological Works of Sigmund Freud. London: Hogarth Press and the Institute of Psycho-Analysis, 1953.

———. *Introductory Lectures on Psycho-Analysis.* Translated by James Strachey. Vol. 15 of The Standard Edition of the Complete Psychological Works of Sigmund Freud. London: Hogarth Press and the Institute of Psycho-Analysis, 1953.

———. *Jokes and Their Relation to the Unconscious.* Translated by James Strachey. New York: Norton, 1963.

———. *The Psychopathology of Everyday Life.* Translated by James Strachey. Vol. 6 of The Standard Edition of the Complete Psychological Works of Sigmund Freud. London: Hogarth Press and the Institute of Psycho-Analysis, 1953.

———. "Revision of the Theory of Dreams." In *New Introductory Lectures on Psycho-Analysis and Other Works,* translated by James Strachey, vol. 22 of The Standard Edition of the Complete Psychological Works of Sigmund Freud, 7–30. London: Hogarth Press and the Institute of Psycho-Analysis, 1953.

Friedberg, Anne. *The Virtual Window: From Alberti to Microsoft.* Cambridge, MA: MIT Press, 2006.

———. *Window Shopping: Cinema and the Postmodern.* Berkeley: University of California Press, 1993.

Friedman, Martin. *The Precisionist View in American Art.* Minneapolis: Walker Art Center, 1960.

Gaudreault, André, and Philippe Gauthier. "Could Kinematography Be Animation and Animation Kinematography?" *Animation: An Interdisciplinary Journal* 6, no. 2 (2011): 85–91.

Garcia, Roger, and Bernard Eisenschitz, eds. *Frank Tashlin.* Locarno: Éditions du Festival international du film de Locarno in collaboration with the British Film Institute, 1994.

Genter, Robert. *Late Modernism: Art, Culture, and Politics in Cold War America.* Philadelphia: University of Pennsylvania Press, 2010.

Gerstner, David A. *Manly Arts: Masculinity and Nation in Early American Cinema.* Durham, NC: Duke University Press, 2006.

Gid, Raymond. "Saul Bass: New Film Titlings and Promotional Films." *Graphis* 19, no. 106 (1963): 150–159.

Giedion, Sigfried. *Architecture, You, and Me: The Diary of a Development.* Cambridge, MA: Harvard University Press, 1958.

———. "Herbert Bayer and Advertising in the U.S.A." *Graphis* 1, nos. 11–12 (Oct./Nov./Dec. 1945): 348–358, 422–424.

———. *Mechanization Takes Command: A Contribution to Anonymous History.* New York: Oxford University Press, 1948.

———. *Space, Time and Architecture.* 5th ed., revised and enlarged. Cambridge, MA: Harvard University Press, 2009.

Giovacchini, Saverio. *Hollywood Modernism: Film and Politics in the Age of the New Deal.* Philadelphia: Temple University Press, 2001.

Goldmark, Daniel, and Charlie Keil, eds. *Funny Pictures: Animation and Comedy in Studio-Era Hollywood.* Berkeley: University of California Press, 2011.

Golec, Michael. "A Natural History of a Disembodied Eye: The Structure of György Kepes's *Language of Vision.*" *Design Issues* 18, no. 2 (January 2002): 3–16.

Gordon, Alastair. *Naked Airport: A Cultural History of the World's Most Revolutionary Structure.* New York: Metropolitan Books, 2004.

Grieveson, Lee. "Visualizing Industrial Citizenship." In *Learning with the Lights Off: Educational Film in the United States,* edited by Devin Orgeron, Marsha Orgeron, and Dan Streible, 107–123. Oxford: Oxford University Press, 2012.

Gropius, Walter. *The New Architecture and the Bauhaus.* Cambridge, MA: MIT Press, 1974.
———. *Scope of Total Architecture.* New York: Harper, 1955.
Gruber, L. Fritz. "Design for Music." *Graphis* 5, no. 25 (1949): 14–23.
Gunning, Tom. "The Cinema of Attractions: Early Film, Its Spectator, and the Avant-Garde." *Wide Angle* 8, nos. 3–4 (Fall 1986): 63–70.
Haber, Samuel. *Efficiency and Uplift: Scientific Management in the Progressive Era, 1890–1920.* Chicago: University of Chicago Press, 1964.
Halas, John. "Graphic Design in Television." *Graphis* 15, no. 86 (1959): 486–499.
Halpern, Orit. *Beautiful Data: A History of Vision and Reason since 1945.* Durham, NC: Duke University Press, 2014.
Hansen, Miriam. "The Mass Production of the Senses: Classical Cinema as Vernacular Modernism." *Modernism/Modernity* 6, no. 2 (April 1999): 59–77.
Harnsberger, R. Scott. *Ten Precisionist Artists: Annotated Bibliographies.* Westport, CT: Greenwood Press, 1992.
Harwood, John. *The Interface: IBM and the Transformation of Corporate Design, 1945–1976.* Minneapolis: University of Minnesota Press, 2011.
Havenhand, Lucinda Kaukas. "American Abstract Art and the Interior Design of Ray and Charles Eames." *Journal of Interior Design* 31, no. 2 (2006): 29–42.
Hayden, Dolores. *Building Suburbia: Green Fields and Urban Growth, 1820–2000.* New York: Pantheon Books, 2003.
Hediger, Vinzenz, and Patrick Vonderau. "Record, Rhetoric, Rationalization: Industrial Organization and Film." In *Films That Work: Industrial Film and the Productivity of Media,* edited by Vinzenz Hediger and Patrick Vonderau, 35–50. Amsterdam: Amsterdam University Press, 2009.
Heilpern, John. "Ralston Crawford's Gift of Selection." *Aperture,* no. 92 (Fall 1983): 66–75.
Heller, Steven. *Born Modern: The Life and Work of Alvin Lustig.* San Francisco: Chronicle Books, 2010.
Hemingway, Andrew. *The Mysticism of Money: Precisionist Painting and Machine Age America.* Pittsburgh, PA: Periscope, 2013.
Hitchcock, Henry Russell, and Philip Johnson. *The International Style.* New York: Norton, 1966.
Howe, George. "Flowing Space: The Concept of Our Time." In *Building for Modern Man: A Symposium,* edited by Thomas H. Creighton, 164–169. Princeton, NJ: Princeton University Press, 1949.
Hubley, John. "Beyond Pigs and Bunnies: The New Animator's Art." *American Scholar* 44, no. 2 (October 1975): 213–223.
Hubley, John, and Zachary Schwartz. "Animation Learns a New Language." *Hollywood Quarterly* 1, no. 4 (1946): 360–363.
Hyman, Sidney. *The Aspen Idea.* Norman: University of Oklahoma Press, 1975.
"International Design Conference: Aspen, Colorado, 1955." *Print* 9, no. 6 (August 1955): 8–32.

Jacobson, Brian. *Studios before the System: Architecture, Technology, and the Emergence of Cinematic Space*. New York: Columbia University Press, 2015.

James, David E. "*The Sky Socialist:* Film as an Instrument of Thought, Cinema as an Augury." In *Optic Antics: The Cinema of Ken Jacobs,* edited by Michele Pierson, David E. James, and Paul Arthur, 64–88. New York: Oxford University Press, 2011.

Jameson, Fredric. *Postmodernism; or, The Cultural Logic of Late Capitalism*. Durham, NC: Duke University Press, 1991.

———. "Transformations of the Image in Postmodernity." In *The Cultural Turn: Selected Writings on the Postmodern, 1983–1998,* 93–135. London: Verso Books, 2009.

Jarzombek, Mark. "'Good-Life Modernism and Beyond': The American House in the 1950s and 1960s." *Cornell Journal of Architecture* 4 (Fall 1990): 76–93, 208.

Jenkins, Bruce. "Making the Scene: West Coast Modernism and the Movies." In *Birth of the Cool: California Art, Design, and Culture at Midcentury,* edited by Elizabeth Armstrong. New York: Prestel Art, 2007.

Jones, Chuck. "Music and the Animated Cartoon." *Hollywood Quarterly* 1, no. 4 (July 1946): 364–370.

Katsumi, Masaru. "Young Japanese Designers." *Graphis* 19, no. 102 (April 1962): 380–382, 453.

Kaufmann, Edgar. Jr. *Good Design: 5th Anniversary*. New York: Museum of Modern Art, 1954.

Keating, Patrick. *Hollywood Lighting from the Silent Era to Film Noir*. New York: Columbia University Press, 2010.

Kelder, Diane. "Stuart Davis and Modernism: An Overview." In *Stuart Davis: American Painter,* edited by Lowery Stokes Sims, 17–30. New York: Metropolitan Museum of Art, distributed by Harry N. Abrams, 1991.

———. *Stuart Davis: Art and Theory, 1920–31*. New York: Pierpont Morgan Library, 2002.

———. "Stuart Davis: Pragmatist of American Modernism." *Art Journal* 39, no. 1 (Fall 1979): 29–36.

Kentgens-Craig, Margret. *The Bauhaus and America: First Contacts, 1919–1936*. Cambridge, MA: MIT Press, 1999.

Kepes, György. "Excerpt from Kepes." *Print* 11, no. 1 (March 1957): 54.

———. *Language of Vision*. Chicago: Theobald, 1944.

Klein, Norman M. *Seven Minutes: The Life and Death of the American Animated Cartoon*. London: Verso Books, 1993.

Klein, William. *New York, 1954–55*. New ed. Manchester, UK: Dewi Lewis, 1995.

Kolker, Robert Phillip. *The Altering Eye: Contemporary International Cinema*. Cambridge: Open Book, 2009.

Kovács, András Bálint. *Screening Modernism: European Art Cinema, 1950–1980*. Chicago: University of Chicago Press, 2007.

Kula, Elsa. "Institute of Design." *Print* 14, no. 1 (February 1960): 49–51.

LaMarre, Thomas. *The Anime Machine: A Media Theory of Animation*. Minneapolis, University of Minnesota Press, 2009.

Lane, John R. *Stuart Davis: Art and Art Theory.* Brooklyn, NY: Brooklyn Museum, 1978.

———. "Stuart Davis in the 1940s." In *Stuart Davis: American Painter,* edited by Lowery Stokes Sims, 70–81. New York: Metropolitan Museum of Art, distributed by Harry N. Abrams, 1991.

Langner, Siegfried, "Transcript of Opening Ceremonies, 'The Architecture of Richard Neutra: From International Style to California Modern,' Bauhaus Archiv, Berlin." January 11, 1984, Cur 1333, Museum of Modern Art Archives, New York.

Lavin, Sylvia. "Open the Box: Richard Neutra and the Psychology of the Domestic Environment." *Assemblage,* no. 40 (December 1999): 6–25.

Lee, Walter W., Jr. "UPA." *Pendulum* 2, no. 3 (Spring 1953): 43–50.

Lefebvre, Martin. "Between Setting and Landscape in the Cinema." In *Landscape and Film,* 19–60. New York: Routledge, 2006.

Le Grice, Malcolm. *Abstract Film and Beyond.* Cambridge, MA: MIT Press, 1977.

Leja, Michael. *Reframing Abstract Expressionism: Subjectivity and Painting in the 1940s.* New Haven, CT: Yale University Press, 1993.

Leslie, Esther. *Hollywood Flatlands: Animation, Critical Theory, and the Avant-Garde.* London: Verso Books, 2002.

Lhamon, W. T. *Deliberate Speed: The Origins of a Cultural Style in the American 1950s.* Washington, DC: Smithsonian Institution Press, 1990.

Lozowick, Louis. "The Americanization of Art." In *Modern Art in the USA: Issues and Controversies of the 20th Century,* edited by Patricia Hills, 48–50. Upper Saddle River, NJ: Prentice Hall, 2001.

Lugon, Olivier. "Dynamic Paths of Thought: Exhibition Design, Photography, and Circulation in the Work of Herbert Bayer." In *Cinema Beyond Film: Media Epistemology in the Modern Era,* edited by François Albera and Maria Tortajada, 117–144. Amsterdam: Amsterdam University Press, 2010.

Lynes, Russell. *The Tastemakers.* New York: Harper, 1954.

MacDonald, Scott, ed. *Art in Cinema: Documents toward a History of the Film Society.* Philadelphia: Temple University Press, 2006.

———, ed. *Cinema 16: Documents toward a History of the Film Society.* Philadelphia: Temple University Press, 2002.

———. *A Critical Cinema 3: Interviews with Independent Filmmakers.* Berkeley: University of California Press, 1998.

Maltin, Leonard. *Of Mice and Magic: A History of American Animated Cartoons.* New York: McGraw-Hill, 1980.

Mannes, M. "Niles Spencer: Painter of Simplicities." *Creative Art,* no. 100 (July 1930): 59–60.

Manovich, Lev. *The Language of New Media.* Cambridge, MA: MIT Press, 2001.

Marchand, Roland. "Visions of Classlessness, Quests for Dominion: American Popular Culture, 1945–1960." In *Reshaping America: Society and Institutions, 1945–1960,* edited by Robert H. Bremner and Gary W. Reichard, 163–190. Columbus: Ohio State University Press, 1982.

Marcus, George H. *Design in the Fifties: When Everyone Went Modern*. New York: Prestel, 1998.
Martin, Reinhold. "Organicism's Other." *Grey Room* 4 (Summer 2001): 34–51.
———. *The Organizational Complex: Architecture, Media, and Corporate Space*. Cambridge, MA: MIT Press, 2003.
McGilligan, Pat, and Faith Hubley. "Faith Hubley: An Interview." *Film Quarterly* 42, no. 2 (Winter 1988–1989): 2–18.
Meyerowitz, Joanne J., ed. *Not June Cleaver: Women and Gender in Postwar America, 1945–1960*. Philadelphia: Temple University Press, 1994.
Michelson, Annette. "Film and the Radical Aspiration." In *Film Culture Reader*, edited by P. Adams Sitney, 404–421. New York: Praeger, 1970.
Moholy-Nagy, László. *The New Vision and Abstract of an Artist*. Translated by Daphne M. Hoffmann. New York: Wittenborn, Schultz, 1947.
———*The New Vision, from Material to Architecture*. Translated by Daphne M. Hoffmann. New York: Brewer, Warren & Putnam, 1932.
———. *Painting, Photography, Film*. Translated by Janet Seligman. London: Lund Humphries, 1969.
———. *Vision in Motion*. Chicago: Theobald, 1947.
Molella, Arthur P. "Science Moderne: Sigfried Giedion's *Space, Time, and Architecture* and *Mechanization Takes Command*." *Technology and Culture* 43, no. 2 (April 2002): 374–389.
Mulvey, Laura. *Death 24× a Second: Stillness and the Moving Image*. London: Reaktion Books, 2006.
———. "Visual Pleasure and Narrative Cinema." *Screen* 16, no. 3 (1975): 6–18.
Naremore, James. *The Films of Vincente Minnelli*. Cambridge: Cambridge University Press, 1993.
———. *More Than Night: Film Noir in Its Contexts*. Updated and expanded ed. Berkeley: University of California Press, 2008.
Neder, Federico. *Fuller Houses: R. Buckminster Fuller's Dymaxion Dwellings and Other Domestic Adventures*. Baden, Switz.: Lars Müller, 2008.
Nelson, Daniel. *Frederick W. Taylor and the Rise of Scientific Management*. Madison: University of Wisconsin Press, 1980.
Neurath, Otto. *International Picture Language: The First Rules of Isotype*. London: K. Paul, Trench, Trubner & Co., 1936.
Neutra, Richard. *Survival through Design*. New York: Oxford University Press, 1954.
Nieland, Justus. "Midcentury Futurisms: Expanded Cinema, Design, and the Modernist Sensorium." *Affirmations: Of the Modern* 2, no. 1 (Winter 2014): 46–84.
"Notes on the Future: Aspen Design Conference." *Print* 12, no. 2 (October 1958): 53–57.
Nye, David E. *American Technological Sublime*. Cambridge, MA: MIT Press, 1994.
O'Connor, Francis V. *Art for the Millions: Essays from the 1930s by Artists and Administrators of the WPA Federal Art Project*. Greenwich, CT: New York Graphic Society, 1973.

Oeri, Georgine. "The Display Window as a Sign of the Times." *Graphis* 4, no. 24 (1948): 378–384, 406–407.

———. "George Giusti." *Graphis* 5, no. 26 (1949): 148–153.

———. "UPA: A New Dimension for the Comic Strip." *Graphis* 9, no. 50 (1953): 470–479.

O'Pray, Michael. *Avant-Garde Film: Forms, Themes, and Passions.* London: Wallflower, 2003.

Palmer, R. Barton. *Hollywood's Dark Cinema: The American Film Noir.* New York: Twayne, 1994.

Peterson, James. *Dreams of Chaos, Visions of Order: Understanding the American Avant-Garde Cinema.* Detroit: Wayne State University Press, 1994.

Pilling, Jayne, ed. *Animating the Unconscious: Desire, Sexuality, and Animation.* London: Wallflower, 2012.

Poyser, E. W. Ted. "Art Directors Club of Los Angeles—A Selection from Three Annual Exhibitions." *Graphis* 18, no. 101 (May–June 1962): 304–308, 370.

Pursell, Carroll W. *Technology in Postwar America: A History.* New York: Columbia University Press, 2007.

Rawlinson, Mark. *Charles Sheeler: Modernism, Precisionism, and the Borders of Abstraction.* London: I. B. Tauris, 2007.

———. "Charles Sheeler's Imprecise Precisionism." *Comparative American Studies* 2, no. 4 (November 2004): 470–486.

Ray, Robert B. *The Avant-Garde Finds Andy Hardy.* Cambridge, MA: Harvard University Press, 1995.

Reens, Anneke. "Modern Architecture Comes of Age." *Magazine of Art* 37, no. 3 (March 1944): 89–93.

Rieder, Howard. "Memories of Mr. Magoo." *Cinema Journal* 8, no. 2 (December 1969): 17–24.

Robé, Chris. *Left of Hollywood: Cinema, Modernism, and the Emergence of U.S. Radical Film Culture.* Austin: University of Texas Press, 2010.

Roberts, Stanley. "Visual Presentation—A Challenge to the Designer." *Graphis* 14, no. 79 (September–October 1958): 406–411.

Rose, Barbara. *American Art since 1900.* Revised and expanded ed. New York: Praeger, 1975.

Rosenberg, Milton J. "Mr. Magoo as Public Dream." *Quarterly of Film, Radio, and Television* 11, no. 4 (Summer 1957): 337–342.

Sammond, Nicholas. "'Who Dat Say Who Dat?': Racial Masquerade, Humor, and the Rise of American Animation." In *Funny Pictures: Animation and Comedy in Studio-Era Hollywood,* edited by Daniel Goldmark and Charlie Keil. Berkeley: University of California Press, 2011.

Samuel, Lawrence R. *Freud on Madison Avenue: Motivation Research and Subliminal Advertising in America.* Philadelphia: University of Pennsylvania Press, 2010.

———. *Shrink: A Cultural History of Psychoanalysis in America.* Lincoln: University of Nebraska Press, 2013.

Sayre, Henry M. "American Vernacular: Objectivism, Precisionism, and the Aesthetics of the Machine." *Twentieth Century Literature* 35, no. 3 (December 1989): 310–342.

———. *The Visual Text of William Carlos Williams*. Urbana: University of Illinois Press, 1983.

Schaefer, Eric. "Exploitation as Education." In *Learning with the Lights Off: Educational Film in the United States*, edited by Devin Orgeron, Marsha Orgeron, and Dan Streible, 316–337. Oxford: Oxford University Press, 2012.

Schleier, Merrill. *The Skyscraper in American Art, 1890–1931*. Ann Arbor, MI: UMI Research Press, 1986.

Schrader, Paul. "Poetry of Ideas: The Films of Charles Eames." *Film Quarterly* 23, no. 3 (Spring 1970): 2–19.

Schuldenfrei, Robin. "Assimilating Unease: Moholy-Nagy and the Wartime/Postwar Bauhaus in Chicago." In *Atomic Dwelling: Anxiety, Domesticity, and Postwar Architecture*, edited by Robin Schuldenfrei, 87–126. London: Routledge, 2012.

Severud, Fred N. "The Values of Visual Education." In *Building for Modern Man: A Symposium*, edited by Thomas H. Creighton, 113–116. Princeton, NJ: Princeton University Press, 1949.

Sidran, Ben. "The Jazz of Stuart Davis." In *Stuart Davis*, edited by Philip Rylands, 14–17. Boston: Bulfinch, 1997.

Silver, Alain, and James Ursini, eds. *Film Noir Reader*. 4th Limelight ed. New York: Limelight Editions, 1998.

Sims, Lowery Stokes. "Stuart Davis in the 1930s: A Search for Social Relevance in Abstract Art." In *Stuart Davis: American Painter*, edited by Lowery Stokes Sims, 56–69. New York: Metropolitan Museum of Art, distributed by Harry N. Abrams, 1991.

Singal, Daniel Joseph. "Towards a Definition of American Modernism." *American Quarterly* 39, no. 1 (Spring 1987): 7–26.

Singer, Ben. *Melodrama and Modernity: Early Sensational Cinema and Its Contexts*. New York: Columbia University Press, 2001.

———. "Modernity, Hyperstimulus, and the Rise of Popular Sensationalism." In *Cinema and the Invention of Modern Life*, edited by Leo Charney and Vanessa R. Schwartz, 72–99. Berkeley: University of California Press, 1995.

Sitney, P. Adams. *Visionary Film: The American Avant-Garde, 1943–2000*. 3rd ed. New York: Oxford University Press, 2002.

Spigel, Lynn. "Back to the Drawing Board: Graphic Design and the Visual Environment of Television at Midcentury." *Cinema Journal* 55, no. 4 (Fall 2016): 28–54.

———. *Make Room for TV: Television and the Family Ideal in Postwar America*. Chicago: University of Chicago Press, 1992.

———. *TV by Design: Modern Art and the Rise of Network Television*. Chicago: University of Chicago Press, 2008.

Spigelgass, Leonard. "Indoctrination and the Training Film: Excerpts of the Discussion." In *Writer's Congress: The Proceedings of the Conference Held in October 1943*

under the Sponsorship of the Hollywood Writers' Mobilization and the University of California. Berkeley: University of California Press, 1944.

Stanitzek, Georg. "Reading the Title Sequence." *Cinema Journal* 48, no. 4 (Summer 2009): 44–58.

Stavitsky, Gail. "The 1930s Paintings of Francis Criss." *American Art Review* 14, no. 2 (March–April 2002).

———. "Reordering Reality: Precisionist Directions in American Art, 1915–1941." In *Precisionism in America, 1915–1941: Reordering Reality*, edited by Gail Stavitsky, 12–39. New York: Harry N. Abrams, in association with the Montclair Art Museum, 1994.

Stewart, Rick. "Charles Sheeler, William Carlos Williams, and Precisionism: A Redefinition." *Arts Magazine* 58, no. 3 (November 1983): 100–114.

Telotte, J. P. *Animating Space: From Mickey to Wall-E*. Lexington: University Press of Kentucky, 2010.

Thomajan, P. K. "George Guisti: Advertisements and Covers." *Graphis* 11, no. 59 (1955): 266–271.

Thomas, Franklin. "The Cartoon and Training Films." In *Writer's Congress: The Proceedings of the Conference Held in October 1943 under the Sponsorship of the Hollywood Writers' Mobilization and the University of California*, 133–137. Berkeley: University of California Press, 1944.

Thompson, Jan. "Picabia and His Influence on Art." *Art Journal* 39, no. 1 (Fall 1979): 14–21.

Thompson, Kristin. "The Concept of Cinematic Excess." *Cine-Tracts* 1, no. 2 (Summer 1977): 54–63.

Thompson, Richard. "Meep Meep." In *Movies and Methods: An Anthology*, edited by Bill Nichols, 126–135. Berkeley: University of California Press, 1976.

Timmer, Andreas A. "Making the Ordinary Extra-Ordinary: The Film-Related Work of Saul Bass." PhD diss., Columbia University, 1999.

Trotter, David. *Cinema and Modernism*. Malden, MA: Blackwell, 2007.

Tsujimoto, Karen. *Images of America: Precisionist Painting and Modern Photography*. Seattle: University of Washington Press, 1982.

Turner, Fred. *The Democratic Surround: Multimedia and American Liberalism from World War II to the Psychedelic Sixties*. Chicago: University of Chicago Press, 2013.

Turvey, Malcolm. *Doubting Vision: Film and the Revelationist Tradition*. New York: Oxford University Press, 2008.

van der Marck, Jan. "Kepes as Painter." In *The MIT Years, 1945–1977*, by György Kepes, 20–24. Cambridge MA: MIT Press, 1978.

Van Leuven, Karl. "The Animated Cartoon Goes to War." In *Writer's Congress: the Proceedings of the Conference Held in October 1943 under the Sponsorship of the Hollywood Writers' Mobilization and the University of California*, 112–21. Berkeley: University of California Press, 1944.

Wasson, Haidee, and Charles R. Acland. "Introduction: Utility and Cinema." In *Useful Cinema*, edited by Charles R. Acland and Haidee Wasson, 1–14. Durham, NC: Duke University Press, 2011.

Wechsler, Judith. "György Kepes." In *The MIT Years, 1945–1977*, by György Kepes, 7–19. Cambridge, MA: MIT Press, 1978.
Wells, Paul. *Animation and America*. Edinburgh: Edinburgh University Press, 2002.
——. *Animation: Genre and Authorship*. London: Wallflower, 2002.
——. *Basics Animation 01: Scriptwriting*. New York: AVA Publishing, 2007.
——. *Understanding Animation*. London: Routledge, 1998.
Whiting, Cécile. *Antifascism in American Art*. New Haven, CT: Yale University Press, 1989.
Whyte, William Hollingsworth. *The Organization Man*. New York: Simon & Schuster, 1956.
Wicke, Jennifer. "Appreciation, Depreciation: Modernism's Speculative Bubble." *Modernism/Modernity* 8, no. 3 (2001): 389–403.
Wilkin, Karen. "'Becoming a Modern Artist': The 1920s." In *Stuart Davis: American Painter*, edited by Lowery Stokes Sims, 45–55. New York: Metropolitan Museum of Art, distributed by Harry N. Abrams, 1991.
——. *Stuart Davis*. New York: Abbeville Press, 1987.
Wilson, Richard Guy. *The Machine Age in America, 1918–1941*. New York: Brooklyn Museum in association with Harry N. Abrams, 1986.
Wood, Aylish. "Re-Animating Space." *Animation* 1, no. 2 (November 2006): 133–152.
Wright, Gwendolyn. *USA*. London: Reaktion Books, 2008.
Youngblood, Gene. *Expanded Cinema*. New York: Dutton, 1970.
Zabel, Barbara. "Louis Lozowick and Urban Optimism of the 1920s." *Archives of American Art Journal* 14, no. 2 (April 1974): 17–21.
Zinn, Howard. *Postwar America: 1945–1971*. Indianapolis: Bobbs-Merrill, 1973.

INDEX

Abstract Expressionism: art style descriptions *vs.* midcentury modernist ideologies, 220n32; avant-garde cinema associations with, 190, 203, 220n31; historical context of, 22, 24, 40, 61; Kepes' criticism of, 38, 225–26n48; Precisionist style descriptions compared to, 29, 35, 62
abstraction: in cinema, 30–31, 179, 182–89, 193–95, 197, 203; for limited animation, 6–7; modern art styles with components of, 22, 23, 26, 28; political associations of, 19, 25; as representing reality, 47. *See also* reductive abstraction
Academy Awards, 1, 4, 164, 217n1
Acland, Charles R., 207
advertising: animated commercials, 4, 11, 16–17, 60, 166; art and society integration through popular culture of, 40, 46; condensation for film, 147–48; film closing titles as time condensation inspired by, 148; as musical set design, 179
airport architecture, 67, 68*fig.*, 76, 96, 104, 110–11
A Is for Atom (1953), 154, 155, 157–59, 159*fig.*
Albers and Moholy-Nagy: From the Bauhaus to the New World (exhibition), 212
Albrecht, Donald, 66, 177, 178, 179, 205–6
Alcoa (Aluminum Company of America), Inc., 88–91, 101, 104
Altering Eye, The (Kolker), 242n3
American Abstract Artists, 47
American Academy of Arts and Sciences, 66
American Artists School, 19

American Cancer Society, 11
American Heart Association, 91–93
American Horror Story: Asylum (television show), 211
American in Paris (1951), 179, 180, 184
American Scene, 25, 26, 28, 29, 49, 52
Amidi, Amid, 4–5, 30, 31, 214, 223n4
Analytical Cubism, 43
Anatomy of a Murder (1959), 148
Animating Space (Telotte), 73
Animation and America (Wells), 52, 120
"Animation Learns a New Language" (Hubley and Schwartz): condensation/compression, 126, 128, 132, 143, 149–50, 239n50; criticism of naturalistic animation, 23, 51–52, 53–54; design principles, 64; function of animation philosophies, 53–54, 64, 66, 67, 76, 120, 207; influences on, 53–54; manifesto mission, 5, 52; metamorphosis, 142, 143; publication of, 5; seeing-as-thinking ideologies, 14–15, 54–55, 153; university lectures featuring, 66
Appleyard, Donald, 76
architectural animation: color and visual perceptions, 87–93; color liberation and spatial perceptions, 76–87; concept descriptions and development, 68–75; directional vectors and emanation, 93–101, 111; early experimentation in, 66–68; function of, 75, 104; transparency and spatial perceptions, 68, 84–86, 97–98, 101–11. *See also* architecture

263

architecture: animated representations of, 31–33, 61, 65–66, 79, 99–100, 106–7, 150, 178; animation as design models for, 67; animation comparisons, 68–69, 82–83, 102–6, 108; animation for education in, 76; color and spatial perceptions, 77, 79, 82–87, 89–91; directional vectors and emanation, 69, 93–95, 96–98, 100–102, 111; photographic experiences of, 101, 244n42; Precisionism and, 28, 34, 42, 62, 63; transparency and spatial perceptions, 68, 84–86, 97–98, 101–4, 105–6, 110–11; visual communication courses for, 65; visual design aesthetics in, 8–9, 66–72, 111–12

Armory Show, 23, 25

Arnheim, Rudolf, 94, 95, 111–12, 233n44

Around the World in 80 Days (film), 148

Art Deco, 177, 179

"Art Directors Club of Los Angeles" series (*Graphis*), 139

Art in Cinema, 191, 192

Arts & Architecture (magazine), 67–68

"Aspects of the American Film: The Works of Fifteen Directors" (Art in Cinema series), 192

Aspen Design Conference, 121, 153–54, 165

At Land (1944), 165

Atoms for Peace (Nitsche), 157

avant-garde (experimental) cinema: film noir light-space modulation, 196–98, 199–201, 202–6; film societies promoting, 191–92; modernist aesthetic development, 165–67, 190–91; pedagogical purpose of, 207, 208–9; superimposed condensation effects in, 141–42, 196, 199; visual abstraction graphics, 192–96, 203

Aynsley, Jeremy, 147

Ballet Mécanique (1924), 30–31, 141

Band Wagon, The (1953), 180–81, 181*fig.*, 184, 196–97

Banham, Reyner, 104

Barn Abstraction (Sheeler), 35, 36, 36*fig.*

Barr, Alfred H., Jr., 223n8

Barrier, Michael, 29–30, 34, 53, 223n6

Barthes, Roland, 170–71

Basics Animation o1: Scriptwriting (Wells), 120

Bass, Saul, 144, 147–49, 165, 178

Baudelaire, Charles, 12, 29

Bauhaus, 15–16, 22

Baur, John I. H., 26

Bayer, Herbert, 156–57

Bell Laboratory Science Series, 133

Belson, Jordan, 192

Benjamin, Walter, 12

Benton, Thomas Hart: *Hollywood*, 176

Berkeley, Busby, 245n49

Best Animated Short Film (Academy Awards), 1, 4, 164, 217n1

"Beyond Human Vision" (Franke), 128, 153, 159

"Beyond Pigs and Bunnies" (Hubley, J.): animation function, 55, 228n103; character design, 56, 102; condensation techniques, 140, 142; metamorphosis, 119–20, 140, 142

Big Combo, The (1955), 203

Big Tim (1949), 133

Bill, Max, 65, 128

Blackton, J. Stuart, 241n89

Blacktop (1952), 65

Blakinger, John R., 16, 18, 72

blank slate (concept), 73, 108, 173

Block Museum, 212

Blume, Peter, 25–26, 41, 45

Boing Boing Show, The (1957), 4, 60, 210

Boing Boing Show, The (2005–2007), 210–11, 211–12

Bosustow, Stephen, 3, 115, 192

Botar, Oliver I. A., 111

Brakhage, Stan, 190

Bridges-Go-Round (1958), 193–96, 195*fig.*, 203

Broadway by Light (1958), 198, 199–200, 199*fig.*

Brotherhood of Man (1946), 17, 18, 63, 132–33, 136, 154–55

Brown, Milton, 44

Bruno, Giuliana, 71, 215

Building for Modern Man (Creighton), 231n13

Building Friends for Business (1949), 218n12

Burtin, Will: animation as narrative, 143; condensation principles, 121, 130–32, 137, 150, 158; space in graphic design, 153; visual perception theories, 118

Calinescu, Matei, 8
Campany, David, 200, 246n81
Campbell, Jan, 168
Cannata, Dolores, 66
Cannon, Robert (Bobe), 1, 34, 154
Capra, Frank, 133, 138, 154
Care-free Homes, 88–91, 101, 104
Cartoon Brew (blog), 214
Case Study House Program, 67–68, 83
centerline animation, 30, 55, 229n119
Cerasulo, Tom, 176
character designs: condensation and flatness of, 161; dematerialization of, 109–11, 154; personification for condensation explanation, 133; psychological realism for, 52, 55, 56, 102, 155; squash-and-stretch, 55, 229n119; UPA style of, overview, 30, 55–56
Christopher Crumpet (1953), 22, 105, 112–14, 113*fig.*, 160
Christopher Crumpet's Playmate (1955), 105, 105*fig.*, 187–88
chronophotography, 242n106
Chuey House, 97–98, 98*fig.*, 100
Church Street El (Sheeler), 31, 33*fig.*
Cinema 16, 191–92
cinema (film): animated shorts for prefilm entertainment, 3–4, 164, 165; with animation, 145–46, 149–53, 164–65, 176, 178, 241n89; animation comparisons, 66–67; animation's relationship to, 173–75; with animation sensibilities, 198; as architectural, 66; architectural animation relationship to early, 73; color liberation and predictions for, 78; Cubist-abstract, 30–31; design gaze principles for, 168–73, 175, 208–9; everyday/vernacular modernism and impact of, 10; extraperceptual condensation in, 239n50; film advertising graphics for, 147–48; film criticism methods, 170–71; midcentury modernist design principles impacting, 165–66, 178–80; midcentury style descriptions in, 226–27n62; military training and limitations of, 130–32; modernist influences on, early, 175–78; modernist representations in, 178; pedagogical purpose of, 207–9; production process, 173, 208; theater experiences and spatial relationships, 71–73; time condensation and, 145–46, 149–53, 150. *See also* avant-garde (experimental) cinema; musicals
cineplastics, 72, 73, 171–72
"Claims of Psycho-Analysis to Scientific Interest, The" (Freud), 124–25
Clarke, C. F. O., 134
Clarke, Shirley, 193–96
Colomina, Beatriz, 101, 244n42
color: advancing/receding properties of, 48, 87–93; for emotional expression, 78–79, 81–82; for film stage sets, 178, 186–89, 193–94, 196–97; health benefits of, 77, 85–86; liberation of, animation experimentation, 78–82; liberation of, architectural experimentation, 82–85; liberation of, as art/design trend, 76–78; static movement and visual perception of, 34–36; transparency and use of, 107, 108, 109–10
Columbia Pictures, 1, 3–4, 207
commercials, 4, 11, 16–17, 60, 166
communication: as animation function, 51–55, 59, 65, 76, 119, 121, 207–9; animation methods of, 66–67, 120, 125, 127, 142, 143; architectural animation for, 75; design principles for, 116–18, 125; Freudian condensation's impact on, 125; as graphic design function, 117, 121, 126, 129, 133; line expression as, 96; postwar ideological education through, 16–17, 49–50, 59, 60, 72
Communications Primer (1953), 66
Communism, 3, 19, 25, 63, 176
condensation (compression): animation and types of, overview, 132; animation as general example of, 160–63; cinematic limitations of, 130–32; concepts of, 137–38; of Cubism perspective, 30, 155; definitions and descriptions, 116–17, 119–21; as design principle, 116, 117;

condensation (compression) *(continued)* graphic design theories on, 123; of material into images, 132–38, 160; psychological theories on *(see* Freudian condensation); purpose and benefits of, 117, 121, 127–30, 133, 137; of space and spatial scales, 153–60, 161–62; superimposition, 138–44, 162–63, 196, 242n106; of time, 140–42, 144–53

Constructivism, 19, 27, 38, 41

consumerism: as animation theme, 160–63; architectural designs based on, 72; Art Deco style and femininity trends in, 177; commercial advertising, 4, 11, 16–17, 60, 166; midcentury modernism resurgence, 211–12, 213; postwar ideological rehabilitation and, 16–17, 18–19; postwar modernism style development based on, 2–3, 7, 9, 57; vernacular Precisionism and, 46. *See also* advertising

Container Corporation mural (O'Brien), 146–47, 147*fig.*

corporate modernism, 8–9

Corwin, Sharon, 43

Crafton, Donald, 174–75

Crary, Jonathan, 58

Crawford, Ralston, 43, 45, 61–62

Creative Arts Studio, 155

Criss, Francis: *Jefferson Market Court House,* 61

Cubism: Davis art style descriptions, 43, 45, 46; perspective styles of, 30, 140, 155; Precisionist comparisons, 26, 27, 29, 45; as UPA influence, 22; UPA style comparisons, 30–31, 57

Culler, George D., 121

Curtis, David, 193

Curtis, Scott, 208

D.O.A. (1949), 204–5, 205*fig.*

Dada, 27

Daggett, Charles, 79, 88, 95, 120, 211, 240n79

Dark Corner, The (1946), 203

Date with Dizzy, A (1956), 62

Davis, Stuart: art philosophies, 46–48; art style classification, 41–46; color theory and spatial perception, 48–49; *Eggbeater* series, 42, 43, 47, 226n64; influences on, 47, 62–63; *Men and Machine,* 50*fig.*, 51; mural commissions, 227n76; *Rue des Rats No. 2,* 48*fig.*, 50–51

Deitch, Gene, 13, 53, 62, 91–93, 151–52, 218n12

dematerialization, 106–7, 109, 179–201, 188, 203

democratic modernism, 15, 16–17, 19, 49–50, 176

Demuth, Charles, 25, 27, 42

DePatie, David, 164

Deren, Maya, 165, 191, 192

"Design for Music" (Gruber), 128

design gaze, 168–73, 175, 208–9

Designing Dreams (Albrecht), 177

Designing Women (Fischer), 177

Desperate Housewives (television show), 212

Destination Earth (1956), 137, 143–44

Dickinson, Preston, 42, 43

Dimendberg, Edward, 197–98

Disney, Walt, 52, 63, 218n8, 228n101

Disney Studios: abstract experimentation films, 78; animation style and production practices, 218n17; artists of, 218n19; art style criticism and debates, 23, 51–52, 63, 228n103; character design descriptions, 55; color philosophies, 77–78; labor strikes, 3, 19, 52, 218n8, 223n6; modernist style productions, 4, 228n101; music style of, 62; science-themed animated films, 154; spatial representation style, 73; time condensation effects, 152; visual reality of, 56

Dmytryk, Edward, 197

Doane, Mary Ann, 242n106

Donen, Stanley, 179, 182–86, 188–89

Doss, Erika, 176

Double Indemnity (1944), 203, 204, 204*fig.*

Dove, Arthur G., 41–42

Dream of the Rarebit Fiend (1906), 238n31

dreams, 125, 140, 238n31. *See also* Freudian condensation

Duchamp, Marcel, 26

Dufy, Raoul: animated short films on, 22, 180; *Place de la Concorde, La,* 180; as UPA animation influence, 2, 22
Dulles International Airport, 67, 96
Dwell (magazine), 211
Dynamics of Architectural Form, The (Arnheim), 94, 95, 111–12, 233n44

Eames, Charles, 65–68, 76, 106, 191
Eames, Ray, 66–68, 76, 106, 191
Eames House, 67–68, 106
education: animation for architectural design, 76; animation for public, 3; as animation function, 3, 49, 51–55, 59, 60, 207, 209; architectural animation for, 75; as art/design purpose, 126–27; as film function, 66, 207–9; postwar ideological rehabilitation through, 16–17, 49–50, 59, 60, 72; training films, 3. *See also* military training; rhetorical modernism
Edwards, Blake, 164–65
Eggbeater series (Davis), 42, 43, 47, 226n64
Eggeling, Viking, 78
Eisenstein, Sergei, 77–78, 79, 87, 104
Eisenstein on Disney (Eisenstein), 77–78
"Electronics—A New Science for a New World" (booklet), 156
emanation (directional vectors), 69, 93–111, 193, 195–96
emotion: character design and inner psychology, 55, 56, 102; color used for, 78–79, 81–82
Emperor's New Clothes, The (1953), 235n84, 242n2
"Emperor's New Clothes, The" (story/film), 102
Energetically Yours (1957), 155
Engel, Jules, 61
Erdoes, Richard, 138–39
everyday (vernacular) modernism, 9–10, 45, 46, 60
excess, film, 170
Expanding Airport, The (1958), 67, 68*fig.*, 76
exploitation cinema, 207–8
extraperceptual/sensatory realities, 127–28, 130, 137, 140

Falkenstein, Claire, 154
Fantasia (1940), 78
fantasy: as animation component, 73, 125; condensation and extra-sensatory reality as, 130; consumer culture and, 57; in early modern cinema, 73; musicals and song interludes, 179–80; superimposition comparisons, 140
Faure, Elie, 72, 73, 171–72, 231–32n17
Fauvism, 22, 27
Federal Art Project, 25
fetishism (film criticism method), 170
Few Quick Facts about Fear, A (1945), 3
Few Quick Facts about Inflation, A (1944), 3
Fifty-First Dragon, The (1954), 79–80
film. *See* avant-garde (experimental) cinema; cinema; musicals
Film Acting (Pudovkin), 221n46
"Film Advertising" (Bass), 147–48
film criticism, 170–71
filmic modernism, 178
film noir, 196–98, 199–201, 202–6
film societies, 191–92
Fischer, Lucy, 177, 178, 179
Fischinger, Oskar, 78, 135
Fisher, David, 56–57, 61
Flat Hatting (1946), 11, 192
flatness: of color fields, 80–81; condensation producing, 161; of film stage design aesthetics, 181, 182, 183–84, 186, 188, 203; Precisionism and, 33; spatial perception of, 73–74, 81, 87; as UPA defining characteristic, 31–32
Flebus (1957), 80–82, 122
Flowers of Evil, The (book cover design), 134
Ford Motor Company, 208
For Scent-imental Reasons (1949), 217n1
Fortune (magazine), 130
Foster, Richard, 191
Four Poster, The (1952), 65, 145–46, 149–53, 151*fig.*
Four Wheels No Brakes (1955), 242n2
Franke, Herbert W., 128(238n41), 153, 159–60
Franklin, Peter, 177
Freleng, Friz, 164
Freud, Sigmund, 122. *See also* Freudian condensation

Freudian condensation: communication impact of, 125–27; composite structures as method of, 135–36, 136–37; graphic design/animation comparisons, 123–24, 125; process descriptions, 117–18, 122–23, 124–25; purpose of, 129–30; sociality of visualization, 125; superimposition as method of, 138, 142–43, 144; of time, 144–45, 152

Friedberg, Anne, 71, 72

Friedman, Martin: Davis art style descriptions and classification, 42, 43–44; Precisionism style and themes, 26, 27, 28, 45; UPA style descriptions, 30

Friedrichstrasse Skyscraper Project (Mies van der Rohe), 104

Fudget's Budget (1954), 22, 51, 51*fig.* 160–63, 163*fig.*

Fuller, R. Buckminster, 70

Funny Face (1957), 179, 184–86, 185*fig.*

Futurism, 27

gag-dependent cartoons, 56

gaiety, 104

Gaudreault, André and Philippe, 175

gaze, 168–73, 175, 208–9

Geisel, Ted (Dr. Seuss), 1, 59

General Dynamics, 157

General Electric, 156–57

Genter, Robert, 10, 173

Gerald McBoing Boing (1951): animation style descriptions, 57, 120; awards, 1, 4; directional vectors/emanation, 99–100, 99*fig.*; modern-day versions of, 210; modernist representations *vs.* architectural style, 178; musical set designs compared to, 187; plot descriptions, 1; public reception and reviews, 1, 217n4; reputation of, 225n32; space and scale condensation, 154; spatial perceptions of, 32–33, 34, 35, 36, 37*fig.*; transparency and spatial perceptions, 107–8, 107*fig.*

Gerald McBoing! Boing! on Planet Moo (1956), 95–96, 97, 160, 217n1

Gerald McBoing Boing's Symphony (1953), 110, 210

German Expressionism, 203, 205

Gestalt psychology, 14, 37, 47

Gid, Raymond, 148

Giedion, Sigfried: architectural animation potential, 323; on Bayer, 156; color liberation, 76–77; directional vectors/emanation, 93–94, 95–96, 99; influence of, 70; transparency and spatial perceptions, 103

Gilbreth, Frank and Lillian, 28, 46, 208

Gillespie, Dizzy, 62

Giovaccini, Saverio, 176

Giusti, George, 127–28

"Glamourized Houses" (*Life* magazine), 101

Goethe, Johann Wolfgang von, 71

Gogh, Vincent van, 180

Goldsholl, Morton and Millie (Goldsholl Design Associates), 212

Golec, Michael, 109, 201, 221n44

"Good Design—An Important Function of Management" (Paepcke), 146–47

Goodman, Charles M., 88–91

googie architecture, 96

Gordon, Alastair, 96, 104, 110–11

graphic design, 120–21, 153–54, 166–67. *See also* graphic design as condensation

graphic design as condensation: definition and descriptions, 116–19, 120–21; as extraperceptual visualization, 127–28, 130; function of, 117, 121, 126, 129, 133; material into images, 132, 134; for military training, 130–32; of musical stage sets, 179–85; of space and scale, 156–57; superimposition, 138–40, 144; of time, 146–48

Graphis (journal), 119, 127–28, 134, 138–39, 146–57

Greenberg, Clement, 190

Grieveson, Lee, 208

Gropius, Walter, 71, 103, 104

Gruber, L. Fritz, 128

Gutkind, E. A., 121–22, 154

Haffenrichter, Hans, 128

Halas, John, 60, 220n27

Halpern, Orit, 9, 12, 14

Hansen, Miriam, 10, 176–77

Harwood, John, 9

Hathaway, Henry, 203

Havenhand, Lucinda Kaukas, 67–68

Hediger, Vinzenz, 209

Hell-Bent for Election (1944), 11, 18, 63, 218n9
Hemo the Magnificent (1957), 154
high modernism, 10, 18–19, 220n31
Hilberman, David, 3, 4, 6
Hirsch, Stefan, 39
Hitchcock, Alfred, 178
Hochschule für Bildende Kunst, 100
Hollywood (Benton), 176
Hollywood modernism, 176–77
Hollywood Quarterly (magazine), 5, 135
House Un-American Activities Committee (HUAC), 19, 63
Howe, George, 70–71
How Now Boing Boing (1954), 22
How to Succeed in Animation (Deitch), 62
HUAC (House Un-American Activities Committee), 19, 63
Hubley, Faith, 19
Hubley, John: animation, function of, 55, 121, 228n103; animation style descriptions, 6, 7, 31, 34*fig.*, 49*fig.*, 50–51; artistic style debates, 228n103; blacklist of, 19; bookplate design commissions, 114–15; character designs, 56, 102, 155; condensation techniques, 119–20, 121, 137, 142, 145–46, 149–53; design philosophies, 228n103; film society networking, 192; influences on, 13, 14–15, 53; music scores for, 62; UPA studio management, 4. See also "Animation Learns a New Language" (Hubley and Schwartz)
Hurtz, Bill, 13, 32–33, 53, 133, 138, 154

Industrial Film and Poster Service. *See* UPA (United Productions of America)
industrialization, 25–26, 27–28
Information Machine, The (1958), 66
inside-outside concepts: animation and spatial representations, 113, 161–62; of architectural design, 83–85, 86, 94, 97–98, 101–4; character design and psychological realism, 52, 55, 56, 102, 155
Institute of Contemporary Art, Manitoba, 212
Institute of Design, Chicago (New Bauhaus), 12–13, 15, 17, 18, 36–37, 55
"Integration, the New Discipline in Design" (Burtin), 158

International Design Conference, Aspen, 121, 153–54, 165
International Style, 76, 86
International System of Typographic Picture Education (isotype), 239n59
inverse-reality dynamic, 56, 58
invisibility: animated environments and dematerialization, 106–8; as animation theme, 105; condensation and extra-sensatory realities for, 14, 117, 127–28, 130, 137, 153
Invisible Moustache of Raoul Dufy, The (1955), 22, 180
isotype (International System of Typographic Picture Education), 239n59
It's Everybody's Business (1954), 155–56

Jacobson, Brian, 72, 73
Jacobson, Egbert, 146
Jamaica Daddy (1957), 218n18
James, David E., 193
Jameson, Frederic, 168, 211
Jam Handy Organization (JHO), 151–52, 218n12
Jaywalker, The (1956), 62, 122, 217n1
jazz, 62–63
Jefferson Market Court House (Criss), 61
Jenkins, Bruce, 108
Jewell, Edward Alden, 26
JFK International Airport, 96, 104
John Sutherland Studios, 137, 143–44, 152, 154, 155–56
jokes, 56, 117–18, 122, 124, 125, 238n33
Jones, Chuck, 134–35

Katsumi, Masaru, 221n44
Keating, Patrick, 203
Kelder, Diane, 29, 47
Kelly, Gene, 179, 180, 182–84, 183*fig.*, 184*fig.*, 188–89
Kepes, György: on Abstract Expressionism, 225–26n48; art style descriptions, 8–9, 220n32; design philosophies and theories of, 37, 121, 123, 169; ideologies of, 18; influence of, 13–15, 24, 36–37, 53, 149, 167, 212; influences on, 14, 37, 47; nightscape urban camouflage designs, 200. *See also Language of Vision*

Kepes Institute, Museum, and Cultural Center, 212
Kidder-Smith, G. E., 110
Klee, Paul, 2, 22
Klein, Norman M., 31, 34, 36, 56, 57–58
Klein, William, 198–200
Kolker, Robert Phillip, 242n3
Kovács, András Bálint, 226–27n62
Krisel, William, 97
Kubrick, Stanley, 164
Kula, Elsa, 13

Lake Shore Mill Container Corporation mural (O'Brien), 146–47, 147*fig.*
landscape gaze, 168–69
Lane, John R., 46, 47
Langner, Siegbert, 100
Language of Vision (Kepes): color theories and spatial perception, 48, 87; content descriptions, overview, 37–38; influence of, 13–15, 37, 53–55, 66, 70; plasticity, 172; Precisionist principles compared to, 38–40; purpose of design, 14–15, 38–40, 46–48, 48, 55, 126; visual language development, 54–55, 58, 64, 142; visual perception/design theories, 108, 109, 111, 123, 200–201
"Language of Vision: The Nuts and Bolts" (Eames, C.), 66
late modernism, 10, 11
Late Modernism: Art, Culture, and Politics in Cold War America (Genter), 10
Laughlin, James, 134
Lavin, Sylvia, 97
Lefebvre, Martin, 168–69
Léger, Fernand, 30–41, 76–77, 141, 232n21, 233n40
Le Grice, Malcolm, 192–93
Leslie, Esther, 31, 59, 73, 74, 206
Lessing, Laurence: animation as narrative, 143; condensation principles, 121, 130–32, 137, 150, 158; space in graphic design, 153
Lewis, Joseph H., 203
Lhamon, W. T., 8
Lichtspiel: Opus series (1921–1925), 233n40
Life magazine, 101, 176
Light Prop for an Electric Stage (Light Space Modulator) (Moholy-Nagy), 201, 202*fig.*, 203, 205, 234n52
light-space modulation: architectural designs using transparency for, 83–86, 97–98; cartoon themes of, 201; in film noir cinema, 198, 199–201, 202–6; sculptural works for, 201, 202*fig.*, 203, 204
limited animation: development motivation for, 128–29; production descriptions, 128–29, 130; purpose of, 64, 66; style descriptions, 5–7, 32–33, 69, 114; television and, 60; as UPA style distinguishing feature, 74
line: directional (emanation), 69, 93–101, 111, 193, 195–96; expressive qualities of, 55, 95
literary modernism, 176–77
Little House, The (1952), 152
Little Nemo in Slumberland (1911), 238n31
Little Orphan, The (1948), 217n1
Longest Journey, The (book cover design), 134
Looney Tunes, 135, 201
Lozowick, Louis: art style descriptions, 25–26, 27, 28, 31, 41, 45, 46; design philosophies, 28, 39; influences on, 53; *New York, Brooklyn Bridge*, 31, 32*fig.*
Lugon, Olivier, 72
Lustig, Alvin, 115–16, 117, 134

Mad Men (television show), 211, 212
Magazine of Art, 75
Magic Fluke, The (1949), 4, 217n1
Magoo's Puddle Jumper (1956), 217n1
Malle, Louis, 198
Man Alive! (1952), 11
Manchester (Sheeler), 140
Mannes, M., 28
Man on the Flying Trapeze, The (1954), 242n2
Manovich, Lev, 173, 174, 175, 191
Man with a Movie Camera (1929), 141–42
Man with the Golden Arm, The (1955), 148
Marchand, Roland, 103
Marey, Étienne-Jules, 242n106
Marshall, George, 178, 186–89

Martin, Reinhold, 8–9, 13, 17, 72, 212, 233n46
Marvin the Martian (cartoon character), 201, 203
Massachusetts Institute of Technology (MIT), 16, 37, 66
"Mass Production of the Senses: Classical Cinema as Vernacular Modernism, The" (Hansen), 176–77
Maté, Rudolph, 204–5
May, Billy, 62
Mayerson on Animation (blog), 214
McCay, Winsor, 73, 238n31, 241n89
McLaren, Norman, 165
"Meep Meep" (Thompson), 56
Méliès, Georges, 72, 73
Melody (1953), 4, 228n101
Men and Machine (Davis), 50fig., 51
metamorphosis: of architectural animation, 69, 84, 100–101; definition and descriptions, 74–75, 119; superimposition condensation as, 142–43; time condensation of, 150
metaphor, 137–38
MGM, 179, 183, 217n1
Michelson, Annette, 190
microphotography, 128
midcentury modernism, overview: architectural animation impacted by, 70, 72; cinema influenced by, 178; cultural prevalence and movement popularity, 2–3, 11, 15, 213; descriptions, 7–8; design influences and developments, 12–15; early modernism comparisons to, 15; forms of, 8–10, 220n31; ideological developments and goals of, 15–20; modern-day resurgence of, 211–12; postwar sensory rehabilitation, 16–17, 49–50, 58–59, 60, 72; as UPA art style context, 7–12
Mies van der Rohe, Ludwig: Friedrichstrasse Skyscraper Project, 104
military training: animated films for, 3, 5, 11, 16, 53, 58, 192, 207; live-action films for, 130, 132; manuals for, 130–31, 131fig.
Minnelli, Vincente, 179–81, 183, 209
Mister Magoo's Christmas Carol (1962), 200

MIT (Massachusetts Institute of Technology), 16, 37, 66
modern art: animated short films on, 22, 180; as animation influence, 22; animation relationship with, 2–3; color usage theories, 76–77; design influences on, 12–16; modernist distinctions in, 10; paintings as film backgrounds, 180; politics and, 19; postwar developments, 24–25. *See also* Cubism; Precisionism
modernism, 11–12, 15, 175–78, 245n49. *See also* midcentury modernism
Moholy-Nagy, László: art style descriptions, 8–9, 220n32; color theories, 78–79; design philosophies, 59; design theories, 75, 109, 111, 140; exhibitions on, 212; influence of, 12–15, 149, 212; *Light Prop for an Electric Stage (Light-Space Modulator)*, 201, 202fig., 203, 205, 234n52. *See also Vision in Motion*
Molella, Arthur P., 82–83
MoMA. *See* Museum of Modern Art (MoMA)
Moore, Phil, 62
movement/motion: animation techniques for, 34–35, 69, 74–75, 154, 188; architectural designs and perception of, 67–71, 74; color liberation and perception of, 76–87; color theory and perceptions of, 48, 76, 87–93; directional vectors and emanation for, 67–68, 69, 93–111, 193, 195–96; theatrical experiences and spectator roles, 71–72; transparency and perceptions of, 84–86, 97–98, 103, 105–6, 106, 110–11
Mr. Freedom (1969), 198
Mr. Magoo (cartoon character): animated shorts featuring, 32, 35fig., 217n1; animation style descriptions, 32, 61, 78, 200; commercials featuring, 11; television cartoon series featuring, 4, 32
Mr. Magoo Show, The (television cartoon series), 4, 32
Mulvey, Laura, 168, 243n20
Murder My Sweet (1944), 197

Museum of Modern Art (MoMA): animated short films commissioned by, 22, 180; animation exhibitions at, 4, 21–23, 33, 165, 189–90
music, 62–63, 71, 128, 134, 135
musicals: advertising posters in, 179; animation-style set designs, 33, 180–84; color fields for set designs, 178, 186–89; French modern painting reproductions in, 180; light-space modulation and film noir effects, 196–97; modernist aesthetics of early, 245n49; musical number interludes, 179–80
"Music and the Animated Cartoon" (Jones), 134–35

Nafus, Chale, 198
Naremore, James, 180
Nellie Bly (cartoon character), 56, 137
Neurath, Otto, 239n59
neurosis, 63, 80, 91–92, 122, 123
Neutra, Richard: color theory, 85–86, 88, 90, 91, 93; directional vectors, 94, 97–98, 98*fig.*, 100, 102; transparency, 105–6, 109; visual and spatial perception theories, 70, 94, 102, 111
New Bauhaus (Institute of Design, Chicago), 12–13, 15, 17, 18, 36–37, 55
New Directions paperbacks, 115, 134
New England Irrelevancies (Sheeler), 140
New Landscape in Art and Science, The (Kepes), 123, 200
"New Landscape in Art and Science, The" (Kepes), 38
New School for Social Research, 47
New Vision and Abstract of an Artist, The (Moholy-Nagy), 78–79, 111
New York: 1954–1955 (Klein), 199
New York, Brooklyn Bridge (Lozowick), 31, 32*fig.*
Nieland, Justus: midcentury modernism descriptions, 9, 11, 12, 54, 63; midcentury modernist ideologies, 15, 17, 19
"Nine Points on Monumentality" (Giedion and Léger), 232n21
Nitsche, Erik: *Atoms for Peace* poster series, 157

Northwest Airlines Terminal (JFK International Airport), 104
Northwestern University, 212
Now Hear This (1946), 134–35
nuclear energy, 138, 153, 154, 157–58

O'Brien, Katherine: Container Corporation mural, 146–47, 147*fig.*
obtuse meaning (film criticism method), 170
Oeri, Georgine, 127–28
O'Keeffe, Georgia, 27, 41–42
O'Neill, Pat, 192–93
Oompahs, The (1952), 62
order and organization: architectural animation and spatial, 75; design philosophies on, 14–15, 38–39, 48, 49; as midcentury modernist style descriptions, 14–15, 52; of postwar animation, 31, 34, 58, 60–61, 64; of Precisionism, 28, 44, 60–61
Ore into Iron (Sheeler), 140
Organizational Complex, The (Martin), 212
Our Friend the Atom (1957), 154
Our Mr. Sun (1956), 133, 154

P.M. East (talk show), 144
Paepcke, Walter, 146
Painting, Photography, Film (Moholy-Nagy), 109
Pan-Am (television show), 211
Parmelee, Ted, 165–66, 235n84, 242n2
Paths of Glory (1957), 164
Penpoint Percussion and Dots (1951), 165
perspective: animation style descriptions, 30, 31–32, 59, 61–62, 64, 158, 182; color fields for, 80–82, 92–93; Cubist, 30, 140, 155; film set designs, 188–89; Precisionist and post-Precisionist, 31, 43, 61–62, 64; spatial condensation and scale for, 155–60, 162
Peterson, James, 190
photography, 53–54, 101, 128, 149–50, 242n016
Picabia, Francis, 22, 25, 78, 233n40
Picasso, Pablo, 22
Piel's Beer commercials, 11, 60

Pink Panther, The (1964), 164–65
Pink Phink, The (1964), 164
Pintoff, Ernie, 80–82
Place de la Concorde, La (Dufy), 180
playfulness, 51, 60–61
political campaign films, 11, 18, 63, 218n9
political ideology, 14–17, 45, 49–50, 52, 176
possessive/pensive spectatorship, 243n20
Precisionism: artist classification challenges, 42–46; art style descriptions, 23, 26, 28, 44, 61–62; criticism of, 40; decline of, 40–41, 45; development of, 25–26; historical context of, 22, 24–25; influences on, 26–27, 45; philosophies of, 29, 38–40, 43, 48; post-period style spin-offs of, 41; postwar resurgence in animation, 52–53, 61–64; subject matter/themes of, 27–28; term origins, 26; time period of, 45–46; UPA animation style comparisons, 22–24, 31–36, 50–53, 61–64
Precisionist View in American Art, The (exhibition), 42
Print (journal), 13, 119, 123, 134, 153–54
profilmic modernism, 178, 179
Prokosch, Walther, 104
psychology: animated characters featuring inner, 52, 55, 56, 102, 155; architectural design impact on, 104; as cartoon theme, 63, 80, 91–92, 106–7, 122, 123, 140–41; color impact on, 77, 85–86; Freudian condensation theories, 117–18, 122–27, 129–30; perceptual theories in, 14, 37, 47; postwar social engineering and rehabilitation, 16–17, 49–50, 59, 60, 72
Public Works of Art Project, 25
Pudovkin, Vsevolod, 221n46
Pump Trouble (1954), 91–93, 92*fig.*
Punchy de Leon (1950), 31, 34*fig.*

race relations, as animation theme, 17, 63, 132–33, 136
Rawlinson, Mark, 43, 140
Ray, Robert, 170, 172
Record Changer, The (magazine), 62
Red Garters (1954), 178, 186–89, 187*fig.*, 188*fig.*

Red Scare, 19, 63, 176
reductive abstraction: as animation style, 35–36, 64; as architecture style, 108; in cinema, 179, 182–83, 193, 196, 197, 200, 203; as modern art style, 26. *See also* condensation; limited animation
Reens, Anneke, 75
Reis, Irving, 145–46, 149–51, 152–53
"Revision of the Theory of Dreams" (Freud), 152
Rhapsody of Steel (John Sutherland Studios 1959), 152
rhetorical modernism: animation function, 3, 11, 209, 214, 220n33; art as, 10; in cinema, 207–9; design gaze comparisons, 173; postwar ideological rehabilitation, 16–17, 49–50, 59, 60, 72
Rieder, Howard, 34, 61
Rise of Duton Lang, The (1955), 109–10, 110*fig.*
Robé, Chris, 176
Robin Hoodlum (1948), 3–4, 217n1
romantic modernism, 10, 220n31
Roosevelt, Franklin D., administration, 3, 11, 25, 63, 218n9
Rooty Toot Toot (1952), 49*fig.*, 50–51, 56, 62, 137
Rose, Barbara, 36
Rousseau, Henri, 180
Rue des Rats No. 2 (Davis), 48*fig.*, 50–51
Russian Constructivism, 19, 41
Ruttman, Walter, 78

Saarinen, Eero, 67–68, 96, 227n76
Samuel, Lawrence, 122, 126–27
Saperstein, Henry, 4
scale, 80–81, 155–60, 161
Schamberg, Morton, 25, 226n61
Schleier, Merrill, 39
Schrader, Paul, 66
Schuldenfrei, Robin, 17, 18, 55, 59
Schwartz, Zack: animation and graphic design comparisons, 120–21; animation style development, 6; influences on, 13, 14–15; UPA departure, 4; UPA founding, 3. *See also* "Animation Learns a New Language"

science: as animated film subject, 154, 160; design experimentation comparisons, 59; nuclear energy, 138, 153, 154, 157–58; postwar ideological developments and, 16; spatial knowledge development, 153; vision enhancement technology, 14, 117, 153

Screen Gems (Columbia Pictures), 1, 3–4, 207

Searching Eye, The (1964), 149

Sensing the Future: Moholy-Nagy, Media, and the Arts (exhibition), 212

Seuss, Dr. (Ted Geisel), 1, 59

7362 (1965–1967), 192–92, 194*fig.*

Severud, Fred N., 76

Shaefer, Eric, 207–8

Sheeler, Charles: art classification designation, 42, 46; art philosophies, 64; art style descriptions, 25, 27, 28, 31, 35–36, 41, 45, 62; *Barn Abstraction*, 35, 36, 36*fig.*; *Church Street El*, 31, 33*fig.*; *Counterpoint*, 140; graphic condensation techniques of, 139–40; Kepes' article review, 38; *Manchester*, 140; *New England Irrelevancies*, 140; *Ore into Iron*, 140; *Windows*, 140

Shulman, Julius, 98*fig.*, 100, 101

Sims, Lowery Stokes, 62

Singal, Daniel, 8

Singer, Benjamin, 12

Singin' in the Rain (1952), 182–84, 183*fig.*, 184*fig.*, 188–89

Sitney, P. Adams, 190

sound, graphic representations of, 134–35

space: animation styles and perceptions of, 31–33, 73; color for manipulation of, 48, 78–81, 87–93; condensation of scale and, 154–62; design gaze analysis of, 168–69; expansion of, 153–54; film stage set decorations and perception of, 178, 181, 183–84, 186–89, 193–201; postwar science research on, 153; time as spatialized, 70, 140–42, 143, 152, 153; visual perception theories on, 111–12. *See also* light-space modulation; movement/motion; perspective; transparency

Space, Time, and Architecture (Giedion), 70, 93–94

Sparks and Chips Get the Blitz (1943), 3

spectatorship: film criticism practices of, 170–71; gaze theory, 168–73, 175, 208–9; theatrical architectural experiences of, 71–73

Spencer, Niles, 25–26, 27, 28, 46, 61

Spigel, Lynn: animation as moving graphic design model, 165; everyday modernism, 9–10, 60; midcentury modernism visual culture development, 12, 166–67, 169, 171, 213

Spigelgass, Leonard, 59

Spy from Mars!, The (1958), 155

squash-and-stretch, 55, 229n119

Stage Door Magoo (1955), 32, 35*fig.*

Stanitzek, Georg, 147

staticity (stillness), 34–35, 69, 71–72, 74, 85–87

Stauffacher, Frank, 191, 192

Stavitsky, Gail: architectural staticity, 225n43; Davis art classification designation, 41, 43, 44; Precisionism decline, 40; Precisionist art style descriptions, 26, 28–29; UPA defining characteristics, 31

Stella, Joseph, 25–26, 39

Storyboard, 19

Strange Case of the Cosmic Rays, The (1957), 133, 137*fig.* 138, 154

Streetcar Named Desire, A (book cover design), 134

superimposition, 138–44, 162–63, 196, 199, 242n106

Suprematism, 38

Surrealism, 27, 29, 41

Survival through Design (Neutra), 85–86, 111

Sutherland, John, 137, 143–44, 152, 154, 155–56

Symphonie Diagonale (1924), 233n40

Synthetic Cubism, 43

Tashlin, Frank, 178, 245n57

Tate Modern, 212

Taylor, Frederick Winslow, 28, 46

television: animation programs for, 4, 60, 210–11; animation styles for, 59–60, 223n4; commercials for, 4, 11, 16–17,

18–19, 60; early practices in, 166–67; everyday modernism enabled by, 9–10; midcentury modernism resurgence on, 211–12; talk show opening titles as superimposition, 144

Tell-Tale Heart, The (1953): architectural dematerialization, 106–7, 188; condensation techniques, 140–41, 141*fig.*; director of, 242n2; modernist representations *vs.* architectural style, 178; musical set designs compared to, 188; spatial recession, 88

Telotte, J. P., 73

therapy and rehabilitation, 16–17, 49–50, 59, 60, 72

"Third Meaning, The" (Barthes), 170

"This Electronic World" (Bayer), 156–57

Thompson, Kristin, 170, 172

Thompson, Richard, 56, 58, 202

time condensation: in animation film interstitial sequences, 145–46, 149–53; descriptions, 144–45; for film advertising, 147–48; in graphic designs, 146–48; in live-action cinema, 148, 150; spatialization of, 70, 140–42, 143, 152, 153; superimposition for, 140–42, 143

Toot, Whistle, Plunk and Boom (1953), 4, 228n101

Toulouse-Lautrec, Henri de, 180

transparency: animation use of, 102, 104–5, 106–8, 109–10; in architectural design, 68, 84–86, 97–98, 101–4, 105–6, 110–11; as cinematic effect, 188, 193, 196, 197; visual perception theories and, 108, 109, 110

Trotter, David, 176

Tsujimoto, Karen, 226n62

Turner, Fred, 9, 16, 17, 72

Turvey, Malcolm, 239n50

TV by Design (Spigel), 166–67

TWA Flight Center (JFK International Airport), 96

"Two Premières: Disney and UPA" (Fisher), 56–57

Unchained Goddess, The (1958), 154

Understanding Animation (Wells), 120

Unicorn in the Garden, The (1953), 63, 122, 191, 234n67

United Artists, 164–65

United Auto Workers, 17, 132–33

United Film Productions. *See* UPA (United Productions of America)

United States Army, 3, 5, 16, 53, 200

United States Army Air Force, 11, 130–32, 131*fig.*

United States Navy, 192

University of California, Berkeley, 65

University of California, Los Angeles, 66

UPA: Form in the Animated Cartoon (exhibition), 4, 21–23, 33, 165, 189–90

UPA (United Productions of America, *formerly* Industrial Film and Poster Service, United Film Productions), overview: animation function, 65, 209; animation style descriptions, 1–2, 5–7, 30–35, 55–56, 57, 60–62, 74, 120; animation style development, 3, 4, 6–12, 58–59; animation style influences, 13–16, 22, 50–51, 62–63 19; architectural courses featuring animation of, 65; awards and nominations, 1, 4, 217n1; color usage techniques, 78; design philosophies, 57; history of, 3–5; influence of, 29–30, 214; museum exhibitions featuring, 4, 21–23, 33, 165, 189–90; Precisionist comparisons, 31, 32–35, 50–53, 61–64; public reception and reviews, 4, 23, 217n4; reviews, 4, 217n4; stock ownership, 66; studio logo designs, 115

utopianism: of architectural design, 70, 72, 75, 85, 103; design principles based on, 17, 18, 38, 40, 49–51, 118, 172–73, 209; postwar ideologies, 16

vectors and emanation: in animation, 69, 95–96, 97, 98–100; in architectural design, 69, 93–95, 96–98, 100–102, 111; in avant-garde cinema, 193, 195–96

vernacular (everyday) modernism, 9–10, 45, 46, 60

Vertigo (Hitchcock film 1958), 178

Vertov, Dziga, 141–42

Vision in Motion (Moholy-Nagy): color theories, 78, 87; condensation techniques, 116 (236n2), 138; influence of, 13–15, 70, 200; light-modulation principles, 201; spatial perception principles, 70; transparency principles, 103–4; visual perception/design theories, 14, 15, 142, 169, 193, 195–98

Vision + Value (Kepe), 222n57

"Visual Presentation—A Challenge to the Designer" (Roberts), 138–39

Vogel, Amos and Marcia, 191

Vonderau, Patrick, 209

Walker Art Center, 26, 42

Walker House, 83–85, 84*fig.*, 86, 106

Warhol, Andy, 46

Warner Brothers, 1, 55, 74, 134–35, 217n1

Wasson, Haidee, 207

Wechsler, Judith, 200

Wells, Paul, 52, 59, 60, 74, 120, 137

Wertheimer, Max, 47

Whitney, John, 178

Who Are You, Polly Maggoo? (1966), 198

Why Man Creates (1968), 149

Wicke, Jennifer, 5

Wiener, Norbert, 9

Wilder, Billy, 203, 204

Wilkin, Karen, 41–42, 44, 45

Wilson, Richard Guy, 226–27n62

Windows (Sheeler), 140

Wings for Roger Windsock (1947), 151–52

Wonder Gloves, The (1951), 22

Wood, Aylish, 112

Wright, Gwendolyn, 105–6

Youngblood, Gene, 9

Zack-David Corporation, 218n10

Zazie dans le Métro (1960), 198

www.ingramcontent.com/pod-product-compliance
Lightning Source LLC
Chambersburg PA
CBHW030528230426
43665CB00010B/811